:-Happy Painting Dorothy:-

John

:-Happy Painting Dorothy:-

THE ACRYLIC PAINTING BOOK

THE ACRYLIC PAINTING BOOK

By Wendon Blake/Paintings by Rudy de Reyna

WATSON-GUPTILL PUBLICATIONS/NEW YORK
PITMAN PUBLISHING/LONDON

Copyright © 1978 by Billboard Ltd.

Published in the United States and Canada by Watson-Guptill Publications, 1515 Broadway, New York, N.Y. 10036

Published in Great Britain by Pitman Publishing Ltd., 39 Parker Street, London WC2B 5PB
ISBN 0-273-01257-6

Library of Congress Cataloging in Publication Data
Blake, Wendon.
 The acrylic painting book.
 1. Polymer painting—Technique. I. De Reyna,
Rudy, 1914- II. Title.
ND1505.B55 1978 751.4'26 78-4263
ISBN 0-8230-0067-2

Manufactured in Japan

First Printing, 1978
Second Printing, 1980

CONTENTS

What Is Acrylic? The most important painting medium invented in the 20th century is acrylic. Every type of paint is actually a combination of three ingredients: powdered color called pigment; a liquid adhesive that blends with the powdered color and literally glues it to the painting surface; and a solvent that makes the paint even more fluid, then evaporates when the paint dries. With a few exceptions, the same pigments are used to make oil, watercolor, and acrylic paints. The liquid adhesive—or vehicle—in oil paint is linseed oil squeezed from the flax plant, and the solvent is turpentine. In watercolor, the vehicle is a water-soluble glue called gum arabic, and the solvent is water. In acrylic, the solvent is also water, but the vehicle is a liquid plastic.

Permanence. Artists have known about acrylics since the 1950s, when the first professionals began to experiment with the medium. The new plastic paint achieved worldwide popularity in the 1960s, when acrylic was discovered by art students and serious Sunday painters. The acrylic paintings produced in the 1950s and 1960s generally look as fresh as the day they were painted. They haven't darkened or cracked, as oil paintings sometimes do. And extensive tests conducted by manufacturers—subjecting acrylic paintings to tremendous wear-and-tear that "ages" the colors very rapidly—indicate that acrylic may be the most durable painting medium ever invented. Professional artists who use acrylic are confident that their paintings will remain unchanged for centuries.

Versatility. Acrylic is particularly remarkable for the variety of ways in which you can use it. Used straight from the tube, perhaps thinned with a touch of water, acrylic has a thick, creamy consistency, like a slightly more fluid version of oil paint. Diluted with much more water, acrylic produces washes of color as fluid and transparent as watercolor. Instead of diluting acrylic paint with water, you can add various painting mediums that will modify both the consistency and the appearance of the paint. One medium makes the paint dry as shiny as a newly varnished oil painting, while another makes it dry to a non-glossy finish, more like pastel. Still another medium will thicken the tube color so you can build up thick layers of paint with a knife or work with brushstrokes as juicy as those of Van Gogh.

Rapid Drying. Because the solvent for acrylic is water, the paint dries to the touch as soon as the water evaporates. This means that you can complete a painting in a matter of hours if you work fast. Equally important, you can pile on layer after layer of color, with just a brief wait between layers. As soon as one layer is dry, you can modify it or totally repaint it with a second layer—which won't disturb the first. This quality makes acrylic particularly good for glazing, which means brushing a transparent layer of color—thinned with water or medium—over a dried layer underneath. Suppose you're painting a portrait of a girl with a luxuriant head of curly hair. You finally get the *shapes* of the curls right, but the *color* isn't quite ruddy enough. You just let the first layer of paint dry, then glaze over it with a transparent, coppery mixture that intensifies the color but still reveals the carefully painted shapes underneath.

Equipment. If you already have the necessary equipment for painting in oil or watercolor, you have a lot of the equipment you need for painting in acrylics. The bristle brushes used for oil painting will do just as well for acrylic, provided that you lather them up carefully with mild soap and water to get rid of every trace of oil or turpentine. You can also use your watercolor brushes. But acrylic can be rough on those delicate, expensive sables, so use the less expensive oxhair, squirrel hair, or white nylon (which handles like natural sable). Acrylic will also stick to the same surfaces as oil or watercolor. The canvas sold in art supply stores *used* to be coated with white oil paint—which repels anything watery, such as acrylic color—but more and more canvas is now sold with a white acrylic coating (or priming) that's fine for acrylic painting. A similar coating is used on most inexpensive canvas boards, so these are suitable for acrylic. And any surface that's good for watercolor—watercolor paper, sturdy white drawing paper, illustration board—will be equally receptive to acrylic color. Just keep acrylic away from any surface that looks oily or waxy.

Convenience and Simplicity. Although every artist loves art supply stores and enjoys buying brushes, colors, and other gear, you really need very little equipment to paint in acrylics. A dozen tubes of color will give you a vast range of color mixtures. A half-dozen brushes will do practically every painting job. A couple of jars of water, a rectangle of illustration board or watercolor paper tacked to a drawing board, perhaps a jar of acrylic painting medium—and you're ready to paint.

Color Selection. The paintings in this book were all done with a dozen basic colors—colors you'd normally keep on the palette—plus a couple of others kept on hand for special purposes. Although the leading manufacturers of acrylic colors will offer you as many as thirty inviting hues, few professionals use more than a dozen, and many artists get by with fewer. The colors listed below are really enough for a lifetime of painting. You'll notice that most colors are in pairs: two blues, two reds, two yellows, two browns, two greens. One member of each pair is bright, the other subdued, giving you the greatest possible range of color mixtures.

Blues. Ultramarine blue is a dark, subdued hue with a hint of violet. Phthalocyanine blue is far more brilliant and has tremendous tinting strength—which means that a little goes a long way when you mix it with another color. So add it very gradually.

Reds. Cadmium red light is a fiery red with a hint of orange. All cadmium colors have tremendous tinting strength; add them to mixtures just a bit at a time. Naphthol crimson is a darker red and has a slightly violet cast.

Yellows. Cadmium yellow light is a dazzling, sunny yellow with tremendous tinting strength, like all the cadmiums. Yellow ochre (or yellow oxide) is a soft, tannish tone.

Greens. Phthalocyanine green is a brilliant hue with great tinting strength, like the blue in the same family. Chromium oxide green is more muted.

Browns. Burnt umber is a dark, somber brown. Burnt sienna is a coppery brown with a suggestion of orange.

Black and White. Some manufacturers offer ivory black, and others make mars black. The paintings in this book are done with mars black, which has slightly more tinting strength. But that's the only significant difference between the two blacks. Buy whichever one is available in your local art supply store. Titanium white is the standard white that every manufacturer makes.

Optional Colors. One other brown, popular among portrait painters, is the soft, yellowish raw umber, which you can add to your palette when you need it. Hooker's green—brighter than chromium oxide green, but not as brilliant as phthalocyanine—may be a useful addition to your palette for painting land-scapes full of trees and growing things. If you feel the need for a bright orange on your palette, make it cadmium orange—although you can just as easily create this hue by mixing cadmium red and cadmium yellow.

Gloss and Matte Mediums. Although you can simply thin acrylic tube color with water, most manufacturers produce liquid painting mediums for this purpose. Gloss medium will thin your paint to a delightful creamy consistency; if you add enough medium, the paint turns transparent and allows the underlying colors to shine through. As its name suggests, gloss medium dries to a shiny finish like an oil painting. Matte medium has exactly the same consistency, will also turn your color transparent if you add enough medium, but dries to a satin finish with no shine. It's a matter of taste. Try both and see which you prefer.

Gel Medium. Still another medium comes in a tube and is called gel because it has a consistency like very thick, homemade mayonnaise. The gel looks cloudy as it comes from the tube, but dries clear. Blended with tube color, gel produces a thick, juicy consistency that's lovely for heavily textured brush and knife painting.

Modeling Paste. Even thicker than gel is modeling paste, which comes in a can or jar and has a consistency more like clay because it contains marble dust. You can literally build a painting ¼" to ½" (6 mm to 12 mm) thick if you blend your tube colors with modeling paste. But build gradually in several thin layers, allowing each one to dry before you apply the next, or the paste will crack.

Retarder. One of the advantages of acrylic is its rapid drying time, since it dries to the touch as soon as the water evaporates. If you find that it dries *too* fast, you can extend the drying time by blending retarder with your tube color.

Combining Mediums. You can also mix your tube colors with various combinations of these mediums to arrive at precisely the consistency you prefer. For example, a 50-50 blend of gloss and matte mediums will give you a semi-gloss surface. A combination of gel with one of the liquid mediums will give you a juicy, semi-liquid consistency. A simple mixture of tube color and modeling paste can sometimes be a bit gritty; this very thick paint will flow more smoothly if you add some liquid medium or gel.

Bristle Brushes. For your acrylic paintings, you can use the same bristle brushes normally used in oil painting. The top brush is called a *filbert*; its long body of bristles, coming to a rounded tip, will make a soft, fluid stroke. The center brush is called a *flat*; its squarish body of bristles will make a squarish stroke. The bottom brush is called a *bright*; its short, stiff bristles can carry lots of thick paint and will make a stroke with a distinct texture. Bristle brushes are particularly good for applying thick color.

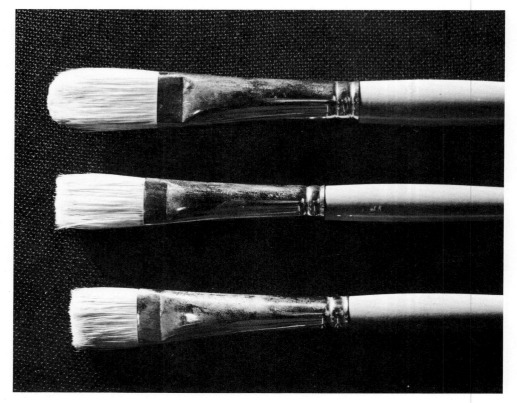

Softhair Brushes. For applying more fluid color—diluted with more water—many painters prefer softhair brushes. The top two are soft, white nylon; the round, pointed brush is good for lines and details, while the flat one will cover broad areas with big strokes. The third brush from the top is a sable watercolor brush, useful for applying very fluid color diluted with a lot of water. (You can also buy a big, round brush like this one in white nylon, which will take more punishment than the delicate sable.) The bottom brush is stiffer, golden brown nylon, equally useful for working with thick or thin color.

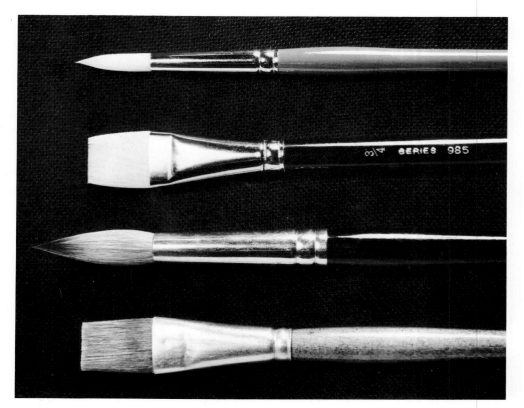

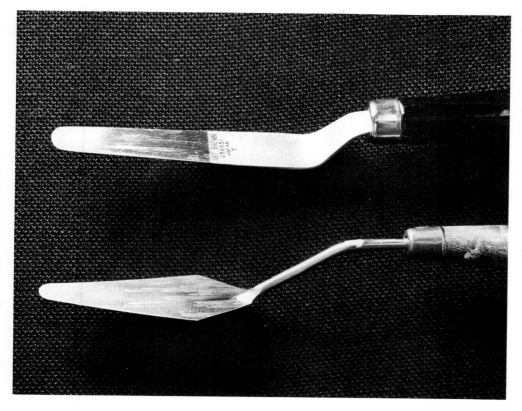

Knives. A palette knife (top) is useful for mixing thick color on your palette—before you add a lot of water—and for scraping wet color off the painting surface if you're dissatisfied with some part of the painting. A painting knife (bottom) has a thin, flexible blade that's designed to pick up thick color from the mixing surface and spread it on the painting surface. The side of the blade will make broad strokes, while the tip can add small touches of color.

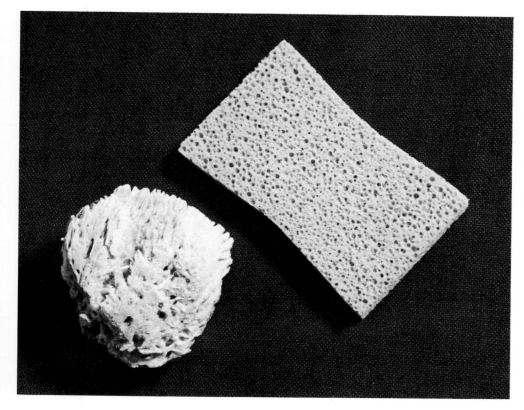

Sponges. A soft, natural sponge (left) is useful for wetting the painting surface when you're planning to try the wet-in-wet technique; for wiping away wet color from some part of the picture that you want to repaint; and even for applying paint. The bigger, coarser synthetic sponge (right) is convenient for mopping up spills and cleaning up the studio at the end of the working day.

Watercolor Palette. This white plastic palette was originally designed for watercolor painting, but it works just as well for acrylic painting. You squeeze your tube color into the circular "wells" and then do your mixing in the rectangular compartments. These compartments slant down at one end; thus the color will run down and form pools if you add enough water.

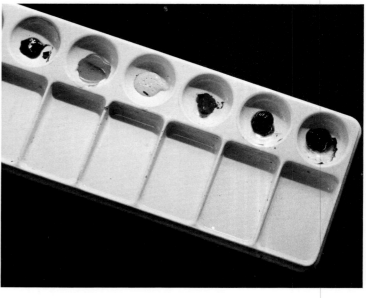

Enamel Tray. For mixing large quantities of color, the most convenient palette is a white enamel tray—which you can buy wherever kitchen supplies are sold. You can use this tray by itself or in combination with one or two smaller plastic palettes like those used for watercolor.

Improvised Palettes. Many acrylic painters find their palettes in the kitchen. At the left is a metal muffin tin with compartments that are just the right size for mixing acrylic colors. Discarded yogurt containers (top right) and margarine containers (bottom right) also make excellent mixing cups. Be sure to scrub the margarine container with lots of soap and water so that you eliminate all the oily residue.

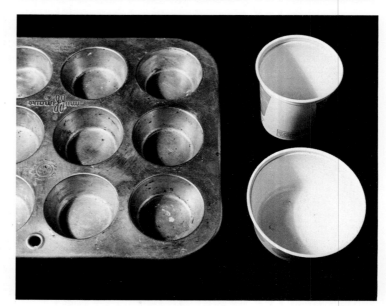

Easel. For painting on canvas boards, canvas, or panels made of hardboard, most artists like to work on a vertical surface. A traditional wooden easel will hold the painting upright. An easel is essentially a wooden framework with two grippers that hold the painting firmly at top and bottom. Be sure to buy an easel that's solid and stable; don't get a flimsy easel that will tip over when you get carried away with vigorous brushwork.

Wooden Drawing Board. When you paint on watercolor paper—or on any sturdy paper—it's best to tape the paper to a sheet of plywood or a sheet of hardboard cut slightly bigger than the painting. If you can, buy plywood or hardboard that's made for outdoor construction work; it's more resistant to moisture. Hold down the edges of the painting with masking tape that is at least 1″ (25 mm) wide or even wider.

Fiberboard. Illustration board is too thick to tape down, so use thumbtacks (drawing pins) or push-pins to secure the painting to a thick sheet of fiberboard. This board is ¾″ (about 18 mm) thick and soft enough for the pins to penetrate. Note that the pins don't go *through* the painting, but simply overlap the edges.

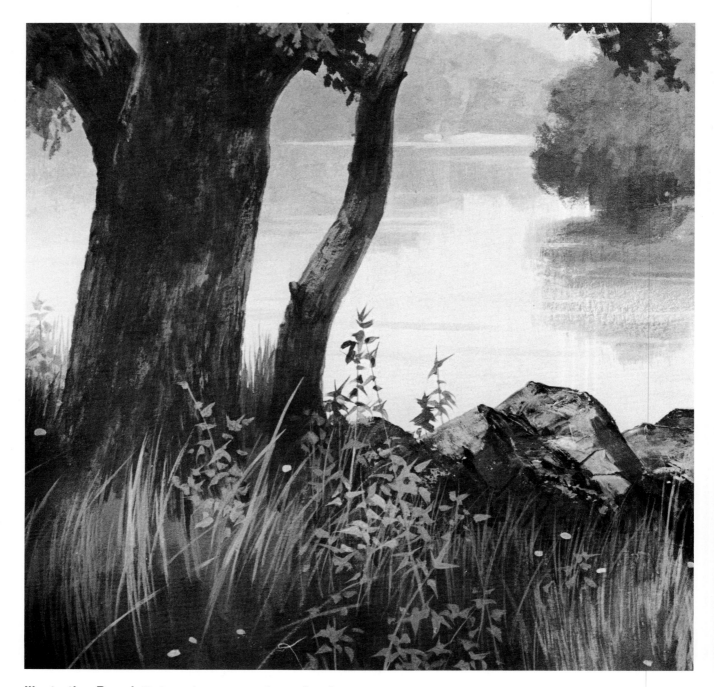

Illustration Board. Perhaps the most popular surface for acrylic painting is illustration board—white drawing paper mounted on thick cardboard. The standard illustration board has just a slight texture—or *tooth*, as painters call it—to respond to all sorts of brushwork. For example, the texture of the paper accentuates the rough brushwork on the tree-trunks. On the other hand, the paper is just smooth enough for precise, detailed work, such as the weeds and grasses in the foreground, which are painted with a slender, pointed brush and fluid color. This all-purpose surface is frequently called a "kid finish," which means that it has a slight texture. You can also buy a "high" or "plate" finish that's absolutely smooth, but this is suitable only for *very* precise, detailed work.

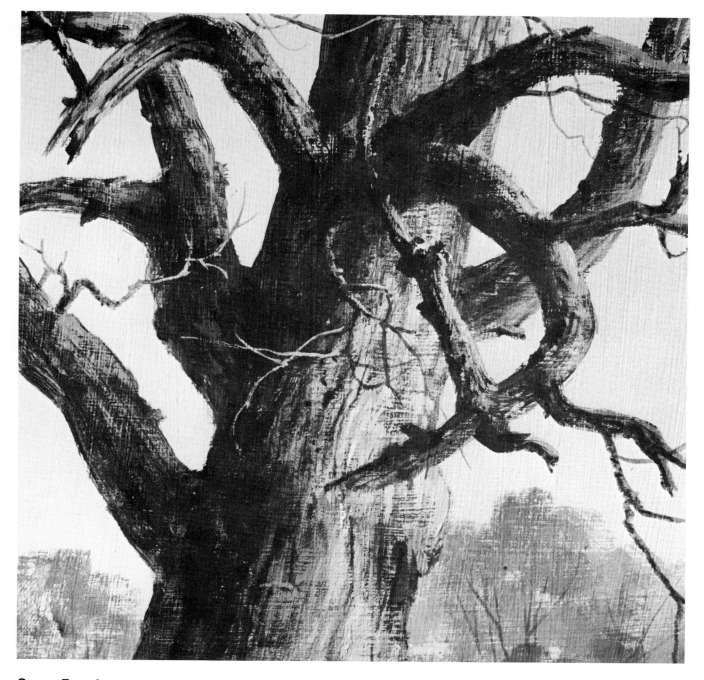

Gesso Board. Manufacturers of acrylic colors also make a thick, white paint for coating hardboard, cardboard, canvas, or any other painting surface. This acrylic gesso, as it's called, is the same chemical formula as the tube colors. As it comes from the can or the jar, the gesso is a very thick liquid. You can apply it directly from the can, without any additional water, using a nylon housepainter's brush. The bristles really dig into the paint and leave a distinct mark on the surface. This treetrunk was painted on such a surface, which roughens the stroke and produces a lively, broken texture. For a slightly smoother surface, you can thin the gesso with enough water to produce a creamy consistency: you'll probably need a couple of coats. For a *really* smooth surface, add enough water to produce a milky consistency and apply three or four coats. Apply successive coats at right angles to one another: the strokes of the first coat should move from top to bottom, while the strokes of the second coat should move from left to right. If the hardboard has a smooth side and a rough side, it's best to apply the gesso to the smooth side. If you're coating illustration board, paint an equal number of coats on both sides so that the board won't warp.

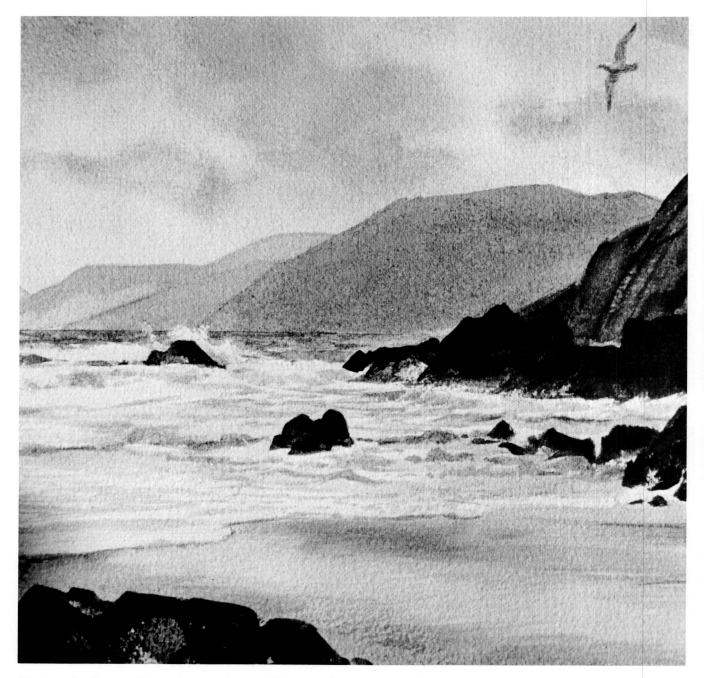

Watercolor Paper. If you discover that you like to work with very fluid color—diluted with lots of water so the paint handles like watercolor—watercolor paper is the ideal painting surface. Here's a section from a coastal scene painted on cold pressed paper, which means a surface that has a moderate texture, not too rough and not too smooth. The most versatile watercolor paper is a fairly thick sheet designated as 140 pound stock, heavy enough so that it won't curl too badly when it gets wet; it's mouldmade, which means that it's machinemade, but surprisingly close to the expensive, handmade papers preferred by professionals; and it's cold pressed—called a "not" surface in Britain. If you like bold, rough brushwork, try a rough surface instead of the cold pressed.

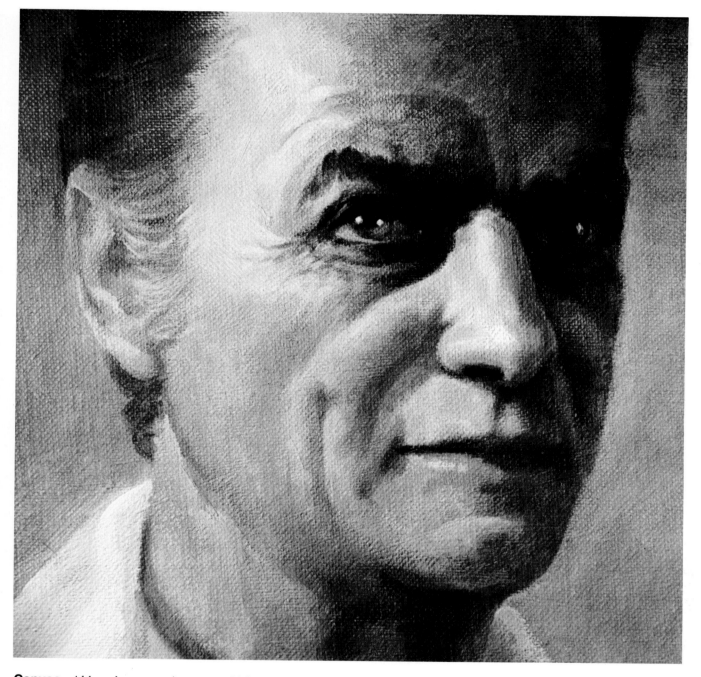

Canvas. Although canvas is most widely used for oil painting, it's also an excellent surface for acrylic. The weave of the canvas produces a beautiful texture that softens and enlivens the brushstroke. In this close-up of a portrait head, for example, you can see how the texture of the canvas softens and blurs the stroke, helping to produce those subtle gradations from dark to light. And the fibers of the canvas tend to appear within the strokes as flecks of light and dark, making the strokes look luminous and transparent. Canvas boards are the most inexpensive form of canvas: just thin fabric glued to cardboard and usually coated with white acrylic, which makes the surface particularly receptive to acrylic colors. You can also buy artists' canvas in rolls, which you cut into sheets and nail to a rectangular frame made of wooden strips called canvas stretchers. If you buy canvas that's precoated with white paint, be sure it's white acrylic, not oil paint. Or buy so-called raw canvas, which is plain linen or cotton. "Stretch" it yourself, and then give it two or three coats of acrylic gesso.

Brushes. Because you can wash out a brush quickly when you switch from one color to another, you need very few brushes for acrylic painting. Two large, flat brushes will do for covering big areas: a 1″ (25 mm) bristle brush, the kind you use for oil painting; and a softhair brush the same size, whether oxhair, squirrel hair, or soft white nylon. Then you'll need another bristle brush and another softhair brush, each half that size. For more detailed work, add a couple of round softhair brushes—let's say a number 10, which is about ¼″ (6 mm) in diameter, and a number 6, which is about half as wide. If you find that you like working in the transparent technique, which means thinning acrylic paint to the consistency of watercolor, it might be helpful to add a big number 12 round softhair brush, either oxhair or soft white nylon. Since acrylic painting will subject brushes to a lot of wear and tear, few artists use their expensive sables.

Painting Surfaces. If you like to work on a smooth surface, use illustration board, which is white drawing paper with a stiff cardboard backing. For the transparent technique, the best surface is watercolor paper—and the most versatile watercolor paper is mouldmade 140 pound stock in the cold pressed surface (called a "not" surface in Britain). Acrylic handles beautifully on canvas, but make sure that the canvas is coated with white acrylic paint, not white oil paint. Your art supply store will also sell inexpensive canvas boards—thin canvas glued to cardboard—that are usually coated with white acrylic, which is excellent for acrylic painting. You can create your own painting surface by coating hardboard with acrylic gesso, a thick, white acrylic paint which comes in cans or jars. For a smooth surface, brush on several thin coats of acrylic gesso diluted with water to the consistency of milk. For a rougher surface, brush on the gesso straight from the can so that the white coating retains the marks of the brush. Use a big nylon housepainter's brush.

Drawing Board. To support your illustration board or watercolor paper while you work, the simplest solution is a piece of hardboard. Just tack or tape your painting surface to the hardboard and rest it on a tabletop—with a book under the back edge of your board so it slants toward you. You can tack down a canvas board in the same way. If you like to work on a vertical surface—which many artists prefer when they're painting on canvas, canvas board, or hardboard coated with gesso—a wooden easel is the solution. If your budget permits, you may like a wooden drawing table, which you can tilt to a horizontal, diagonal, or vertical position just by turning a knob.

Palette. One of the most popular palettes is the least expensive—just squeeze out and mix your colors on a white enamel tray, which you can probably find in a shop that sells kitchen supplies. Another good choice is a white metal or plastic palette (the kind used for watercolor) with compartments into which you squeeze your tube colors. Some acrylic painters like the paper palettes used by oil painters: a pad of waterproof pages that you tear off and discard after painting.

Odds and Ends. For working outdoors, it's helpful to have a wood or metal paintbox with compartments for tubes, brushes, bottles of medium, knives, and other accessories. You can buy a tear-off paper palette and canvas boards that fit neatly into the box. Many acrylic painters carry their gear in a toolbox or a fishing tackle box, both of which also have lots of compartments. Two types of knives are helpful: a palette knife for mixing color; and a sharp one with a retractable blade (or some single-edge razor blades) to cut paper, illustration board, or tape. Paper towels and a sponge are useful for cleaning up—and they can also be used for painting, as you'll see later. You'll need an HB drawing pencil or just an ordinary office pencil for sketching in your composition before you start to paint. To erase pencil lines, get a kneaded rubber (or "putty rubber") eraser, which is so soft that you can shape it like clay and erase a pencil line without abrading the surface. To hold down that paper or board, get a roll of 1″ (25 mm) masking tape and a handful of thumbtacks (drawing pins) or pushpins. To carry water when you work outdoors, you can take a discarded plastic detergent bottle (if it's big enough to hold a couple of quarts or liters) or buy a water bottle or canteen in a store that sells camping supplies. For the studio, find three wide-mouthed glass jars, each big enough to hold a quart or a liter.

Work Layout. Before you start to paint, lay out your supplies and equipment in a consistent way, so everything is always in its place when you reach for it. Obviously, your drawing board or easel is directly in front of you. If you're right-handed, place your palette, those three jars, and a cup of medium to the right. In one jar, store your brushes, hair end up. Fill the other two jars with clear water: one is for washing your brushes; the other provides water for diluting your colors. Establish a fixed location for each color on your palette. One good way is to place your *cool* colors (black, blue, green) at one end and the *warm* colors (yellow, orange, red, brown) at the other. Put a big dab of white in a distant corner, where it won't be fouled by the other colors.

PART ONE

ACRYLIC PAINTING

Painting in Acrylic. For as long as human beings have painted pictures, artists have searched for the ideal painting vehicle. In the manufacture of paint, the vehicle is the liquid glue that's blended with powdered color to produce the colored paste you squeeze out of the tube. The brilliance, durability, and handling qualities of paint depend, above all, on the character of the vehicle. And for many artists, the acrylic vehicle comes close to being the ideal. The acrylic vehicle is a cloudy liquid with a consistency somewhat like cream. When wet, you can dilute it with water. When dry, it's no longer soluble in water, forms a leathery coating, and turns as clear as glass. Thus, each granule of colored pigment is encased forever in a tough, waterproof coat of invisible plastic.

Ways of Painting. There are so many ways of painting with acrylic that no book can possibly do justice to them all. However, there are certain basic techniques that every acrylic painter should master, so we'll begin with these. Then you'll see Rudy de Reyna—a noted contemporary artist who works in a variety of acrylic techniques—paint thirteen demonstration pictures that show you how to put these basic techniques into practice. Finally, you'll learn a variety of special techniques—which artists like to call "technical tricks"—and several methods of correcting acrylic paintings when things go wrong.

Opaque Technique. The simplest way to work with acrylic is to squeeze color directly from the tube onto the palette, brush in just enough water to produce a creamy consistency, and then apply masses of solid color to the painting surface. The creamy color immediately covers the canvas, paper, or board underneath. And the second layer of color will hide the first. For obvious reasons, this is called the opaque technique. It's a rapid, direct way to paint. You'll see how it's done.

Transparent Technique. If you add much more water to the tube color, you'll produce a pool of tinted water called a wash. You can see right through it to the surface of your palette, and you'll also see through the transparent color when you brush it onto the painting surface. The dried paint is like a sheet of colored glass. A second coat will modify the first—the two coats will mix in the viewer's eye—but one coat won't conceal another. That's why this is called the transparent technique.

Scumbling and Drybrush. To create tonal gradations from dark to light, or to shade one color into another, it's important to learn two ways of handling the brush. Scumbling is a kind of scrubbing motion that spreads a veil of color across the surface. Drybrush is a method of skimming the brush across the painting surface so that the paint hits only the high points of the textured canvas or paper, leaving behind flecks of color wherever the brush touches the ridges.

Combining Techniques. Naturally, there are many ways of combining these techniques. In painting a portrait head, it's common to paint the lighted areas opaquely and then paint the shadows in transparent color. The soft transitions from light to shadow, at places such as the cheek or the brow, might be produced by scumbling. Then details like the bony structure of the nose and the eye sockets might be rendered in drybrush. As you spend more time working with acrylics, you'll find your own combinations.

Painting Demonstrations. De Reyna begins his painting demonstrations with simple objects such as fruit, flowers, and kitchenware. These are the best subjects to start with when you're learning how to handle brushes and color. Then he moves on to four outdoor subjects: summer, autumn, winter, and coastal landscapes. You'll find that these landscapes incorporate various techniques. Some are painted broadly, and others are done with more precise brushwork. You'll see examples of opaque painting, transparent painting, and combinations of both. Last, de Reyna demonstrates the hardest subjects of all: a male and a female portrait head. Thus, the painting demonstrations progress from the simplest subjects to the most demanding.

Special Techniques. Following the demonstrations, you'll learn some unlikely techniques such as scratching, painting with a scrap of cloth folded into a dabber, painting with a wad of crumpled paper, spattering, painting with a sponge, and the impasto method—which means working with thickly textured paint. Of course, no painting is ever perfect, and you'll certainly want to know how to amend something that's gone wrong—so you'll learn three methods of correcting an acrylic painting. Fittingly enough, the last thing you'll learn will be how to preserve your acrylic paintings for years of pleasure.

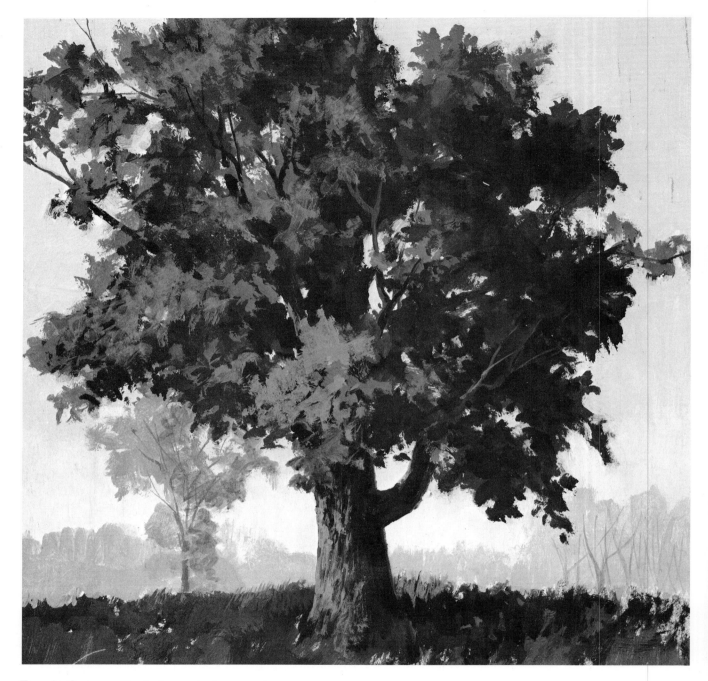

Tree in Opaque Technique. As it comes from the tube, acrylic color is thick and opaque. That is, the color will cover whatever is underneath. Normally, you add a bit of water to make the color more fluid and "brushable." And you mix it with some other colors—including white, which is the most opaque color on your palette. So even when the tube color is thinned to a more fluid consistency, it's still fairly opaque. This opacity means that one layer of color will cover another, even if the top layer is paler than the one underneath. In this tree, for example, the lighter leaves were painted over the darker leaves. The opaque technique is the easiest way of working with acrylics because you can paint dark over light, light over dark, and simply cover a mistake by painting over it.

Tree in Transparent Technique. If you add lots of water to your tube color, the paint turns into something like watercolor. You're really working with tinted water. When you mix your colors, you don't add any white, which would turn the mixture opaque. When liquid color dries on the painting surface, you can see right through the color, which is like a thin sheet of stained glass. When you work in the transparent technique, it's best to proceed from light to dark, since pale strokes won't cover dark ones. In this tree, you can see how the dark branches shine through the clusters of leaves. A painting in the transparent technique has a wonderful delicacy and luminosity that are quite different from the heavier, more solid look of a painting in the opaque technique.

OPAQUE TECHNIQUE

Step 1. For your first taste of acrylic painting, choose a simple subject like a tree. On a white sheet of illustration board or a thick, sturdy sheet of white drawing paper, make a free pencil drawing, indicating the main shapes of the tree.

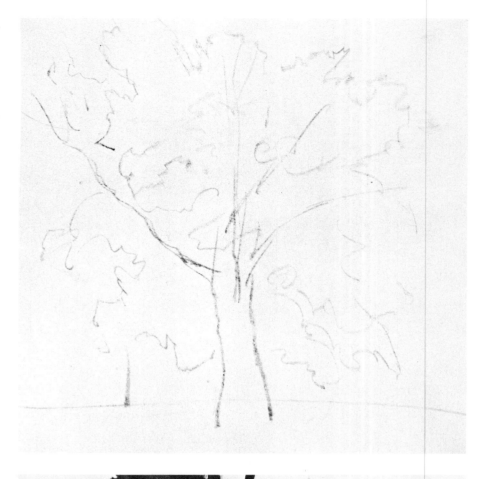

Step 2. You're going to work from dark to light, so brush in the overall shape of the tree and the ground with mixtures that are actually the darkest colors in your picture. Don't thin your tube color too much—just a few drops of water or medium will do, keeping it a rich, creamy consistency so that the paint really covers the paper. Allow this layer to dry.

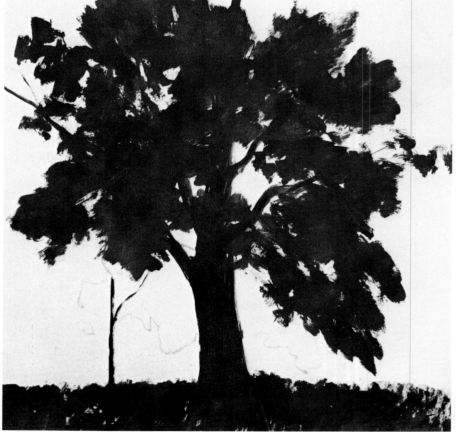

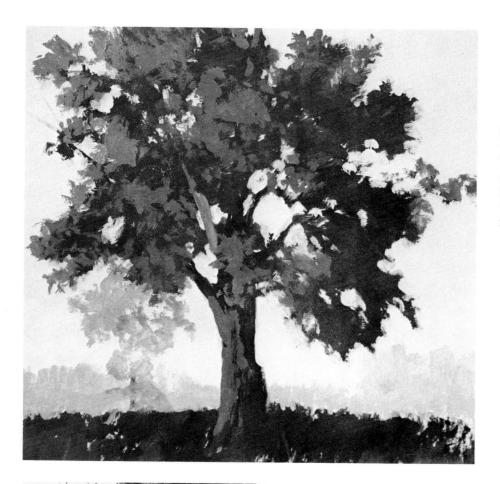

Step 3. Mix some paler tones for the sunlit parts of the tree and brush them over the darks, which now really look like shadows. Then mix even paler tones for the sky, brushing them around the leafy mass and punching some holes into the tree where the sky shows through. These lighter tones should be thick and creamy so that they really cover the darks underneath. Now you see why this is called the opaque technique.

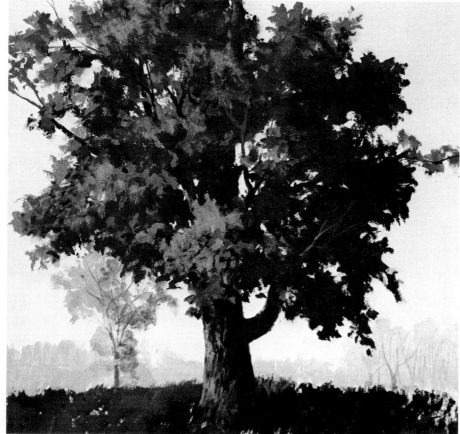

Step 4. Always save your small details for the very end. Now you can use opaque light and dark strokes to pick out individual branches, to suggest the texture of the bark, and to indicate a few leaves. The secret of the opaque technique is that each stroke is thick and solid enough to cover what's underneath.

Step 1. Now try the transparent technique by painting another tree with very fluid color that's diluted with a lot of water. On a white sheet of watercolor paper—or another piece of illustration board, if you prefer—start with a free pencil drawing that outlines the clusters of leaves, the trunk, and the landscape background.

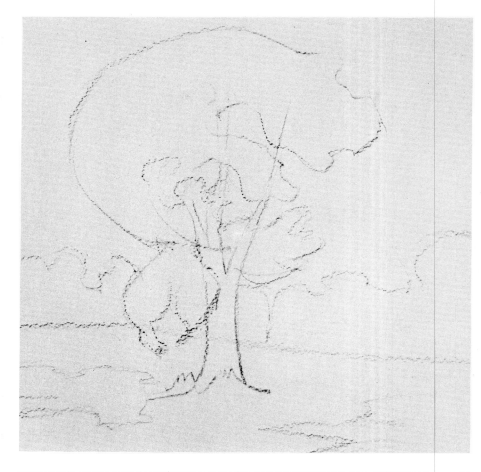

Step 2. Mix some pale *washes*, as they're called, thinning your tube color with lots of water. With a round, softhair brush, block in the palest tones of the picture with free, relaxed strokes: the general shapes of the leafy masses, the trees along the horizon, and the shadows in the foreground. Don't be too precise and don't think about details just yet.

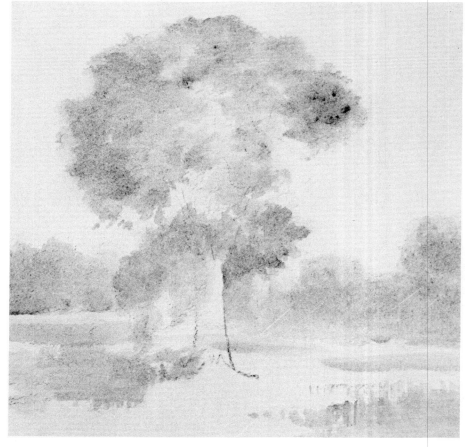

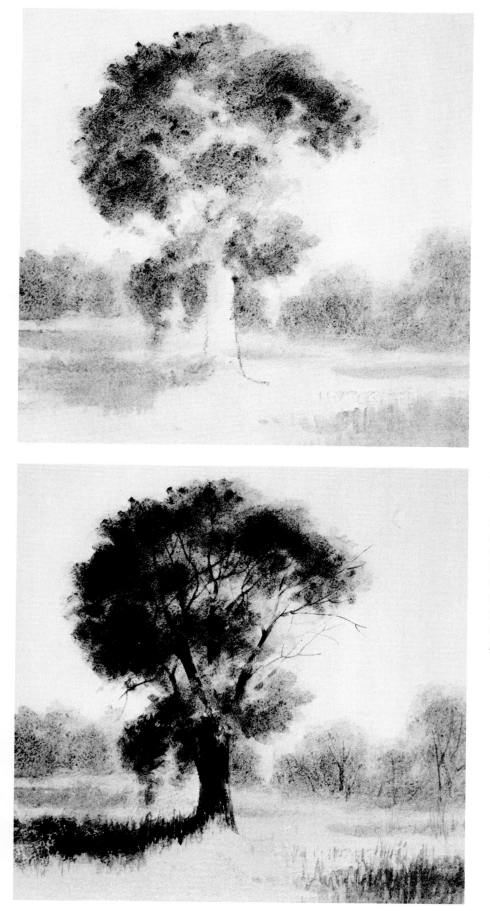

Step 3. Next, mix some darker tones on your palette. You're still using plenty of water, but not quite so much as you used in Step 2. Work with big, free strokes, darkening some parts of the tree and some areas of the trees in the background. Let the wet strokes overlap so that they blur together. Notice that the color tends to pool in the valleys of the watercolor paper, so you get darker flecks here and there, suggesting leaves.

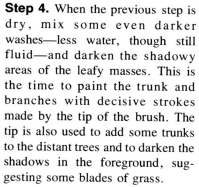

Step 4. When the previous step is dry, mix some even darker washes—less water, though still fluid—and darken the shadowy areas of the leafy masses. This is the time to paint the trunk and branches with decisive strokes made by the tip of the brush. The tip is also used to add some trunks to the distant trees and to darken the shadows in the foreground, suggesting some blades of grass.

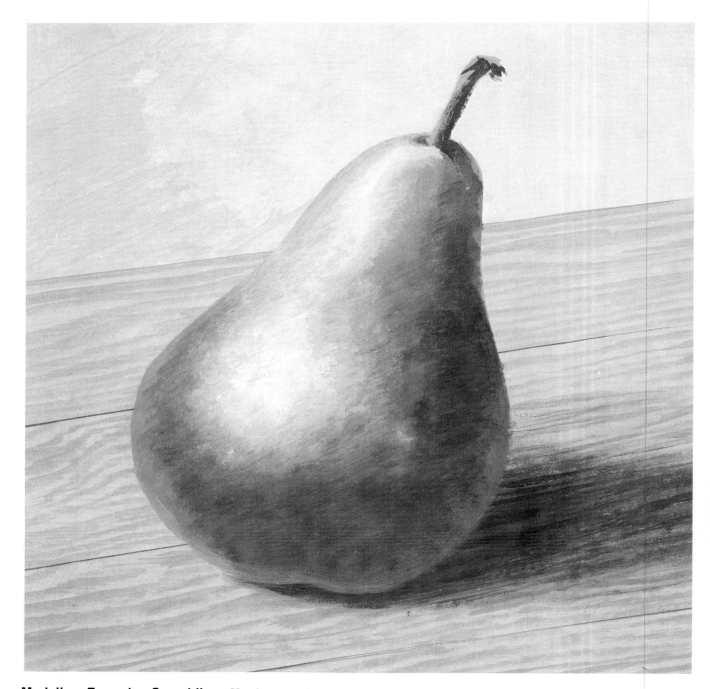

Modeling Form by Scumbling. Here's an enlarged close-up of a painting of a pear, showing the technique called scumbling. The lights and shadows on the pear are rendered by picking up a bit of paint on the tip of a brush and then scrubbing with a quick back-and-forth motion. Acrylic paint dries so quickly that it's hard to blend one wet stroke smoothly into another. Instead, you apply a series of individual strokes with that scrubbing—or scumbling—motion that blurs the mark made by the brush. One stroke overlaps another, and they seem to blend in the viewer's eye. As your eye moves from right to left over the surface of this pear, you can see dark strokes, then lighter strokes, and then *very* light strokes, all combining to give you a feeling of light and shadow traveling over the rounded form of the fruit.

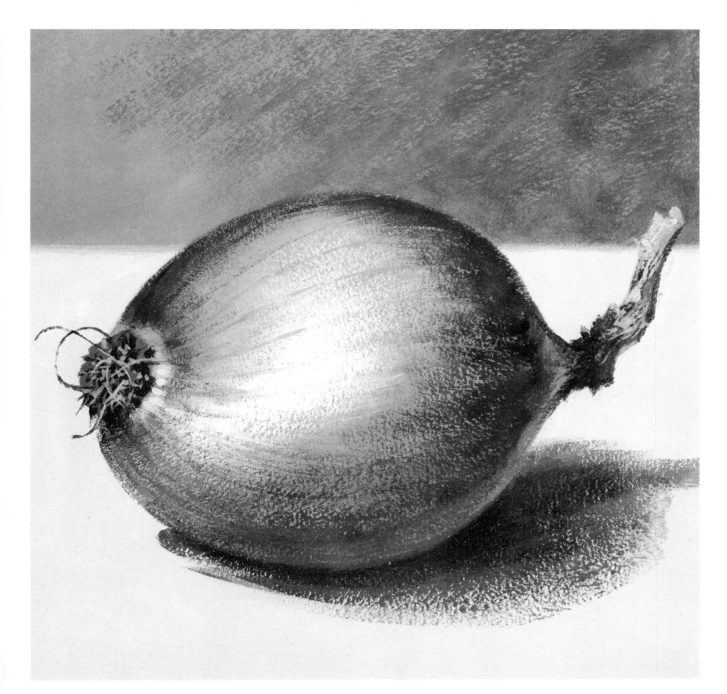

Modeling Form with Drybrush. Another way to create subtle gradations from dark to light is the technique called drybrush. The brush isn't literally dry, but carries tube color that's been thinned with just a little water. If the color on the brush is too fluid, you can touch the bristles to a paper towel and soak out some of the water. You paint on a surface with a distinct texture, such as watercolor paper, canvas, kid-finish illustration board, or a gesso panel on which the gesso has been applied so thickly that the brushstrokes have left a distinct texture. The brush travels lightly over the painting surface, hitting the high points of the texture and skipping over the low spots in between. The more pressure you apply on the brush, the more color you deposit. By passing the brush back and forth over the surface, sometimes applying more pressure, sometimes less, you gradually build up very subtle tones—actually composed of tiny flecks of color caught on the ridges of the paper. Drybrush strokes are so soft that they seem to blend into one another. On this onion, you can see dark strokes at the right and at the top, gradually giving way to paler and still paler strokes as the brush approaches the center.

Step 1. To learn the technique called scumbling, begin with some simple form like this pear. Work on a piece of illustration board or a piece of sturdy, thick drawing paper that has a slight texture. Begin with a pencil drawing that outlines the forms.

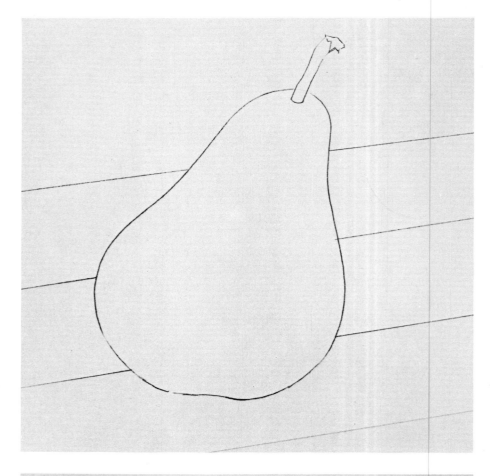

Step 2. On your palette, mix a tone for each of the main color areas. Add enough water to make the paint fairly fluid, like cream or milk. Cover each area with a flat tone. Allow each area to dry before you paint the next.

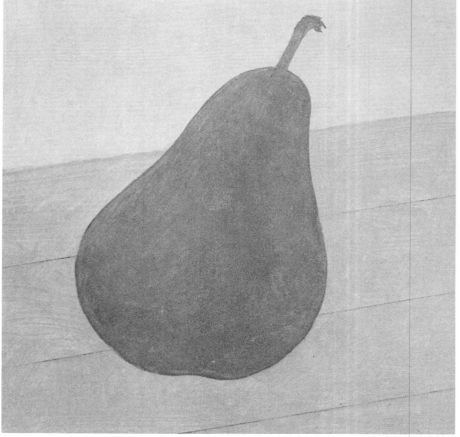

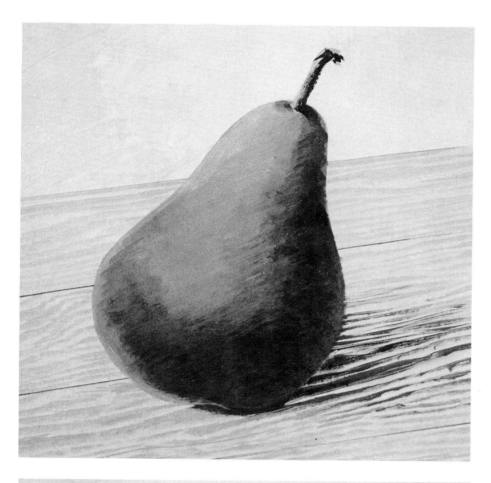

Step 3. Now mix a dark tone for the shadow side of the pear, pick up a bit of paint on the tip of a bristle or nylon brush, and apply the color in a series of strokes, moving the brush back and forth with a scrubbing motion that softens and blurs the stroke. Place some lighter strokes alongside the darker strokes so that you get the feeling of dark blending into middletone. You can also paint the grain of the tabletop with a pointed, softhair brush and more fluid color, placing darker strokes in the shadow area.

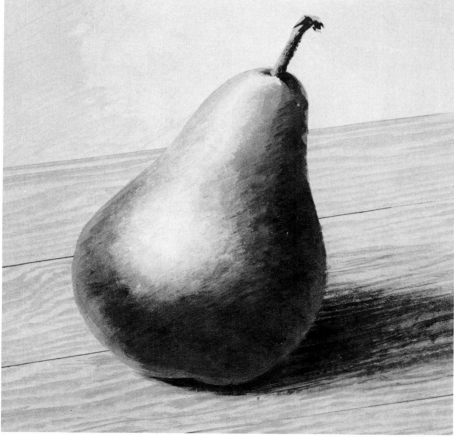

Step 4. Now mix a much lighter tone for the center of the pear. Again using a resilient brush, such as bristle or nylon, scrub on the color with a back-and-forth motion, blurring the light strokes as you approach the darker area of the pear. Placed side-by-side, the dark and light scumbled strokes will seem to blend into one another. You can also darken the shadow with more scumbling strokes.

DRYBRUSH TECHNIQUE

Step 1. Drybrush is a method of producing subtle dark-to-light gradations by skimming the brush lightly over the surface of the paper. The brush is damp, never sopping wet, because the color doesn't contain too much water. It's important to work on a surface that has a distinct texture. This demonstration is painted on rough illustration board, but you could also use watercolor paper. To learn how to handle drybrush, pick some simple, natural form like this onion. Begin with a careful pencil drawing that defines the outer edge of the form.

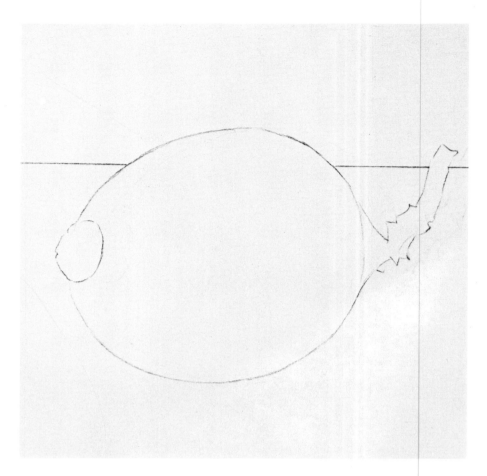

Step 2. Cover each major color area with a thin layer of fluid color. Dilute the color with enough water to produce a milky consistency—not thick enough to obliterate the texture of the painting surface. Let each area dry before you paint the next.

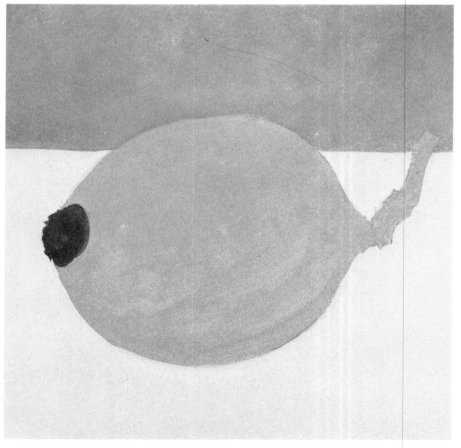

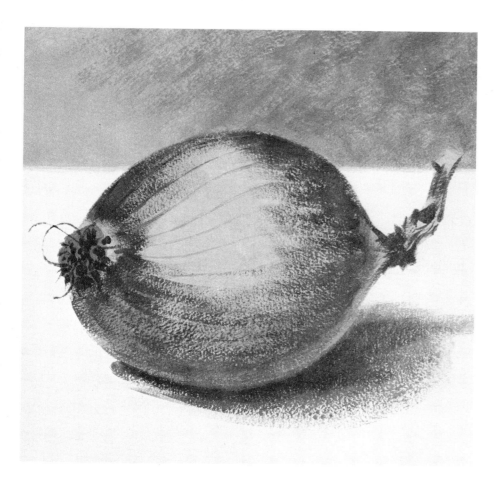

Step 3. Start by mixing the shadow tones, adding just enough water to make the paint brush easily. Move the brush lightly over the textured painting surface, hitting the peaks and skipping over the valleys so that color is deposited on the high points, while the low points shine through as lighter flecks. Move the brush back and forth over certain areas and press a bit harder to deposit more paint and make those areas darker. You can see these darks at the top of the onion, at the extreme right, and in the shadow beneath. The background is also darkened with drybrush strokes.

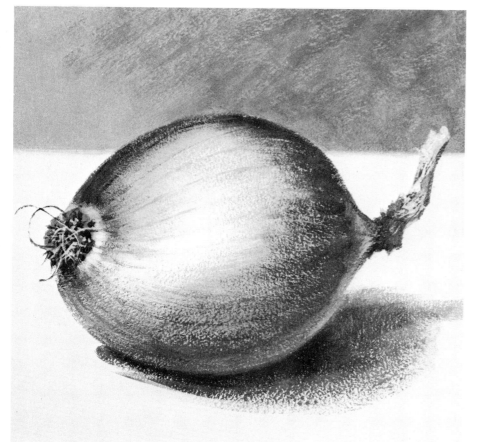

Step 4. Now wash out the brush, draw it across a paper towel to get rid of most of the water, and pick up lighter tones for the center of the form. Once again, skim the brush over the rounded form, curving the strokes to follow the shape of the onion, moving back and forth and pressing harder to deposit more color. Where the light strokes intersect with the darker strokes applied in Step 3, you get a soft gradation from light to dark. With the tip of a round, softhair brush and more fluid color, add lines and details.

Setting the Palette. Naturally, you start the painting day by squeezing out your dozen colors on the palette. Squeeze the collapsible tube from the end, replace the cap, and then roll up the empty portion of the tube. You'll get more paint out of the tube this way—which obviously means that you'll save money on expensive artists' colors. Acrylic paint dries quickly, as you know, so keep an eye on the mounds of colors on your palette and periodically sprinkle a few drops of water on any mound that looks like it's starting to solidify.

Thinning with Water. To blend tube color with water, wet the brush *first*, then dip it into the paint—never vice versa. Touch the tip of the wet brush to the mound of color, then blend the color and the water on the mixing area of your palette. Keep the paint in the mixing area away from the edges of the palette where the moist paint is stored. Don't let the fluid mixtures foul the mounds of pure color.

Thinning with Medium. If you're going to thin your tube color with gloss or matte medium, start by wetting the brush thoroughly, then pick up some tube color on the tip and transfer the color to the mixing area. Dip the tip of the brush into the medium and blend it into the color that's waiting on the mixing surface. To keep the medium clean—so you can add it to other mixtures—it's a good idea to rinse the brush before you dip it into the cup of medium. If you want to blend tube color with gel medium, pick up some fresh color with the tip of the wet brush, squeeze out some gel onto the mixing surface, and blend them. If you want a *lot* of thick paint, just squeeze a gob of color and a gob of gel side-by-side on the mixing surface and blend them with a knife.

Keep Your Brush Wet. As you can see, it's essential to keep your brushes wet at all times. Always pick up color or medium with a wet brush and rinse the brush frequently so that no paint or medium ever dries on those delicate hairs. Once acrylic dries on a brush, the hairs will be stiff as a board. The dried paint will never wash out with water. You *can* buy a powerful solvent called a "brush cleaner," but even if you do succeed in removing the dried color, the brush is never the same.

Mixing Colors. The ideal way to mix colors is to transfer some color from the edge of the palette to the mixing surface—with a wet brush, of course—then rinse the brush before you pick up each successive color. But, in reality, many artists get carried away with the excitement of color mixing and don't take the time to rinse the brush every time they pick up a new color. If you don't have the patience to do all that rinsing, just keep your mounds of color as clean as possible by doing your mixing in the center of the palette. And do rinse your brush before you start a *new* mixture. If you don't, the first mixture will work its way into the second.

Avoiding Mud. Two or three colors, plus white, should give you just about any color mixture you need. One of the unwritten "laws" of color mixing seems to be that more than three colors—not including white—will produce mud. If you know what each color on your palette can do, you should never really *need* more than three colors in a mixture. And just two colors will often do the job.

Testing Mixtures. It's worthwhile to spend an afternoon just mixing colors. Be methodical about it: mix every color on your palette with every other color. You can brush samples of all the mixtures on sheets of thick white drawing paper and label every sample to record the components of the mixture. You might have one sheet for blues, another sheet for greens, and so on. Try varying the proportions of the mixtures. For example, if you're mixing a red and a yellow to produce orange, start with equal amounts of red and yellow; then try more red and less yellow; finally, see what you get with more yellow and less red. You'll be astonished to see how many variations you can get with just two colors. And when you start working with three—varying the proportions of all three components—the sky's the limit!

Mixing on the Painting. The palette is only one place where you can mix colors. The special qualities of acrylic make it possible to mix on the painting surface too. When a layer of color is dry, there are ways to produce *optical* mixtures, which means putting one layer of color over another, so the underlying layer shows through, and the two layers "mix" in the eye of the viewer. Over one dried layer of color, you can brush a second color that's been thinned with enough water or medium to make it transparent. When the second layer dries, it's like a sheet of colored glass through which you can see the color beneath. That transparent color is called a *glaze*. Another type of optical mixture can be produced by scumbling. When the underlying color is dry, you apply a second opaque color with a back-and-forth scrubbing motion that distributes a thin veil of paint through which you can still see the underlying hue. Unlike the glaze, the scumble consists of opaque color, but it's distributed so thinly that you can see through it.

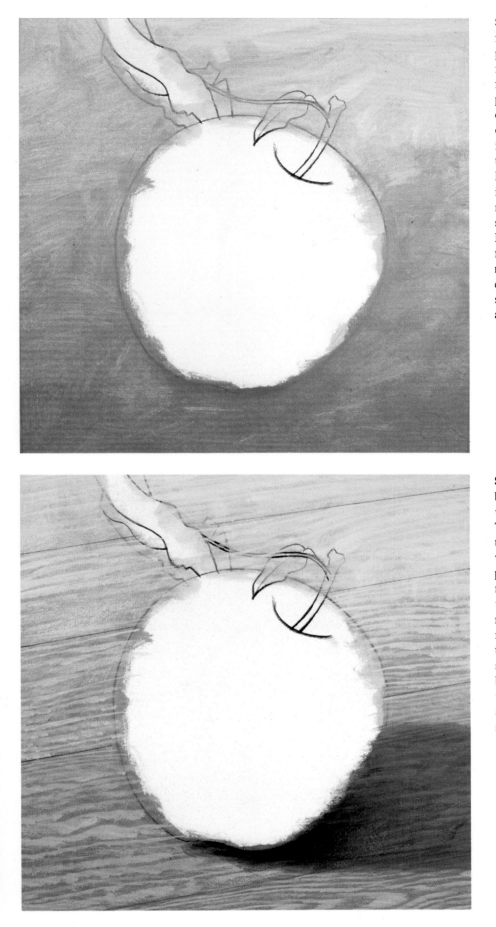

Step 1. To learn how to model form in acrylic—that is, how to paint something so it looks three-dimensional—start with some simple, familiar shape like an apple. It's important to begin with a careful pencil drawing of the form. This study of an apple begins with a line drawing that defines the round shape of the apple, its stem, and a couple of leaves. Then a bristle brush scrubs in the background tone, which is a mixture of ultramarine blue, burnt sienna, yellow ochre, and white. Notice that the tone is darker in the foreground, where it contains a bit more ultramarine blue and burnt sienna. It doesn't matter if these casual strokes overlap the edges of the apple.

Step 2. The lines between the boards of the tabletop are drawn with a sharp pencil and a ruler. Then the tip of a round sable draws the grain of the tabletop with a paler version of the same mixture used to paint the background in Step 1. This mixture simply contains more white. A darker version of the same mixture—less white, more ultramarine and burnt sienna—becomes the shadow cast by the apple. The shadow tone is first painted with a bristle brush. Then the lines of the wood grain within the shadow are added with the tip of the round sable.

Step 3. Now the entire shape of the apple is covered with a flat tone. This is a blend of cadmium red, naphthol crimson, yellow ochre, and white, applied with a flat bristle brush. A very thin wash of yellow ochre, ultramarine blue, and burnt sienna—containing lots of water, but no white—is brushed over the leaves. A darker version of this same mixture, with less water, is used for the shadow areas on the leaves. The intricate forms of the leaves are painted with a round sable.

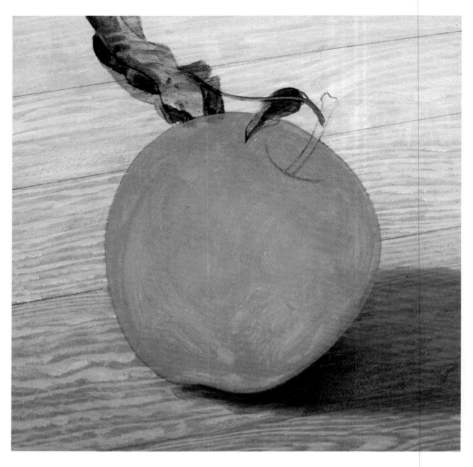

Step 4. Now it's time to start modeling the apple—which means adding darks and lights on top of the flat tone painted in Step 3. A round, softhair brush paints the dark red at the top of the apple in short, slender strokes that curve to follow the round shape. These strokes are a mixture of naphthol crimson, cadmium red, yellow ochre, and white. More white is added to these strokes as they move downward from the midpoint of the apple to the bottom. The highlights on the apple are mainly yellow ochre and white, with just a hint of the reddish mixture that's used to paint the rest of the apple. These lights are painted with scumbling strokes, so they seem to blend into the red.

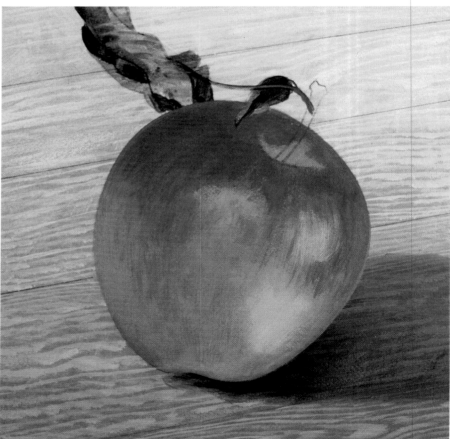

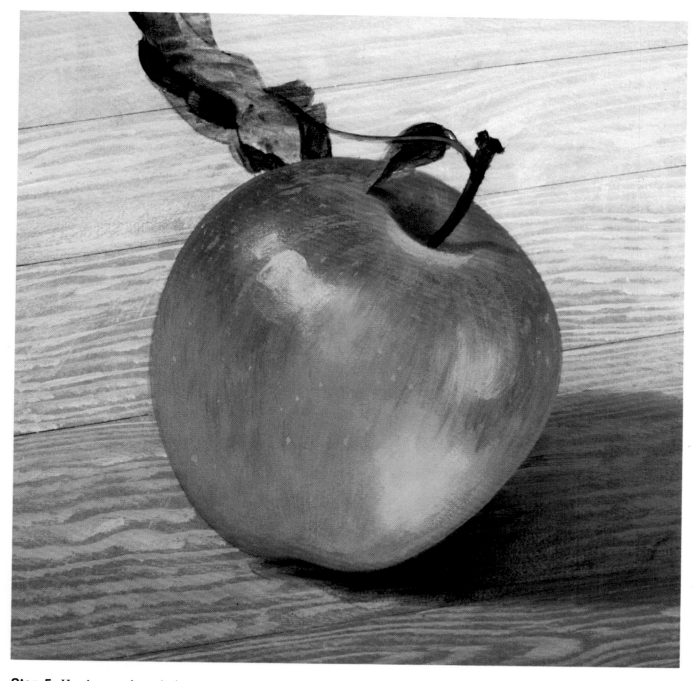

Step 5. Here's an enlarged close-up of the apple, so you can really see the brushwork. The precise details of the apple are saved for the final stage. The subtle tone around the stem is painted with the tip of a round, softhair brush carrying a mixture of ultramarine blue, yellow ochre, and burnt umber. Tiny spots of this mixture are added to the sides of the apple with the point of the brush. The stem is a dark mixture of burnt sienna and ultramarine blue. Now review the basic modeling procedure. You begin by painting the flat, overall tone of the subject. Then you block in the lights and darks. Next come the highlights. You finish with the details. And you'll enhance the three-dimensional feeling if your brushstrokes follow the form, just as the strokes curve around the apple here.

Step 1. Painting a slightly more complicated natural form such as this green pepper will give you an opportunity to develop your skill with drybrush. Once again, start with a simple pencil drawing and then brush in the background with free strokes. This demonstration is painted on watercolor paper whose slightly rough texture is especially good for drybrush. The tones of the wooden tabletop are drybrush strokes made by the edge of a bristle brush dampened with a mixture of ultramarine blue, burnt sienna, and white. The lighter strokes obviously contain more white. For the shadowy wall at the top of the picture, the same brush carries the same mixture.

Step 2. To unify the strokes of the tabletop, the bristle brush coats the entire area with a transparent wash of burnt sienna and ultramarine blue—and lots of water. When this is dry, the entire shape of the pepper is covered with a mixture of phthalocyanine green, yellow ochre, a little burnt umber, and white. The lines in the center of the pepper are reinforced with the pencil, since they'll be helpful in guiding the modeling in Step 3.

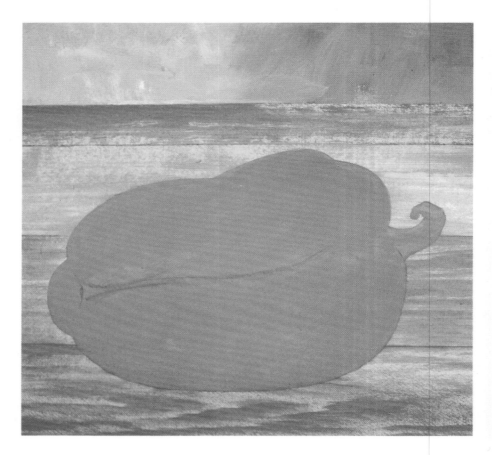

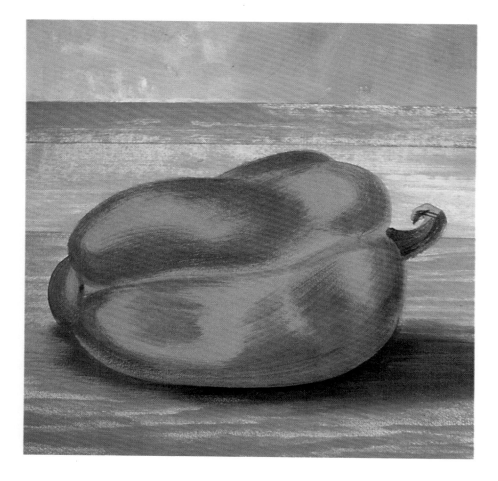

Step 3. Now the darks are added with a mixture of phthalocyanine green, burnt umber, and yellow ochre. There's just a bit of color on the brush so that the bristles are damp, not wet. And the brush skims quickly over the surface of the paper, depositing ragged, broken strokes rather than solid color. The darks are built up gradually, one stroke over another. The same method is used to paint the shadow cast by the pepper and to darken the grain of the tabletop in front of the pepper—mixtures of ultramarine blue, burnt umber, yellow ochre, and white. These soft drybrush strokes are executed with a round, softhair brush.

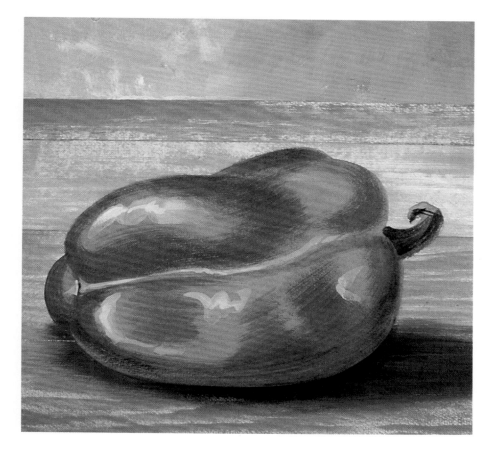

Step 4. Now the light areas between these shadowy strokes are strengthened with the same green mixture used in Step 2, but with a bit more white added. Finally, the highlights are added with the tip of a round, softhair brush. These are mainly white, with just a bit of the green mixture, plus lots of water. As you can see, drybrush is used mainly for modeling, while more fluid color is used for the precise, final touches.

Step 1. Painting the fuzzy surface of a peach is particularly good practice in the technique called scumbling. To make the job a bit easier, you might like to select a sheet of textured watercolor paper that will accentuate the scrubby character of the back-and-forth scumbling strokes. This demonstration begins with a pencil drawing that carefully defines the contours of the peaches, the dish, and the line of the tabletop. A flat, softhair brush covers the background with a fluid tone of black, yellow ochre, and a touch of white. The same brush covers the tabletop with this mixture, plus phthalocyanine blue and a lot more white.

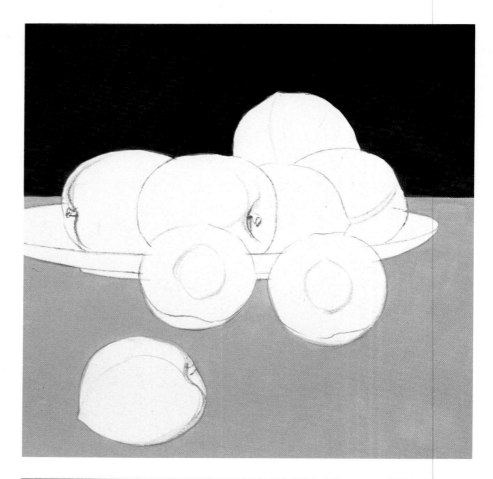

Step 2. Ultramarine blue, burnt sienna, and white are blended on the palette to a thick mixture that contains only a bit of water. Then this thick paint is scrubbed onto the peaches with short, back-and-forth strokes of a bristle brush. The dark sides of the forms contain less white. Bare paper peeks through the lighter areas. You can see how the texture of the paper roughens and breaks up the brushstrokes.

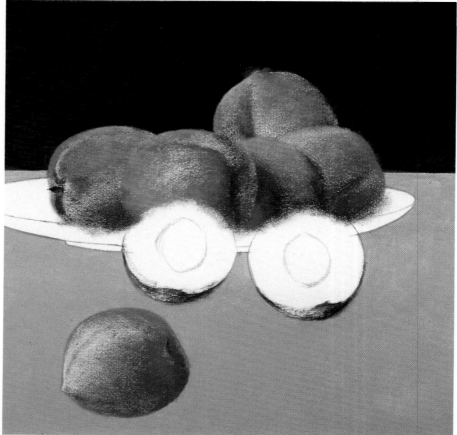

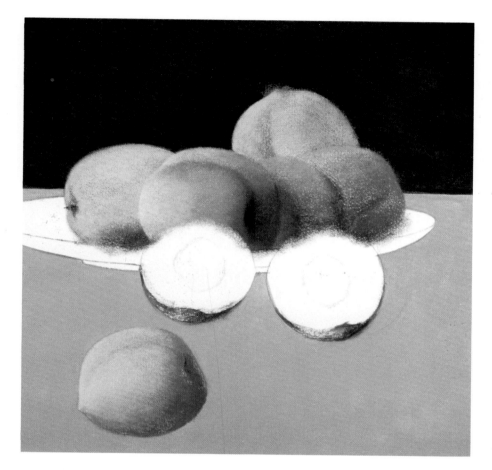

Step 3. The purpose of Step 2 is to establish the pattern of light and shadow on the peaches. Now the same brush and the same short, scrubbing strokes are used to build color over this undertone. When Step 2 is dry, a simple mixture of yellow ochre and white is then scumbled over several of the peaches to suggest a golden tone. The ruddy tone is a mixture of naphthol crimson, cadmium red, a little ultramarine blue, and white. These colors aren't completely opaque; thus the underlying shadowy tone comes through.

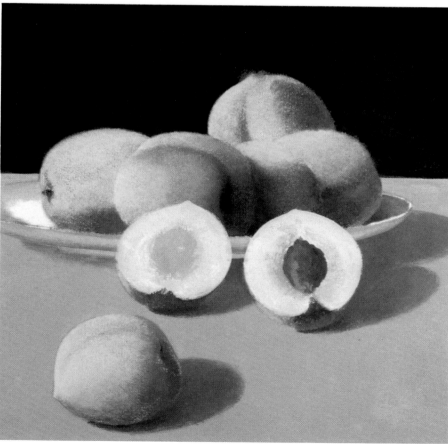

Step 4. The lighter tops of the two peaches to the right are scumbled with this yellow ochre and white mixture. The shadows on the peaches are strengthened with the same mixture used in Step 2. The ruddy tone used in Step 3 is added to the undersides of the two peach halves. The shadows are scumbled with ultramarine blue, naphthol crimson, yellow ochre, and white. Now the juicy insides of the peaches are painted with a round, softhair brush and mixtures of yellow ochre, cadmium red, ultramarine blue, and white.

Step 5. The warm tones of the peaches are now scumbled with a flat bristle brush—a mixture of naphthol crimson, yellow ochre, ultramarine blue, and white. The lighter areas are strengthened with more scumbling strokes of yellow ochre and white. Placed side-by-side, these scrubby strokes of thick color, broken up by the texture of the paper, seem to blend into one another.

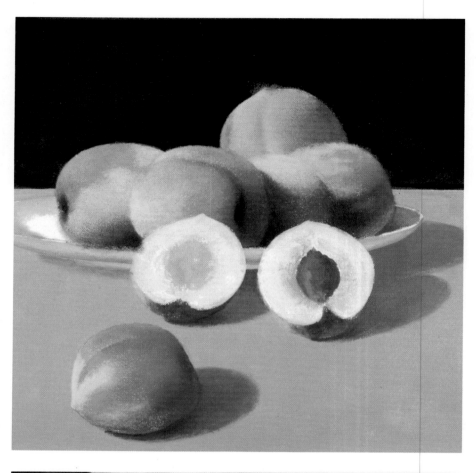

Step 6 (close-up). The precise details are saved for the final stage, as usual. Now the tip of a round, softhair brush picks up fluid color to paint the pit of the peach to the right, plus the juicy fibers of the peach to the left. The darks of the pit are ultramarine blue and burnt sienna. The warm glow around the pit is the same mixture used for the ruddy tones in Step 5. This same warm mixture appears inside the cut peach to the left, with the glistening fibers painted in a pale mixture of yellow ochre and white. The slender, pointed brush is also used to paint the precise form of the plate with the same mixture used for the shadows in Step 4, plus more white.

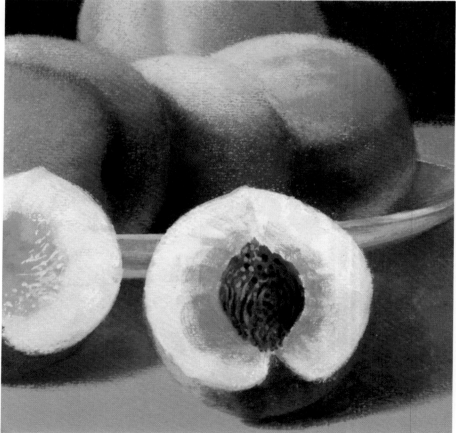

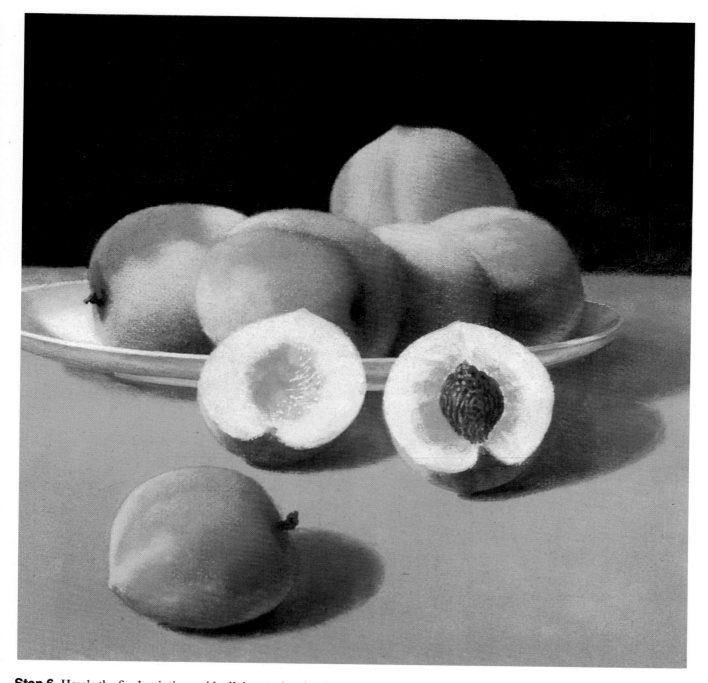

Step 6. Here's the final painting, with all the precise details added with the tip of a round, softhair brush. Dark notes are discretely added to complete the stems of the peaches and to darken the shadows right under the edges of the peaches on the tabletop. Such subtle darks aren't black, but blue-brown mixtures, such as ultramarine blue and burnt umber. Study the brushwork carefully. The beautiful gradations on the peaches *are not* the result of blending one wet color into another, but the result of placing scumbled strokes side-by-side. These ragged, scrubby strokes do overlap just a bit, but they seem to blur softly into one another. The whole trick is to work with thick color and light strokes, gradually laying one stroke over another so that the color builds up gradually.

Step 1. Underpainting and glazing is an old-master technique that takes advantage of the transparency of the acrylic painting medium. To practice this technique, find some common household object like this kettle. This demonstration is painted on a canvas board and begins with a pencil drawing of the intricate forms of the kettle, plus the lines of the tabletop. Then the shadow areas of the kettle and table are painted with a fluid mixture of black, white, and ultramarine blue, diluted with lots of water. A thicker version of the same mixture (less water) is used for the background, which is painted very carefully around the shape of the kettle.

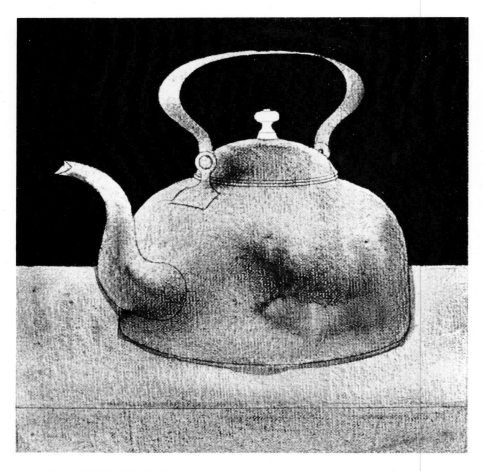

Step 2. The pattern of shadows on the kettle is now painted with the same mixture, but containing much less water so that the paint is really thick and opaque. For the first step, where you're working with very fluid paint, you can use a softhair brush. But now it's best to switch to a bristle brush to carry the thick color of Step 2.

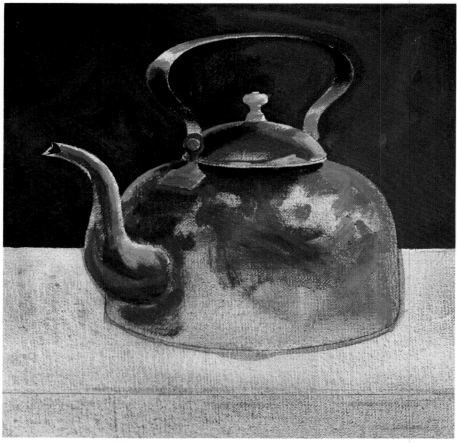

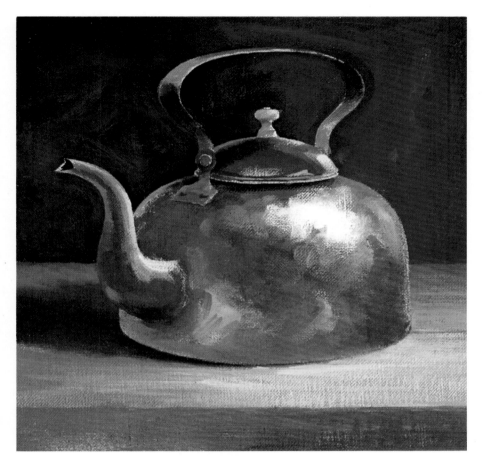

Step 3. The pattern of lights and shadows on the kettle is now completed. A bit more white is added to the same mixture for the middletones. A lot more white is added for the lightest areas. The tabletop is painted with exactly the same mixtures. The shadow that's cast by the kettle is painted with the same dark mixture used in the background. As you can see, the entire picture is painted in monochrome, concentrating only on the pattern of light and shade. Color is saved for the final step.

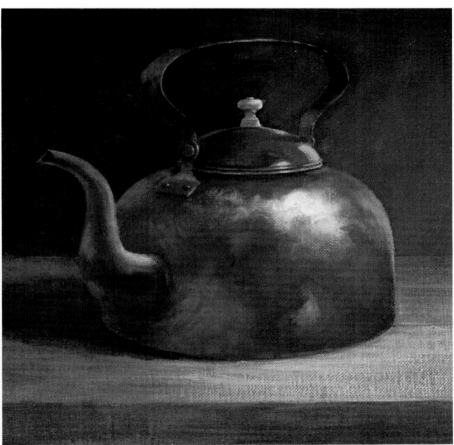

Step 4. A fluid, coppery glaze is mixed on the palette—burnt sienna, cadmium red, yellow ochre, and gloss medium. This luminous, transparent tone is brushed over the entire kettle, which suddenly turns a warm, metallic hue. A few touches of ivory black are added to strengthen the darks on the kettle. A much paler glaze of burnt sienna, yellow ochre, and ivory black—with lots of gloss medium—is carried over the background and the tabletop to add a touch of warmth. The underpainting and glazing technique is extremely useful when you're painting a subject in which the lights and shadows are complicated: first you paint the lights and shadows in monochrome; then you complete the job with colored glazes.

Step 1. To practice rendering textures, find yourself some rough, weathered outdoor subject like this old, dead tree. You'll also find it helpful to paint on a roughly textured surface. This demonstration is done on a sheet of illustration board that carries two coats of thick acrylic gesso applied with a stiff, nylon housepainter's brush that leaves the marks of the bristles in the surface. One coat is applied from top to bottom; the other coat runs from right to left, creating a crisscross texture. The painting begins with a careful pencil drawing, and a transparent sky tone is brushed right over the pencil lines with ultramarine blue, white, just a hint of burnt sienna, and lots of water.

Step 2. When the sky is dry, the tree is painted right over it with a mixture of burnt sienna, ultramarine blue, black, and just a little white. The general shape of the tree is blocked in with a flat, softhair brush; then the lines in the bark are drawn with a pointed, softhair brush. In the lighter areas of the trunk, the brushes are skimmed quickly over the painting surface, hitting just the ridges of the rough gesso to produce a drybrush effect. More pressure is applied, and the color is more fluid in the darker areas. The leaves at the base of the tree are painted with the same mixture, dabbed on with the tip of a filbert.

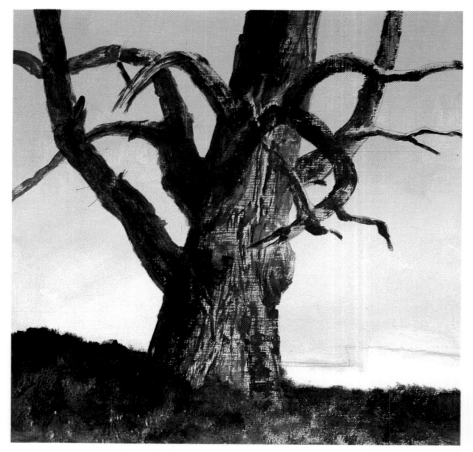

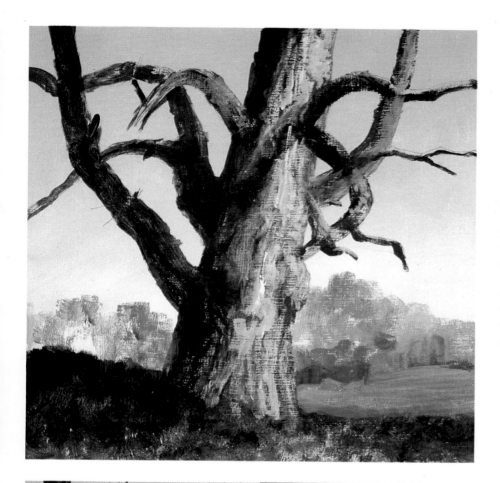

Step 3. Next come the lighter tones on the tree. A bristle brush picks up a thick mixture of burnt sienna, ultramarine blue, yellow ochre, and lots of white—very little water—and drags this mixture over the surface of the rough gesso without pressing too hard. Once again, the texture of the gesso breaks up the strokes into a drybrush effect. The warm tone of the distant trees is a mixture of burnt sienna, yellow ochre, white, just a hint of ultramarine blue, and not too much water. This thick mixture is scumbled over the rough gesso, whose texture comes through once again. The bit of meadow to the right is a more fluid version of this same mixture, with more ultramarine blue and more water.

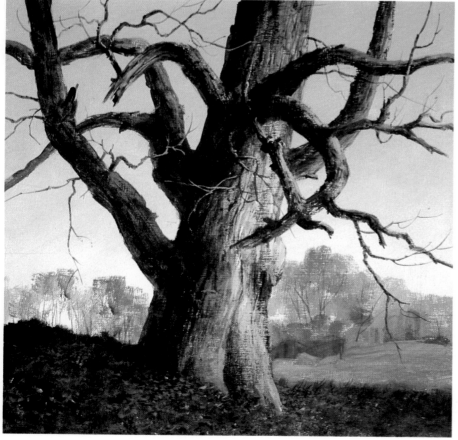

Step 4. The tip of a round, softhair brush adds the twigs and other details of the tree, using the same dark and light mixtures introduced in Steps 2 and 3, but with more water for a precise, fluid stroke. The same mixture and the same brush add some trunks to the distant trees. A transparent glaze of cadmium red, yellow ochre, and water is carried over the leaves on the ground to complete the picture.

Step 1. Now that you've tried out a variety of acrylic painting techniques, it's time to put them to work on a more ambitious still life. A wooden bowl of fruit, with so many different colors and textures, is a good subject. Once again, begin with a careful pencil drawing that defines the outer edges of all the forms. This demonstration begins with a background tone of black, white, and a little yellow ochre, applied with a bristle brush. The strokes are bold and obvious. Notice how the background is darker behind the fruit—to dramatize their shapes and colors.

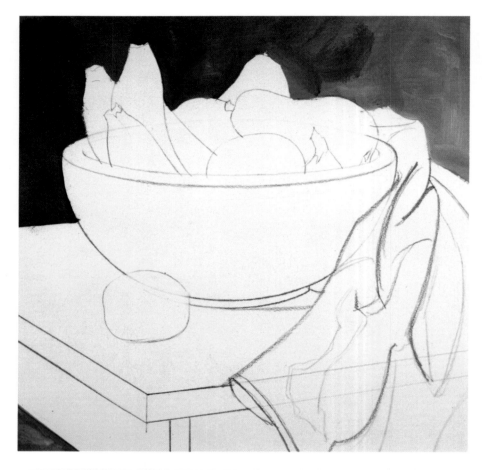

Step 2. The flat tones of the bananas and pears are painted with a smooth, fluid mixture of cadmium yellow, white, and just the slightest hint of ultramarine blue. The plums are painted with slightly thicker color and scumbling strokes, like the peaches in Demonstration 3—a mixture of ultramarine blue, naphthol crimson, and white. The bowl is begun with burnt sienna, ultramarine blue, yellow ochre, and white. A flat, softhair brush is used for all the operations in Step 2.

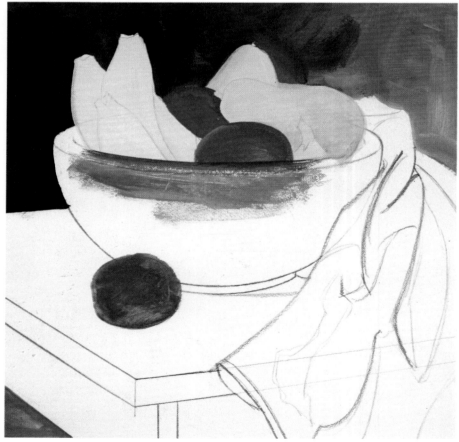

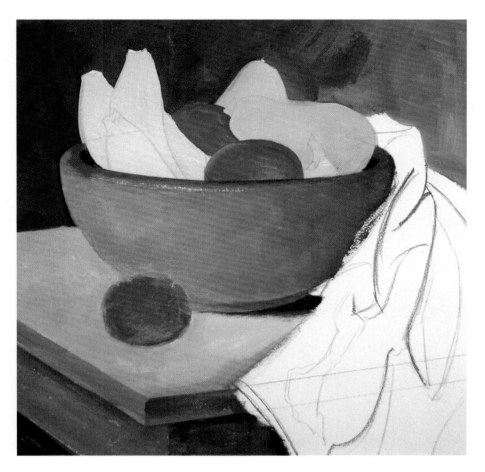

Step 3. The wooden bowl and table are painted with fluid mixtures of burnt sienna, yellow ochre, ultramarine blue, and white, with enough water to produce a creamy consistency. The darks obviously contain more blue and brown. A flat, softhair brush places the wet strokes side-by-side and quickly blends them together before they dry—a technique called wet blending. This kind of brushwork produces a casual, irregular blend in which the strokes are still partly visible—just right for the texture of the wood.

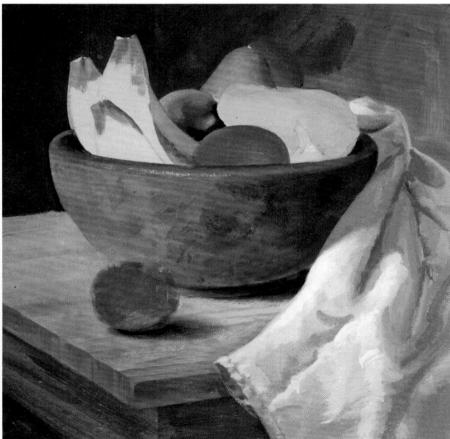

Step 4. The darks of the banana and the shadow side of the more distant pear are painted with touches of burnt sienna, yellow ochre, ultramarine blue, and a bit of white. The warm notes in the pears are burnt sienna, cadmium yellow, and yellow ochre. The grain of the wood is drybrushed with a darker version of the mixture in Step 3— more blue and brown. One plum in the bowl is modeled by scumbling phthalocyanine blue, naphthol crimson, and white. The napkin is painted with form-following strokes of ultramarine blue, burnt sienna, yellow ochre, and white.

Step 5. Now it's time to start refining the forms of the fruit. A round, softhair brush paints the lighted sides of the bananas with yellow ochre, cadmium yellow, white, and just a touch of burnt umber. The shadow sides are scumbled with burnt umber, yellow ochre, ultramarine blue, and white. To make the big pear rounder, the darker tones are scumbled with ultramarine blue, yellow ochre, burnt sienna, and white—with wet, juicy highlights of white and yellow ochre quickly brushed onto both pears when the scumbles are dry. The other plum in the bowl is scumbled with the same mixture used in Step 4, adding a bit more crimson and a lot of white in the highlights.

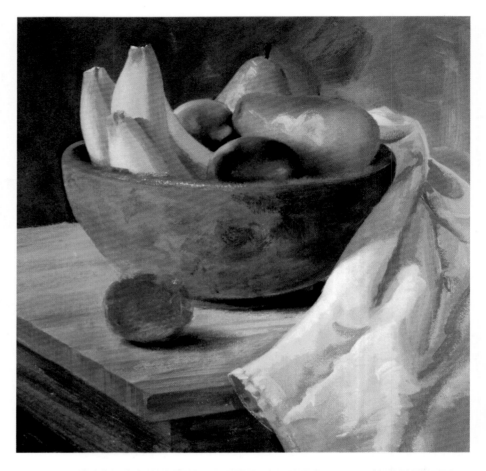

Step 6 (close-up). Here you can see how the finishing touches are added in the final stage. The tip of a bristle brush adds quick dabs of burnt sienna, ultramarine blue, and yellow ochre to suggest the dark spots on the bananas. The point of a round, softhair brush adds the stems with ultramarine blue and burnt umber. Compare the highlights on the pears and the plums. The former are quick, fluid strokes, while the latter are thick scumbles.

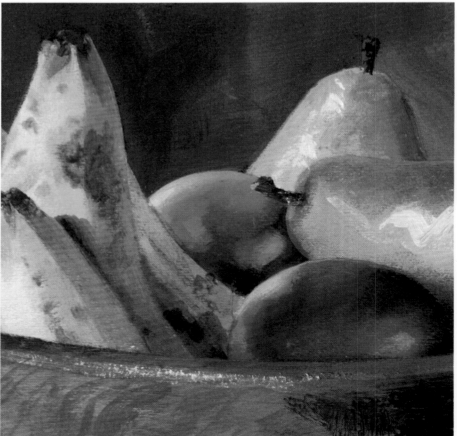

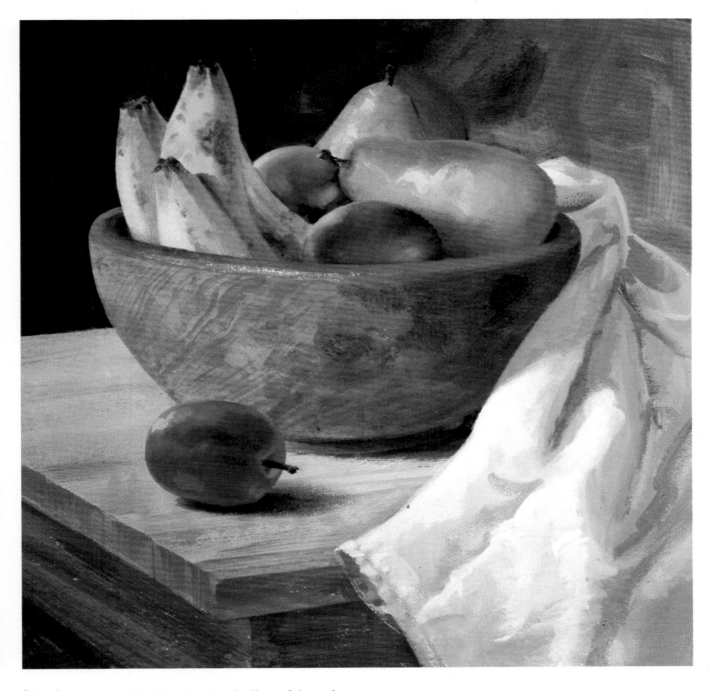

Step 6. A round, softhair brush traces the lines of the grain in the wooden bowl with a mixture of ultramarine blue, burnt umber, and white. The same mixture—and the same brush—add a bit more grain to the table. The plum on the table is modeled by scumbling—the same mixtures as the plums in the bowl. You can see quite clearly that the shadow under the plum is drybrushed with the same colors used on the shadow side of the bowl. By now, you know that there's a logical sequence of operations in all these paintings: covering the shapes with flat tones; modeling the lights and darks over the flat tones; then adding highlights, textures, and details.

Step 1. For your next still-life project, now try the more complex shapes of flowers, perhaps in a transparent vase—a particularly interesting challenge to paint. You'll need to make a precise pencil drawing of the flowers, leaves, and stems. Pick a simple, geometric vase, nothing ornate. As usual, this demonstration begins with a freely painted background—broad, bristle brushstrokes of ultramarine blue, burnt sienna, black, and a fair amount of white on the right side. This demonstration is painted on a canvas board whose woven surface will soften the strokes.

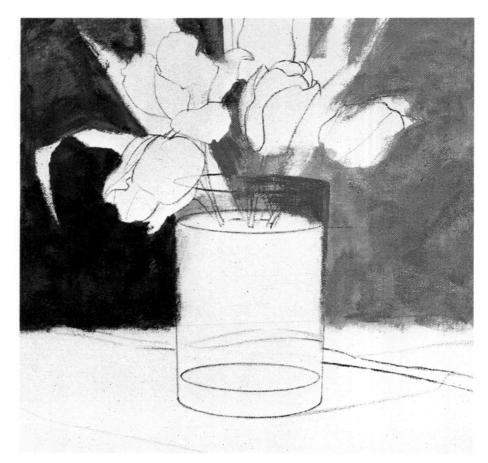

Step 2. The flat undertones of the flowers are painted with liquid color and a bristle brush. The yellow flowers are covered with a shadowy tone of yellow ochre, white, and ultramarine blue; the more brilliant colors will be painted over these muted tones in the later steps. In the same way, the white flower begins as a shadowy tone of ultramarine blue, burnt umber, and white. Only the red flower is painted with its full brilliance, since this will be the brightest note in the picture—a mixture of cadmium red and naphthol crimson, with a touch of ultramarine blue.

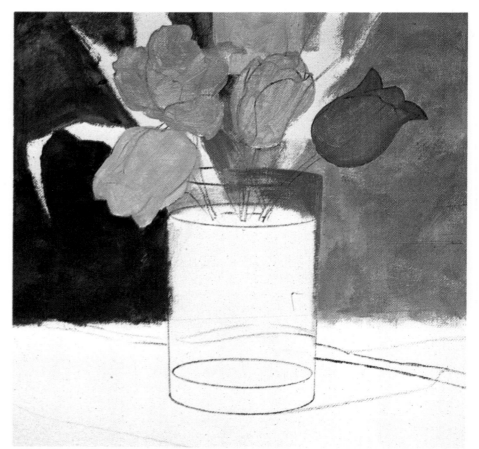

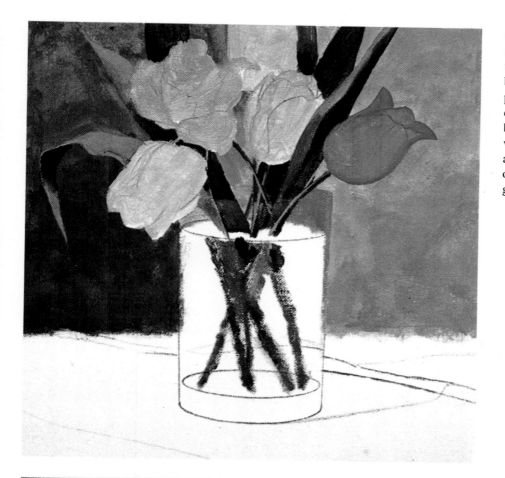

Step 3. The darks of the leaves and stems are painted with a mixture of ultramarine blue, yellow ochre, and burnt sienna. Then the lights are painted right over the darks with cadmium yellow, ultramarine blue, burnt sienna, and white. Inside the vase, notice how roughly the stems are painted, since they'll be partly obscured by the reflections in the glass.

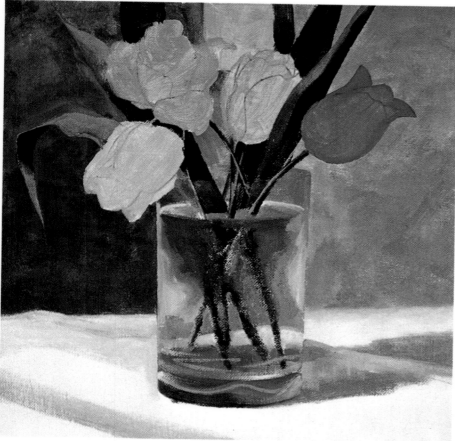

Step 4. Clear glass and clear water have no color of their own, but simply reflect the color of their surroundings. In Step 1, you may have noticed that the color of the background was carried over into the upper portion of the vase. Now the same color is carried down into the water to the very bottom of the vase. The mixtures are the same as the background—ultramarine blue, burnt sienna, black, and white—with more white for the lights and middletones. There's no special trick to painting water or glass; you just have to forget that you're painting a transparent substance and simply paint the patches of light and dark. The same mixtures are used to paint the shadows of the folds in the tablecloth.

Step 5. The dark tones on the yellow flowers are added with a fluid mixture of burnt sienna, yellow ochre, and ultramarine blue, diluted with plenty of water so the color really flows onto the canvas. A flat, softhair brush applies the color very smoothly. The rough brushwork done in the background will now accentuate the smoother brushwork of the flowers and the leaves.

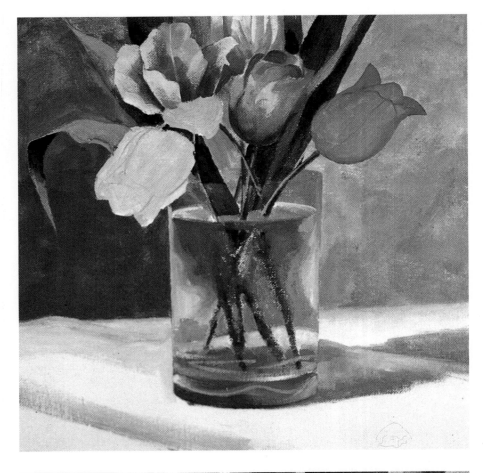

Step 6 (close-up). This "life-size" close-up shows you the modeling on the flowers. The light areas of the yellow flowers are applied with a round, softhair brush carrying a fluid mixture of cadmium yellow, yellow ochre, a little burnt sienna, and white. The edges of the strokes are scumbled, so they seem to merge softly with the shadow tones. Strong darks are added to the undersides of the red and yellow flowers with burnt umber and ultramarine blue. This same mixture, with a lot of water, is used to add some subtle darks to the bright side of the red flower. Observe how the texture of the canvas breaks up and softens the brushstrokes.

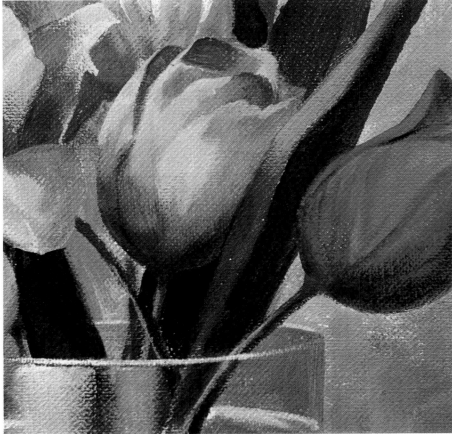

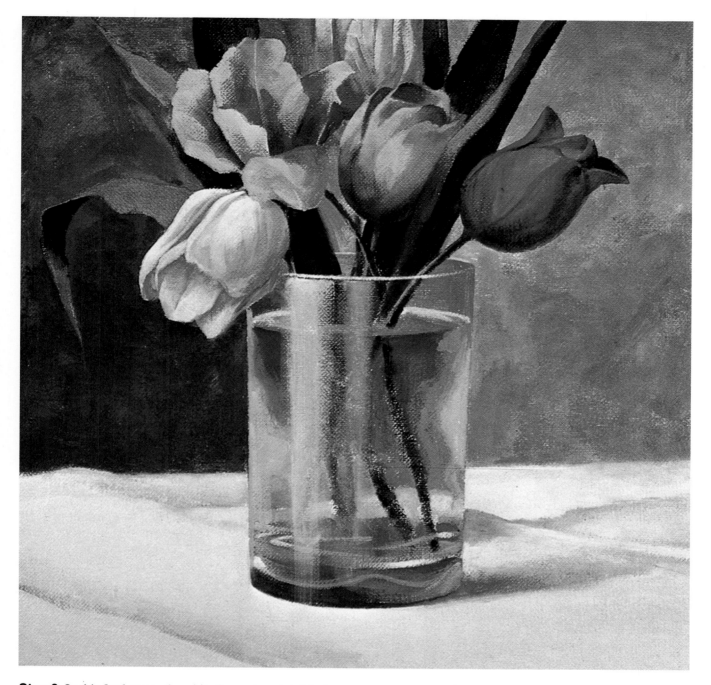

Step 6. In this final stage, the white flower is painted in the same way as the yellow ones. Soft shadows are added with ultramarine blue, burnt sienna, and white. Then the lights are added with almost pure white, faintly tinted with the shadow mixture. The vertical highlights and the bright edges of the vase are painted with this same mixture—mostly white, with just a little burnt sienna and ultramarine blue. The highlights on the glass are painted with just enough water to make the tones translucent so that you can still see the stems within the glass and the background tone beyond. Some of this mixture is brushed into the center of the shadow on the tablecloth, which seems a bit too dark in Step 5. It's worth noting that the bright tones of the flowers look even brighter because they're surrounded by muted colors.

Step 1. Having practiced your basic techniques on several still-life subjects, this is a good time to try a landscape. You can make some sketches outdoors and then go back home to paint your picture from these sketches. Or you can load your paintbox, take along a big plastic bottle of water, and try painting on location. Begin with a pencil drawing of main shapes—trunks, branches, rocks, and the masses of leaves—but don't try to draw every leaf. Here, the sky is painted right over the pencil lines with phthalocyanine blue, ultramarine blue, a little burnt sienna, and lots of white. The mixture contains much water, so the color doesn't completely obscure the pencil lines.

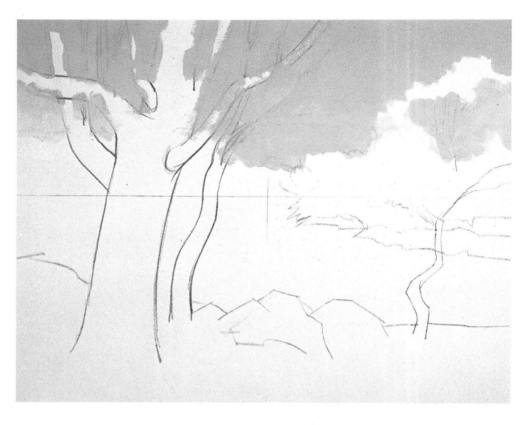

Step 2. The sky mixture is carried down over the water with just a bit more white. Then the trees are painted with short, scrubby strokes of phthalocyanine green, cadmium yellow, a little burnt umber, and white. The distant trees contain more white, while the darker trees on the right contain more green and brown. The reflections in the water are the same mixtures, softened with a bit more brown. The warm strip along the shore to the right is burnt umber, phthalocyanine green, and white. Everything in Steps 1 and 2 is done with the bold strokes of a bristle brush.

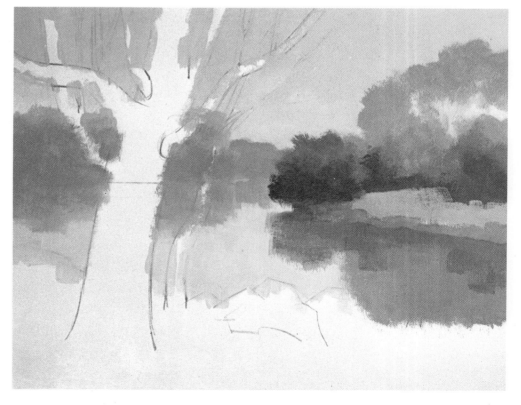

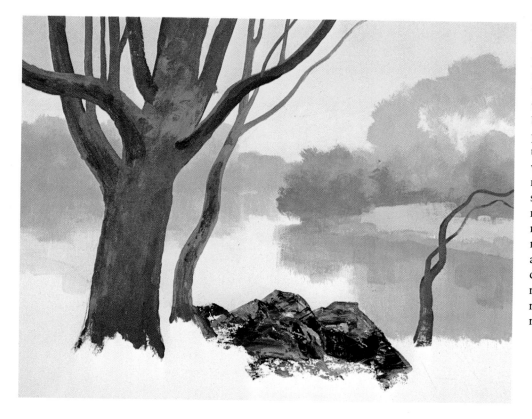

Step 3. Shifting to a flat, softhair brush, the trunks are painted with black, white, and yellow ochre. Notice how the strokes follow the direction of the trunks and branches. The mixture on the palette is thick enough to pick up with a painting knife, which is used to paint the rocks with straight, squarish strokes. The darks of the rocks are painted first; then more white is added to the mixture, and the lighter tones are painted right on top of the darks. The knife strokes are rough and imprecise—just right for the texture of the rocks.

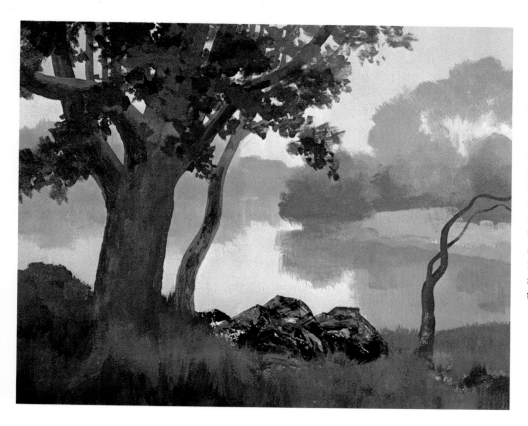

Step 4. The tip of a filbert is tapped against the painting surface—which is illustration board—to suggest clusters of leaves. The leafy tones are phthalocyanine green, burnt sienna, yellow ochre, plus a touch of white for the lighter leaves. The same mixtures are used to paint the darks and lights of the grass. The tip of a round, softhair brush paints the darks first; while these tones are still wet, lighter strokes are painted over and into them. The vertical strokes follow the direction of the grass.

Step 5. Some light tones are added to the trees on the most distant shore—chromium oxide green, ultramarine blue, yellow ochre, and a lot of white—so you can now see a clear division between light and shadow. This same mixture, with a little less white, adds some lighter details to the foliage on the shore to the right. For the light shining on the water, even more white is added to the mixture; now the mixture is fairly thick, and it's drybrushed across the water with the horizontal strokes of a round, softhair brush. It doesn't matter if some of these lines are carried over the trees, which will be darkened in the next step.

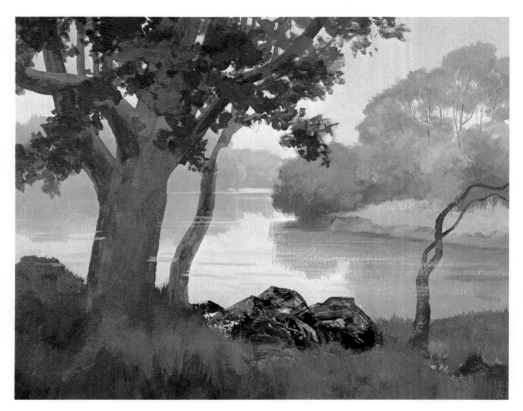

Step 6. A transparent glaze of phthalocyanine green, burnt umber, and water is brushed over the trunks and branches. When this is dry, the dark textures of the bark are painted with this same mixture, but containing more brown. Individual blades and clusters of grass are added to the immediate foreground with mixtures of phthalocyanine green, cadmium yellow, and a touch of burnt sienna, plus a little white to make the strokes stand out against the darker background. Touches of richer green are added to the foliage with the tip of a round, softhair brush—mixtures of phthalocyanine green, cadmium yellow, burnt umber, and a little white.

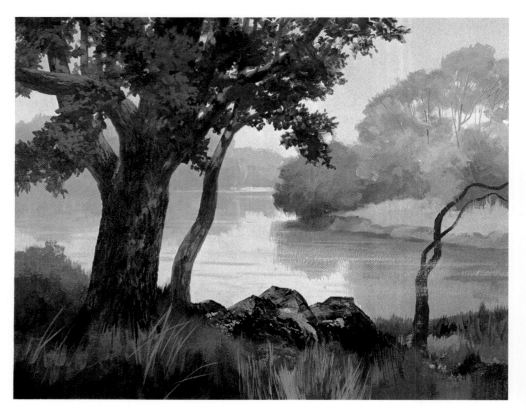

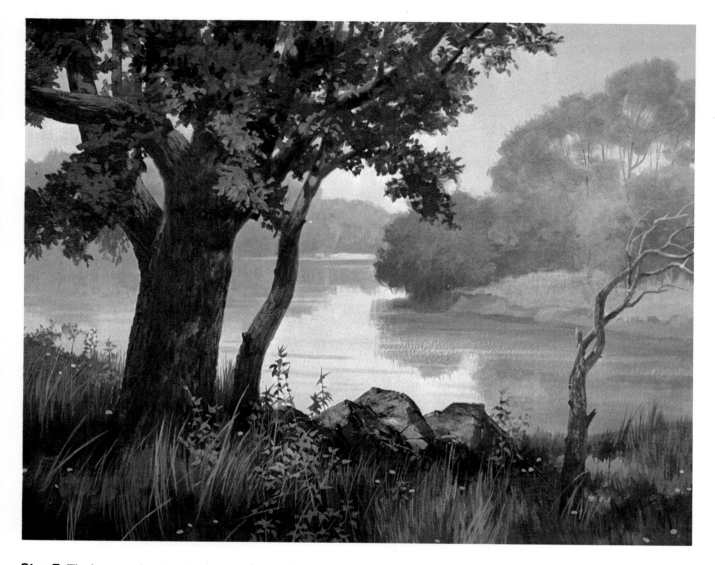

Step 7. The last, precise details are saved for this final step. More blades of grass plus some leafy weeds are added to the foreground with the same mixtures used in Step 6. Notice, however, that the *entire* foreground isn't covered with these strokes; you can still see lots of the broad, rough brushwork from Step 4. A few tiny touches of cadmium yellow suggest scattered wildflowers among the weeds. A few more touches of really bright green—phthalocyanine green, cadmium yellow, and white—are added to the foliage. The small tree to the right is completed with strokes of ultramarine blue, burnt umber, and white. You'll notice a slight change in the color of the trees on the distant shore to the right. They're enriched with a glaze of chromium oxide green, yellow ochre, and water. This transparent tone is carried down over the reflection of these trees in the water to the right. A very fluid, transparent glaze is an almost invisible way to enrich the color of your painting in the final stages.

Step 1. The shapes of the trees, road, and clouds are drawn in pencil. Then the dark trunks are drybrushed with a bristle bright carrying a blackish mixture of ultramarine blue and burnt sienna. The blue patches in the sky are painted with ultramarine blue, yellow ochre, and white. Some burnt sienna is added to this mixture for the shadow areas of the clouds. Then the sunlit edges of the clouds are scumbled with a mixture of white and yellow ochre, connecting the blue and the gray. These cloud tones will flow more softly if you add gloss or matte medium. The white-yellow ochre mixtures carry down toward the horizon; this will add a warm glow to the lower sky.

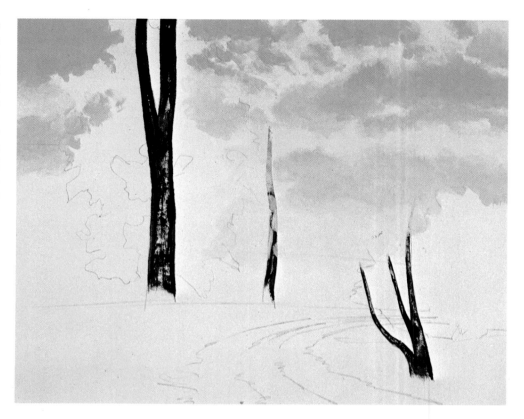

Step 2. The brilliant tones of the autumn trees are painted with scrubby, scumbling strokes of cadmium red and yellow ochre applied with a bristle bright. These slightly ragged strokes suggest the texture of the foliage. The strip of landscape at the horizon is painted with a mixture of ultramarine blue, naphthol crimson, burnt sienna, and white—with a bit less white at the lower edge. The short, stiff bristles of the brush give this shape a ragged edge. Notice that the hot color of the foliage begins to overlap the dark treetrunks, but the color is still quite thin and doesn't obscure the trunks just yet. In later stages, the trunks will begin to disappear under foliage.

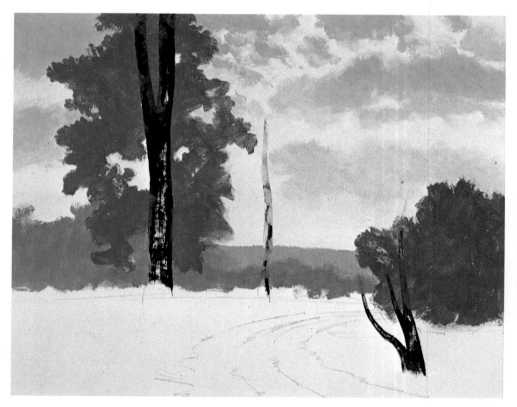

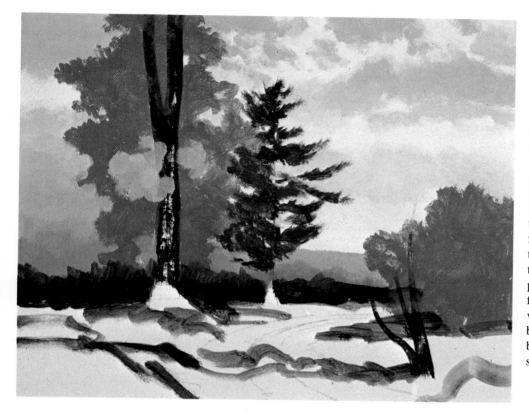

Step 3. The same stiff, short brush scrubs in the foliage of the dark evergreen with ultramarine blue and yellow ochre. At the extreme left, the lower sky is darkened with a thin, fluid mixture of ultramarine blue, burnt sienna, and white, scumbled downward to blur the outline of the distant horizon. Some of the blue sky mixture from Step 1 is painted into the center of the tree to suggest gaps in the foliage where the sky shines through. The dark mass of trees just below the horizon, plus some of the darks in the foreground, are brushed in with a very fluid mixture of burnt umber, ultramarine blue, a little naphthol crimson, and lots of water.

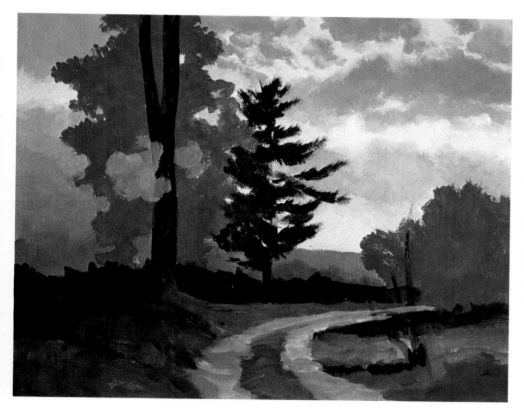

Step 4. The cool tones of the grass are scrubbed in with a bristle bright and a mixture of ultramarine blue, yellow ochre, burnt sienna, and white—with less white in the shadows and more white in the sunlit patches. In the warmer areas, cadmium red is substituted for the burnt sienna. The road is painted with ultramarine blue, burnt sienna, and white, with more blue in the shadows. Notice that the tree in the lower right is beginning to disappear under all that paint; but its shape will be strengthened in the final stages.

Step 5. The lighter trees to the left are brushed in with cadmium red, cadmium yellow, burnt sienna, and white, dabbed onto the illustration board with the tip of a filbert. The shadow tones on the big tree and on the smaller tree to the right are painted with short, scrubby strokes of the same brush—a mixture of ultramarine blue, burnt sienna, and cadmium red. The tones of the foliage are gradually working their way over the shapes of the treetrunks. This same mixture, with more blue, is scrubbed in over the dark strip at the horizon.

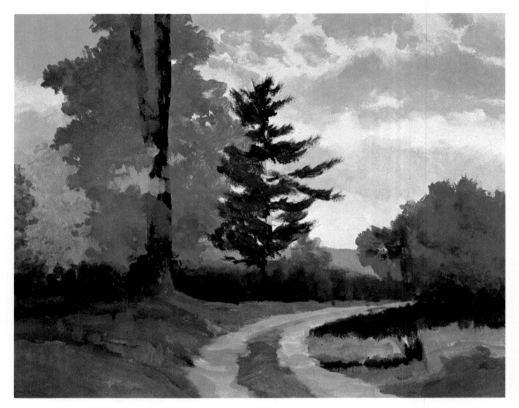

Step 6. The tip of a filbert now adds lighter, sunlit foliage to the trees at the left with cadmium red, cadmium yellow, and yellow ochre. The big treetrunk is now partially covered by foliage. A round, softhair brush adds trunks to the smaller trees at the left and branches to the big tree—a mixture of ultramarine blue and burnt umber. The light edges on the trunks are white with just a hint of burnt umber. A trunk and branches are added to the evergreen with the same dark mixture, which is also used to reconstruct the tree at the right. Then the light foliage mixture is scattered across the right with taps of the filbert.

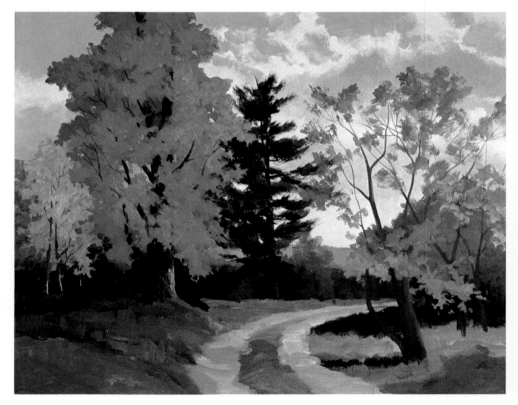

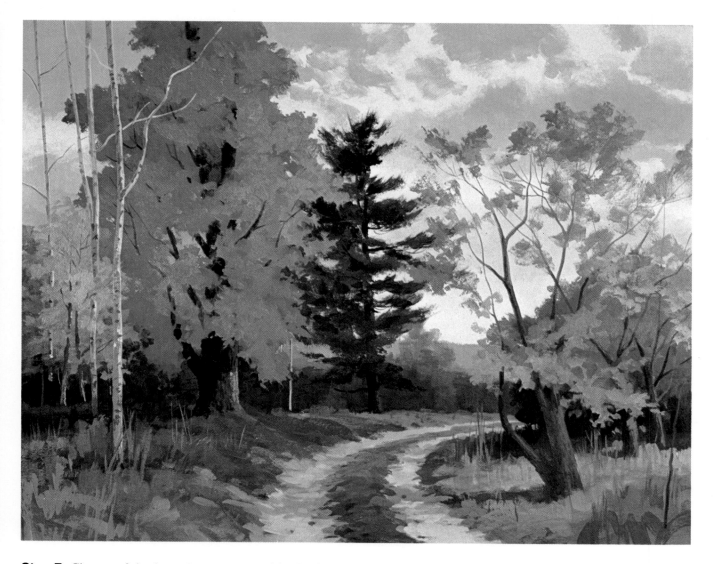

Step 7. Clumps of dead weeds are suggested in the foreground with a round, softhair brush. These strokes are all mixtures of ultramarine blue, burnt sienna, yellow ochre, and white, with more brown in the warmer strokes, more blue in the cooler strokes, and more white in the paler tones. The very tip of the brush uses the pale mixture to indicate individual blades of dried grass. The pale trunks of the birches at the left are painted with two mixtures: white with a faint tinge of burnt umber on the sunlit side; burnt umber, ultramarine blue, and white on the shadow side—with a darker version of this same mixture for the flecks on the bark. This dark mixture is also used to add dark edges to the trees and branches on the right. The somber, grassy tones in the center of the picture, running up the road and reappearing under the evergreen, are ultramarine blue, yellow ochre, white, and an occasional hint of burnt sienna. Although the painting seems to be full of rich detail, the entire landscape is very loosely painted. It's hard to pick out a single leaf— the leaves are just rough touches made by the tip of the brush. Although the ground *seems* to be covered with withered weeds and grasses, only a few individual blades are suggested by the brush.

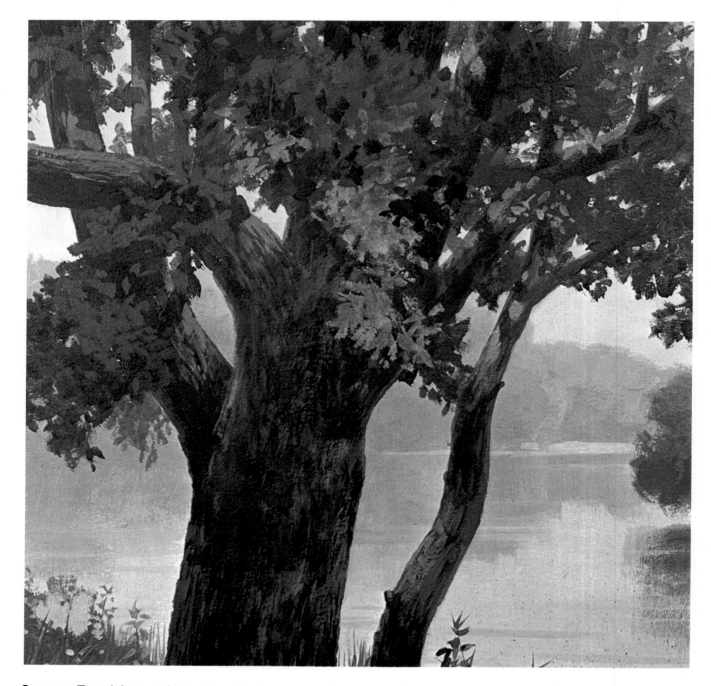

Summer Tree (close-up). It's interesting to compare the brushwork used to render the trees on this page and on the facing page. In both cases, the general shapes of the trunks, branches, and masses of leaves are blocked in with broad strokes of a large, flat brush. But then this summer tree is completed with small, precise strokes made by the tip of a round, softhair brush. Short, slender strokes follow the trunk upward and then curve to follow the branches. The leaves are painted with rapid touches of the tip of the round, softhair brush, which is quickly pressed against the painting surface and then pulled away. These touches gradually add up to clusters of leaves. The dark leaves are painted first and then allowed to dry. Then the sunlit leaves are painted right over them, so the brighter clusters seem to come forward into the sunlight, and the darker ones seem to recede into the shadows. But how precise is this brushwork, really? Each leaf is nothing more than a rough dab of paint deposited by the tip of the brush. You can't find a single leaf whose shape is painted with scientific precision. This tree may be painted with small strokes, but the brushwork is still loose and suggestive.

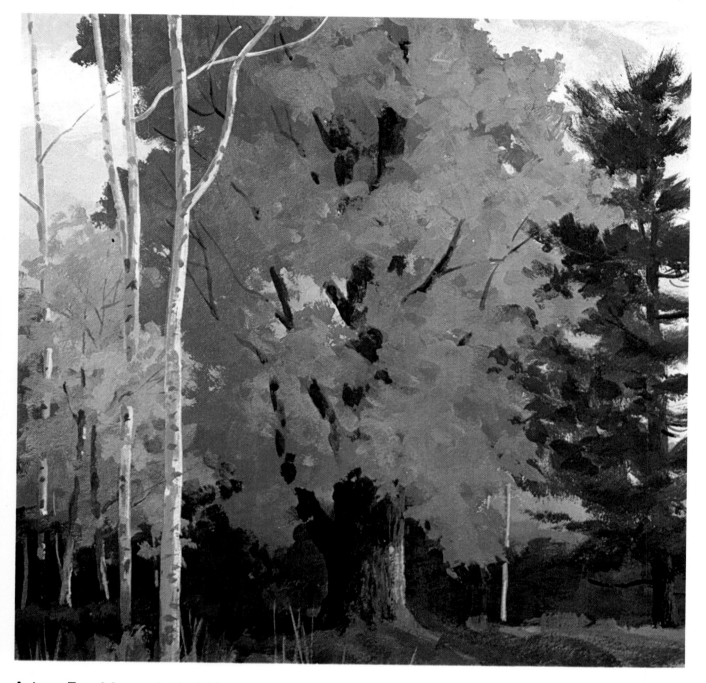

Autumn Tree (close-up). The brilliant colors of this tree are painted entirely with very broad, rough strokes. In fact, the color is scrubbed on so freely that one stroke seems to merge with the next—it's difficult to decide where one stroke begins and another ends. The artist focuses on the overall shape of the tree. He distinguishes between the sunlit foliage and the shadowy foliage but makes no attempt to suggest individual leaves. The same is true of the evergreen to the right, where you see clusters of foliage, but not a single needle. The detailed, precise brushwork is restricted entirely to the slender lines of the branches. Why choose precise brushwork for one painting and rough brushwork for another? Both kinds of brushwork are equally effective. There are no "rules." However, the precise, detailed brushwork of the summer tree works well because it contrasts with a very simple background. If the dense mass of autumn trees were painted with so many tiny strokes, there would be more detail than the viewer could stand—so simpler brushwork is often the best way to paint a complex subject.

Step 1. The key to this stark winter landscape is the pattern of the dark trunks and branches. So the preliminary pencil drawing defines these shapes very clearly, tracing the outline of every trunk and branch. The outer edges of the snowbanks are drawn more simply. The outer and inner shapes of the stream are drawn carefully, although these will change somewhat in the process of painting. Then the darks of the trees are painted in pure black, with a round, softhair brush. The idea is to make these very important shapes dark enough so that they won't disappear as colors are applied behind and around them.

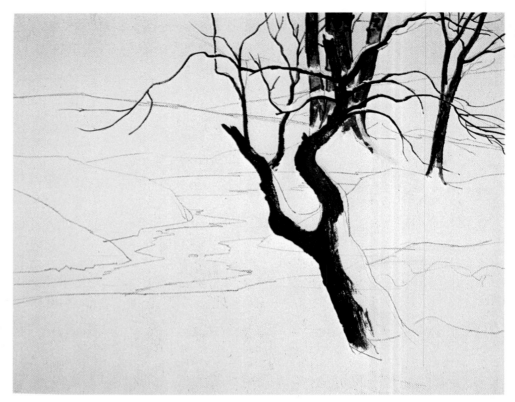

Step 2. The sky is painted with broad strokes of a bristle brush. The tone is a mixture of ultramarine blue, cadmium red, yellow ochre, and white. Since water most often reflects the color of the sky—and ice is just another form of water—the sky mixture reappears along the edges of the frozen stream. The sky tone overlaps the darks of the distant trees, but the trees are still there. The muted tones of the trees along the horizon are now scrubbed in with burnt umber, ultramarine blue, and white. This painting is on a canvas board, selected so that the texture of the weave will soften and blur the brushstrokes.

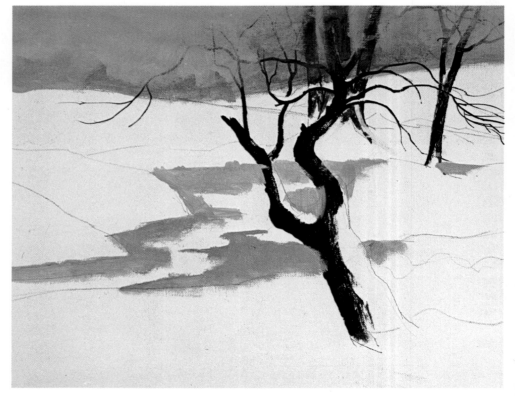

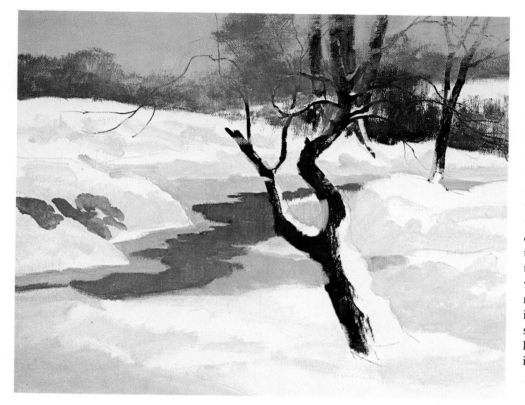

Step 3. The trees at the horizon are extended upward with scumbling strokes of the sky mixture—containing much less white. Then the warmer tree tones—below the horizon and to the right—are scumbled in with burnt sienna and black. For both these operations, the paint is fairly thick and a bristle brush is used. You can see where the texture of the canvas breaks through the strokes. An even darker version of the sky mixture is painted across the center of the stream. And a paler version of that mixture—more white and more water—is used to block in the shadow sides of snowdrifts. Snow, like ice, is just water, reflecting the color of the sky.

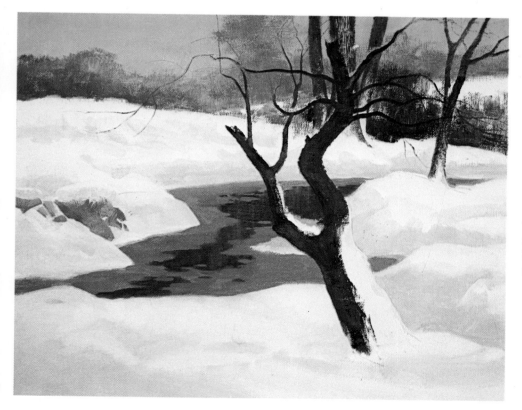

Step 4. The lighted tops of the snowdrifts are scumbled with fluid white, faintly tinted with naphthol crimson, yellow ochre, and ultramarine blue. These scumbled strokes seem to blend into the shadows. A round, softhair brush defines the dark shape within the frozen stream—an even darker mixture of the sky color. The darks of the trees are reinforced now with burnt umber, ultramarine blue, and white. A bit of white is drybrushed over the distant trunks.

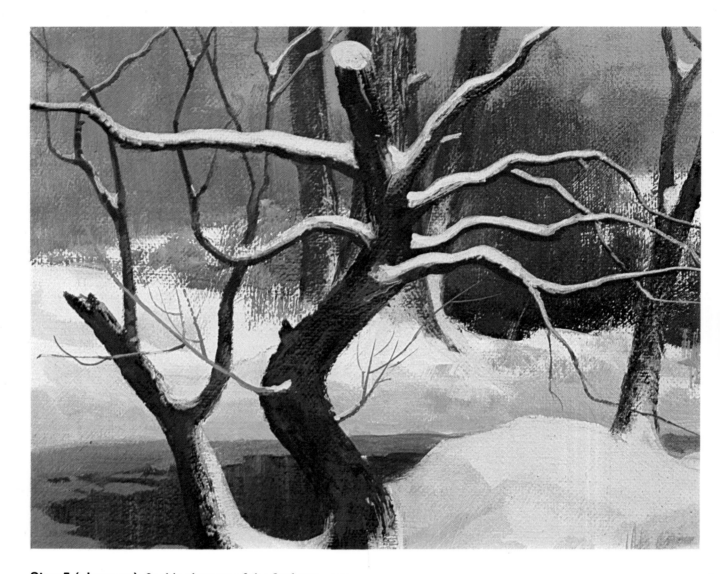

Step 5 (close-up). In this close-up of the final step, you can see how the trunks and branches are completed with two drybrush operations. Over the dense black of Step 1, a slightly paler tone of burnt umber, ultramarine blue, and white is drybrushed to suggest the texture of the bark. Then the snow is drybrushed over the edges of the dark trunks and branches—mostly white, with just a tinge of the snow mixture used in Step 4. This section of the painting is shown the actual size of the original so that you can examine how the texture of the weave influences the brushwork. The canvas makes it easier to scumble and blend the smoky tones in the distance. And the weave also makes it easy to drybrush the bark textures on the trunks and branches.

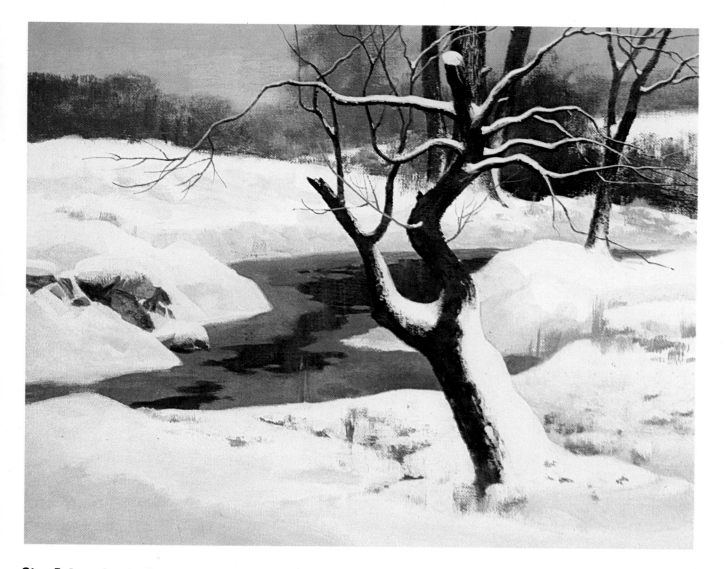

Step 5. Just a few details are added in the final stage. Some warm strokes are added to the lower sky; horizontal strokes of naphthol crimson, yellow ochre, ultramarine blue, and white. All the dark trunks and branches are reinforced with burnt umber, ultramarine blue, and white. The lighted tops of the snowdrifts are reinforced by scumbling a bit more of the mixture used in Step 4. Some shadows are added to the rocks at the left—partly concealed by snow—with burnt umber and ultramarine blue. Here and there, the point of a round brush adds some dead leaves with burnt sienna, a little black and white, and enough water to make the strokes more fluid. Don't make the mistake of thinking that a winter landscape is all dull gray and white. As you see here, winter is full of subtle color.

Step 1. This demonstration shows how to use acrylic in a fluid, transparent technique that's similar to watercolor. The shapes of this rocky coastal scene are drawn with a pencil on cold-pressed (called "not" in Britain) watercolor paper. Then the entire sky area is brushed with clear water—you can use a large, flat brush or a sponge—and the water is allowed to sink in for just a moment. While the paper is still wet and shiny, the dark shapes of the clouds are brushed onto the wet surface with a mixture of ultramarine blue, naphthol crimson, and yellow ochre. The strokes spread and blur. If any color goes where you don't want it, you can blot it up with a paper towel or tissue.

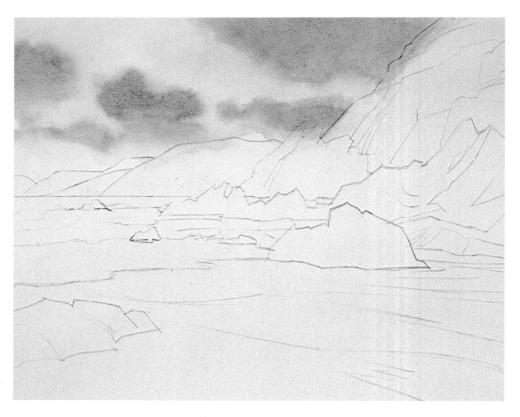

Step 2. The cloud shapes are allowed to dry. Because acrylic is waterproof when it dries, the clouds won't dissolve when more color is brushed over them. Now the sky area is brushed with clear water once again. A pale mixture of ultramarine blue and phthalocyanine blue—with lots of water—is brushed over the entire sky area, right down to the horizon. The color is carried over the distant hills. While the sky is still very wet, a hint of yellow ochre is brushed between the horizon and the lower clouds to add a suggestion of warmth. Notice that no white is used to make the colors lighter. It's all done with water; thus the colors remain transparent, like watercolor.

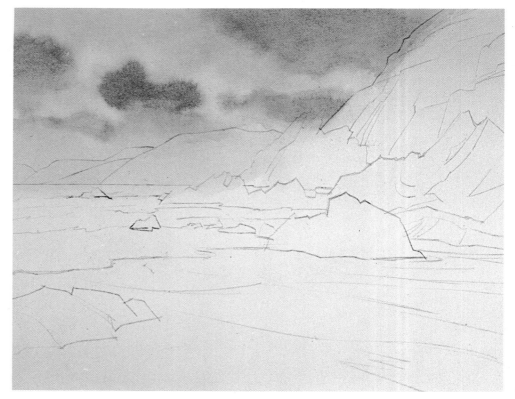

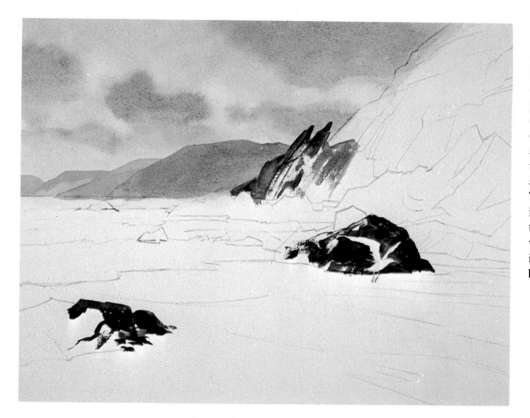

Step 3. When the sky is bone dry, the distant hills are painted over it with the same mixture as was used for the clouds. The paler hills are painted first, then allowed to dry. The darker tones of the cliff and the foreground rocks are begun with the sky mixture, containing more blue and with burnt umber added. The dark side of the big rock is carefully painted around the shape of the gull. Like a watercolor, this entire picture is painted with only softhair brushes.

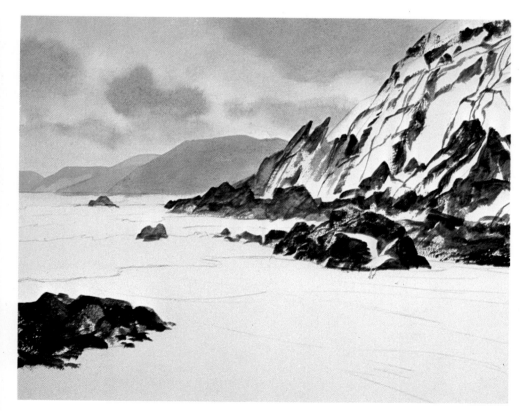

Step 4. More darks plus some details of cracks and crevices are added to the cliffs and rocks with the same mixture used in Step 3. Notice how drybrush strokes accentuate the craggy texture of the rocks. The details of the rocks are painted with great care and allowed to dry. They're now waterproof, so wet tones can be washed over them.

Step 5. A fluid wash of ultramarine blue and burnt sienna is brushed over the entire cliff area. While this tone is still wet and shiny, the dark rock mixture is blended in at the top of the cliff; thus this looming rock formation becomes more shadowy. The tip of a round brush carries slender, curving strokes of the cloud mixture across the water. This same brush draws slender lines of burnt sienna and ultramarine blue across the beach to suggest ripples in the sand. The beach in the immediate foreground is first sponged with clear water and then the ripples are painted onto the wet surface, where they tend to blur.

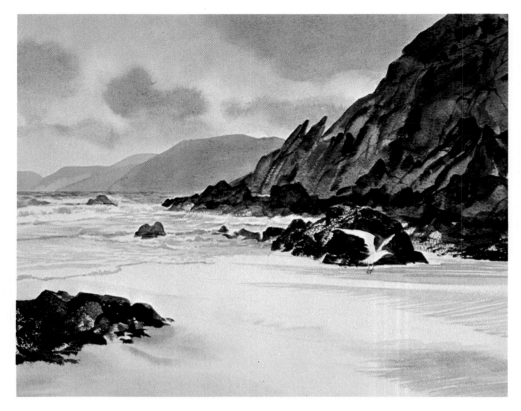

Step 6 (close-up). In the final stage, the rocks at the foot of the cliff are darkened with a wash of burnt sienna and ultramarine blue. The brushwork is interesting. Notice how the lower edges of the rocks are drybrushed so they seem to disappear into the foam of the breaking waves. Drybrush strokes also suggest the rough texture of the rocks in the lower right section. The dark flecks in the distant hill are a phenomenon called granulation, which adds to the atmospheric feeling: a very wet wash of acrylic color, diluted with lots of water, settles into the valleys of the textured paper.

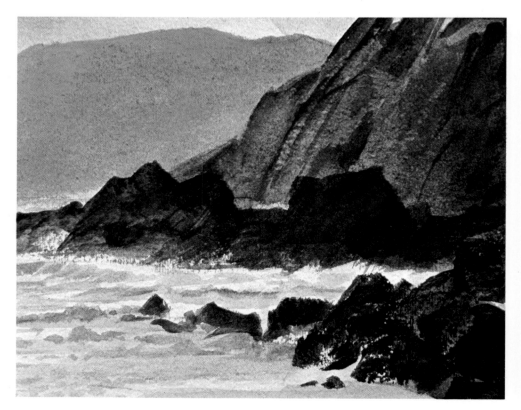

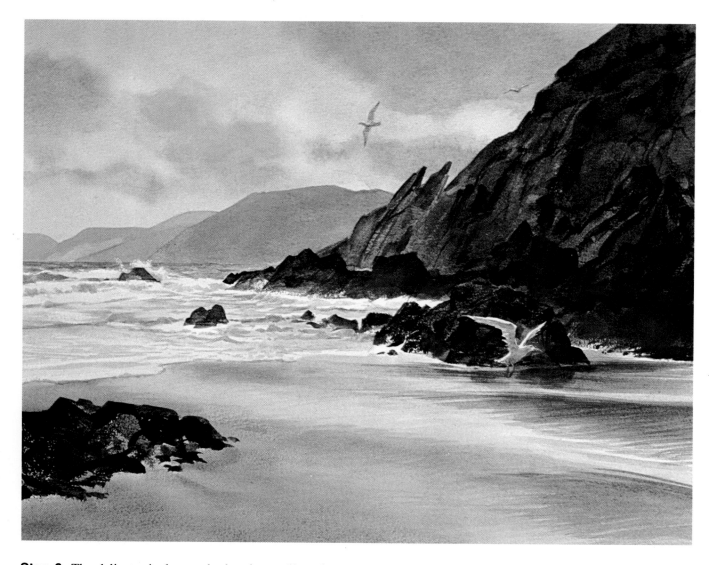

Step 6. The delicate ripples on the beach are allowed to dry. Darker strokes are added on the right to accentuate the ripples—a mixture of burnt umber and ultramarine blue. This same mixture adds reflections beneath the rocks and cliff at the right. And a paler version of this mixture adds the shadows under the wings and body of the gull. When this detailed work is dry, the entire beach is brushed with clear water once again. While the surface is wet, a mixture of burnt sienna, ultramarine blue, and yellow ochre is brushed over the foreground, fading away into the distance. Before the beach loses its shine, a paper towel blots up a light path from the lower right to the edge of the water, suggesting sunlight reflecting on the wet beach. For dry-brush strokes like those on the rocks, one good trick is to work with the side of a round, softhair brush, not with the tip. The side will make a more ragged stroke.

Step 1. For the soft, luminous flesh tones of the human head, canvas is the ideal painting surface. This portrait begins with a meticulous pencil drawing on tracing paper. The back of the sheet is then covered with pencil, and the sheet is laid over the canvas. The lines on the front of the sheet are retraced with a sharp pencil so that they're automatically transferred to the painting surface. A bristle brush paints a background tone around the edge of the face to define the contours. This is a mixture of cadmium red, yellow ochre, and ultramarine blue. The paint is diluted with gloss medium to make it flow smoothly. The darkest shadows on the face are added with touches of burnt sienna, ultramarine blue, and white.

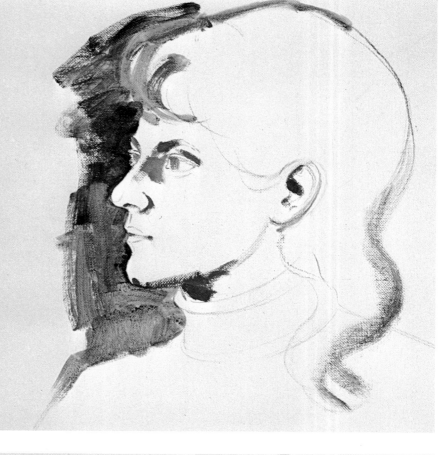

Step 2. The shadows around the features are painted with a small, flat, softhair brush with a creamy mixture of cadmium red, yellow ochre, ultramarine blue, white, and gloss medium. The shadow under the neck is painted with this mixture. The hair is covered with a mixture of burnt sienna, ultramarine blue, yellow ochre, and gloss medium—the long, rhythmic strokes following the direction of the hair. This mixture also suggests the curving shadow on the collar. The lips are painted with a flat tone of cadmium red, burnt umber, and white.

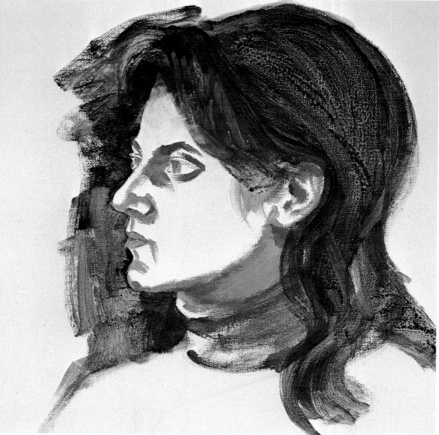

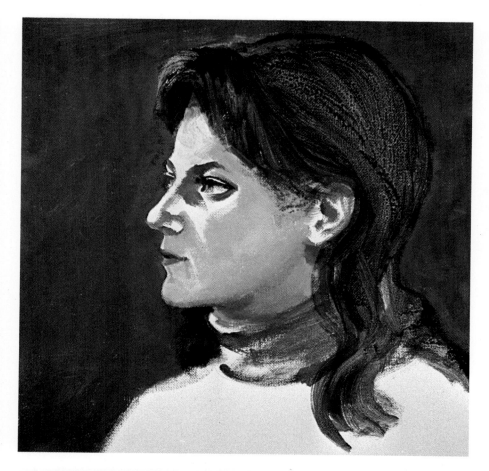

Step 3. A bristle brush paints the middletones of the face with the same mixture used to paint the shadows around the features in Step 2—but with more white. This mixture is scumbled over the shadow on the neck. The eyes are darkened with burnt umber and ultramarine blue. Now the entire head is surrounded with a background tone of phthalocyanine blue, burnt umber, black, and white, so that the head stands out boldly from the background. The brightest areas on the forehead, nose, cheeks, and ear are still bare canvas.

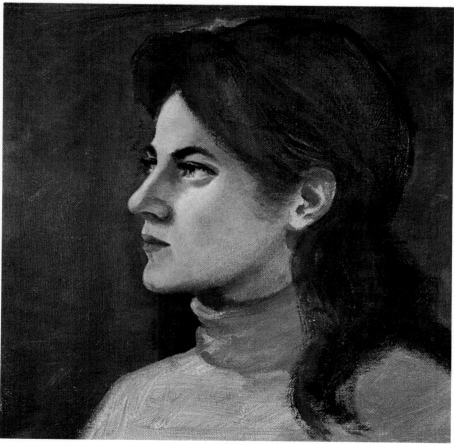

Step 4. With more white added, the same mixture is scumbled over these light areas with a bristle brush, which blends the lights into the middletones. Then a darker, warmer version of this mixture—more red and yellow, less white—is scumbled over the middletones that were originally painted in Step 3. A still darker version of this mixture, with a bit more blue, reinforces the darks around the nose, eyes, jaw, and ears. A deeper tone of ultramarine blue, burnt sienna, and yellow ochre is brushed over the hair. A thin tone of ultramarine blue, naphthol crimson, and white covers the blouse.

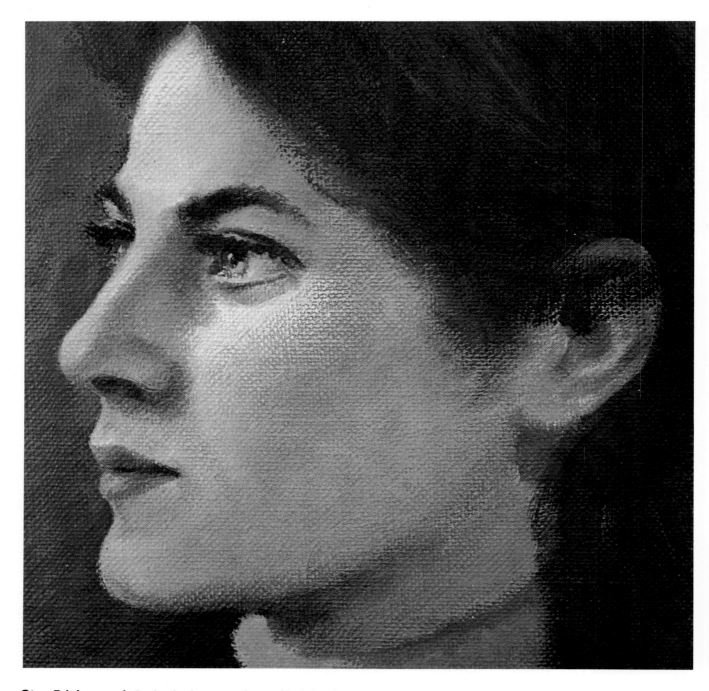

Step 5 (close-up). In the final stage, a flat, softhair brush skims gently over the entire face, softening and enriching the tone. A very pale version of the skin tone, with lots of white and gloss medium, is gently drybrushed over the forehead, the forward edge of the nose and upper lip, and the lighted area of the cheek. More of the warm flesh tone— introduced in Step 4—is drybrushed over the side of the nose, forehead, and cheek to strengthen the contrast between the light and shadow sides of the face. Where it overlaps the brow and cheek, the soft line of the hair is drybrushed to melt away softly into the skin. Drybrushing makes the lips rounder too.

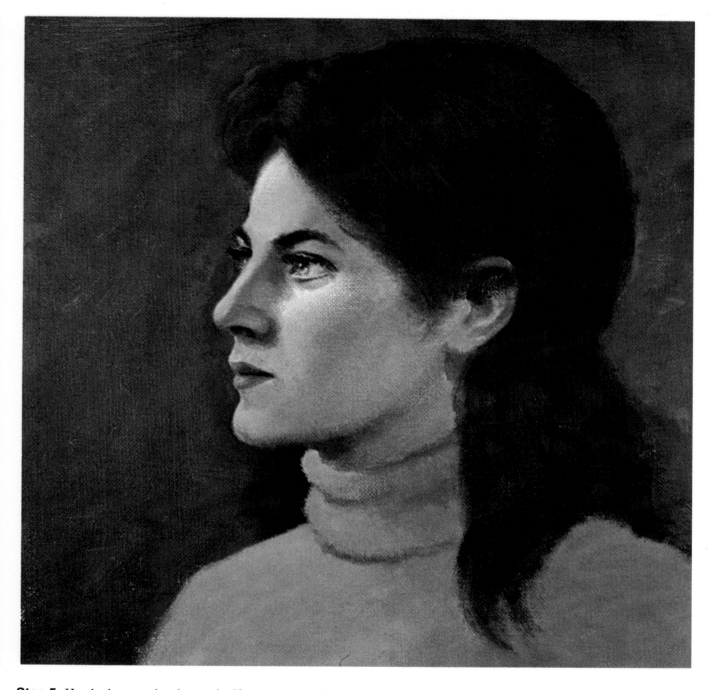

Step 5. Here's the completed portrait. If you compare the final step with Step 4, you'll see that the entire head is rounded and softened with repeated drybrushing. The lights are even lighter, while the middletones are warmer and darker. All the flesh tones are painted with the same palette, with more white in the lights, more red and yellow in the middletones, and a bit more blue in the darks. The shape of the hair is covered with a mixture of burnt umber, ultra-marine blue, black, and just a little white. More white is added to this mixture for the lighter strokes in the hair. The blouse is now covered with a thick, opaque mixture of ultra-marine blue, alizarin crimson, yellow ochre, and white—with more blue in the darker areas to the right and in the lines around the turtleneck. Finally, the background is warmed with a transparent glaze of yellow ochre diluted with gloss medium and water.

Step 1. Like the female head in the previous demonstration, this male head is first drawn on tracing paper and then transferred to canvas by the same method. The first painting operation is to establish the strongest darks in the head. The shadows around the eyes are painted with a dark mixture of raw umber, black, and white, applied with a bristle brush.

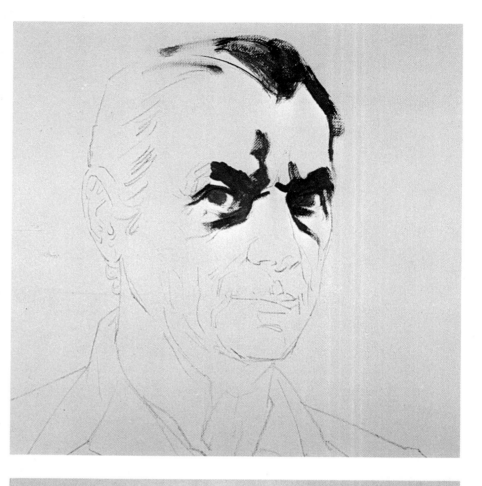

Step 2. The major dark notes of the head are now completed with the same mixture. The edges of the face and shoulders—where they meet the background—are also defined with dark lines. As the shapes of the face, shoulders, and background are filled with color in later stages, these dark lines will tend to disappear. The broad shadow under the chin contains just a bit more white.

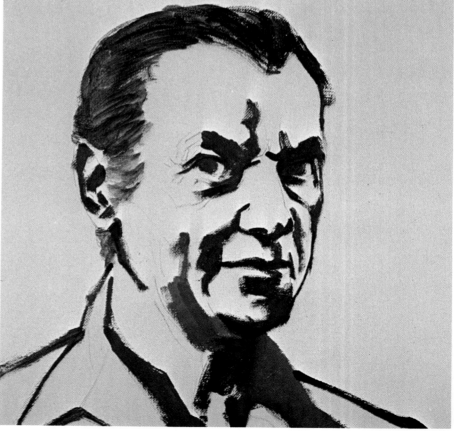

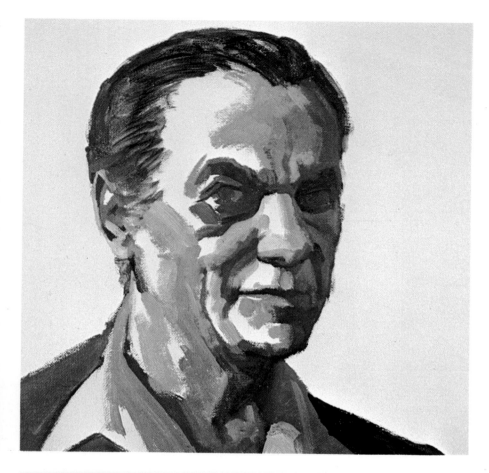

Step 3. More white is added to the same mixture to paint the middletones—the tones that are lighter than the shadows but darker than the lights. You can see where these middletones are added between the darks on the forehead, eyes, nose, ears, cheeks, chin, jaw, and neck. Gaps of bare canvas are left for the lightest tones, which will come next. More dark strokes are added along the right side of the forehead and jaw. The shadows of the features are reinforced with more darks too. And the shoulders are painted with flat tones.

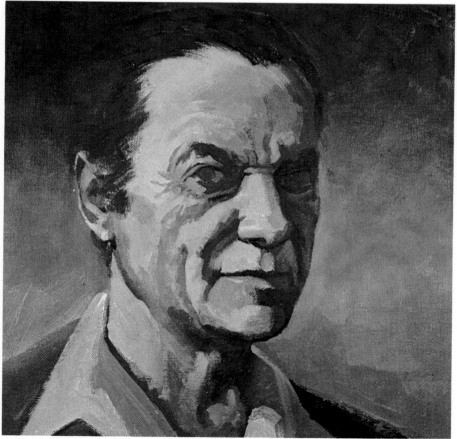

Step 4. Now the lightest tones are scumbled in with the same mixture, which now contains much more white. You can see these tones where there was just bare canvas in Step 3: the left side of the forehead, cheek, nose, upper lip, jaw, neck, and Adam's apple. The shapes of the ear are more clearly defined with this light tone too. A dark version of this mixture covers the hair. The background is painted with various tones of this mixture—darkest at the top, lighter at the middle, then darker again at the bottom—blended by scumbling. The broad tones are all painted with a bristle brush. Then a round, soft-hair brush adds a few more details, such as wrinkles around the eyes.

Step 5. Small bristle brushes strengthen the lights and darks, still working with lighter and darker versions of the same mixture used in all the preceding steps. You can see where strong highlights are added to the brow, nose, and chin, while the darks are strengthened on the right side of the face and neck. The shadow inside the collar is strengthened too. The background is lightened with more scumbling strokes to make the head stand out more boldly. Then the tip of a small, round, softhair brush sharpens the details of the eyes and eyebrows, defines the mouth more clearly, and adds light and dark lines to the hair. At this point, the picture is completely painted in monochrome, like the kettle you saw in Step 3 of Demonstration 4.

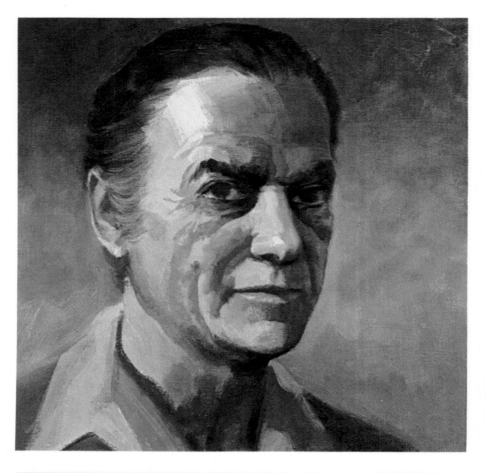

Step 6. The lights and shadows of the head are completely defined. The portrait is already a convincing likeness—like a black-and-white photograph. Now the color is added in transparent glazes that reveal the underlying pattern of lights and shadows. The glazing begins on the face with very pale tones of burnt sienna and yellow ochre, plus a lot of gloss medium—paler in the light areas, darker in the shadow areas. The background is slightly toned with a glaze of naphthol crimson, ultramarine blue, yellow ochre, and gloss medium. The glazing operation is performed with flat, softhair brushes. The whole idea is to build up the color very gradually, so it doesn't obscure the monochrome underpainting.

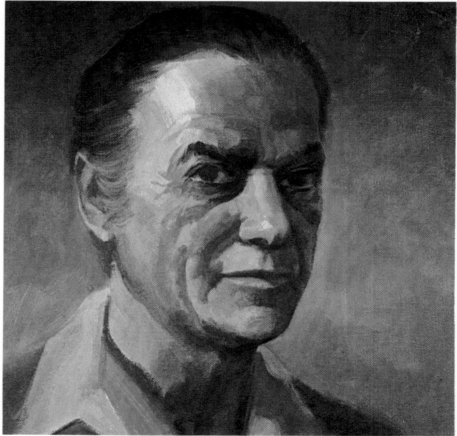

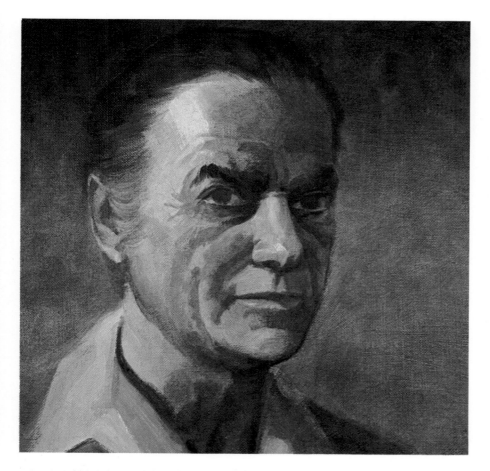

Step 7. When the first glazes are dry, the middletones and shadow areas of the face are darkened with more of the same mixture. The glaze is heavily applied in the shadow areas, a bit thinner in the middletones, and skimmed very lightly over the more brightly lit areas. The lines in the face are darkened with the same mixture, applied with a round, softhair brush. The background is darkened with a glaze of alizarin crimson, yellow ochre, and black, which is carried over the shoulders.

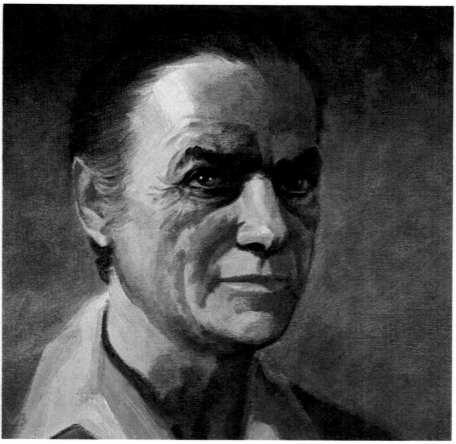

Step 8. When the glazes in Step 7 are dry, the darker tones of the face are strengthened with a mixture of black, burnt sienna, and yellow ochre. A bit more burnt sienna and yellow ochre are glazed over the lighter areas. Now the face begins to glow with the colors of life. The whites of the eyes are lightened with a whisper of white and ultramarine blue diluted with a lot of medium, while highlights are added to the eyes with the same mixture diluted with much less medium. The background is darkened with a glaze of ultramarine blue and a little yellow ochre.

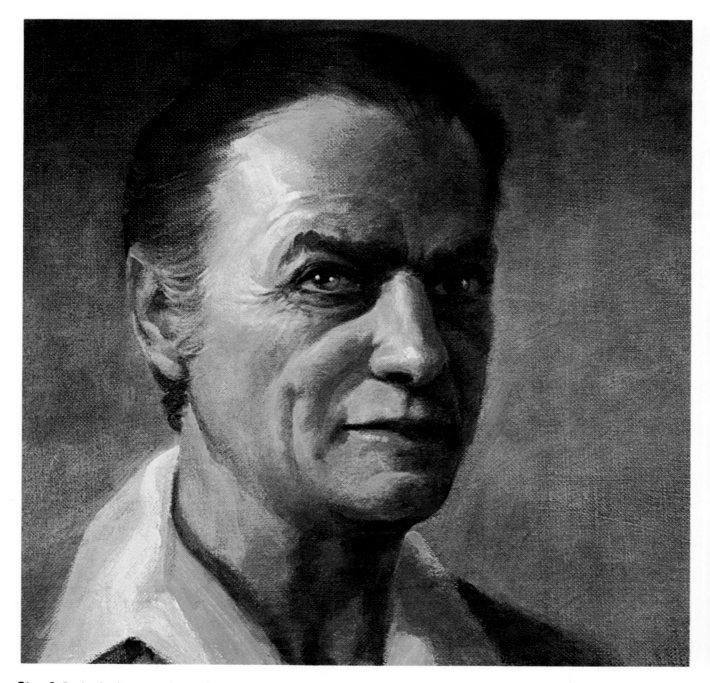

Step 9. In the final stage, a flat, softhair brush picks up just a bit of white and yellow ochre—diluted with gloss medium—and lightly scumbles over the lighted areas of the face, gradually softening the edges and blending them into the darks. All the lines and contours are softened and made more luminous. Compare Step 9 with Step 8, looking carefully at the lighter sides of the brow, cheek, nose, chin, and neck. This scumbled white is quite thin and transparent, softening the darks, but never concealing them. The scumbled strokes are built up very gradually—stopping before there's any danger of covering the darks that were so carefully painted in monochrome. Notice how small touches of white, tinted with yellow ochre, are added to the wrinkles on the brow and eyes, to the nose, and to the lips. In the same way, an additional glaze of black, burnt sienna, and yellow ochre—diluted with a lot of gloss medium—is scumbled over the shadow side of the face, which becomes darker and contrasts more strongly with the light background. A great deal of gloss medium is added to all these glazes and scumbles to make sure that they're thin and transparent. They must never be allowed to obscure the monochrome foundation on which the entire painting is built. The luminosity of the flesh tones is the result of this transparency.

Improvised Tools. Acrylic is such a versatile medium that artists are still finding new ways of applying paint. Although brushes are certainly the most popular painting tools, artists are always improvising—always coming up with new and unexpected painting tools. Here are some. As you experiment with acrylic, you'll probably come up with others.

Scratching. A dried layer of acrylic paint is a lot tougher than oil or watercolor, but you *can* produce some interesting effects with the sharp point of a knife or the sharp corner of a razor blade. If you're working on illustration board or watercolor paper, you can scratch through a layer of paint to expose the white surface beneath. This can be a very effective way to suggest blades of grass in sunlight or sunstruck twigs against a background of dark trees. If one layer of paint covers another, you might also try scratching away the top layer to reveal a bit of the underlying layer.

Painting with Cloth. You can also roll up a rag into a ball or a rectangular wad, dip this in acrylic color, and apply the paint with a dabbing motion. You actually *pat* the color onto the paper. If the cloth dabber is covered with a lot of color and you press hard, you'll leave behind a fairly solid layer of paint. Less paint and less pressure will leave behind a veil of color. You can also experiment with different textures of cloth: smooth cloth will obviously leave behind a different imprint than rough cloth.

Painting with Paper. Just as you make a dabber out of cloth, you can wad up paper to produce an interesting painting tool. A soft, absorbent paper towel will soak up color and generally leave a soft, blurry mark on your painting surface. A stiffer, less absorbent sheet of paper, such as smooth drawing paper, will make a wrinkled, irregular dabber that will leave a more irregular mark on the painting surface.

Spattering. For subjects like a pebbly shore or a roughly textured stone wall, you can spatter color onto the painting surface. One way is to dip the brush into color, hold one hand stiffly in front of the painting surface, and then whack the handle of the brush against that hand so the color flies off the bristles and leaves an irregular pattern of droplets on the painting. Another way is to dip a stiff toothbrush into liquid color and spray the paint by pulling a flat piece of wood across the bristles.

Sponging. The soft, irregular texture of a natural sponge can become one of the most versatile painting tools. Wet the sponge first, of course, and squeeze out as much water as you wish—depending upon how fluid you want the paint to be. Then dip the sponge into the color on your palette and apply the paint by patting or scrubbing.

Textural Painting. For painting richly textured subjects like rocks or weathered wood, you can use or *create* thickly textured paint. You can work with paint directly from the tube, without water. You can blend the paint with gel medium or acrylic modeling paste or a combination of both. And you can apply this color either with stiff bristle brushes (leaving the imprint of the bristles in the paint) or with any of the improvised tools listed above—each of which will leave its own special texture in the thick color. When that heavily textured layer of paint is dry, you can accentuate the texture with drybrush strokes. Or you can apply very liquid color that sinks into the pits and valleys of the irregular paint surface.

Correcting by Darkening. When things have gone wrong, an acrylic painting is easy to correct. Let's say you've painted a picture in which the drawing, composition, and detail all seem right, but some portion is just too pale. You want to darken that area without covering up all the hard work you've done. A thin wash of transparent acrylic color—diluted with water or with one of your liquid mediums—can be brushed carefully over the offending section. The section will become darker, but the underlying brushwork will still show through.

Correcting by Lightening. What if you have exactly the opposite problem? The drawing, composition, and detail all seem right, but some part of the painting is just too dark. By blending color, water or liquid medium, and just a hint of white, you can create a semi-transparent "fog" of color to wash over the problem area. This veil of liquid color will lighten the offending passage but still allow a certain amount of your careful work to show through. It's usually best to apply two or three very thin veils of semi-transparent color—rather than one heavy coat—to be sure you're not covering up too much.

Correcting by Repainting. Because a dried layer of acrylic paint is insoluble in water, nothing is easier than *repainting* a passage that's gone wrong. You can apply a fresh coat of acrylic gesso to bring that part of the painting back to pure white so you can start again. Or you can just ignore the offending passage and paint over it with fresh color until you get the effect you want—and the problem literally disappears.

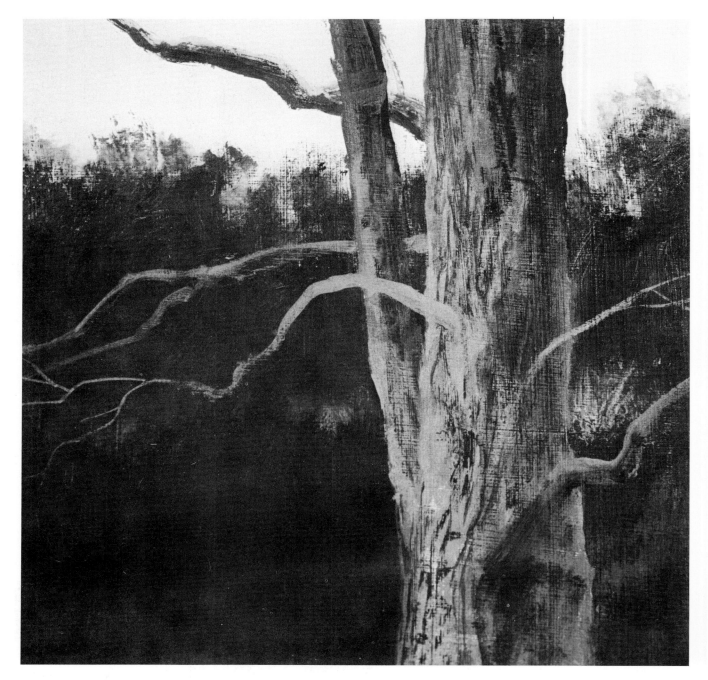

Step 1. This tree and its dark background are painted on illustration board coated with acrylic gesso. The gesso is applied thickly so that the bristles of the nylon house-painter's brush leave grooves in the surface. You can see the texture of these brushmarks peeking through the shadow side of the trunk. At this stage, the picture is painted with broad, rough strokes. You can see a lot of drybrush work in the bark. A few branches and some cracks are added to the trunk with the tip of a round brush. But most of the details will be added in the next stage—with a sharp blade.

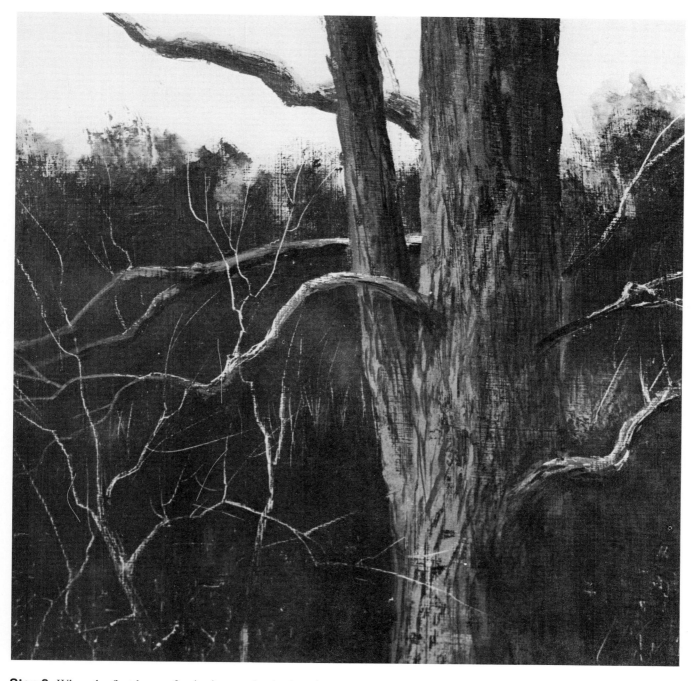

Step 2. When the first layer of paint is completely dry, the tip of a sharp blade—or the corner of a razor blade—scratches into the dark color to reveal the white gesso underneath. The blade lightens the edges of the heavier branches to suggest sunlight striking these branches from above. And a network of smaller branches is suggested to the left of the trunk. The rough texture of the gesso makes the scratches look rough: they're not continuous, wiry lines, but have an irregular texture, like wood. Now the tip of a small, round brush is used to add the final details to the trunk.

Step 1. Brushes and knives aren't the only painting tools. The soft cloud forms in this sky are painted with a rag that's been rolled into a ball, dipped into some paint, and patted against the painting surface. In this first step, the dabber carries a pale tone and is pressed lightly against the illustration board.

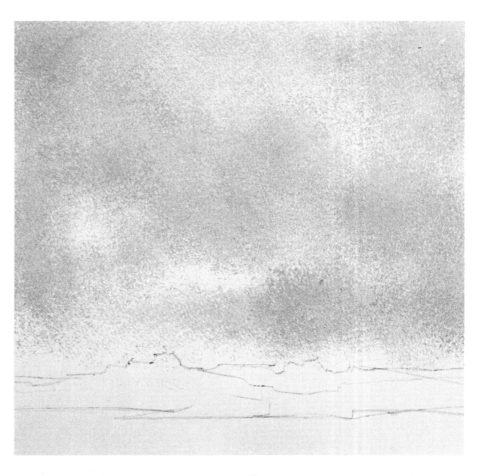

Step 2. Now the dabber picks up a slightly darker tone and presses harder against the painting surface to deposit denser color. The sky is darkened in certain areas, while other areas remain pale to suggest light breaking through the shadowy clouds. Brushes are used to indicate the landscape at the bottom of the picture.

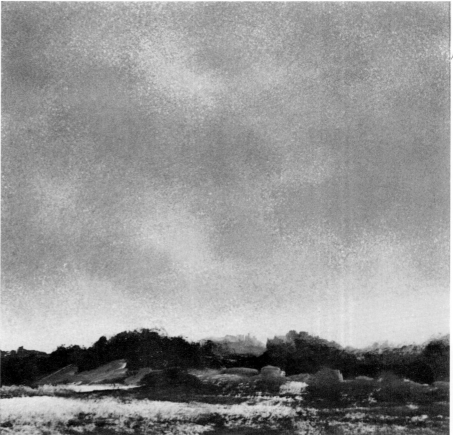

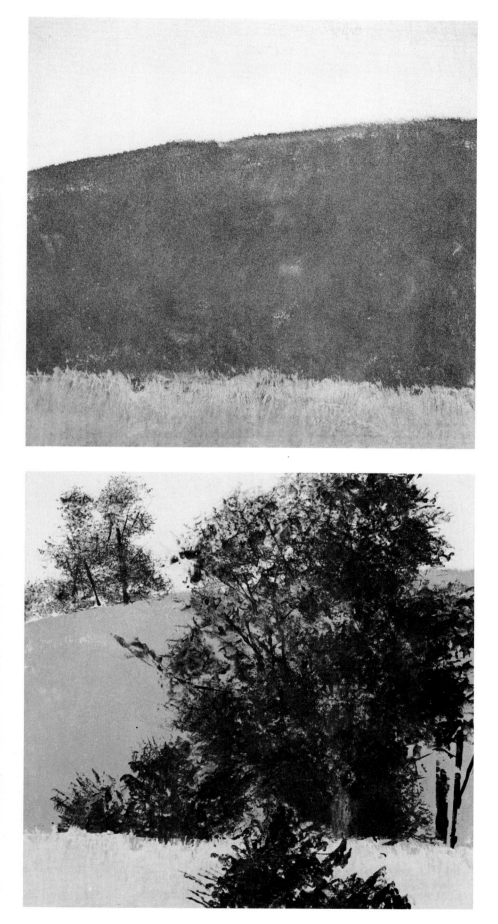

Step 1. Another improvised painting tool is a sheet of paper squeezed into a ball, dipped in color, and pressed against the painting surface. Crumpled paper is particularly effective for painting trees. But it's best to begin by painting the background—like these fields, hill, and sky—and letting it dry before you paint the trees over it.

Step 2. A thin sheet of drawing paper is crumpled into an irregular ball, soaked in water to soften the paper a bit, dipped in thick color, and pressed against the painting surface to suggest the clusters of leaves. In the shadow areas of the trees, the paper carries more color and is pressed down harder. Less pressure is applied on the fainter trees at the horizon. When the leaves are dry, a small, round brush adds trunks and branches.

SPATTERING

Step 1. One of the hardest subjects to paint is a pebbly beach. You can't possibly paint every pebble. One good solution is to paint the broad tones of the beach with a brush, then follow with the technique called spattering. In this first step, the brush renders the cloud forms in the sky, the shape of the distant dunes to the right and a strip of sea to the left, the overall tone of the beach, and the shadows in the foreground.

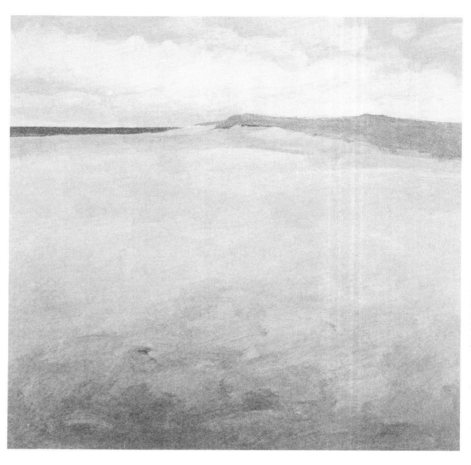

Step 2. Now a stiff brush—it might be a toothbrush, a bristle brush, or a stiff housepainter's brush—is dipped into liquid color. The handle of another brush (or a flat piece of wood such as an ice cream stick) is drawn over the tips of the bristles, which spring back and spray droplets of color against the painting. The brush is dipped first into light color, then into dark color, and then into light color again to produce this pepper-and-salt effect. It's a good idea to cover the distant dunes and sky with stiff paper or masking tape.

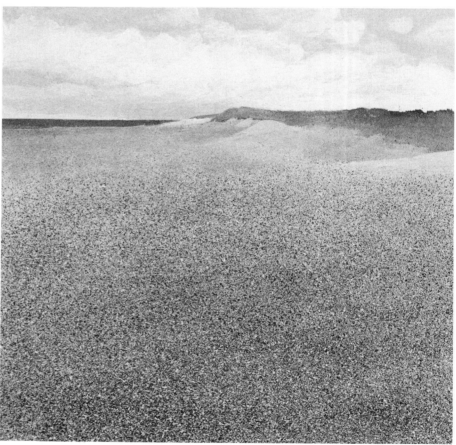

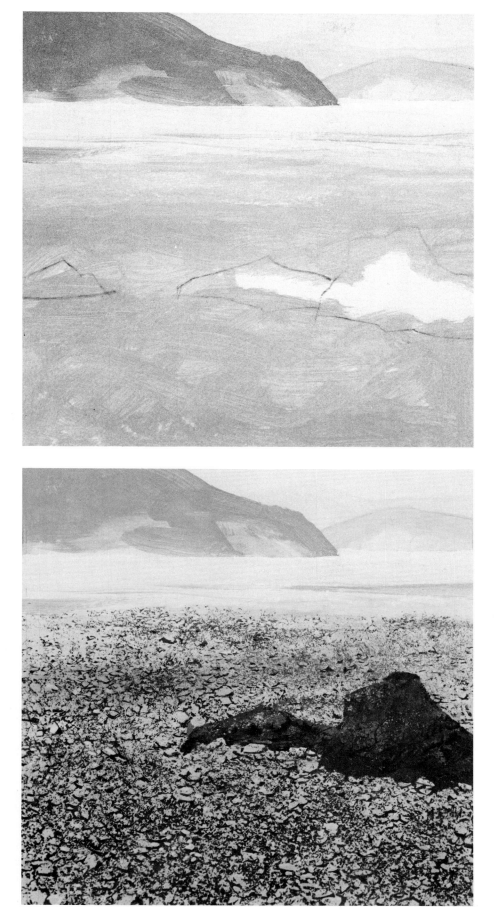

Step 1. If you want to paint a beach with even bigger pebbles, a sponge may be the ideal painting tool. Once again, it's best to begin by painting the major forms of the landscape with brushstrokes. The distant shore, the water, and the beach in the foreground are painted with free strokes. Only the rocks on the nearby beach are left untouched.

Step 2. A rounded, rough, natural sponge is dipped in clear water, squeezed out until it's just damp, and pressed against a pool of very thick color on the palette. Then the sponge is pressed against the foreground, depositing a pattern of irregular flecks of color. When these flecks are dry, the point of a small, round brush adds a few lines and shadows around some of the bigger flecks to make them look like pebbles. The entire beach is covered with this rough texture, and then the rock is painted right over it with semi-transparent color that allows the marks of the sponge to shine through.

Step 1. A good way to suggest the rough texture of a rock formation is to work with thick, rough paint. This piece of illustration board is first covered with a pale tone that will later become sea and sky. When this tone is dry, the rock formation in the foreground and the smaller rock formation in the distance are both covered with a claylike mixture of acrylic modeling paste, white tube color, and just enough gloss medium to make the paste easier to brush on. The paste is applied with thick, rough brushstrokes and knife strokes.

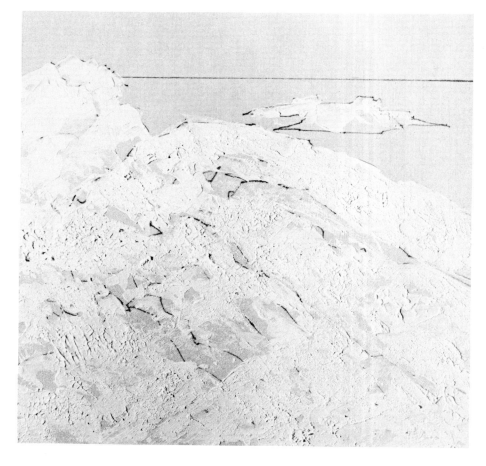

Step 2. When the rocks are absolutely dry, they're covered with liquid color—containing lots of water—which darkens the surface and sinks into the cracks and crevices left by the brush and knife. The dark wash accentuates the rough texture of the thick underpainting.

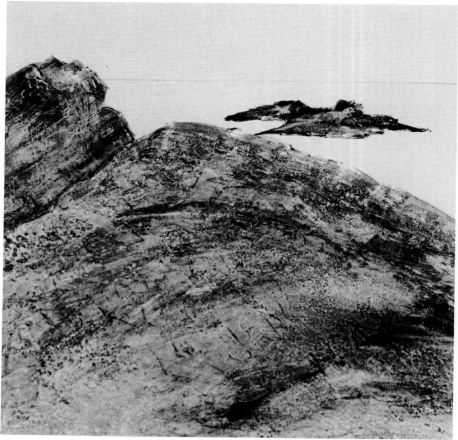

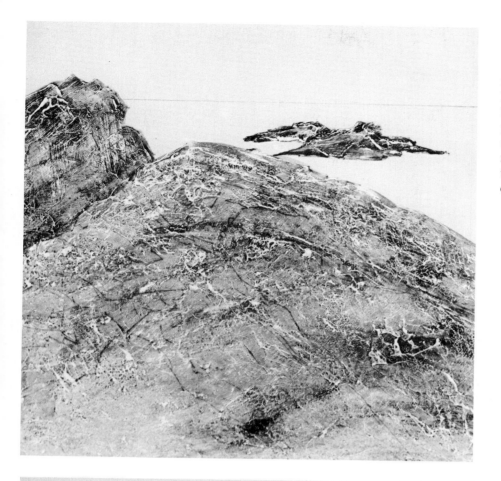

Step 3. When the dark wash is dry, the edge of a sharp blade—not the tip—is skimmed over the rock formation. Wherever the brush and knife strokes stand up highest, the blade shaves them away like sandpaper. (In fact, you might like to try sandpaper.) Now, a network of rough, white lines interweaves with the network of dark cracks and crevices created in Step 2.

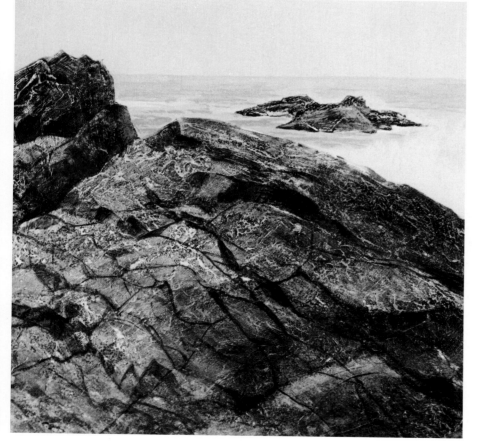

Step 4. In this final stage, a round, softhair brush is used to paint shadows, cracks, and other details that complete the rock formation. The tone of the sky is darkened, and the distant sea is painted with horizontal strokes. When you experiment with textural painting, you might also try working simply with thick paint straight from the tube; with tube color and gel medium; and with various combinations of modeling paste, gel medium, gloss or matte medium, and tube color. Some combinations will be thicker and rougher, while others will be smoother and more fluid.

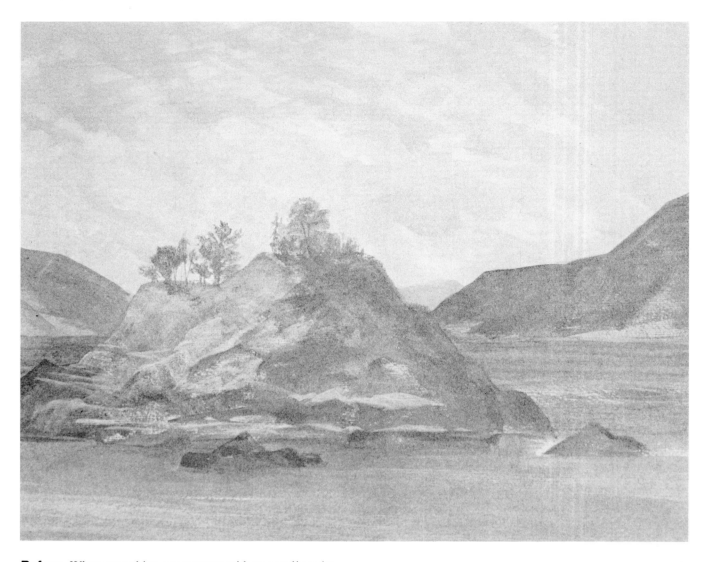

Before. When something goes wrong with an acrylic painting, corrections are easy because acrylic paint is so versatile. One common problem is a painting that's too pale. Everything else seems right: you're satisfied with the composition, the drawing, and the complex pattern of lights and shadows that you worked so hard to render accurately. You know that some parts of the painting need to be repainted—made darker—but you don't want to obliterate the work you've done so far. In this coastal scene, the sky and the shapes along the horizon are just right, but the island in the foreground is too pale; it needs to be repainted so that it's darker and moves forward in the picture. How do you do it?

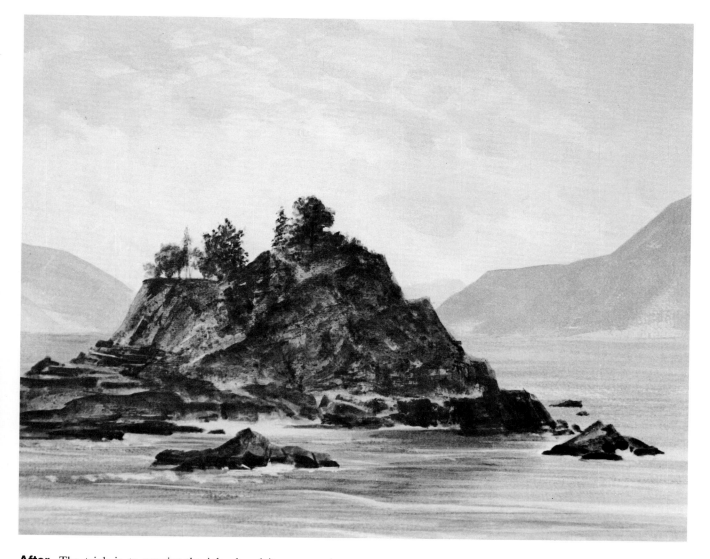

After. The trick is to repaint the island and its surrounding rocks with transparent color. You mix up a fresh batch of color with lots of water or with one of your mediums—gloss or matte, whichever you prefer. As you brush the liquid color over the painting, you can see right through the strokes and follow all the forms you've labored so hard to render. When the transparent color dries, the underlying brushwork will still show through. If you look closely at the island, you'll see that all the original shadows have been darkened and so have the trees, but none of the original detail has been lost. On the contrary, the detail has been strengthened by dark strokes built on top of the lighter strokes. All the original shapes are still there, but now the island moves forward in the picture, while the distant shapes are much farther away. Because the island and the rocks are now darker, it's important to darken their reflections in the sea below. So the sea is also repainted with transparent strokes.

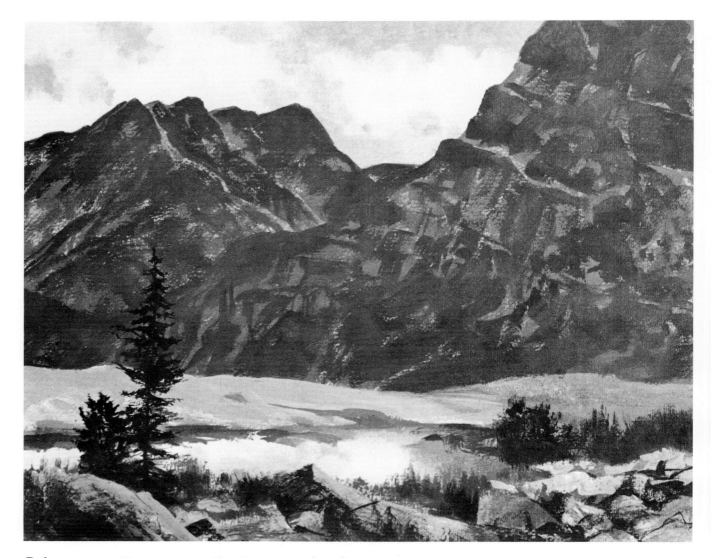

Before. An equally common problem is some section of a painting that looks too dark. Once again, you've worked hard to get all the details exactly right. The pattern of lights and shadows seems right too. You want to lighten the whole section without covering up your original work and having to redo everything. In this mountainous landscape, there's something wrong with the distant peaks to the left. Because they're too dark, they seem too close—they're not distant enough. The extraordinary versatility of acrylic paint provides the solution.

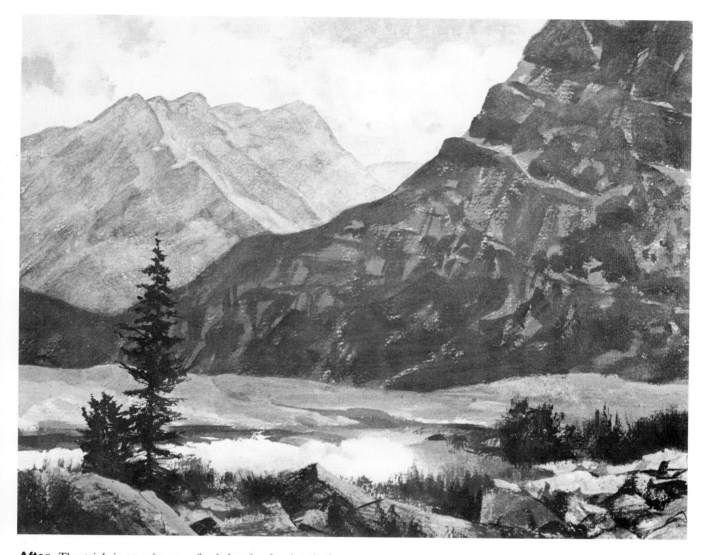

After. The trick is to mix up a fresh batch of paint that's not transparent, but just *semi-transparent*. You mix the color that you want, add plenty of water or medium, and then add just enough white to make the wash hazy. When you brush this semi-transparent color over the distant mountains, this smoky wash seems to cover the painting surface with a kind of fog through which you can see all your original brushwork. The original pattern of lights, shadows, and details is intact, but everything is paler. The mountains suddenly recede into the distance, where they belong. Beware of one danger, however. It's easy to add too much white to the semi-transparent wash and discover, when the wash is dry, that you've covered up too much. It's best to work in several stages. Add lots of water and just a little white. Brush on one veil of color and let it dry. Then brush on a second veil if you think you need it. And don't be surprised if you need a third or a fourth veil to complete the job.

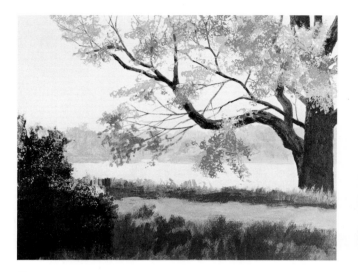

Step 1. How do you correct an acrylic painting if something is in the wrong place—like this tree—and needs to be moved elsewhere in the picture? You've already seen that you can darken an acrylic painting with transparent color and lighten it with semi-transparent color. Here's where opaque color comes into play. The tree is too close to the edge of the picture and needs to be moved toward the center.

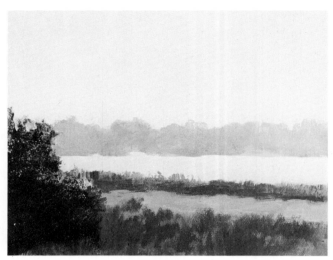

Step 2. Working with opaque color, diluted to the consistency of cream and containing a fair amount of white, you can just paint out the tree. Here, the tones of sky, distant shore, and water are just carried over the tree—which disappears altogether.

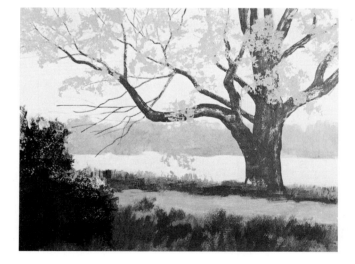

Step 3. When the sky, shore, and water tones are dry, you can just start again. A new tree is painted right over them, starting with the lighter tones of the trunk, branches, and leaves.

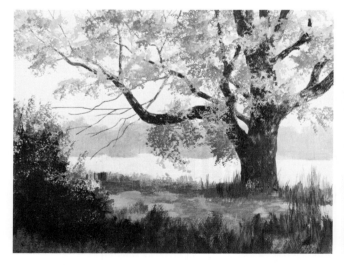

Step 4. When these lighter tones are dry, the trunk, branches, and leaves are completed with darker tones and touches of detail. (The leaves are painted with a sponge, by the way.) A shadow is added to the ground at the foot of the tree. Blades of grass are added with the tip of a round brush. The original tree has disappeared totally, and the new tree is in exactly the right place.

Learning the Rules. Acrylic is extraordinarily durable, but this can be a problem if you don't learn certain "rules." The basic thing to remember is that acrylic, once it dries, is almost impossible to remove from any absorbent surface. So be sure to wear old clothes when you paint. Like every artist, you'll get paint on your clothes, and you won't want to bother washing out every spot before it dries. So simply expect to ruin what you wear—and wear something you were ready to throw out anyhow. This includes footwear: wear your most battered old shoes, sandals, or sneakers so you won't worry when they're spattered with paint. You can also expect drops of paint to land on the top of your work table, the floor, and perhaps even the wall. So try to avoid working in a room where you've got to worry about antique furniture, your best rug, or new wallpaper. It's best to work in a room where you can really make a mess. If that's not possible, protect your surroundings with newspapers or the kind of "dropcloth" used by housepainters.

Care of Brushes. Your brushes are your most valuable equipment. While you're painting, always keep your brushes wet, wash them frequently, and (above all) never let acrylic paint dry on the brush. When you're finished, rinse each brush thoroughly in clear water—not in the muddy water that remains in the jars. That rinsing should remove most of the visible color, but there's often some invisible paint, particularly at the neck of the brush, where the hairs enter the metal tube called the ferrule. So it's wise to stroke the brush gently across a bar of mild soap (not corrosive laundry soap) and lather the brush in the palm of your hand with a soft, circular motion until the last trace of color comes out in the lather. Rinse again. When all your brushes have been washed absolutely clean, shake out the water and shape each brush with your fingers. Press the round brushes into a bullet shape with a pointed tip. Press the flat brushes into a neat square with the hairs tapering in slightly toward the forward edge. Don't touch them again until they're dry.

Storing Brushes. Allow the brushes to dry by placing them in a clean, empty jar, hair end up. When they're dry, you can store them in this jar, unless you're worried about moths or other pests who like to eat natural fibers. If these insects are a problem, store bristles, sables, and oxhairs in a drawer or box. Just make sure that the hairs don't press up against anything which might bend them out of shape. Sprinkle mothballs or moth-killing crystals among the brushes. You don't have to worry about synthetic fibers like nylon, which you can leave in the jar if you prefer.

Cleanup. As you work, you'll certainly leave droplets and little pools of liquid color on your work table, your drawing board or drawing table, your easel, and your paintbox. Ideally, you should sponge these up as they happen, but it *is* hard to do this in the excitement of painting. So sponge up what you can—while it's still wet—but then be prepared for more cleanup work after the painting session is over. At that point, the droplets and spills will be dry. If they've fallen on newspaper or a dropcloth, you can just toss out the papers, fold up the dropcloth, and forget about them. But you *will* want to remove dried color from other surfaces. Some of the color will come off if you scrub vigorously with a damp sponge or a wet paper towel: the paint won't really dissolve, but the dampness will soften it, and the friction will rub it away. If that doesn't work, try a mild household cleanser.

Cleaning Your Palette. By the time you've finished painting, a lot of paint will certainly have dried on your palette. You can easily wash off the remaining liquid color, but that leathery film of dried color won't come off under running water. If you're working on an enamel tray or a palette that's made of metal or plastic, the simplest solution is to fill the tray or palette with a shallow pool of cold water and let the dried paint soak for half an hour. The color won't dissolve, but the water will loosen it, so you can peel off the dried color or rub it away with your fingertips. A blunt tool such as a flat wooden stick or a plastic credit card may also help. Don't use a razor blade or a knife, which will scratch the palette. Of course, if you use a tear-off paper palette, just peel away the top sheet and you are done.

Care of Tubes and Bottles. At the end of the painting session, take a damp paper towel and wipe off the "necks" of your tubes and bottles to clean away any traces of paint or medium that will make it hard to remove the caps the next time you paint. Do the same inside the caps themselves. If you do have trouble getting off the cap, soak the tube or bottle in warm water for ten or fifteen minutes. That should soften the dried color in the neck so that you can then wrestle off the cap.

Washing Your Hands. There's no way to avoid getting paint on your hands. So don't eat or smoke while you paint, since certain pigments such as the cadmiums are mildly toxic and should be kept away from your mouth. Wash your hands carefully with soap and water after a painting session. Human skin contains oil, so it won't be too hard to remove dried acrylic color. A small scrub brush will help.

Permanence. The surface of an acrylic painting is far tougher than the surface of an oil or watercolor painting, but *all* paintings require special care to insure their durability. Although the subject of framing, in particular, is beyond the scope of this book, here are some suggestions about the proper way to preserve finished paintings in acrylic.

Permanent Materials. You can't paint a durable picture unless you use the right materials. All the colors recommended in this book are chemically stable, which means that they won't deteriorate with the passage of time and won't produce unstable chemical combinations when they're blended with one another. However, it's not always a good idea to mix one *brand* of acrylic color with another. The good brands are equally permanent, but there are sometimes slight variations in the formulas of the different manufacturers. The biggest problem isn't the acrylic paint; it's the painting surface, which is often less durable than the paint itself. While you're learning, there's nothing wrong with working on illustration board or canvas board, but remember that the cardboard backing will deteriorate with age. Once you feel that your paintings are worth preserving, work on real artists' canvas or prepare your own boards by coating hardboard with acrylic gesso. And if you're working on watercolor paper, invest in "100% rag" stock, which means paper that's chemically pure and won't discolor with age.

Matting. A mat (which the British call a mount) is essential protection for an acrylic painting that's done on watercolor paper or illustration board, since the paper isn't nearly as tough as the paint. The usual mat is a sturdy sheet of white or tinted cardboard, generally about 4″ (100 mm) larger than your painting on all four sides. Into the center of this board, cut a window slightly smaller than the painting. You then "sandwich" the painting between this mat and a second board the same size as the mat. Thus, the edges and back of the picture are protected, and only the face of the picture is exposed. When you pick up the painting, you touch the "sandwich," not the painting itself.

Boards and Tape. Unfortunately, most mat (or mount) boards are far from chemically pure, containing corrosive substances that will eventually migrate from the board to discolor your painting. If you really want your painting to last for posterity, you've got to buy the chemically pure, museum-quality mat board, sometimes called conservation board. Of course, the ordinary mat board does come in lovely colors and textures, while the museum board comes in a very limited color selection. But it's easy to mix acrylic colors to produce the hue that you want for your mat, thin the color to the consistency of cream, and brush it over the museum board. Brush the color on both sides of the board so it won't curl. Avoid pasting your paintings to the mat or the backing board with masking tape or Scotch tape. The adhesive remains sticky forever and will gradually discolor the painting. The best tape is the glue-coated cloth used by librarians for repairing books. Or you can make your own tape out of strips of drawing paper and white water soluble paste.

Framing. If you're planning to hang an acrylic painting that's done on paper or illustration board, the matted picture must be placed under a sheet of clear glass (or plastic) and then framed. Most painters feel that a matted picture looks best in a simple frame: slender strips of wood or metal in muted colors that harmonize with the painting. Avoid bright mat colors or ornate frames that command more attention than the picture. An acrylic painting on canvas, a gesso board, or a canvas board doesn't need a mat or glass. A frame is enough. Since there's no mat, you can choose a heavier, more ornate frame, like those used for oil paintings. If you're planning to make your own mats and frames, buy a good book on picture framing. If you turn the job over to a commercial framer, make certain that he uses museum-quality mat board and tell him *not* to use masking tape or Scotch tape—which too many framers use just to save time and money.

Varnishing Acrylic Paintings. The tough surface of an acrylic painting can be made still tougher with a coat of varnish. The simplest varnish is an extra coat of gloss medium, thinned with some water to a more fluid consistency than the creamy liquid in the bottle. At first, this coat of medium will look cloudy on the painting, but will soon dry clear. If you want a nonglossy finish, follow the coat of gloss medium with a coat of matte medium, again diluted with water to a fluid consistency. If the manufacturer of your colors recommends that you use a varnish that is different from the medium, follow his advice. Apply the medium or varnish with a big nylon housepainter's brush. Work with straight, steady strokes. Don't scrub back and forth too much or you'll produce bubbles. For an acrylic painting framed under glass, varnish is optional. Without glass, a coat or two of varnish will give you a surface that cleans with a damp cloth and resists wear for decades to come.

PART TWO

LANDSCAPES IN ACRYLIC

Landscapes in Acrylic.

Painting landscapes in acrylic is a pleasure. If you work on-the-spot, you can work just as rapidly as you would in watercolor. If you work with broad areas of color and decisive strokes, you can finish a painting on location in a few hours. When you're ready to pack up and head for home, the painting is bone dry. If you prefer, you can make quick color studies on-the-spot and take them home for development into larger paintings. Or you can simply begin a painting outdoors and finish it in the studio. Back home, you can work at your leisure, overpainting areas that need adjustment, building up texture, and adding detail. Unlike oil paint, which takes days to dry, a coat of acrylic dries in minutes. And unlike watercolor, which can dissolve if you overpaint it too vigorously, a layer of dried acrylic is immovable. So you can overpaint a dozen times a day until you're satisfied.

Basic Techniques.

Landscapes in Acrylic begins with a condensed review of four fundamental ways to handle acrylic paint—showing how these techniques might be used for typical landscape subjects. First you'll see how to paint mountains in the opaque technique. Then you'll see how another mountain landscape is painted in the transparent technique. The opaque picture will look somewhat like an oil painting, while the transparent technique will look somewhat more like a watercolor. You'll study a similar comparison in two sky paintings. First, a sky is painted in the opaque technique, and then another sky is painted in the transparent technique. To show the drybrush technique, you'll see how the brush moves across the ridges of a rough painting surface to suggest the irregular texture and detail of trees. Then, a wintry landscape shows the scumbling technique in which the brush is scrubbed over the paper to deposit a semiopaque veil of color that suggests snow.

Color Sketches.

A series of small color sketches will give you some guidelines for painting the colors of land, trees, and water. You'll compare the gray stony tones of distant mountains with the lush greens of tree-covered hills. You'll also compare the colors of deciduous trees, evergreens, and autumn trees. And you'll see how the colors of water change as they're influenced by the sky and the surrounding landscape.

Painting Demonstrations.

Following the review of basic techniques and the color notes, you'll watch the noted painter Rudy de Reyna paint eleven complete landscapes, step-by-step. Each landscape will incorporate one or more of the basic techniques, and you'll learn a lot more about color mixing. The first four demonstrations will show you how to paint various trees and growing things: deciduous trees, evergreens, an autumn forest, and a meadow filled with grasses and wildflowers. Then de Reyna moves on to the big, solid shapes of the landscape, demonstrating how to paint mountains, hills covered by vegetation, and a desert with its dramatic rock formations. A stream is painted to show you how to render moving water. Then you'll see how to paint two other forms of water—ice and snow. The painting demonstrations conclude with two sky pictures: a blue sky with massive white clouds and finally a sunset. Of course, these demonstrations are filled with many other details that you'll learn how to paint: rocks, pebbles, weeds, fallen leaves.

Special Problems.

You'll also find guidance on selecting landscape subjects and some "rules of thumb" for composing effective landscapes. You'll see how the direction of the light can change the entire character of a tree or a rock. You'll see the difference between high key and low key—how to recognize these phenomena and how to paint them. You'll learn a very simple method of planning a landscape according to the "three-value system." To train your powers of observation, there are demonstrations that show you how to draw rocks, clouds, and trees. These demonstrations will also teach you how to make on-the-spot drawings that you can assemble into paintings when you get back to the studio. Last of all, you'll see how an understanding of aerial perspective can enhance the feeling of space and atmosphere in your acrylic landscapes.

Outdoors or Indoors?

Some people are outdoor painters who love to brave the elements (and the insects) to record what they see on location. Others are indoor painters who like the leisure and comfort of home. Landscapes painted indoors can be just as exciting and just as authentic as those painted on-the-spot. But remember that the best landscape paintings always *start* outdoors, even if they're finished at home. Spend as much time as you can painting on location, even if those paintings are small, quick studies for larger paintings that you hope to develop in the studio. Working on location will strengthen your powers of observation and train your visual memory. The only way to learn about landscape is firsthand.

Step 1. Used straight from the tube or diluted to a creamy consistency—with a little water or medium—acrylic paint is fairly opaque. That is, the color will conceal whatever is underneath. And since practically every mixture includes some white—the most opaque color on your palette—a mixture will be even more opaque than the pure tube color. The simplest way to apply acrylic paint is the opaque technique, which exploits the fact that one stroke will cover another. You'll see how this works in a demonstration painting of mountains. Here, the painting begins with a very simple line drawing in pencil on illustration board. There's not much point in a highly detailed drawing, since the paint will cover the pencil lines.

Step 2. The main shapes in the picture are covered with flat tones, working from light to dark. The sky and water are painted first in a mixture that contains plenty of white. Then comes the tall, distant mountain, containing a bit less white, followed by the darker, lower mountain to the right, which contains even less white. The dark shapes on either side of the water are painted last, and these contain practically no white. The color is diluted with just enough water to produce a smooth, flowing, creamy liquid—but not enough water to make this liquid transparent.

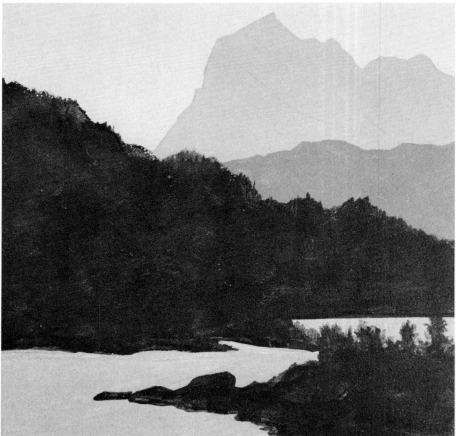

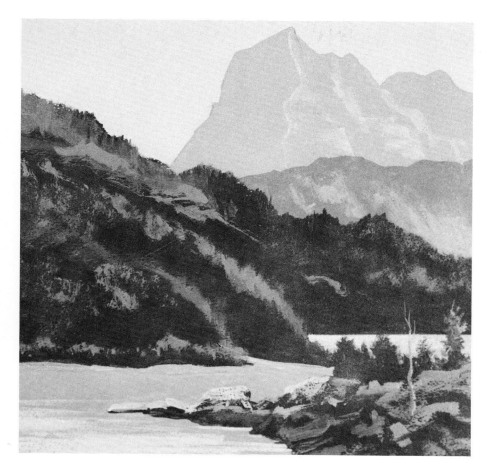

Step 3. Over these flat masses of tone, strokes of lighter color are applied to suggest detail. Containing plenty of opaque white, these strokes are dense enough to cover the darker tones underneath. The tip of a round brush picks out the lighted sides of the distant mountains, the sunlit foliage on the dark shore at the far edge of the stream, the sunlit tops of the rocks on the near shore, and some streaks of light on the water at the lower left. Acrylic dries quickly, so the flat tones of Step 2 are dry as a bone before they're covered with the lighter strokes of Step 3.

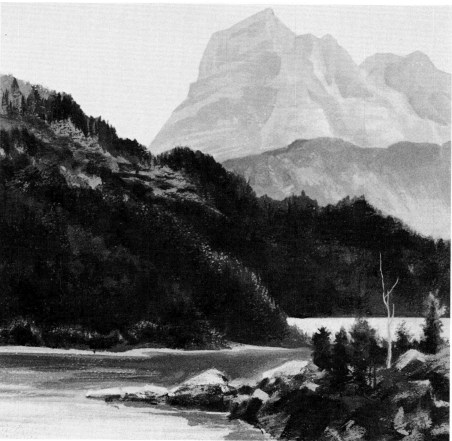

Step 4. When the light tones of Step 3 are dry, the picture is completed with small, dark and light strokes that suggest details. More light strokes are added over the darker tones of the distant peak. Dark strokes strengthen the shadows of the distant shore, partially concealing some of the lighter strokes that were added in Step 3. On the near shore, some darker shadows are added to the rocks; the sunlit tops of the rocks are brightened with lighter strokes; shadows and trunks are added to the trees. Dark reflections appear in the water. Throughout the picture, one opaque stroke covers another.

Step 1. Another way to apply acrylic paint is to thin your tube color with lots of water and steer clear of white paint altogether. Water, not white paint, makes your color paler. And the consistency of the paint is so fluid that you're really working with tinted water—very much like watercolor. Now you're working with transparent color—you can see right through it, as you'd see through a sheet of colored glass. Each successive layer of color *reveals* what's underneath. Here's another demonstration painting of a mountain, this time in the transparent technique, so you can see the difference between this and the opaque technique shown in the previous demonstration. The preliminary pencil lines are drawn on a sheet of watercolor paper.

Step 2. Just a bit of tube color is mixed on the palette with lots of water, and a pale, even tone is brushed across the sky. When this tone dries, a slightly darker tone—still containing lots of water, but not quite as much—is brushed over the distant mountains to the right and left of the big peak. When these shapes are dry, a slightly darker tone is mixed for the big peak and carried down to the bottom of the picture in a series of overlapping horizontal strokes that blur into one another to produce a smooth tone. Where the color grows paler beneath the midpoint of the picture, the strokes contain more water. Where the tone darkens at the very bottom, the last few strokes contain more color. Notice the patch of bare paper in the lower left section; this will become a lake.

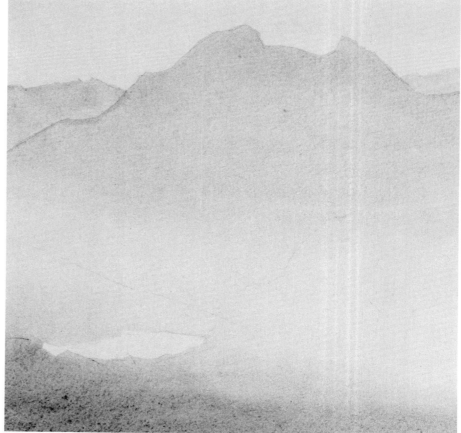

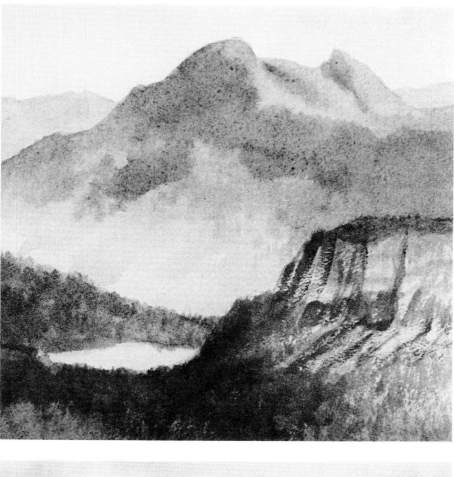

Step 3. In the *opaque* technique, you can paint dark over light or light over dark, whichever you choose. But in the *transparent* technique, you *must* paint dark over light. Over the flat tones painted in Step 2, darker tones are added for the shadows on the distant mountains. Shadows and dark details now begin to appear in the foreground and on the shoreline beyond the lake. These strokes contain a little less water and a little more tube color, but they're still transparent and almost as fluid as pure water. Notice how the rough texture of the watercolor paper breaks up the strokes in the foreground to suggest the textures of rocks and foliage.

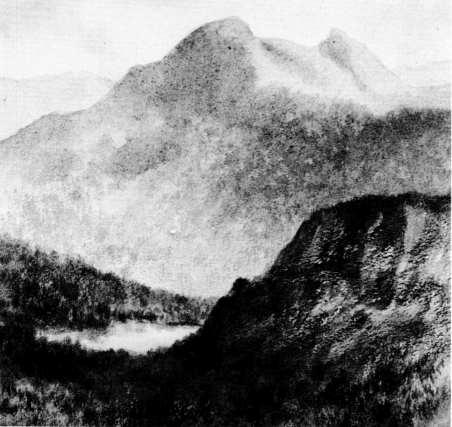

Step 4. When the tones of Step 3 are dry, more details are added with slightly darker strokes of fluid color. These strokes are carried right over the dry undertone, which shines through. You can see how many small touches of the brush tip suggest trees on the slopes of the distant mountain and more foliage on the rocky foreground. All the original tones are still there—enriched, but not concealed, by the final touches of the brush.

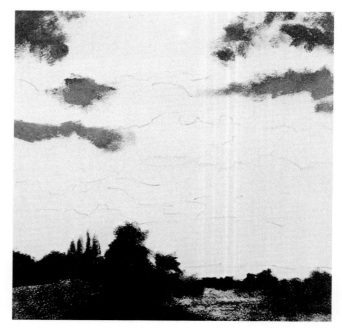

Step 1. Now see how a cloudy sky is painted in the opaque technique. The shapes of the clouds and the landscape beneath are drawn in pencil on a sheet of roughly textured illustration board. These pencil lines can be rough and casual, since the opaque color will quickly conceal them. In the process of painting, some cloud shapes will be altered.

Step 2. The dark patches of sky between the clouds are painted with quick, rough strokes. So are the dark shapes on the horizon. These shapes will all be amended when lighter, opaque colors are painted around them and perhaps over them. So it's not necessary for these early strokes to be too precise.

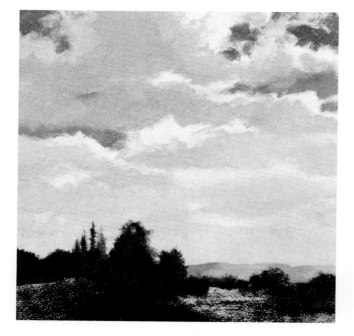

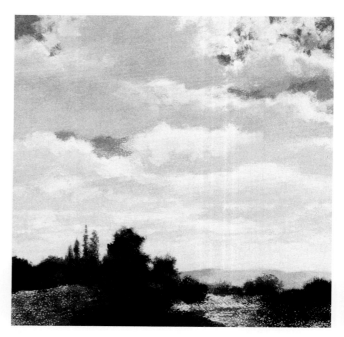

Step 3. The shadowy undersides of the clouds are painted next, leaving gaps of bare, white paper for the sunlit edges. Some of the dark sky shapes are beginning to change as the opaque shadow tones are carried over them. The distant hills are also painted in a pale, opaque tone. The clouds are painted in a technique called *scumbling*, which is a back-and-forth scrubbing motion that blurs the strokes.

Step 4. Finally, the sunlit edges of the clouds are scumbled with thick, white, opaque color. Some of these strokes are carried over the patches of bare sky and over the shadows painted in Step 3, changing some of these darker shapes. Step 4 shows less bare sky than Step 2. Corrections are easy to make in opaque color.

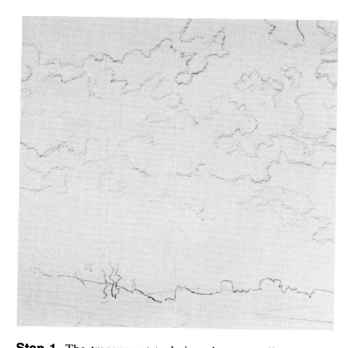

Step 1. The transparent technique is an excellent way to paint a sky, since the transparency of the color matches the luminosity of the subject. But the preliminary pencil drawing—on watercolor paper—must be more careful, since there's no way to change your mind and cover up a mistake. Transparent color won't hide what's underneath.

Step 2. Once again, the dark patches of bare sky are painted first. But they're painted exactly as they're going to appear in the finished painting, since their shapes can't be changed by later strokes of opaque color. To produce a soft, blurry effect, the sky is first brushed with clear water. The strokes blur when the brush touches the wet paper.

Step 3. The dark sky shapes of Step 2 are allowed to dry. Then more clear water is brushed over the paper. The shadowy undersides of the clouds are added, again blurring slightly on the wet surface. Because acrylic dries waterproof, the sky shapes that were painted in Step 2 won't be dissolved when the paper is rewetted. Painting on wet paper is called the wet-in-wet technique.

Step 4. When the sky is completely dry, the forms of the landscape are completed. The lighter tones are painted first and allowed to dry. Then the darker tones follow. The roughness of the paper tends to produce a ragged brushstroke that expresses the character of the trees.

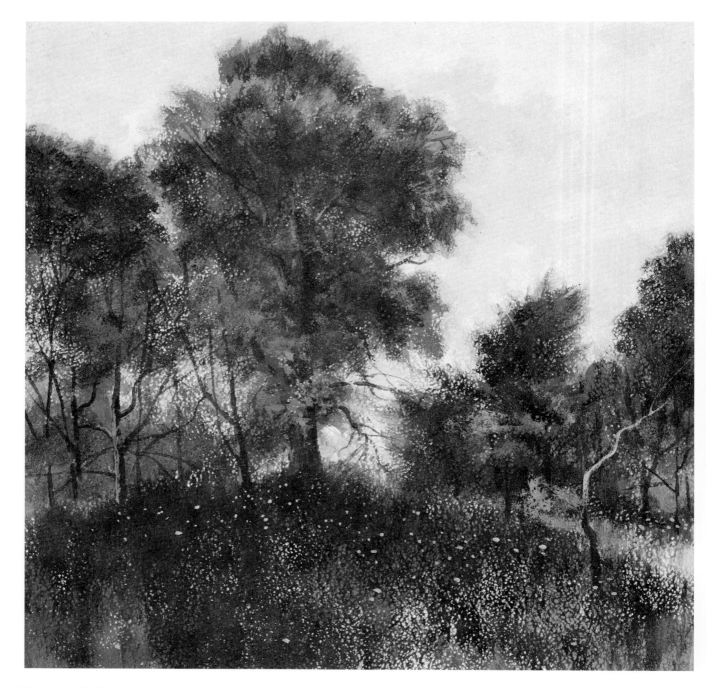

Trees and Grass. Landscapes always contain far more texture and detail than you can possibly paint. The trick is to find some way to *suggest* the infinite number of leaves on a tree or the infinite number of blades of grass in a meadow—without attempting to paint each one. The technique called *drybrush* is a particularly effective way to solve this problem—as you can see in this landscape filled with lush foliage rising above a grassy meadow. The picture is painted on a rough sheet of watercolor paper. The brush carries color that is not too fluid. As the brush moves over the roughly textured painting surface—which is all small peaks and valleys—the high points of the surface catch the color, and the low points are left bare. If you scrub back and forth and push down on the brush, you can force more color into the valleys; but because the brush is damp, not sopping wet, you can never cover the paper with a smooth, even layer of liquid color. The result is a ragged, irregular stroke that suggests leaves, grass, and bark with a minimum of effort.

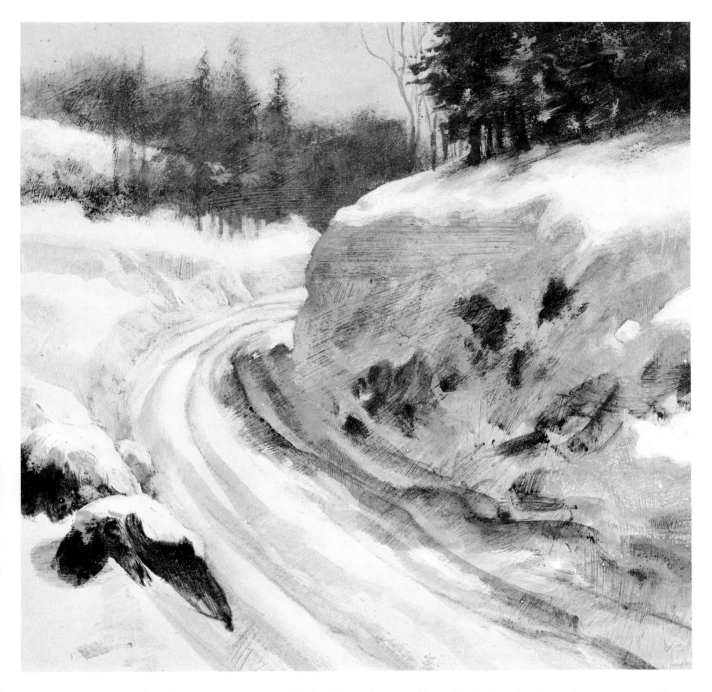

Snow in Light and Shadow. Landscapes are filled with subtle gradations of light and shadow, such as the sunlit top plane of a snowbank or a dune that curves softly into a shadowy side plane. It's also tricky to capture the delicate transparency of the lights and shadows. One solution is the technique called *scumbling*, described earlier as a back-and-forth scrubbing motion of the brush, which leaves a soft, blurry stroke. This kind of stroke can be opaque or can leave a thin veil of color that is semi-opaque, revealing a hint of whatever tones or details have been painted underneath. If you add a bit more water or painting medium, a scumble grows slightly more transparent and has an inner glow that's almost as luminous as pure, transparent color. That's how these snowbanks are painted. Scumbled strokes of thin, semi-opaque color give luminosity to the lights and transparency to the shadows.

Step 1. To paint a landscape in the drybrush technique, it's best to pick a painting surface with a distinct texture—a surface with lots of peaks and valleys, such as a sheet of rough watercolor paper or roughly textured illustration board. In this preliminary pencil drawing, you can see how the *tooth* of the watercolor paper—the peaks and valleys of the painting surface—breaks up the pencil lines. The same thing will happen to the brushstrokes.

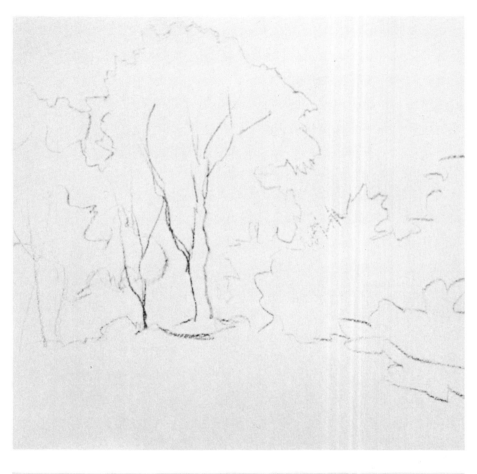

Step 2. The brush picks up a color mixture that doesn't contain too much water, so the paint isn't too fluid. Drybrush doesn't really mean that the brush is dry—but it *is* damp instead of soaking wet. Moving across the peaks and valleys of the painting surface, the brush tends to deposit color on the peaks and skips over many of the valleys. The color isn't fluid enough to run down into these valleys, so they remain bare paper. The result is a speckled effect that's perfect for suggesting dark foliage with flecks of light breaking through. In this demonstration, the big masses of foliage, grasses, and weeds are painted first with broad, rough strokes.

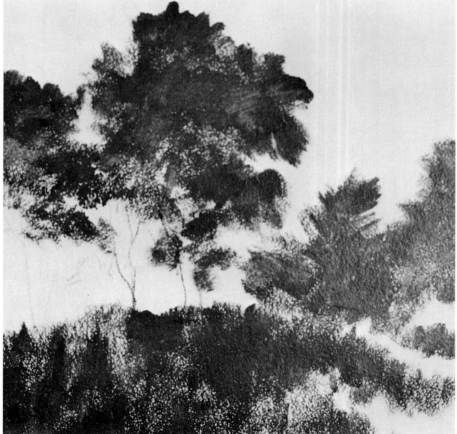

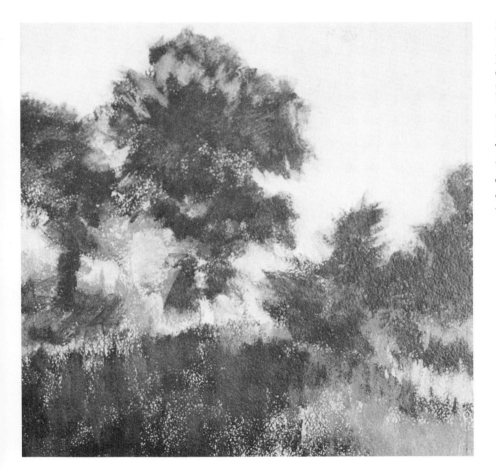

Step 3. The lighter areas—among the trees and on the meadow—are painted next. The brush is still damp, rather than wet, carrying paint that doesn't contain too much water. If the brush seems too wet or the paint seems too fluid, you can wipe some off on a paper towel. The brush should carry *less* color than you'd need to paint a smooth, even tone. The lighter strokes easily cover the darks beneath, so it's obvious that the color is opaque.

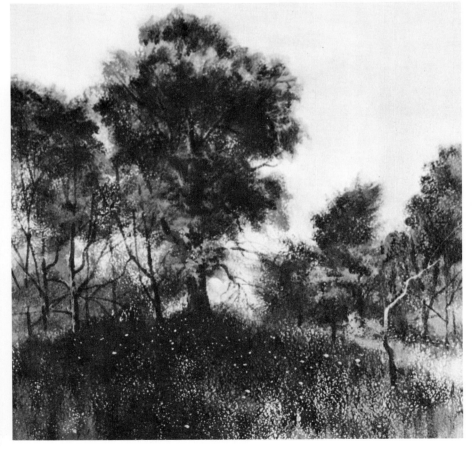

Step 4. The picture is completed by adding the darkest darks. Deep shadows are drybrushed under the leafy masses and on the patches of meadow directly beneath the trees. A path of sunlight is drybrushed beneath the trees at the lower right. Then the tip of a small, round brush picks up more fluid color to add the precise details of treetrunks, branches, and a few pale spots that suggest wildflowers in the meadow. It's difficult to paint a complete picture in the drybrush technique. Usually, it's best to paint the broad masses with drybrush strokes, then switch to more fluid color for precise details.

Step 1. You've already seen how the back-and-forth scrubbing stroke, called scumbling, is used to paint the soft forms of clouds in the opaque technique. Scumbling can also be used to deposit semi-opaque veils of color that will produce luminous lights and shadows on a subject like snow or sand dunes. This winter landscape begins with a careful pencil drawing on a sheet of illustration board that's been coated with acrylic gesso. The gesso is applied thickly, retaining the marks of the brush, thus giving the surface an interesting, irregular texture.

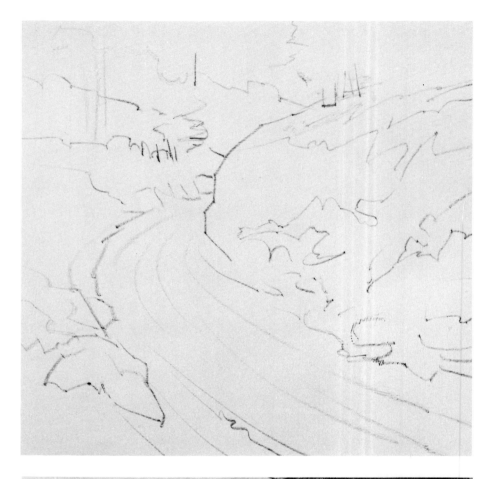

Step 2. The main light and dark areas of the picture are first covered with fluid color. Transparent tones, containing lots of water, are freely brushed in to suggest the darks of the trees, the shadows on the sides of the snowbanks, and the shadowy ruts in the road. Within these transparent tones, you can see the irregular, streaky pattern of the brushstrokes in the gesso surface. The color is so transparent that you can still see the pencil lines.

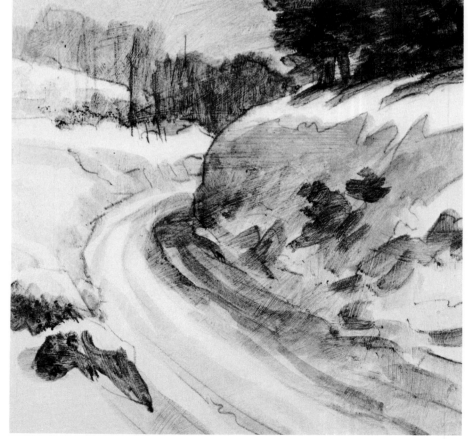

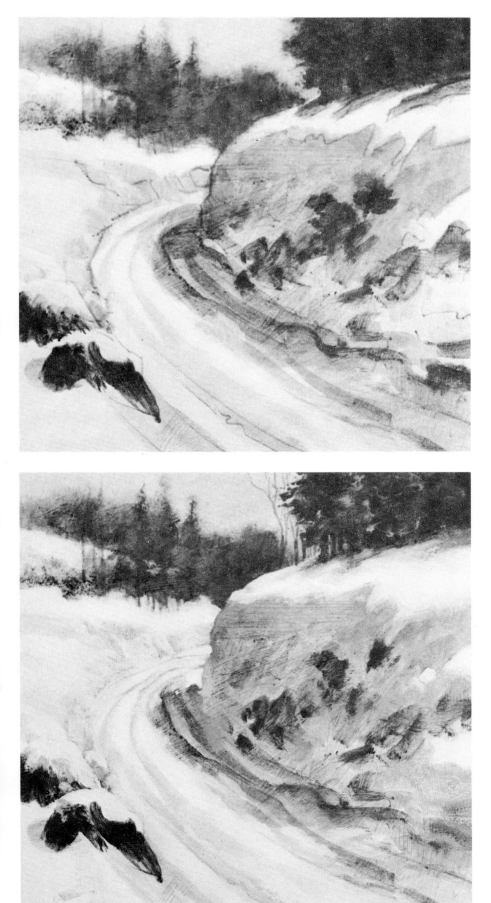

Step 3. Now the darkest areas are strengthened with heavier, more opaque color that's scrubbed over the trees on top of the snowbank, the more distant trees at the horizon, and the rocks in the foreground. Some of the ruts in the road are darkened too. The scrubby, back-and-forth brushwork tends to produce strokes with soft, slightly blurred edges—most apparent in the trees, which seem to melt away into the atmosphere.

Step 4. The painting is completed by scumbling soft veils of very pale color. The sunlit tops of the snowbanks are painted with the same sort of soft, blurry strokes as the trees, covering the pencil lines and blurring softly into the shadows. Then a very delicate veil of semi-opaque color is carried over the shadow side of the big snowbank at the right; the mixture contains so much water that the paint is like a mist that softens the shadow but still permits the underlying darkness to shine through. The same technique softens (but doesn't conceal) the shadows on the road and on the snowbanks to the left. The picture is completed with a few brushlines to suggest trunks and branches among the dark trees.

Plan Your Mixtures. There are two main secrets to successful color mixing. First, try to visualize the components of the mixture *before* you start to mix them—don't just pick up colors at random and scrub them together on the palette, hoping that the mixture will turn out right. Second, add colors to the mixture very gradually. Look carefully at the subject and try to decide which two or three tube colors will come closest to the right mixture. (You'll probably need some white too.) Start out by mixing small quantities of just two colors. Then add a small quantity of the third, if you need it. Keep adding color in small amounts until you have the exact hue.

Procedure. Let's see how this would work with a typical mixture. You need a rich, deep green for a clump of trees; naturally, you start with blue and yellow. You blend a small quantity of phthalocyanine blue with some cadmium yellow light. These two brilliant colors produce a brilliant green, but it seems too blue. Now you add a bit more cadmium yellow to make a "greener" green. Finally, you've got the right balance of blue and yellow to give you a satisfactory green. But it's too bright. You pick up some burnt umber to create a more subdued flavor. Not quite enough umber, so you add a bit more. The mixture finally looks right, and you add more of the three components to get the quantity of color you need. For the paler, more distant trees, you use the same mixture, but with some white added.

Mixing Greens. It's hard to imagine painting landscapes without painting trees, shrubs, and grasses. So it's essential for the landscape painter to learn how to mix the greatest possible variety of greens. Just the two blues and two yellows on your palette will give you quite a range. The most brilliant mixture will be phthalocyanine blue and cadmium yellow light. Ultramarine blue and cadmium yellow light, or phthalocyanine blue and yellow ochre, will give you more subdued mixtures. And the most muted greens will combine ultramarine blue and yellow ochre. Black and cadmium yellow will give you another rich green, while black and yellow ochre will give you a very subtle brownish green. These hues will change radically as you vary the proportions of blue and yellow or black and yellow. Major changes will also take place when you add a slight touch of red or brown. You also have two readymade greens on your palette: the brilliant phthalocyanine and the subdued chromium oxide. Don't merely use these straight from the tube. Learn to modify them with blue to produce blue-greens, with yellow to produce yellow-greens, and with browns and reds to produce brownish greens. If you decide to add Hooker's green to the palette, try the same combinations.

Mixing Browns. In outdoor subjects, browns are as widespread as greens. Your palette gives you just as many interesting possibilities. Any blue-red-yellow combination will produce an interesting variety of browns, which will change radically as you adjust the proportions of the three components. More blue will give you a darker, grayer brown. More red will push the mixture toward copper. And more yellow will give you a golden brown. Try substituting black for blue. You can also create interesting browns with red-green combinations such as cadmium red light and phthalocyanine green, or naphthol crimson and chromium oxide green. You do have two browns on your palette—burnt umber and burnt sienna—which can be modified in all sorts of ways. Touches of blue will give you grayish browns. You can add any other color on the palette to give you reddish, greenish, blackish, and yellowish browns.

Adding White. Buy the largest available tube of titanium white, since you'll use more white than any other color. It's a rare mixture that doesn't include some white. In fact, many colors look rather drab as they come straight from the tube, not revealing their true richness until you add some white. The blues and greens, in particular, often look blackish as they come from the tube and need a touch of white to reveal their true color.

Color Schemes. The need to plan the overall color scheme of a landscape is just as important as planning the individual color mixtures. What you may actually see is a uniformly green landscape in midsummer. But a solid green landscape can be terribly monotonous, so now you've got to find some way to relieve the uniformity. A few brownish or yellowish trees will help, even if you have to paint them from memory or from sketches. When you find yourself looking at a monotonous gray winter landscape, the solution may be to add some evergreens or some brownish treetrunks. Try to orchestrate your bright and subdued colors to direct the viewer's eye. It's good strategy to save your strongest colors or your strongest contrasts for the center of interest, where you want the viewer's eye to go. Those bright yellow wildflowers will look most vivid against a gray, fallen treetrunk. If you're painting a rocky landscape and you want one rock formation to stand out, exaggerate the contrast between the sunlit and shadow sides of the boulders.

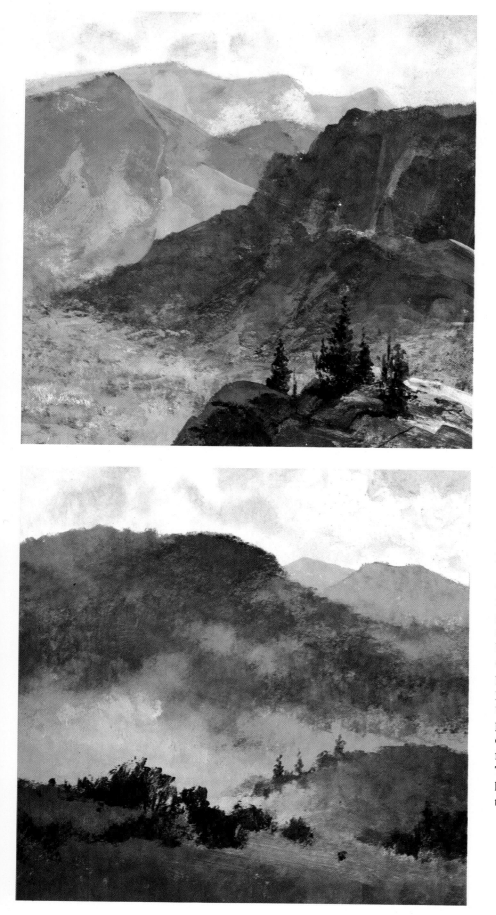

Mountains. The stony forms of mountains are far more colorful than you might think at first glance. The diverse browns, gray-browns, and blue-grays of this landscape are mainly mixtures of blues and browns. The darkest mountain is a blend of burnt umber, ultramarine blue, yellow ochre, and white—with more white and yellow ochre in the lighter areas, more blue and brown in the shadows. The more distant mountains are mixtures of burnt sienna, ultramarine blue, white, and yellow ochre—with lots of white in the lighted areas and lots of blue in the shadows. The rocks in the lower right are essentially the same mixtures as the darker mountain. Mountains are just big piles of rock, after all.

Hills. When you paint hills covered with trees and underbrush, try to emphasize the variety of color within the green. Don't try to paint each tree on the side of the hill; paint masses of trees that merge with one another but still have their own distinct colors. This green hill is a subtle patchwork of various green mixtures: ultramarine blue and cadmium yellow; ultramarine blue and yellow ochre; phthalocyanine blue and yellow ochre; phthalocyanine blue, cadmium yellow, and a touch of burnt umber to soften this brilliant mixture; phthalocyanine green and burnt sienna; mars black and yellow ochre for the most muted greens of all. The sunlit meadow at the foot of the hill consists of several of these mixtures, with more white.

Deciduous Tree. Don't try to paint every leaf with precise strokes, but paint the *masses* of leaves with broad strokes. Note that these masses have sunlit and shadow sides. Here, the sunlit sides are ultramarine blue and cadmium yellow, plus a little white, while the shadowy areas are ultramarine blue, yellow ochre, and burnt sienna. On the grass at the foot of the tree, the light and shadow areas are the same mixtures. And these mixtures reappear in the paler tones of the distant trees, which obviously contain much more white. The trunk of the big tree is ultramarine blue, burnt sienna, yellow ochre, and white—with more white on the sunlit side.

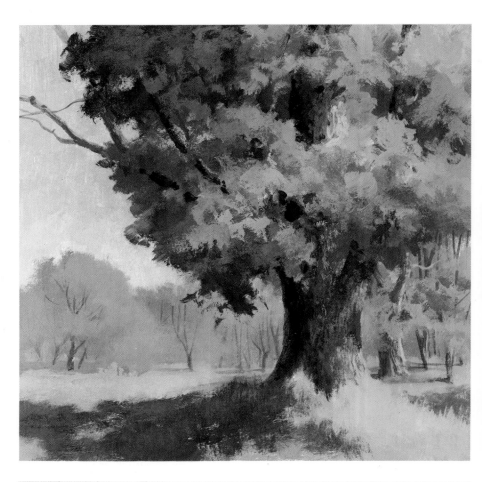

Evergreen. Pines, spruces, firs, and other evergreens tend to be a darker, less sunny green than deciduous trees. Once again, don't paint every needle, but try to paint the masses of foliage, paying attention to their sunlit and shaded sides. Some good mixtures for the sunlit sides are phthalocyanine blue, yellow ochre, and burnt umber, or ultramarine blue, cadmium yellow, and burnt sienna—with some white, of course. For the darks, you can use the same mixtures, but with less yellow and white. The distant trees contain more white in both the lights and the shadows. To create other muted greens, try modifying the brilliant phthalocyanine green or the more subdued chromium oxide green with a brown like burnt umber or burnt sienna, plus yellow ochre and white.

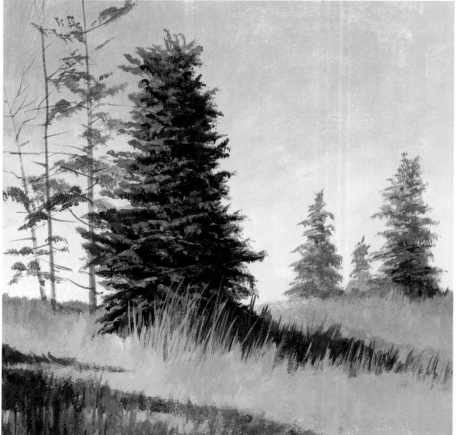

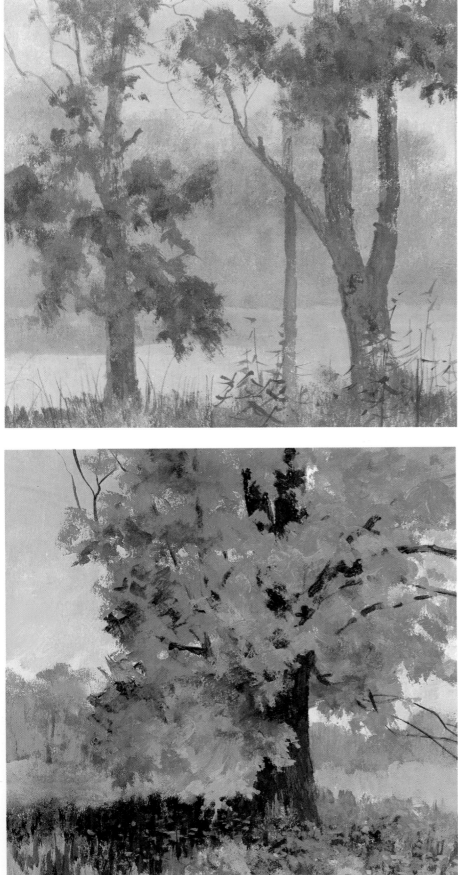

Trees in Mist. On a misty day, trees lose their brilliant colors, but new, equally interesting, colors emerge. You can mix lovely, muted greens, like the foliage in the foreground, with ultramarine blue, yellow ochre, white, and perhaps a touch of burnt umber or burnt sienna. You can also use just a little phthalocyanine blue or phthalocyanine green, burnt umber or burnt sienna, yellow ochre, and white, or mars black, cadmium yellow, and white. You can quickly transform any blue or green into a pale, atmospheric tone by adding brown and lots of white. That's how the ghostly forms of the distant trees are painted here.

Autumn Tree. The brilliant colors of an autumn tree can be just as monotonous as the side of a green hill if you don't look for variations within those hot colors. It's also best to mingle the brilliant mixtures with more muted tones, as you see here. The brightest clusters of leaves are cadmium red and cadmium yellow. (You could also try cadmium orange, yellow ochre, and a touch of cadmium red.) The softer, golden tones are cadmium red, yellow ochre, white, and an occasional touch of burnt sienna. The darker, coppery tones in the shadows are cadmium red, burnt umber, yellow ochre, and a touch of white. Small strokes of these same mixtures suggest fallen leaves at the foot of the tree. For other autumn colors, try mixing burnt sienna and cadmium yellow, or naphthol crimson and cadmium yellow, or burnt umber and cadmium orange.

Pond in Sunlight. Water is essentially a reflecting surface, which means that it has no color of its own, but takes its color from its surroundings. Most often, a body of water reflects the color of the sky. So it's not surprising that this pond repeats the blues and whites of the sky and clouds above. Along the shoreline, of course, the pond reflects the tones of trees and grass—not only the sunny greens, but the shadow tones as well. Across these darker reflections move a few ripples that reflect the color of the sky. To produce delicate blues, add plenty of white to ultramarine or phthalocyanine blue, then modify the mixture with the slightest touch of burnt umber, burnt sienna, or yellow ochre.

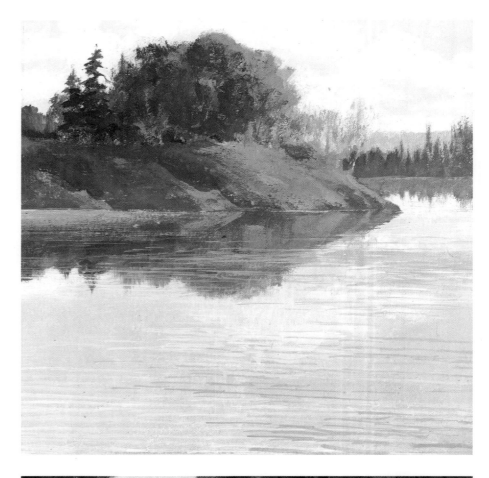

Pond in Deep Woods. Surrounded by the shadowy forms of trees and rocks that block out most of the sky, a body of water will turn a totally different color. This pond is dominated by the dark tones of the surrounding landscape, reflecting just a small patch of pale sky that breaks through the trees. These trees and rocks—and their reflections—are mixtures of burnt umber, ultramarine blue, yellow ochre, and white. You can also produce mysterious, shadowy mixtures with mars black, yellow ochre, and white; or phthalocyanine green, burnt umber, and white; or Hooker's green, burnt sienna, and white.

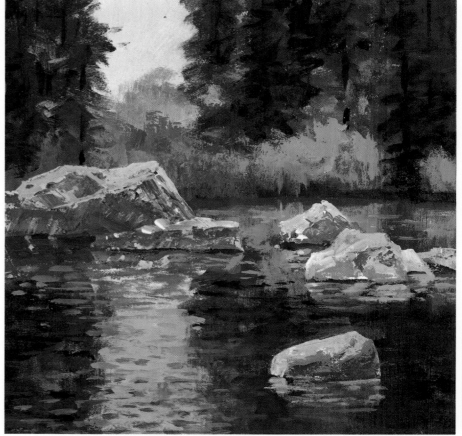

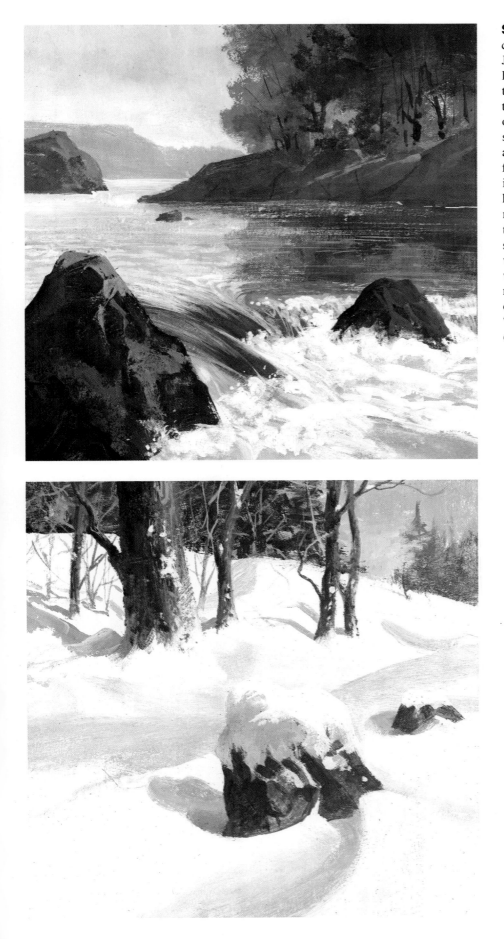

Stream. In moving water, the color effects are more complicated. Just above the rock in the lower left, the water reflects the colors of the sky. To the right of the sky tone, the water picks up the colors of the trees and rocks on the distant shore—with sky colors appearing among the pale ripples. But in the foreground, where the rapids burst into foam, several different things happen at once. Where the water rushes over the rocks, you can see the darkness of the concealed rocks shining through. As the rushing water bursts into foam, it turns white, but then the shadows beneath the foam pick up the sky color once again. Never paint foam "dead white": add a hint of sky color or a touch of sunlight.

Snow. When you paint snow, the most important thing to remember is that snow is simply water in another form—and obeys the same "laws": like a pond or a stream, snow has no special color of its own, but reflects the colors of its surroundings. On a sunny day, the lighted tops of snowbanks seem to reflect the warm glow of the sunlight, while the shadows pick up the cooler tones of the sky. Within the shadows cast by these treetrunks— and particularly in the shadow cast by the big rock in the immediate foreground—you can also see a subtle reflection of the dark tone of bark or stone. Snow, like foam, should never be painted pure white: on a bright day, add a hint of sunlight; on an overcast day, add a hint of gray.

Step 1. This demonstration painting of a tree begins with a pencil drawing that defines the contours of the trunks and branches, the curves of the meadow, the shapes of the three rocks beneath the tree, and the clusters of leaves against the sky. The lines of the tree and rocks will be followed carefully in the final painting. But the shapes of the leafy clusters and the landscape will disappear under rough, impulsive brushwork, so a precise drawing isn't really essential. The main thing is to establish the locations and the general shapes of the leafy masses and the horizon.

Step 2. A mixture of white, a touch of ultramarine blue, and lots of water is brushed over the entire surface of the illustration board, casting a semi-opaque veil over the pencil drawing, which is now almost invisible—just a faint ''ghost'' of the lines remains. A flat bristle brush covers the top half of the picture with a sky tone: ultramarine blue and white at the top, and ultramarine blue, phthalocyanine blue, yellow ochre, and white for the paler tone that approaches the horizon. When this sky tone is dry, the tree can be painted right over it without disturbing the underlying color.

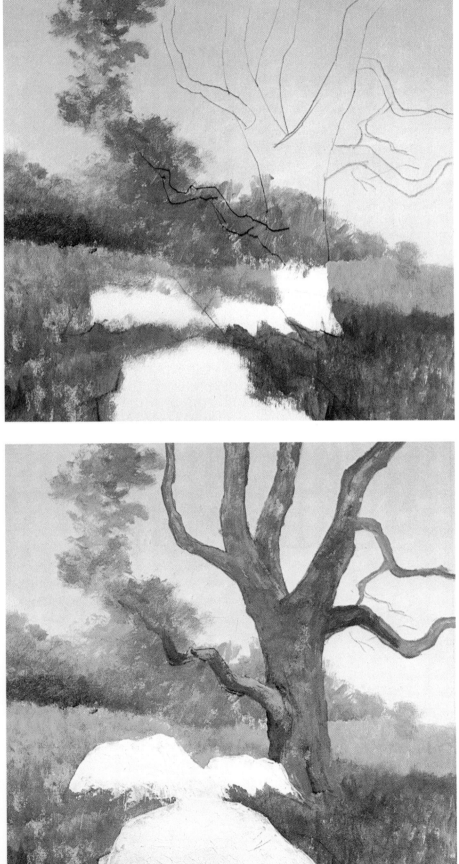

Step 3. The foliage along the horizon and against the sky is painted with short, scrubby strokes of thick color—not too much water—containing ultramarine blue, yellow ochre, and white. Now it's getting too hard to see the faint lines of the treetrunk and branches, so they're redrawn in pencil over the dried color of the sky and the distant foliage. The grassy tones of the meadow are painted with the same short, scumbling strokes of a bristle brush, carrying dark and light mixtures of ultramarine blue, yellow ochre, cadmium yellow, and white. There's more yellow to the left and more blue in the shadowy tone at the lower right.

Step 4. A small bristle brush scrubs a thin mixture of burnt umber, chromium oxide green, and white over the trunk and branches. (The grayish tone of the bark would be a lot less interesting if it were merely a mixture of black and white!) Then a painting knife picks up a thick mixture of white, yellow ochre, and gel medium. This pasty color is roughly stroked over the shapes of the three rocks, leaving a ragged, irregular texture. It's important to let this *impasto* passage dry thoroughly before going back to work on the rocks.

Step 5. When the rocks are bone dry, they're glazed with a transparent mixture of cadmium red, yellow ochre, ultramarine blue, and gloss painting medium, applied with a softhair brush. This glaze settles into all the cracks and crevices left by the painting knife at the end of Step 4. Then the foliage on the tree is begun with quick taps of the tip of a bristle brush, carrying two different mixtures: ultramarine blue, cadmium yellow, and white for the sunlit leaves; phthalocyanine blue, yellow ochre, cadmium yellow, and white for the darker clusters of leaves.

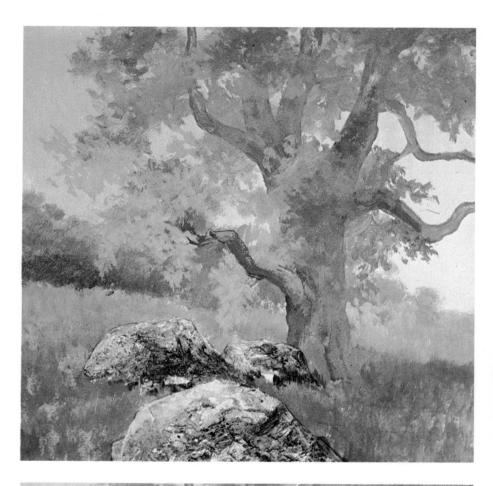

Step 6. The shadows on the trunk and the branches are begun with ultramarine blue and burnt sienna—the strokes follow the upward curves of the tree. The shadow to the right of the tree is painted with short, scrubby strokes of a bristle brush that suggest the texture of the grass with a mixture of Hooker's green and burnt sienna. Then, with the same tapping motion that first appeared in Step 5, the rich, dark greens of the lower leaves are added with Hooker's green, burnt sienna, cadmium yellow, and just a little white. The color used to paint the foliage is fairly thick—not diluted with too much water or painting medium—so it retains the marks of the bristles, suggesting leaves. Notice that a pale, greenish wash of this leaf mixture, containing lots of water, is carried over the rocks.

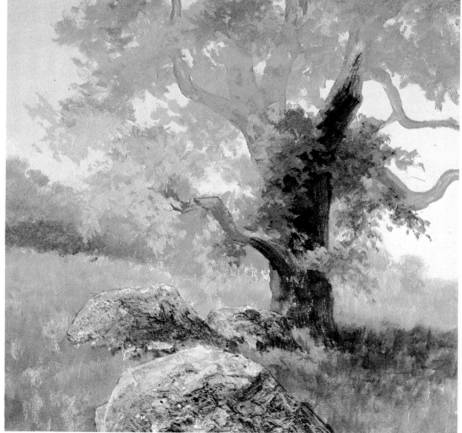

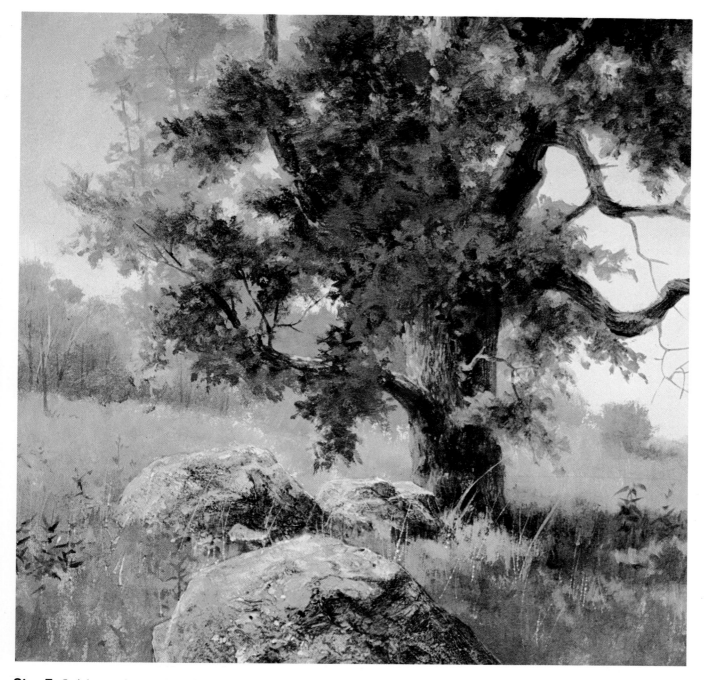

Step 7. Quick, tapping strokes of this mixture of Hooker's green, burnt sienna, cadmium yellow, and a touch of white are carried upward to cover all the deep green shadows of the foliage. Amid these shadowy clusters of leaves, you can see even deeper tones: mixtures of ultramarine blue, Hooker's green, and burnt sienna. More light and dark strokes of Hooker's green, burnt sienna, cadmium yellow, and white are scrubbed over the grass in the foreground. The shadows and dark lines on the trunk and branches are completed with slender strokes of ultramarine blue and burnt sienna, made with the tip of a round softhair brush. More twigs are added to the big tree, and trunks are added to the distant trees in the upper left with a pale mixture of ultramarine blue, burnt sienna, yellow ochre, and white.

Some pale strokes of this same mixture—containing lots of white—are dragged over the tops of the rocks to strengthen the contrast of light and shadow. Then the shadow sides of the rocks are deepened with the same mixture used on the trunk. Final details are added with the sharp corner of a razor blade and the pointed tip of a small, round softhair brush. The blade scratches weeds and blades of grass in the meadow. The round brush picks up some of the tree mixtures to add some leafy weeds. Look again at the foliage on the tree. The edges of the leafy masses, caught in sunlight, are a brilliant yellow-green. But most of the foliage is really in shadow. If you half-close your eyes, you'll see that the tree is essentially a shadowy silhouette.

Step 1. Like the deciduous tree in Demonstration 1, this painting of a group of evergreens begins with a precise pencil drawing of the trunks and branches, but a much more casual indication of the masses of foliage. It's important to visualize foliage as big, simple shapes. Just draw the general outlines of these shapes in pencil, but don't follow the drawing too closely when you start to paint. Foliage must be painted with free, ragged strokes, which will soon cover up these pencil lines.

Step 2. The pencil drawing is partly concealed by a "mist" of white, a little ultramarine blue, and a lot of water, so the lines are almost invisible. Then the sky is painted in two operations. First, the sky is brushed with clear water. While the surface of the illustration board is still wet and slightly shiny, a mixture of ultramarine blue and phthalocyanine blue is carried from the top of the picture down to the horizon, gradually adding more water as the brush approaches the horizon, so the sky is dark at the top and pale below. This *graded wash*, as it's called, is allowed to dry. Then the sky is again wetted with clear water and the same type of graded wash is carried upward from the horizon; this time, the mixture is simply naphthol crimson and water, with more color at the horizon and more water at the top.

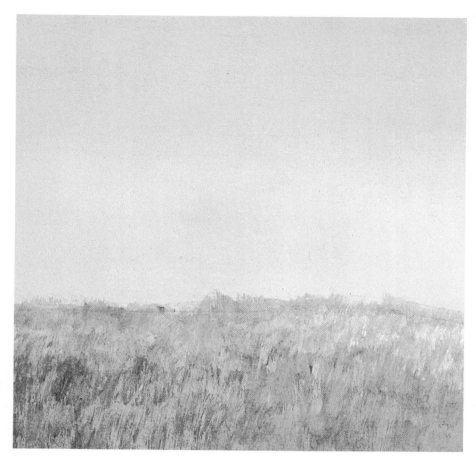

Step 3. The grassy area is scribbled with up-and-down strokes of a flat bristle brush dampened with burnt sienna and water. Because the brush carries so little color, the marks of the bristles are clearly seen and give the distinct impression of blades of grass. When this scrubby passage dries, it's covered with a fluid, transparent glaze of yellow ochre and water, applied with a large softhair brush. When the yellow ochre dries, the strokes of burnt sienna shine through.

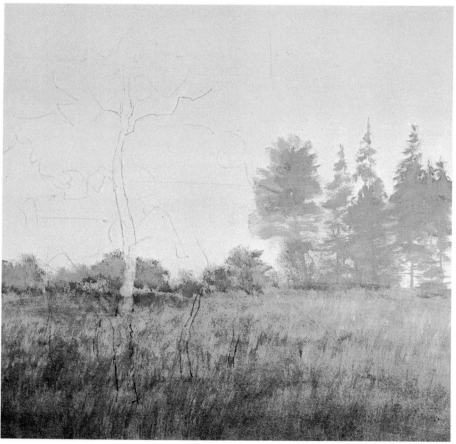

Step 4. The distant trees along the horizon are painted with short, scrubby strokes of ultramarine blue, cadmium red, yellow ochre, and white, applied with a bristle brush. This same tone, containing more water and more white, is carried over the upper half of the meadow, just beneath the trees—the color is a thin scumble, so the tones of Step 3 still shine through. The immediate foreground is glazed with a transparent wash of chromium oxide green and ultramarine blue, applied with a large softhair brush; again, the tones of Step 3 shine through the transparent glaze. It's getting hard to see the lines of the trees, so they're lightly redrawn in pencil.

Step 5. A bristle brush scrubs a mixture of Hooker's green and yellow ochre over the foliage areas of the pines in the foreground. The color on the brush is damp, not really wet, so the strokes have a ragged quality that suggests clusters of pine needles. The tip of a small, round softhair brush builds up the trunks and branches with many little lines of Hooker's green and burnt sienna. Look closely at the trunks and you can see that they're not one solid tone, but are composed of many parallel lines that suggest the texture of the bark.

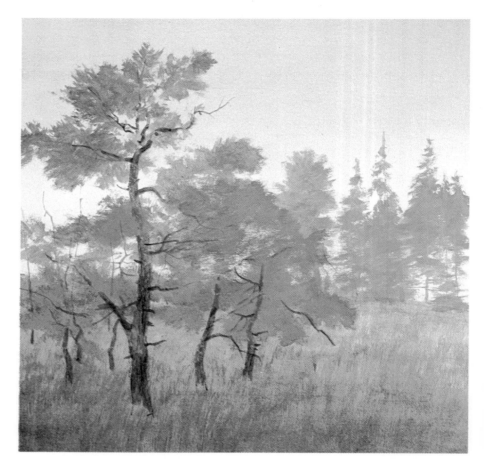

Step 6. The shadow tones on the foreground pines are painted with the same brush and the same type of brushwork, but the colors are a bit more fluid and "juicy." These darks are a mixture of Hooker's green and burnt sienna thinned with water to the consistency of watercolor, containing no white. The bristles of the brush now leave a very distinct mark that suggests pine needles even more clearly. These dark strokes are allowed to dry, and then more scrubs of this dark mixture are added to certain areas where the shadows are particularly dense.

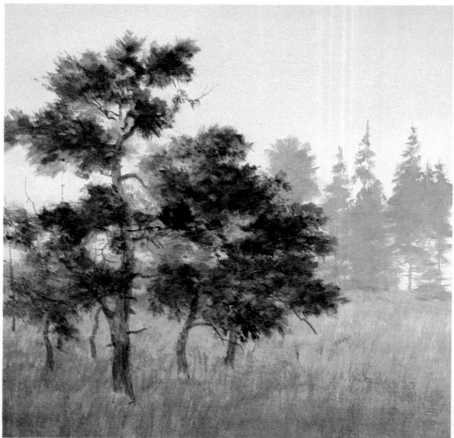

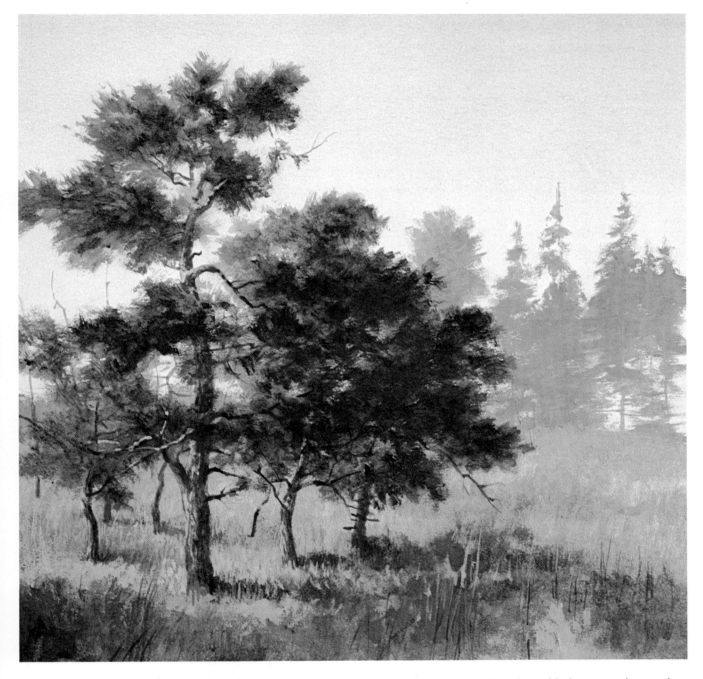

Step 7. The foreground of the meadow is enriched with scumbling strokes of thick color: burnt sienna, cadmium yellow, a touch of Hooker's green, and lots of white in the sunlit areas; ultramarine blue, burnt sienna, yellow ochre, and a touch of white in the shadows. The broad tones are painted with a flat bristle brush. Notice how the tip of a small, round softhair brush carries blades of sunlit grass up over the shadows. The same brush strikes in darker blades of grass with a mixture of ultramarine blue, Hooker's green, and burnt sienna. This small brush strengthens the shadow sides of the trunks and branches with the same mixture, then blends white into this mixture and adds a few strokes of sunlight to the left sides of the trunks and branches. This painting is an interesting combination of transparent and opaque color—a combination that's particularly effective for painting atmospheric landscapes. The sky is completely transparent. The meadow begins with transparent color and is completed with more opaque color. Conversely, the trees begin with opaque color and are finished with transparent color that gives you the sensation of luminous shadows.

Step 1. There's so much detail in a forest that it's important to be highly selective about just how much to include. All that foliage can become just one big blur, so it's critical to focus on just a few treetrunks of various sizes and make them the dominant shapes in the picture. In the pencil drawing, it's obvious that the picture will be dominated by one thick trunk to the left, played off against some smaller trunks to the right and some really slender trunks in the distance. Once again, the treetrunks and branches are drawn precisely, while the clusters of foliage are merely indicated with casual lines. The drawing also defines the shape of the shadow at the foot of the large tree.

Step 2. The final painting will have a patch of bright sunlight breaking through the dense foliage. So this sunlit break is indicated with a pale wash of cadmium yellow and yellow ochre, thinned with water to the consistency of watercolor. When this yellow shape dries, it's surrounded by a warmer, darker tone that suggests the overall color of the surrounding woods: a mixture of naphthol crimson, yellow ochre, ultramarine blue, and lots of water. You've probably noticed that the original pencil lines are almost invisible once again, having been covered with a "mist" of white, ultramarine blue, and water, which is allowed to dry before the painting operation begins.

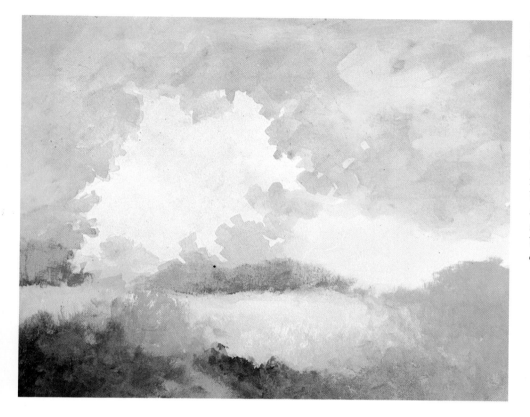

Step 3. The sunlit patch of ground is scumbled with a mixture of cadmium yellow, yellow ochre, and burnt sienna. The dark tones above this and to the right are mixtures of naphthol crimson, ultramarine blue, yellow ochre, and white. And the rich tone in the lower left is cadmium red, cadmium yellow, and burnt umber. All these tones are scumbled in with the short, stiff bristles of the brush known as a *bright*. The color is thick and opaque.

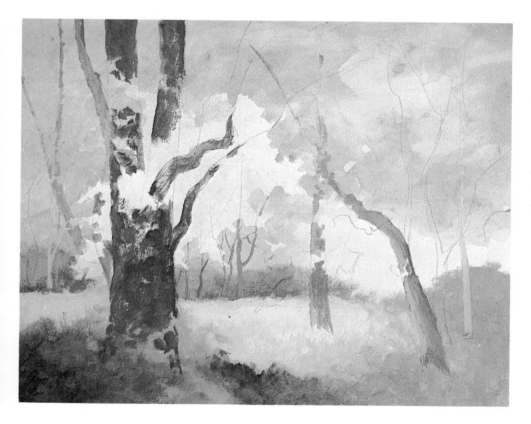

Step 4. The trunks and branches are redrawn with light pencil lines. The thick trunk is begun with a small, flat bristle brush carrying a much darker version of the mixture used in Step 3: ultramarine blue, naphthol crimson, yellow ochre, and white. This same mixture appears in the shadowy tone to the right of the tree. And the point of a round softhair brush begins to trace the slender shapes of the smaller trunks with the same mixture, which now contains more white.

Step 5. The glowing colors of the foliage are tapped in with the tip of a bristle bright carrying a mixture of cadmium red, cadmium yellow, yellow ochre, and white. The dark note on the side of the tree—naphthol crimson, yellow ochre, and ultramarine blue—is scrubbed in with the longer, more flexible bristles of a *flat*. At this point, all the color is thick and opaque, gradually covering most of the transparent sky tones.

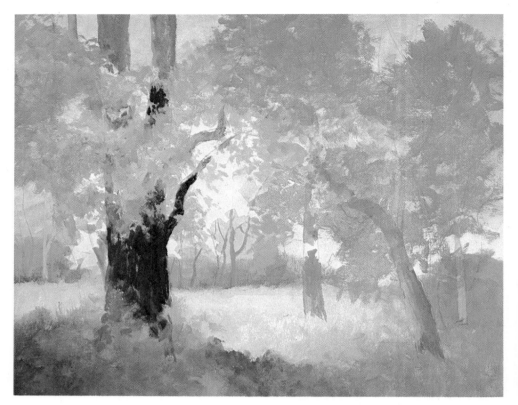

Step 6. The dark mixture of naphthol crimson, yellow ochre, and ultramarine blue is carried up over the main trunk and branches, leaving the paler undertone uncovered here and there to suggest lighter patches. Short strokes of the same dark mixture are scattered at the foot of the tree to suggest shadows in the underbrush. A large bristle brush adds darker tones to the foliage: various mixtures of naphthol crimson, cadmium red, cadmium yellow, yellow ochre, ultramarine blue, and white—never more than three colors to a mixture. The darks in the upper right corner are cadmium red, ultramarine blue, yellow ochre, and a little white.

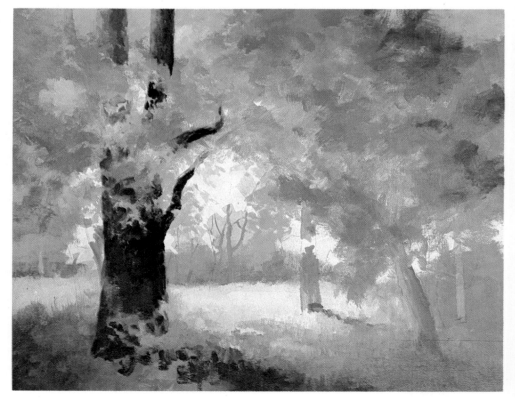

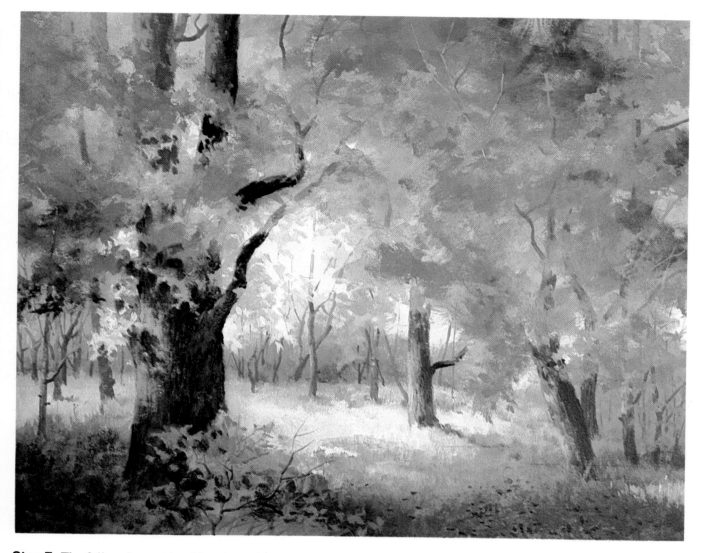

Step 7. The foliage is completed by alternating strokes of the gold and coppery mixtures introduced in Steps 5 and 6. Darks are added to the sides of the smaller trees with ultramarine blue, burnt sienna, yellow ochre, and white. More white is added to this mixture to strengthen the lighted sides of the small trunks and also the big trunk to the left. This same mixture is used to add more trunks and branches in the distance. All this work is done with the tip of a small, round, softhair brush that also picks up more of the foliage mixtures to suggest the dried leaves of a bush at the foot of the large tree. A few strokes of this coppery tone are dry-brushed over the shadow to the left of the big tree. And the tip of the brush adds a few flecks of this color to the right foreground, suggesting fallen leaves. Here and there among the foliage, a thick, pale mixture of ultramarine blue, white, and a little naphthol crimson appears to suggest pale sky breaking through the dense forest. The texture of the bark on the big tree is completed with dark, slender lines of ultramarine blue and burnt umber, drawn with the smallest round brush. By the time the picture is finished, it's almost entirely covered with opaque color. Only the glow of golden light breaking through the forest to the right of the big tree is the original transparent wash. And this remains the most luminous spot of color in the painting.

Step 1. The preliminary pencil drawing is extremely simple, defining the zones of light and dark with wandering horizontal lines. Then a flat bristle brush picks up a mixture of Hooker's green and burnt sienna and brushes this dark tone across the horizon with some long horizontal strokes, plus some short vertical ones. The color is thick and opaque, roughly indicating the trees at the horizon, without any detail.

Step 2. A mixture of ultramarine blue, yellow ochre, and burnt sienna is diluted with water to a very fluid consistency. The underlying tone and texture of the meadow are painted by tapping the flat side of a bristle brush against the painting surface, which is a sheet of illustration board. The brush is held almost parallel to the painting surface, with the tip pointing toward the sky and the end of the brush handle pointing to the bottom of the painting. The "taps" are applied in a series of horizontal rows, one below the other, until the entire meadow area is filled with ragged, horizontal bands of brush marks. As you can see, each "tap" leaves the imprint of the bristles.

Step 3. When the meadow is dry, a very pale mixture of burnt sienna and yellow ochre—mostly water—is brushed over the grassy texture to add warmth. Then the sky area is brushed with clear water. A large, flat sable is used to brush in a mixture of yellow ochre and water, which blurs and spreads softly over the wet surface. When the wash of yellow ochre is dry, the process is repeated with blue. The sky is brushed with clear water; then a large, flat sable brush "floats" on a mixture of ultramarine blue, phthalocyanine blue, and water. The blue starts at the top of the picture, spreads softly, but stops just short of the horizon, where a "blush" of yellow remains.

Step 4. The point of a small, round softhair brush adds stronger lights, darks, and details to the grass and weeds. The point of the brush scribbles up and down with a mixture of cadmium red, yellow ochre, and ultramarine blue to make row after row of dark strokes, smaller and less distinct in the distance, larger and more distinct in the foreground. Adding a bit of white to this mixture, the tip of the brush scribbles rows of lighter strokes between the dark ones. This same mixture is used to paint the rocks: more white for the lighted tops and less white for the shadows. A few strokes are added beneath the distant trees. Here and there, the warm, transparent undertone still shines through.

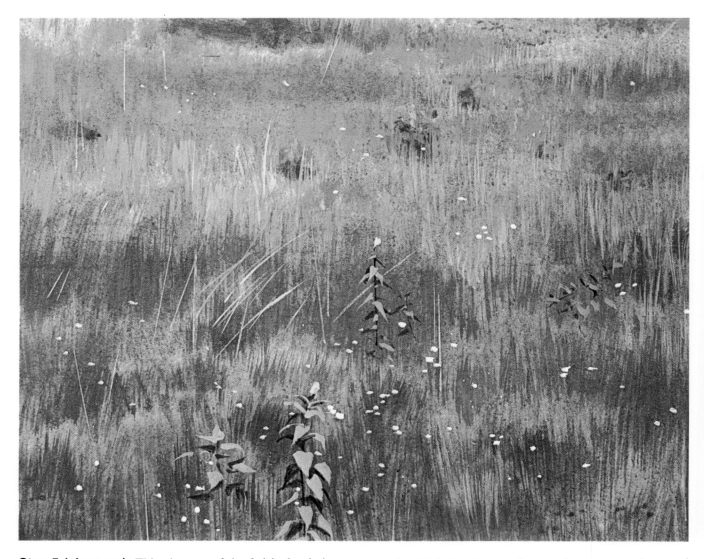

Step 5 (close-up). This close-up of the finished painting shows how the color of the grass is enriched—in the final stage—with a transparent glaze of burnt sienna, Hooker's green, water, and some gloss medium to keep the mixture from becoming too watery. This glaze adds an extra note of warmth to the tone of the meadow. When this warm tone dries, some of the greener patches are brushed with a transparent glaze of chromium oxide green, water, and a little gloss medium. The shadowy patches of grass are then strengthened with an opaque mixture of cadmium red, ultramarine blue, and white. In this final stage, a few individual blades of grass are picked out with the point of the smallest, round softhair brush, carrying a pale, opaque mixture of chromium oxide green, yellow ochre, white, and enough water to make the strokes fluid and precise. The lighted tops of the leafy weeds in the foreground are painted with this same mixture, which is darkened with ultramarine blue to paint the shadowy leaves beneath. The more distant clumps of weeds are painted with phthalocyanine green, burnt sienna, yellow ochre, and white. And the scattered wildflowers are painted with specks of white tinted with a touch of yellow ochre plus an occasional dab of pure cadmium yellow.

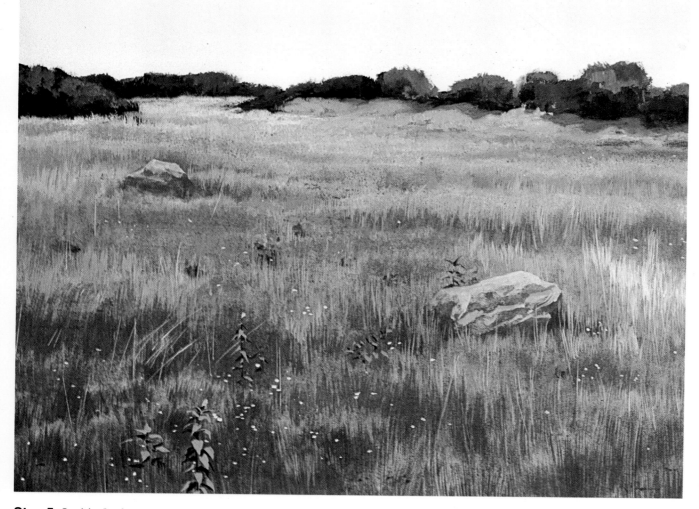

Step 5. In this final stage, a bristle brush lightens parts of the trees by scrubbing on a thick, opaque mixture of yellow ochre, ultramarine blue, burnt sienna, and white. This gives the trees a pattern of light and shadow and makes them look more three-dimensional. It also softens the bright tone with which the trees were originally painted in Step 1. Some shadows are painted under the trees with cadmium red, ultramarine blue, and white. Next to these shadows, sunlit areas are indicated with thick strokes of yellow ochre, just a little burnt sienna and ultramarine blue, plus lots of white. To strengthen the effect of sunlight on the meadow, strokes of this mixture are scribbled over the lighter patches of meadow, between the rows of shadow strokes. The rocks are glazed with a pale, transparent tone of burnt sienna, yellow ochre, and a little ultramarine blue. This landscape is an effective combination of opaque and transparent color. The sky is clear and transparent, which is just right for the subject. The distant trees are thick and opaque. The transparent undertones of the meadow still shine through in many places, particularly in the foreground between the patches of darker weeds. But this transparent undertone has been lightened, darkened, and enriched with strokes of opaque color. Note how much variety this simple subject now contains: an intricate pattern of light and shadow; a variety of lively brushstrokes; and a rich pattern of sunny and subdued colors in alternating bands.

Step 1. The pencil drawing—on a sheet of illustration board—defines not only the shapes of the various peaks, but also traces the details within these peaks. These lines record the complicated pattern of light and dark shapes that will appear in later steps. Then the sky is roughly covered with a mixture of phthalocyanine blue, ultramarine blue, white, and just enough water to make a mixture that is milky and semi-opaque so that the pencil lines will shine through. This combination of the two blues is worth remembering. Phthalocyanine blue may be too bright for the sky, while ultramarine blue can be too subdued. When you blend them and add white, you get the perfect compromise.

Step 2. The darker tones of the distant mountains in the upper right are painted with a blend of burnt sienna, ultramarine blue, and white. The strokes are made with a flat softhair brush, pulled downward and quickly lifted to leave an effect something like drybrush. Then a touch of this mixture is added to a great deal of white to paint the snowy peak with the point of a round softhair brush.

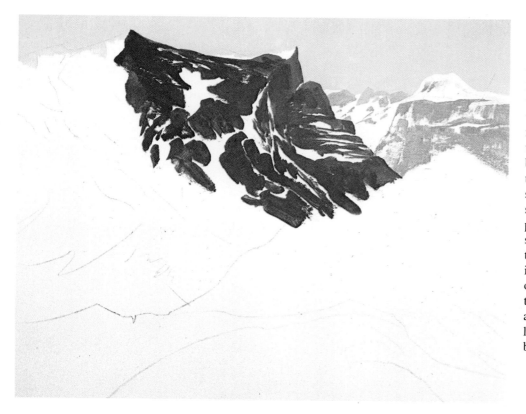

Step 3. The darks of the tallest mountain are brushed in with a mixture of burnt umber, ultramarine blue, a little cadmium red, and some white. The paint is thinned with water and a little gloss medium to a creamy consistency; thus the flat nylon brush carries the paint across the board in smooth, solid strokes. Between the strokes, strips and patches of bare paper are left to suggest the snow. Now you can see why the preliminary pencil drawing is so important: the beauty of the mountain depends on that intricate design of lights and darks, which must be followed carefully with the brush.

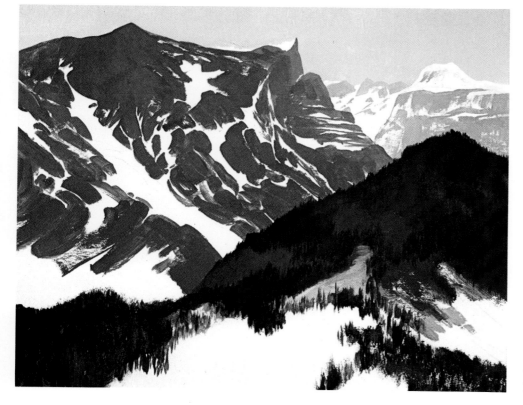

Step 4. The remaining slopes of the high mountain are painted with the same mixture used in Step 3: burnt umber, ultramarine blue, a little cadmium red, and white. Throughout, the paint is kept thick and creamy. Then the dark shape of the tree-covered mountain in the foreground is brushed in with that same mixture, containing less white. When the dark tone dries, a small, flat nylon brush scribbles in the suggestion of trees with up-and-down strokes of burnt umber, ultramarine blue, cadmium red, and yellow ochre. The shadows on the snow are the same mixture used for the distant mountains, but with more white. And the sunlit patches of snow are still the bare painting surface.

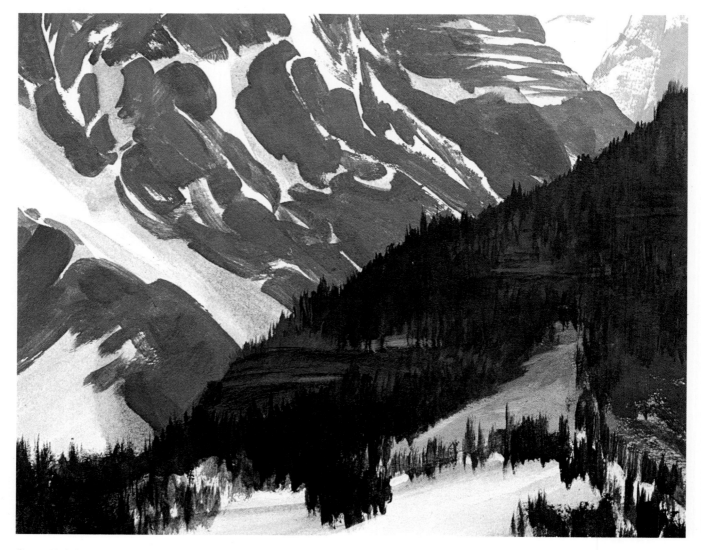

Step 5 (close-up). This life-size section of the finished painting shows the various kinds of brushwork used to paint the mountains, snow, and trees. The dark shapes of the rocks peeking through the snow on the slopes are painted with straight and curving strokes of a flat brush. The strokes follow the diagonal contours of the mountainside. The layered rock formations in the upper right are painted with horizontal strokes. The pine forest on the shadowy slope of the mountain in the foreground is painted with the point of a round softhair brush that moves up-and-down with a scribbling movement. You can't really pick out the form of any single tree, but the scribbling strokes cluster together to suggest hundreds of evergreens. The shadows on the snow are also painted with form-following strokes that move up the steep, diagonal slopes of the rocky mountainside, but move in a more horizontal direction on the snowy slopes of the mountain in the foreground, which is less steep.

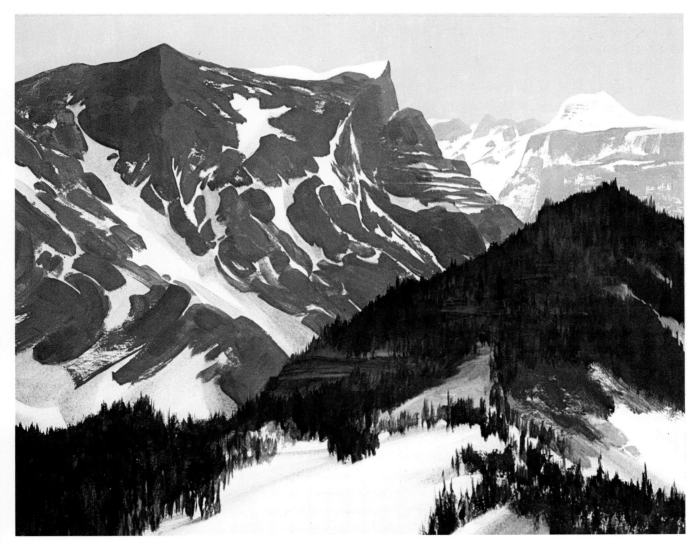

Step 5. The shadows on the snow are glazed with a transparent tone of ultramarine blue and cadmium red, plus a good deal of water and a little painting medium. The job is done with a flat softhair brush. It makes sense to use transparent color to paint the transparent shadows on the snow. Among the trees of the dark mountain in the foreground, a small, round softhair brush paints some traces of shadow with ultramarine blue, cadmium red light, and white. This brush picks up some pure white to paint a snowy shape along the topmost edge of the tall mountain. Pure white is also used to "trim" the lower edges of some of the tree strokes in the foreground, giving the impression that the trunks are growing out of thick snow. Finally, the tip of a small, round softhair brush adds tiny strokes of dark color—burnt umber, ultramarine blue, yellow ochre, and a whisper of white—to the silhouette of the pine forest, suggesting individual trees that stand up clearly against the paler mountains beyond.

Step 1. The hills will be covered with dense foliage, but there's not much point in trying to draw all those little trees. The pencil drawing defines the overall shapes of the hills and the land beneath, which will be divided into strips of light and dark. The blues between the clouds are first brushed in with a mixture of ultramarine blue, phthalocyanine blue, and white. While this blue tone is still moist, a touch of burnt sienna is added to this mixture—and then the shadows of the clouds are brushed in. The thick, creamy, opaque color of the shadows tends to merge slightly with the opaque color of the undertone. The effect is a soft, lovely fusion of the two colors.

Step 2. At the end of Step 1, the sunlit areas of the clouds remain bare white. Now the whites of the clouds are scumbled with a mixture of white plus the slightest touch of burnt umber and phthalocyanine blue. This is done with a flat nylon brush, which reshapes the clouds, the shadows, and the patches of blue sky. Now it's easier to see the forms of the clouds. The entire landscape is covered with a transparent mixture of phthalocyanine green and a little burnt sienna, plus plenty of water. The tone is painted with a big, flat brush, leaving obvious brushstrokes that will soon be covered with opaque color. The strokes contain more water in the lighter area at the foot of the hills.

Step 3. The dark areas of the hills are scrubbed in with a bristle bright that carries an opaque mixture of ultramarine blue, Hooker's green, yellow ochre, naphthol crimson, and white. (Notice that this is one of those rare times when four colors are needed to get exactly the right mixture.) This same color, minus the white and the yellow ochre, is used to brush in some rough strokes for dark trees at the crests of the hills and on the landscape below. The light patches toward the tops of the hills are the same mixture as the shadows, but with more white and yellow ochre—scumbled with a bristle bright to blend into the edges of the shadows.

Step 4. Stronger darks are added with ultramarine blue, Hooker's green, burnt sienna, and a hint of white. Stronger lights are added with Hooker's green, burnt sienna, plus a lot of yellow ochre and white. The glowing tone at the foot of the hills, just left of center, is the same mixture, plus cadmium yellow. Rich, cool notes are added with phthalocyanine green, burnt sienna, and yellow ochre. And the darks of the foreground are added with phthalocyanine green and burnt sienna. The subtle gradations on the hillsides are all scumbled with bristle brushes.

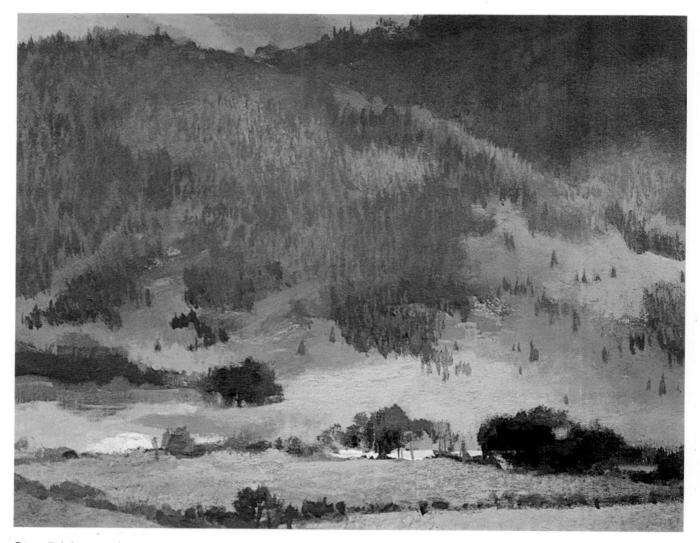

Step 5 (close-up). Here's a close-up of a section of the finished painting, showing the variety of brushwork that suggests much detail without every tree having been painted. The lights and shadows on the hillsides are all scumbled with thick, opaque color. Notice how the areas of sunlight and shadow in the lower right seem to blend softly together. That's the effect of that back-and-forth scumbling motion, which softens the edges of the brushstrokes so they seem to melt away into the color alongside them. When these scumbles are dry and won't be disturbed by further brushwork, the tip of a round softhair brush suggests those masses of trees with the same up-and-down scribbling mo-

tion that is used to paint the pines in the mountain demonstration you saw a moment ago. In some areas, the tree strokes are close together, suggesting dense growth. At other points, the tree strokes are farther apart, suggesting sparse growth. But the tree strokes never completely cover the scumbled undertones—which render the lights and shadows on the hills and make the big, rounded forms look three-dimensional. The triangular shapes of the individual evergreens, standing alone here and there, are painted with a single touch of the point of the round brush, pressing down slightly to make the brush spread at the bottom of the stroke.

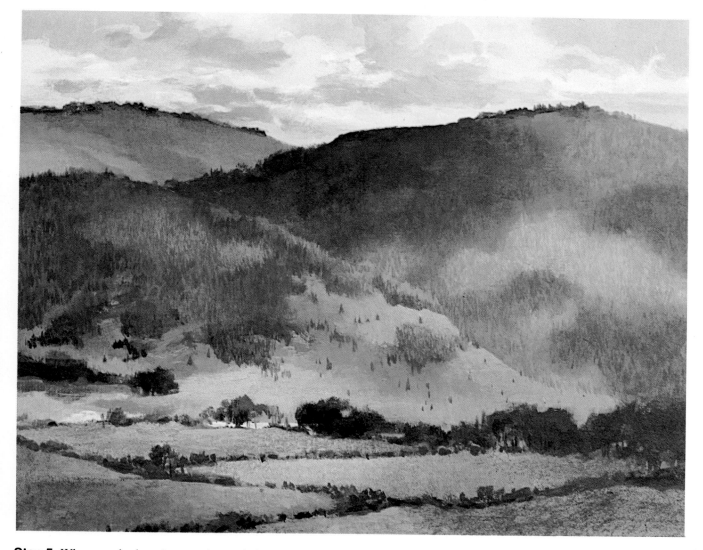

Step 5. When you look at the complete painting, the small, scribbly strokes of the dark trees merge and melt away into the shadow sides of the hills. These tree strokes are a mixture of ultramarine blue, naphthol crimson, yellow ochre, and a hint of white. In some of the sunlit areas of the hills— particularly to the right—sunstruck foliage is suggested with the same kind of brushwork. But these strokes are light mixtures of chromium oxide green, cadmium yellow, and white, with the warm undertone still shining between them. The light and dark mixtures on the hillsides are also scumbled over the fields in the foreground. The forms of the trees at the foot of the hill, as well as the hedges between the fields, are sharpened up with small strokes of burnt sienna, Hooker's green, yellow ochre, and a little white. The tip of the brush adds some trunks to the trees. An occasional warm note appears among the trees to relieve all that green—a mixture of cadmium red, burnt sienna, and a little ultramarine blue. At the crest of the hill to the left, the trees poke too far up into the sky, so they're trimmed down with a few strokes of sky tone. The painting has come a long way from the uniform green of Step 2. These hills are now a rich tapestry of color, warm and cool, dark and light.

Step 1. These desert rock formations and their sandy surroundings are painted on smooth watercolor paper. The rocky forms are complicated, so the pencil drawing records them as precisely as possible. The pencil traces not only the outer edges of the rock formations, but the planes of light and shadow that will make the forms look three-dimensional. The cloud forms and the shapes of the sandy foreground are drawn more freely.

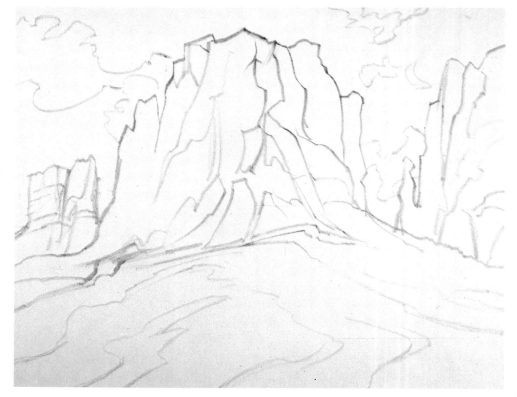

Step 2. The pencil lines are lightened with an eraser and are practically invisible. The sky is painted with a transparent wash of ultramarine blue, phthalocyanine blue, and water, carried around the rock formations. The shadow side of the big shape is painted with ultramarine blue, naphthol crimson, and water. Cadmium red, ultramarine blue, and water are freely brushed over the lighted side and blended into the wet shadow tone. This same warm mixture is brushed over the rocky shape to the right. Then a little white and a lot of water are mixed with the shadow tone, which is brushed over the foreground and over the edge of the rocky shape.

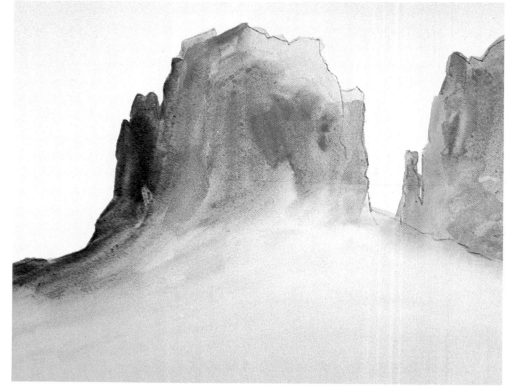

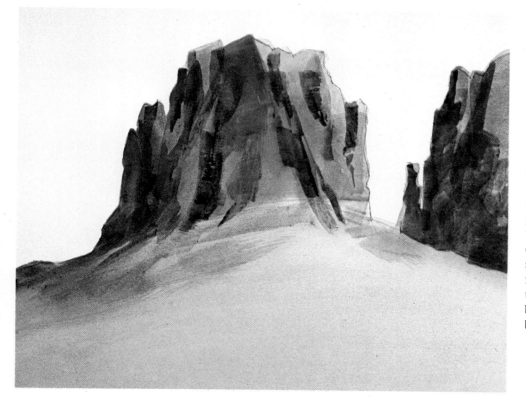

Step 3. When Step 2 is dry, a flat softhair brush picks up the same shadow mixture—ultramarine blue, naphthol crimson, and less water—to paint the shadows with squarish strokes. When these strokes are dry, a darker wash of cadmium red and ultramarine blue (containing less water) is carried over the rocks with the same brush. At this stage, there are clearly defined planes of light and shadow on the two big rock formations, creating a feeling of strong sunlight striking the rocks from the right. A bit more of the shadow mixture is brushed along the sand at the base of the biggest rock.

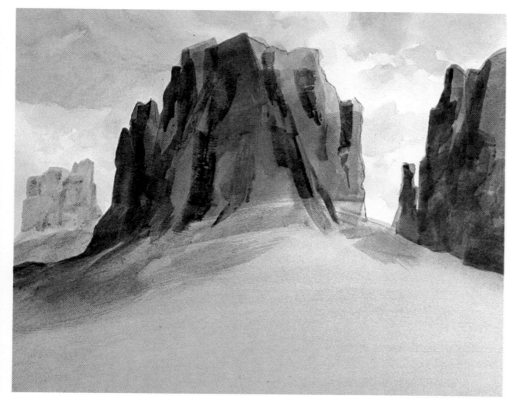

Step 4. At the end of Step 3, the sky is still the very pale blue that was applied at the very beginning. Now deeper blues are added with a round softhair brush: ultramarine blue, plus a little naphthal crimson and yellow ochre and a lot of water. Alongside these wet patches, the same brush brings in shadowy tones of the same mixture—with more crimson and less blue—to blend wet-in-wet with the blue shapes. Here and there the brush softens the edges of the wet shapes with clear water, as you can see most clearly in the upper right. The distant rock formation at the left is painted with the shadowy sky mixture—more water on the lighted side and less on the shadow side.

Step 5. A touch of white is added to each of the sky mixtures—the blue and the shadow tone—making them more opaque. Then these mixtures are scumbled over the sky area in the upper left, still leaving the sky in the upper right untouched. The cloud behind the small rock formation at the left is scumbled with white tinted with just a little ultramarine blue and naphthol crimson. The curving contours of the sandy foreground are suggested with scrubby strokes of cadmium red, ultramarine blue, yellow ochre, and white. A few touches of this mixture are added to the sunlit planes of the biggest rock formation.

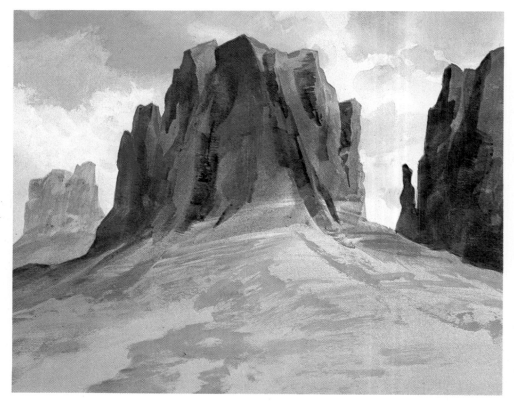

Step 6. Strong shadows are added to the bigger rock formation with square strokes made by a flat softhair brush. These darks are a mixture of ultramarine blue, cadmium red, and a little water. The point of a round softhair brush draws some crisp lines over the rocks to suggest cracks and crevices. A touch of white is added to this mixture for the shadow that's carried across the left. A few strokes of the sandy tone—cadmium red, yellow ochre, and white—are carried up into the base of the center rock.

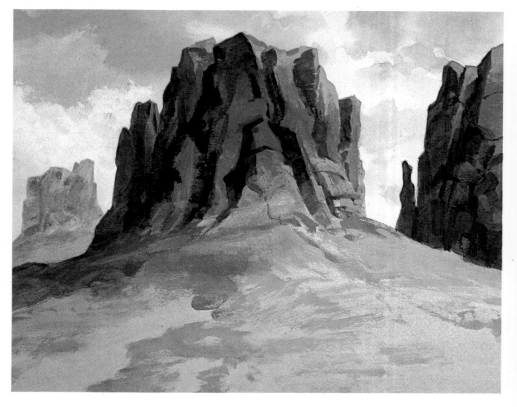

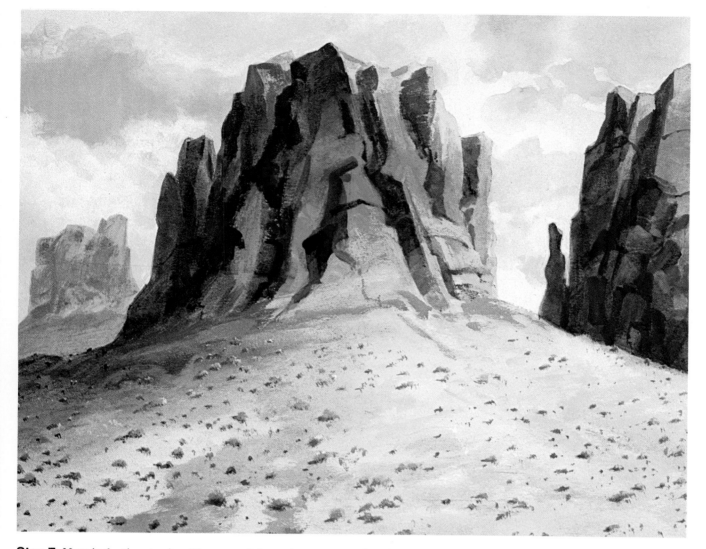

Step 7. Now is the time to simplify some of the major areas of the picture before going on to the final details. The sky behind the big rock formation looks a bit too dark; the rock will stand out more strongly against a lighter sky. So a pale, opaque mixture of ultramarine blue, naphthol crimson, phthalocyanine blue, and white is scumbled around the big, ruddy shape to make the sky drop back slightly. Too much seems to be happening in the sandy foreground, so this is scumbled with various mixtures of naphthol crimson, cadmium red light, yellow ochre, cadmium yellow, ultramarine blue, and white—never more than three or four of these colors to a mixture. These sandy tones obliterate a lot of the distracting brushwork that you saw in Step 6, producing a slightly smoother tone. The last details are those small touches of green that suggest the desert weeds. These are nothing more than little dabs made by the tip of a bristle brush carrying a thick, not-too-fluid mixture of chromium oxide green, yellow ochre, and white. The touches of dark shadow under these weeds are the same mixture used for the shadows on the rocks: ultramarine blue, naphthol crimson, and a hint of white. These touches of shadow are often placed slightly to the left of the green strokes, reinforcing the feeling that the strong sunlight comes from the right. One strong shadow remains in the foreground, just left of center, subtly leading the eye upward toward the central rock formation. Once again, this landscape is an effective combination of transparent and opaque color. The most brilliant, luminous colors on the rocks are transparent washes, thinned only with water. The softer colors of the foreground are opaque. The sky is painted in transparent color at the beginning, but opaque color is added for certain necessary corrections.

Step 1. The painting begins with a pencil drawing on a sheet of illustration board. Burnt sienna, ultramarine blue, and water are mixed on the palette to a very fluid consistency. A roughly textured synthetic sponge is soaked in clear water; then most of the water is squeezed out, leaving the sponge moist. One flat side of the sponge is dipped into the pool of color on the palette. Then the sponge is carefully pressed against the surface of the illustration board and lifted away, leaving a mottled pattern that suggests the texture of the rocks in the stream. Just one area—in the upper right—is scrubbed in with a brush, since this is a reflection, not a rock.

Step 2. A large, flat softhair brush scribbles in the tones of the trees with a mixture of Hooker's green and burnt umber, diluted only with water so that the color is transparent. More water is added for the lighter areas. The marks of the brush are left to suggest the texture of the leaves.

Step 3. Still working with very fluid, transparent color—the consistency of watercolor—the brush adds the cool tones of the stream with ultramarine blue, burnt umber, and yellow ochre. The color is diluted only with water. Notice how the strokes seem to follow the movement of the water rushing between the rocks. Gaps of bare paper are left to suggest foam. Just below the distant shoreline, the brush scrubs in some of the tree mixture—the same colors used in Step 2—for reflections. So far, all the work is done with round and flat softhair brushes.

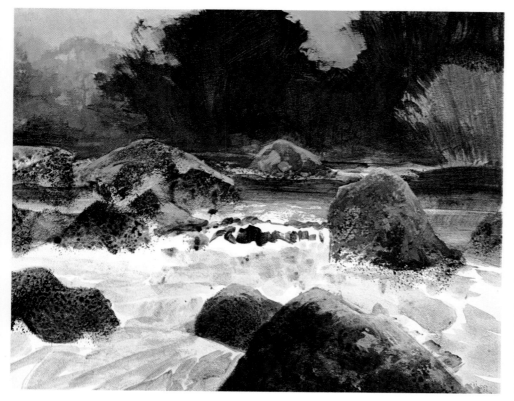

Step 4. Now the first opaque color appears. The sky is painted with rough strokes of ultramarine blue, burnt sienna, yellow ochre, and white. These strokes reshape the edges of the trees, enlarging the patches of sky. This same mixture, containing less white and a little more burnt sienna, is scumbled over the distant trees to the extreme left; now they seem farther away. The rocks are glazed with a transparent wash of burnt sienna, Hooker's green, water, and a little gloss medium, deepening their tone while still allowing the underlying texture to come through. When this glaze is dry, the brush picks up some pale sky color and scumbles it over the lighted tops of the rocks.

Step 5. The rocks at the left seem too scattered, so now they're pulled together. The dark tone of the rock in the lower left is extended upward with another sponge mark. The sky tone is scumbled over the other rocks at the left, making them one big rock formation and covering up the patch of water. Then the foam patterns are painted with white, tinted with a touch of sky tone. The broad strokes are made by a flat softhair brush, while the slender lines are made with the tip of a round brush. The lines follow the flow of the stream. The solid patches of foam are dense and opaque. But the other white strokes are semi-opaque, revealing the cool undertones.

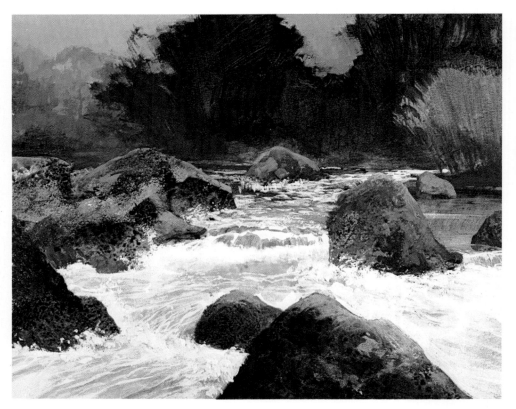

Step 6 (close-up). This section of the final painting shows how different kinds of brushwork combine to create the various textures of rocks and water. The shadow tones of the rocks clearly show the mottled marks of the sponge. Over this transparent color, the brush deposits short, thick strokes of opaque color to accentuate the lights. The cool, transparent undertone of the water shines through the opaque and semi-opaque strokes of the foam. The foam is painted with short, thick dabs where it's most dense, small dots to suggest flecks of foam splashing upward, and slender lines where the foam trickles over the dark water.

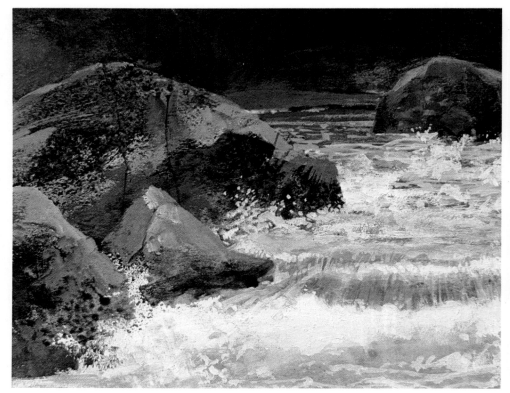

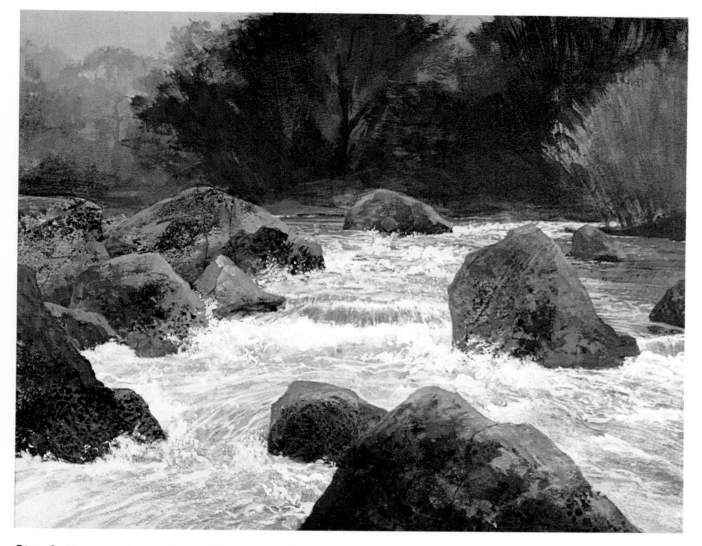

Step 6. The water is completed with many small, semi-opaque lines of white—tinted with sky color—that methodically follow the flow of the stream around and between the rocks. The cool, underlying tone, applied in Step 3, is never completely covered; it's this combination of transparent color beneath and semi-opaque color above that gives the water that special luminosity. .A few more touches of sky tone are scumbled over the tops of the rocks and allowed to dry. Then the point of a small, round softhair brush draws a few cracks on the sides of the rocks. Final adjustments are made to the trees. A bit of opaque sky color is mixed with the original tree tone—making the mixture more opaque— and the darks of the trees are extended to narrow the patch of sky that breaks through the trees just to the right of center. A little sky tone is scrubbed into the middle of the big tree at the center of the picture and allowed to dry; then a trunk and some branches are painted over this lighter tone. This painting follows a couple of "rules" that can be helpful, though they shouldn't be followed rigidly. First, a good way to paint a landscape is to start with transparent color and then finish with opaque color. Second, when you combine transparent and opaque color, try to keep your shadows transparent and save your opaque strokes for the lights.

Step 1. The pencil drawing defines the outer edges of the big, snow-covered tree, the snow-covered rocks, and the frozen stream. Equally important, the pencil lines trace the shapes of the dark rocks that appear within the snow to the left. Then a bristle brush scrubs a thick, opaque mixture of ultramarine blue, burnt sienna, cadmium red, and white over the sky. The sky is dim and overcast, but some light comes through to the left of the big tree. This tone contains less ultramarine blue and more white.

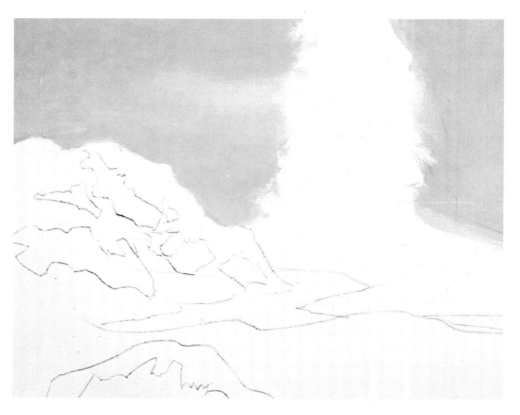

Step 2. The dark patches of rock, so carefully drawn in Step 1, are now painted with a blend of ultramarine blue, burnt sienna, and white. The color isn't too thoroughly mixed on the palette. Nor are the strokes blended together on the painting surface—a sheet of illustration board. So these strokes have a ragged, irregular texture, like that of the rocks. The snow-covered branches on either side of the tree are painted with wavy strokes of white, tinted with a little sky tone.

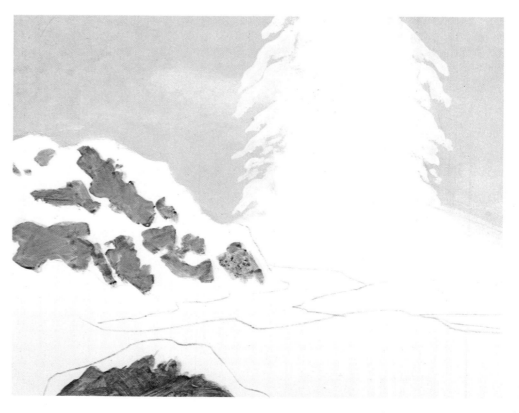

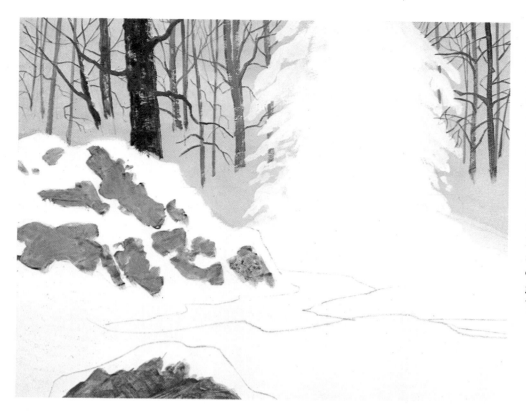

Step 3. The trunks and branches of the distant trees are painted with a mixture of ultramarine blue, cadmium red, yellow ochre, and white. The thicker trunks are painted with a flat softhair brush, while the thinner trunks and branches are painted with a round softhair brush. The paint is thick and creamy, so it doesn't flow too smoothly over the painting surface; the result is an effect something like drybrush, which you can see most clearly in the trunk of the dark tree. As the trunks grow more distant, more white is added to the mixture.

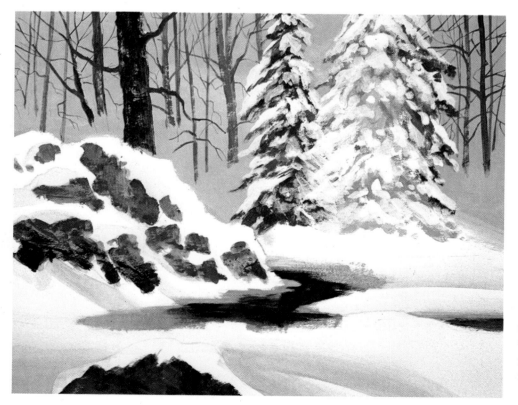

Step 4. The original sky mixture is thinned with more water to paint the shadows on the snowbanks with transparent color. The edges of these shadow strokes are softened with clear water. The rocks are darkened with a thick mixture of ultramarine blue, burnt sienna, yellow ochre, and white. This same mixture, with a little more white, is used to paint the pale edges of the frozen stream, while a darker version is used to paint the deepest tones. A few strokes of sky color divide the big tree shape in two. Strokes of rock tone suggest shadowy branches. Then strokes of white, tinted with sky color, represent the clumps of snow resting on these branches.

Step 5. More strokes of white, tinted with a little sky tone, are added to thicken the snow on the trees. The shadowy band of trees at the horizon is scumbled in with ultramarine blue, cadmium red, yellow ochre, and white, partially obscuring the bases of the treetrunks. Snowbanks are added beneath the horizon and between the trees with more sky mixture and white. The edges of the snowbank to the left are sharpened with pure white toned with the faintest touch of sky color.

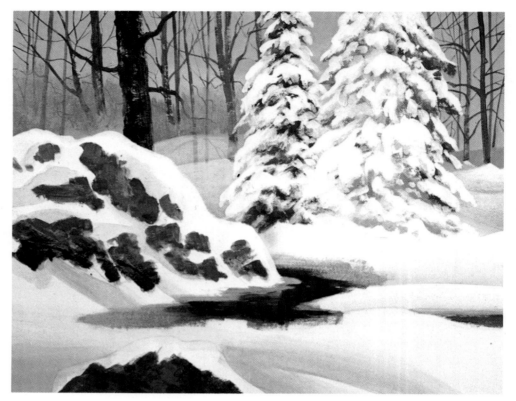

Step 6 (close-up). In the finished painting, the solid patches of snow on the rocks and branches are painted with thick strokes of creamy, opaque color. The darks of the rocks and branches, showing through the snow, are done with thinner, more fluid color. The dark tones of the frozen stream are painted in the same way. Then a bit of the snow color, tinted with sky tone, is scumbled over the dark strokes of the rocks and branches here and there. This same color is thinned with water to paint the reflection of the snowbank in the frozen stream; these semiopaque strokes allow the darkness of the stream to shine through.

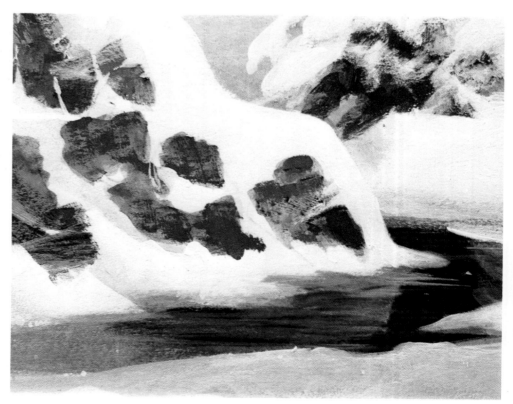

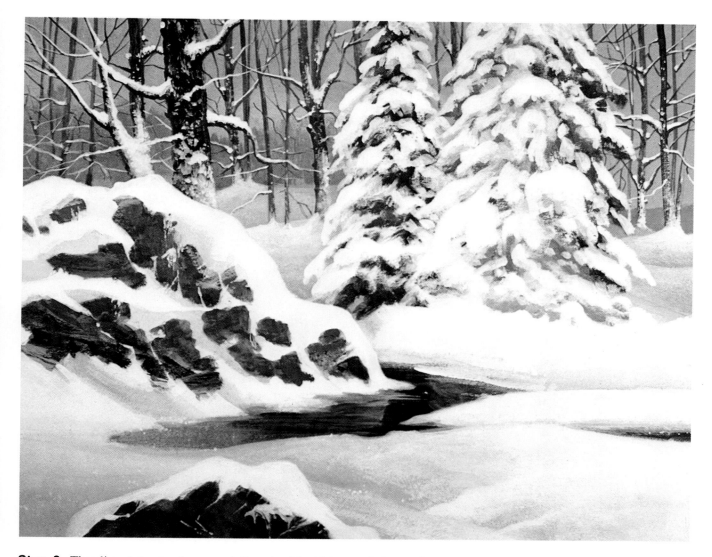

Step 6. The distant treetrunks are reinforced with thick strokes of burnt sienna, ultramarine blue, yellow ochre, and white. When these strokes are dry, snow is dabbed on the trunks and branches with thick white tinted with a little ultramarine blue and applied with the tip of a small bristle brush. The point of a round softhair brush draws snowy lines on the tops of the thinner branches. A large bristle brush scumbles this same bluish-white mixture over the sunlit portions of all the snowbanks in the middle distance and the foreground. The back-and-forth scrubbing stroke blends the pale tops of the snowbanks into the darker shadow planes. Thick strokes of this snowy mixture are car-

ried over the top of the dark rock in the left foreground. A few touches of snow are drybrushed over the dark shapes of the rocks. The tip of a round brush paints a few light lines on the rocks to suggest snow that's settled in the cracks. Pure white is mixed on the palette with lots of water. A big bristle brush—or perhaps a toothbrush—is dipped into this milky fluid. Then a stiff piece of wood, such as a brush handle or an ice cream stick, is drawn over the tips of the bristles to spatter a few snowflakes over the foreground. You can see them clearly in the lower left. Notice how the warm sky tone, which you first saw in Step 1, remains behind the trees, just above the horizon.

Step 1. The preliminary pencil drawing—on a sheet of watercolor paper—traces the outlines of the clouds, the shapes of the blue patches between the clouds, and the contours of the hills at the horizon. Although the contours of the clouds will change slightly, it's important to decide exactly where the clouds go. It's equally important to make sure that the clouds and the patches of sky form an interesting and varied design. The three main clouds are all different shapes and sizes. The strip of sky between the clouds is wide at some points, narrow at others, and keeps the eye interested.

Step 2. The blue shapes of the sky are painted with a mixture of ultramarine blue, phthalocyanine blue, and white at the very top of the picture. Just a little yellow ochre is added to this mixture at the center. The lower sky, right above the horizon, contains more white and yellow ochre. The clouds are just white paper at this point, but their shapes are becoming more ragged. The sky tones are freely scrubbed in with a bristle brush.

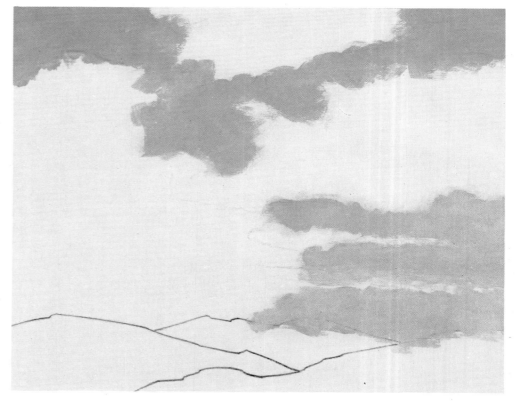

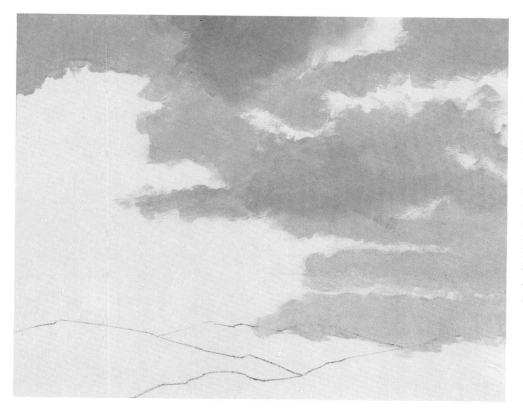

Step 3. The same bristle brush begins to scumble in the cloud shadows. This shadow tone is a mixture of ultramarine blue, cadmium red, yellow ochre, and white. Actually, you can see two distinct shadow tones. The lighter tone obviously contains more white; it's also slightly warmer, containing more cadmium red and yellow ochre. The darker, cooler tone contains more ultramarine blue. The scumbling stroke creates a soft edge where the shadow sides of the clouds seem to melt away into the blue of the sky.

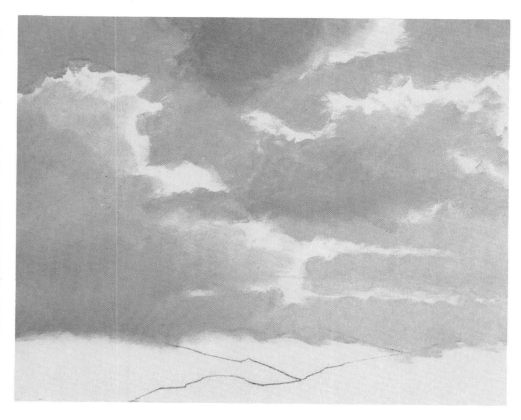

Step 4. The shadow side of the biggest cloud is painted with the same mixtures and the same scumbling strokes. The scrubbing motion of the brush creates a soft edge where the shadow side of the cloud ends and the sunlit side begins. All these sky tones are thick and opaque enough to cover most of the pencil lines.

Step 5. The clouds cast strong shadows on portions of the land below. At other points, the sun breaks through the clouds and illuminates parts of the hills. The shadow on the distant hill is painted with ultramarine blue, yellow ochre, and white—with a little more white on the lighted portion of the hill. The shadow tones on the foreground hills are ultramarine blue, yellow ochre, cadmium yellow, and white. The sunlit hill to the right is painted with phthalocyanine blue, cadmium yellow, yellow ochre, and white. The bristle brush drags thick color over the textured painting surface, leaving some flecks of bare paper for a drybrush effect.

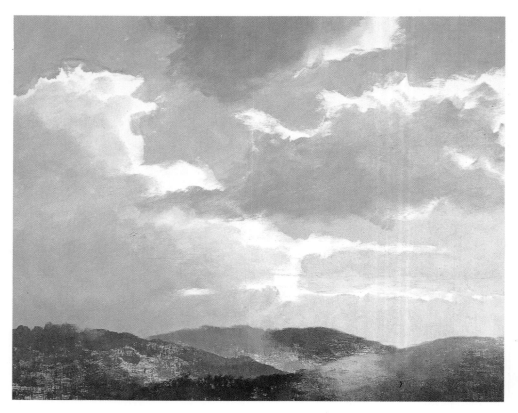

Step 6. Until now, the sunlit edges of the clouds are bare paper. Now these lights are scumbled with lots of white faintly tinted with ultramarine blue, yellow ochre, and naphthol crimson. The shapes of the clouds grow rounder and fuller. The scumbling stroke blends the lights softly into the edges of the shadows. This same stroke softens the lighted edges so they don't look too harsh and mechanical against the blue sky. Just above the horizon, several long, slender, shadowy clouds are painted with the same mixture that's used to paint the shadows in Step 4: ultramarine blue, yellow ochre, cadmium red, and white.

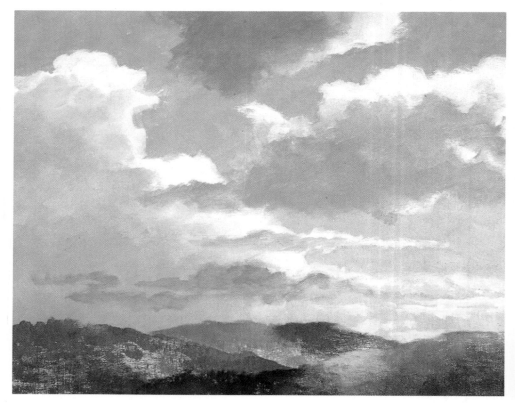

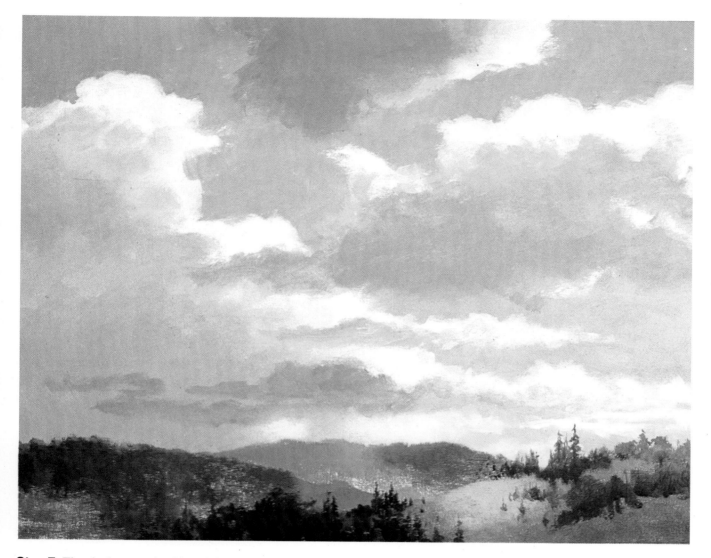

Step 7. The shadowy undersides of the clouds are strengthened and enriched with scumbled strokes of ultramarine blue, cadmium red, yellow ochre, and white. This isn't one consistent shadow tone: at some points you can see where it contains more red and yellow. At other points you can see where the shadow tone contains more blue. The individual strokes stand out more clearly than the strokes in Steps 3 and 4, when the shadow tones were first blocked in. The hill in the left foreground is darkened to strengthen the shadow cast by the clouds. A dark mixture of phthalocyanine blue, cadmium yellow, and burnt sienna is drybrushed over the top of the hill. The shadow on the distant hill is also strengthened with this mixture, which now contains a bit more white. This same mixture—now mostly phthalocyanine blue and burnt sienna—is used to paint the trees on the hilltop with small touches of a round softhair brush. This is a good example of a picture painted almost entirely by scumbling. The soft shapes of the clouds are scumbled. The soft transitions between the light and dark areas of the hills are scumbled too. Just a bit of drybrush appears in the hills to suggest some texture. Only the trees are painted with precise touches of fluid color.

Step 1. This pencil drawing defines the outer edges of the clouds, the shapes of the landscape below, and the line of the water. Then the deep, cool tones of the sky are scumbled with a bristle bright carrying a mixture of ultramarine blue, phthalocyanine blue, a touch of naphthol crimson, and white. More white is added to this mixture as the brush moves downward toward the horizon. The brush scrubs the darker and lighter strokes together to produce a subtle dark-to-light gradation. The big cloud at the center is bare paper. The smaller clouds above the horizon are strokes of white tinted with a little sky mixture. The picture is painted on cold pressed watercolor paper.

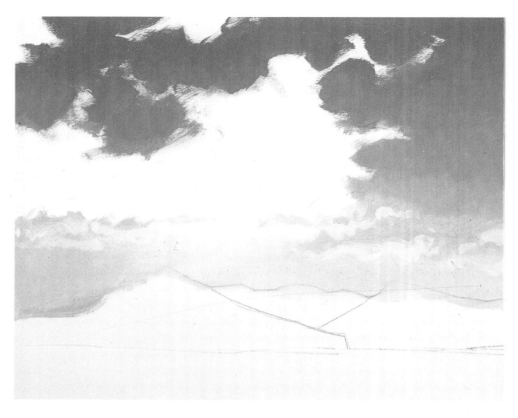

Step 2. When the sky is dry, the dark tones of the clouds are scumbled with a deep mixture of ultramarine blue, cadmium red, and just a hint of white. The back-and-forth scrubbing stroke produces soft edges where the clouds meet the sky. More white and blue are added to this mixture for the paler clouds in the lower sky. Along the bottom of the big, dark cloud, the bristle brush scumbles a mixture of cadmium red, yellow ochre, and white. Looking back at Step 1, you can see that the sky is palest directly under the sunlit edge of the big cloud; this suggests the intense light of the sun behind the cloud.

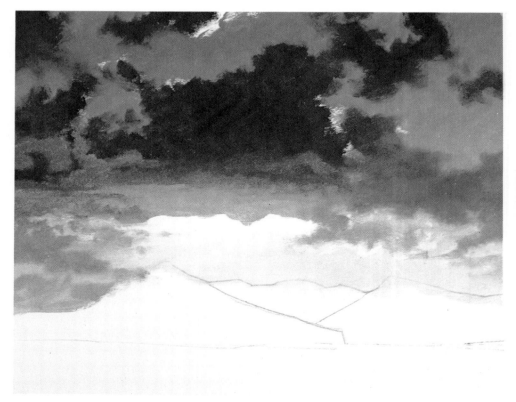

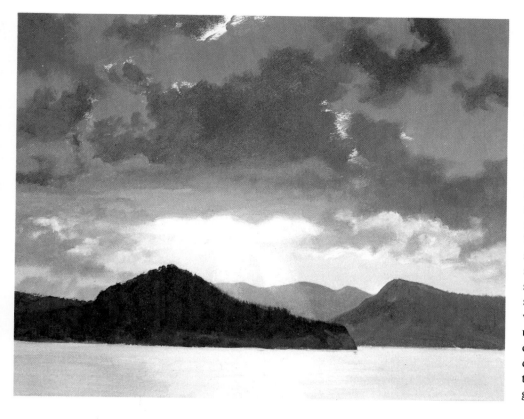

Step 3. A mixture of cadmium red, yellow ochre, ultramarine blue, and white—the consistency of cream—is brushed smoothly over the shapes of the island peaks. The most distant peak contains more white and blue; the nearest peak contains almost no white. This same mixture, containing more white and more water, is drybrushed over the band of water below the horizon, leaving some bare paper at the center to suggest the reflection of the sun. Sunlit edges are added to some of the lower clouds with strokes of thick white tinted with a speck of cadmium red, ultramarine blue, and yellow ochre. This same mixture is drybrushed downward from the center of the sky to suggest rays of light.

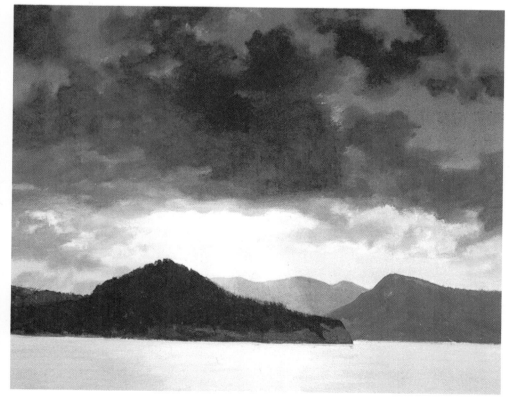

Step 4. A big, flat softhair brush glazes the upper sky with a transparent mixture of ultramarine blue, naphthol crimson, and mars black, thinned with water and gloss painting medium. Now the upper sky is darker and contrasts more dramatically with the sunlit lower sky. The dark clouds are reshaped and enlarged with scumbled strokes of ultramarine blue, cadmium red, and some white. The ruddy band at the bottom of the central cloud becomes narrower. The brilliant light of the lower sky is strengthened with pure white tinted with cadmium yellow. And the water is cooled with the same transparent glaze as the upper sky, but containing much more water here.

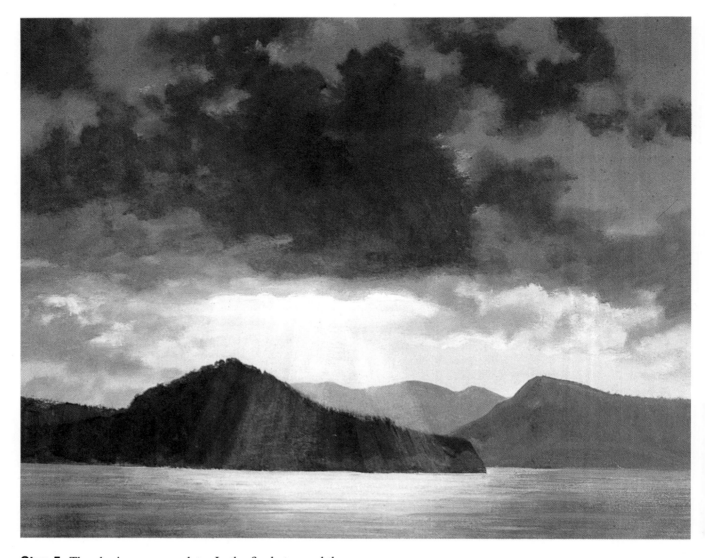

Step 5. The sky is now complete. In the final step, subtle touches are added to the islands and the water to make them harmonize with the sky. At the right and left, the water is darkened with drybrush strokes of cadmium red, yellow ochre, ultramarine blue, and white to suggest the reflections of the dark islands in the water. When these reflected tones are dry, a small softhair brush is used to drybrush thin, horizontal lines across the water. These strokes are the same combination as the dark reflections, but the proportions of the colors change from stroke to stroke. The strokes at the edges contain more blue or red. The strokes at the center contain more yellow and white to suggest the brilliant sunlight shining on the water. This same pale mixture is drybrushed with diagonal strokes over the islands to carry the sun's rays all the way down to the water. This final landscape demonstration shows three different ways to apply color: scumbling in the sky; creamy, fluid color on the islands; and drybrush in the water.

Potential Pictures. One way to tell the difference between an experienced painter and a beginner—without even looking at their work—is to watch how they find a subject to paint. The experienced artist walks for ten or fifteen minutes (maybe less), then quickly sets up his gear and gets to work. The beginner often wanders for an hour or more, looking for "just the right subject," and finally gets to work when the experienced painter is half finished. Why does the "veteran" find his subject so much more quickly? Does he just have a better eye, so he spots the "right subject" more quickly? On the contrary, he knows that he *won't* find perfect pictures, so he doesn't waste his time looking for them. He seizes on a subject that seems to have *potential*. The elements of the picture may be out there, but they're usually scattered, the wrong size, the wrong shape, or just too far away. They become a picture because the artist sees how they might be reassembled into a satisfying pictorial design. The experienced artist spends his time *creating* the painting, while the beginner wastes his time looking for it.

Looking for Potential. There are many ways to spot a potential picture. The most obvious way is to look for some big shape that appeals to you, such as a clump of trees, the reflections in a lake, a rock formation, or a mountain peak. You organize the other parts of the landscape around this center of interest, deciding how much foreground, background, and sky to include, then bring in various "supporting actors" such as smaller trees, rocks, and more distant mountains. Still another approach is to look for some interesting color contrast, such as dark blue-green evergreens against the brown trees of an autumn landscape, or the hot colors of desert rock formations against a brilliant blue sky. You might also be intrigued by a contrast of light and shadow, like a flash of sunlight illuminating the edges of treetrunks in dark woods.

Orchestrating the Picture. Having decided on a focal point, you still have to decide how to organize the various elements that make a picture. You can't just stick that clump of trees or that rock formation in the middle of the painting, include a little sky and a little background, and then go to work. Just as a famous star needs a supporting cast, the focal point of your picture needs some secondary elements. If the dominant shape in your picture is a big tree, place it a bit off center and balance it against some smaller trees—which will make the big tree look that much bigger. A mountain peak will look more imposing with a meadow and some low hills in the foreground, plus some paler, more distant peaks beyond. If those

smaller trees, that meadow and hills, or those distant peaks aren't exactly where you want them, you can move them to the right spot in the picture. If they're too big or too small, don't hesitate to change their scale.

Keep It Simple. Just as you decide what to put *into* the picture, you must also decide what to leave *out*. You may actually see dozens of trees, but a big one (or a big clump) and a few smaller ones are enough to make a picture. Don't try to paint every pebble scattered at the foot of that rock formation; just a few pebbles are enough to make the big rocks look bigger by contrast. A sky is often filled with clouds, all roughly the same size and shape. They look beautiful in nature, but they make a dull picture, so enlarge one, reduce two or three others, and leave out the rest.

Make a Viewfinder. Many painters use a simple device that helps them isolate pictures within the landscape. To make a viewfinder, as it's called, take a piece of white or gray cardboard about the size of the page you're now reading. In the center of the cardboard, cut a "window" that's about 5″ x 7″ (125 mm x 175 mm). Hold this viewfinder at a convenient distance from your eye—not too close—and you'll see lots of pictorial possibilities that you might not spot with the naked eye. You can also make a viewfinder by making a rectangular window with the fingers of both hands, like a motion picture director might do.

Try Again. An unpromising subject often turns into a winner with a slight change in the light, the weather, or your vantage point. If you want to capture the blue of a lake at its most brilliant, the color will be strongest at midday, when the sun is brightest. But later in the afternoon, as the sun drops low in the sky, the shoreline of the lake may have a dark, mysterious silhouette, and dark ripples will appear on the surface of the water—giving you a second picture of the same subject. It's also a good idea to walk around the subject and look at it from different angles. From one vantage point, those distant hills may be framed by trees, while the hills may have a more interesting shape from another angle. One view may interest you more than the other—or you may want to paint both. Some subjects look more paintable when you move closer, such as the gnarled texture of an old tree stump, which you can't see so easily from a distance. At other times, it's best to step back: that cluster of wildflowers may merge into an interesting, irregular shape if you paint them from farther away. Keep watching. Keep moving. There are more pictures out there than you think.

 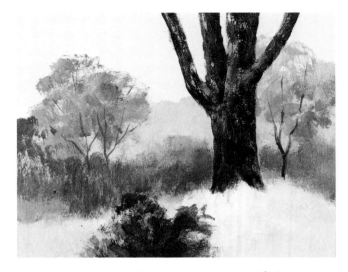

Don't split your composition into two vertical halves by running something like a tree down the center. Nor is it a good idea to split the composition into two horizontal halves by running the horizon across the midpoint as you see here. A completely symmetrical composition is boring.

Do place that tree off center and move the horizon up (or down) to divide the composition into unequal parts. Asymmetry is usually more interesting than symmetry.

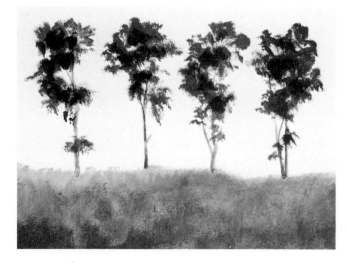 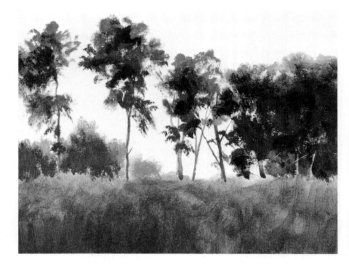

Don't space things out equally and make them all the same size, like a row of wooden soldiers. In this monotonous composition, not only are the trees all the same size and shape, but so are the spaces between them.

Do space things out unevenly, making them different sizes and shapes. Now some of the trees are clustered together. Some are smaller and others are larger. The trees are different sizes and shapes, and so are the spaces between them. The composition is a lot more interesting.

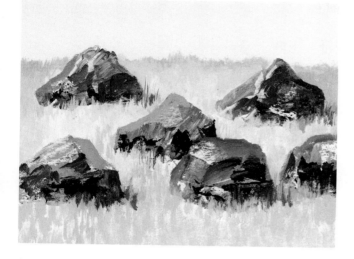

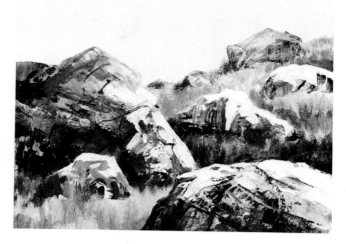

Don't scatter things all over the landscape so the eye keeps jumping around. Furthermore, these rocks are dull because they're all roughly the same size and shape.

Do group your most important pictorial elements so the eye knows where to go—in this case, the eye goes to the lighted face of the rock at the center. This composition is also more interesting because the sizes of the rocks have been altered: some are bigger and some are smaller. The spaces between the rocks are more varied too.

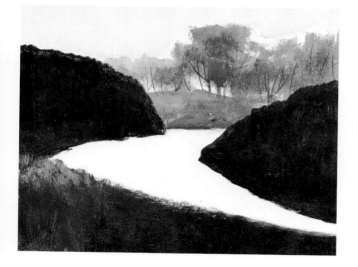

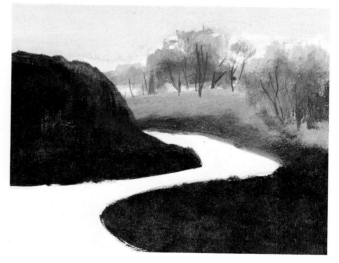

Don't lead the eye out of the picture. Notice how the eye starts out at the center of the curving stream and is then pulled out of the composition toward the lower right corner.

Do lead the eye into the picture. Now the eye enters the picture at the lower left, winds around to the right, then swings back toward the center. This "rule" applies not only to a stream, but to a path, a wall, or a row of trees.

Mountains in Side Light. Observe the direction of the light whenever you start to paint any landscape subject. The light can completely transform the shapes of the landscape. The sunlight is coming from the right side of this mountain, throwing the right slopes into bright sunlight and plunging the left slopes into deep shadow. This kind of lighting emphasizes the three-dimensional quality of the forms.

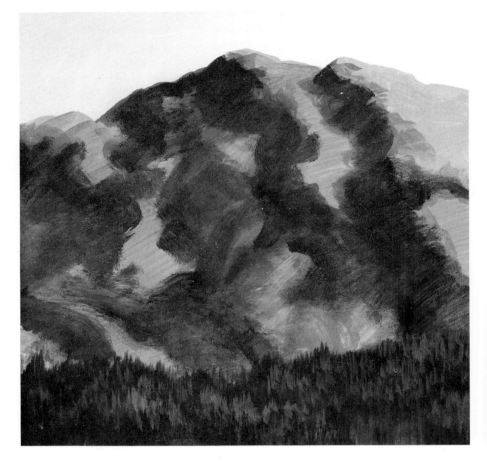

Mountains in Back Light. Early in the morning or late in the day, the sun starts to sink behind the horizon. At that time, the same mountain becomes a dark silhouette against the glowing sky. Now you can no longer see distinct planes of light and shadow, but one dark shape. Many landscape painters love to work in the early hours of the morning or just before sunset because they like to capture these strong silhouettes.

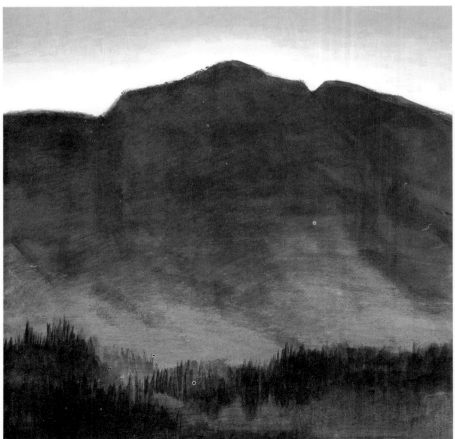

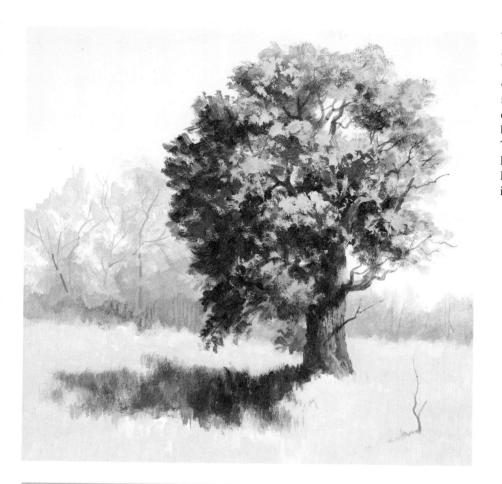

Tree in 3/4 Light. The light falls on this tree from the upper right. Thus, each cluster of leaves has its own distinct pattern of light and shadow. The top and right side of each cluster is in the light, while the bottom and left side is in shadow. The trunk follows the same pattern: light on the right and shadow on the left. On the ground, the tree casts its shadow to the left.

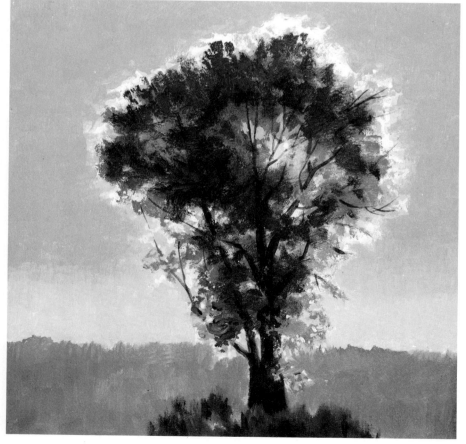

Tree in Rim Light. When the sun is directly behind a shape—such as this tree—the front is in deep shadow and the edges often glow like a halo. This effect is called rim lighting. It's one of the most dramatic effects in landscape painting.

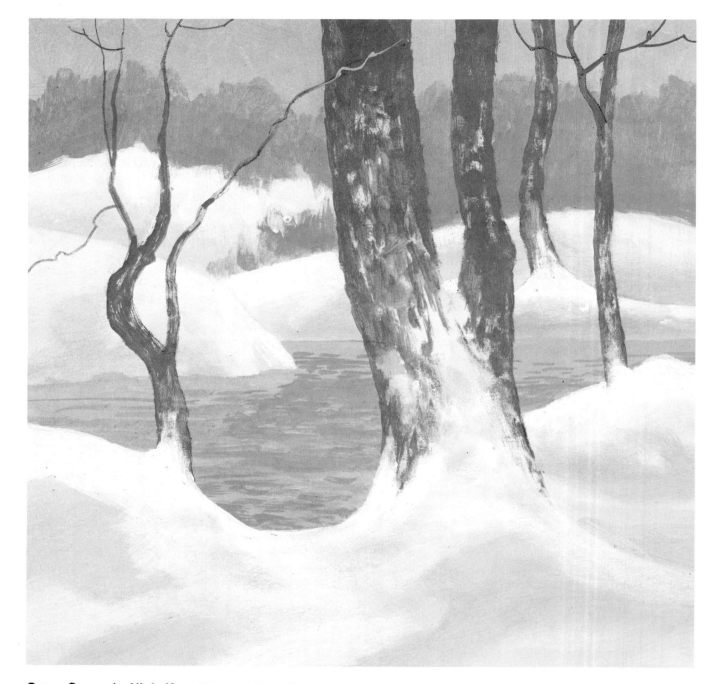

Snow Scene in High Key. The term *key* refers to the overall lightness or darkness of the subject. A high-key painting is generally light—even the darks are fairly pale. A misty or hazy landscape is often a high-key subject. In this high-key snow scene—painted on a misty, overcast day— the shadows on the snow are only a little darker than the sunlit patches of snow. The dark trunks *are* darker than the shadows, but they're still quite pale. Before you start to paint *any* landscape subject, try to determine whether it's high key, low key, or somewhere between.

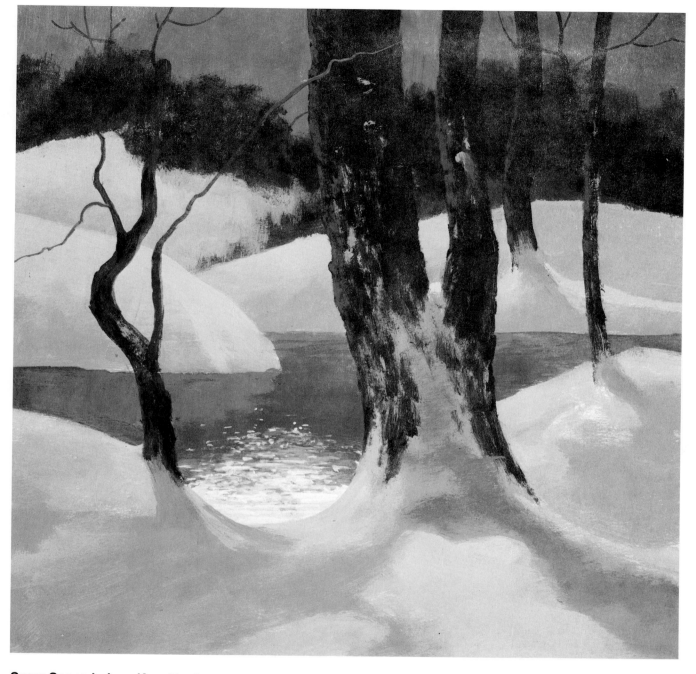

Snow Scene in Low Key. Here's exactly the same snow scene painted in a much lower key, which means that the landscape is generally dark. Low-key landscapes are common in the early morning, before the sun rises above the horizon; in the late afternoon, when the sun has dropped below the horizon, but before night sets in; and at night, of course. In this moonlit landscape, even the lighted patches on the snow are quite dark—darker, in fact, than the shadows on the snow in the high-key picture. The shadows on the snow are as dark as the treetrunks on the facing page. Here, the trees are almost black against the murky sky. The only bright light is the reflection of the moonlight in the water. Remember two guidelines. In a high-key landscape, even the darks are pale. Conversely, in a low-key landscape, even the lights are fairly dark.

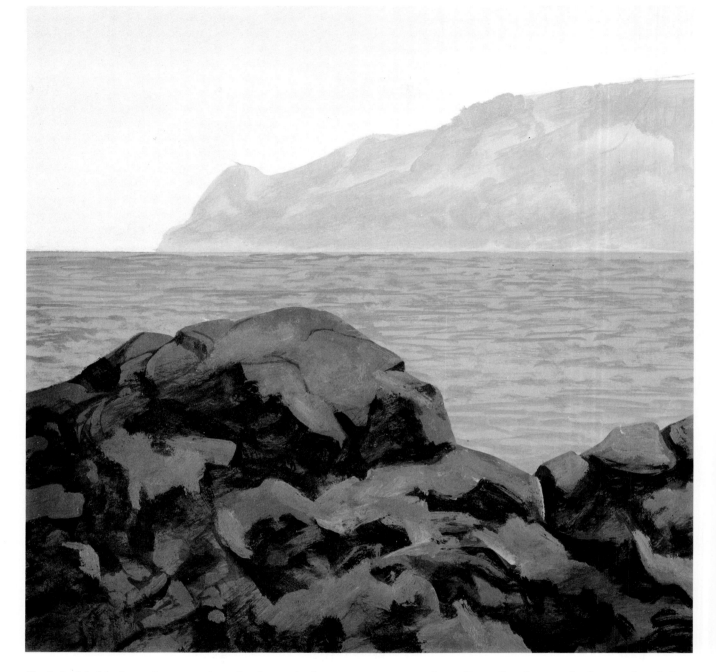

Dark to Light. A good way to plan a landscape is the so-called three-value system. Before you begin to paint, you identify the values—the relative lightness or darkness—of different parts of the picture. It helps to divide the picture into darks, middletones, and lights, which generally correspond to the foreground, middleground, and distance. In this case, the darkest tones are in the foreground rocks; the ‚middletones are in the sea just beyond; and the light tones are on the distant shore. The sky often forms a fourth tone, as you see here. Naturally, there are further·tonal variations within each of these areas, such as the lights and shadows on the rocks or the light and dark waves in the water. Note that the lighted areas on the rocks are *darker* than the shadows on the distant shore. This lesson is worth remembering when you mix your colors. A famous painter used to teach his students the rule: "The shadows in the light are paler than the lights in the shadows!"

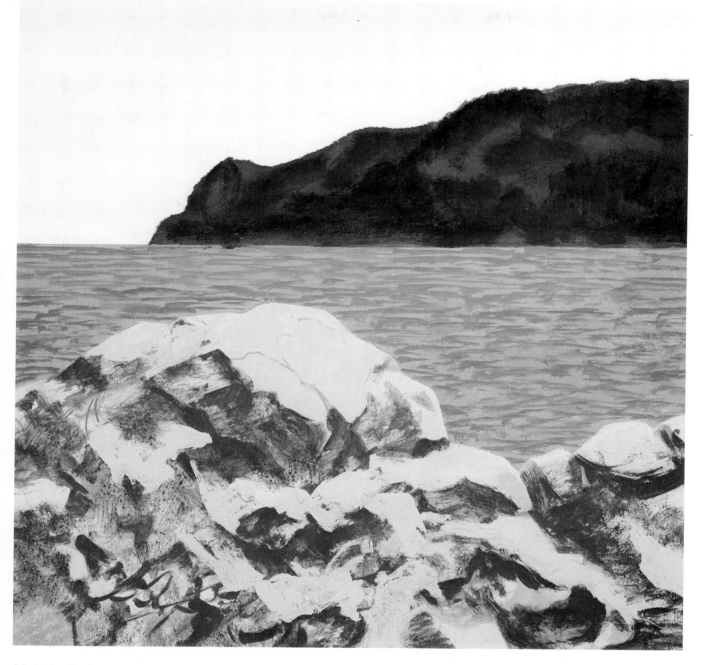

Light to Dark. When the light conditions change on this coastal landscape, so does the progression of values. Now the subject moves from light to dark. The foreground rocks represent the lightest area; the sea is the middletone once again; and the distant shore is the darkest shape. The sky is a fourth value, as pale as the tops of the rocks. The shadows of the rocks grow paler, while the lights on the distant shore grow darker. Before they start to paint a landscape, many professionals make a small three-value sketch with three pieces of chalk: one very pale gray, one darker gray, and one black. This value sketch becomes their guide when they mix their colors. Try it.

DRAWING ROCKS

Step 1. Many of your landscape paintings will certainly be done indoors, based on sketches you've made on location. Here are some guidelines for drawing rocks. Start out with a few pencil lines that visualize the forms of the rocks in the simplest possible terms. These rocks begin with straight lines that reduce the rocks to geometric shapes.

Step 2. Now the pencil goes back inside those geometric forms and traces the actual contours of the rocks. When the *outer* edges of the rocks are accurately drawn, then the pencil draws the *inner* lines that divide the planes of light and shadow. Each rock is carefully divided into light and shadow zones.

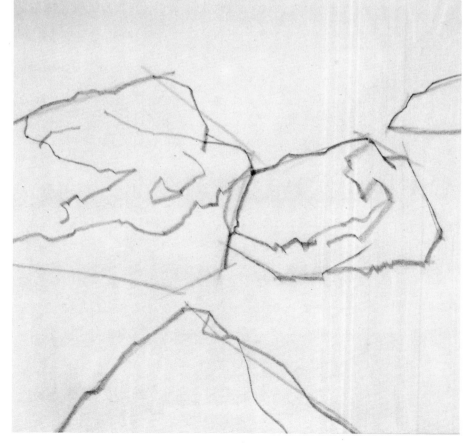

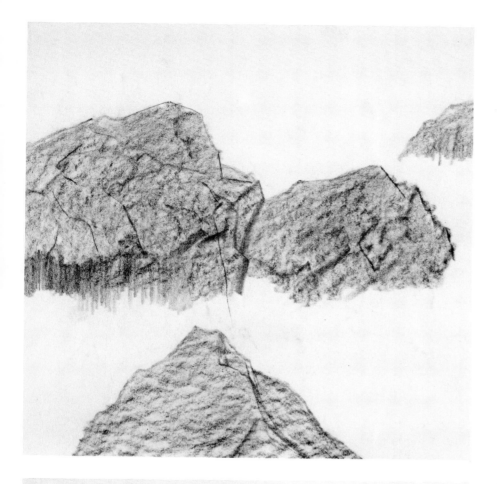

Step 3. The side of the pencil scrubs in the overall tone of the rocks with broad strokes, almost like a brush. The pencil presses harder to begin the dark underside of the big rock to the left. An interesting trick is tried here. The drawing paper is laid over some heavily textured surface—a piece of weathered wood or a book bound in rough cloth—so the pencil strokes become rougher and more irregular. The point of the pencil begins to draw some cracks in the rocks.

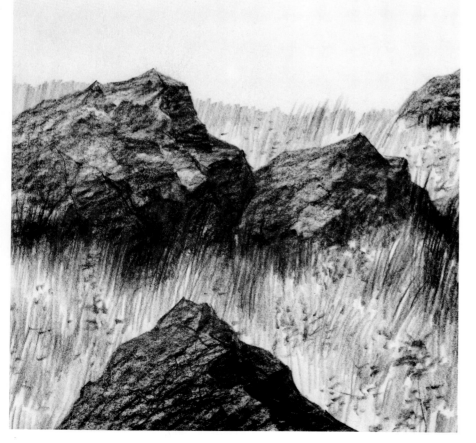

Step 4. Pressing harder still, the side of the pencil darkens the shadow planes of the rocks. The lighter tones of Step 3 are left to represent the sunlit tops. The surrounding meadow is completed with rapid up-and-down strokes of the pencil point to suggest grass and weeds. These strokes are carried upward into the dark shadows of the rocks, which seem to merge softly into the grass. Quick touches of the pencil point suggest wildflowers.

Step 1. Working indoors, you'll certainly want to have sketches of various cloud effects. When you're drawing clouds, you've got to work quickly before the wind changes these fast-moving shapes. This cloud study begins with free, rapid lines that define the shapes of the clouds and the patches of darker sky between them.

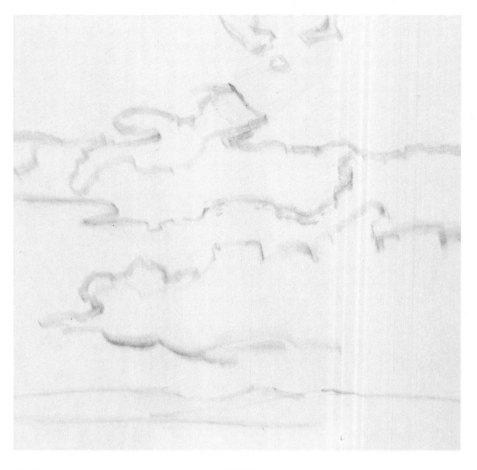

Step 2. The side of the pencil is used like a brush to block in broad tones of sky between the clouds. Get to know the different pencils in your art supply store. They're usually marked H for hard and B for soft. The hard pencils make lines that are gray and slender. Soft pencils make lines that are darker and broader. Artists generally prefer the soft ones. They're numbered to indicate the degree of softness, which means blackness. A 4B, which is used for this sky study, is softer and blacker than a 2B.

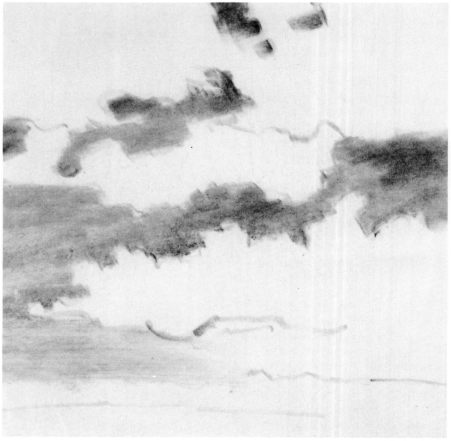

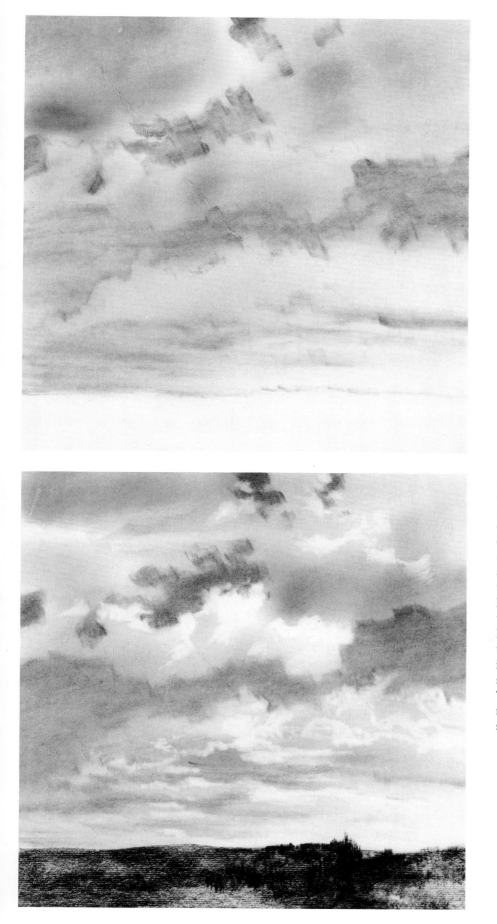

Step 3. The marks of a soft pencil are easy to smudge with the fingertip. Here, a finger smudges, blends, and lightens the sky tone. Now the fingertip is covered with the black graphite of the pencil and is used to darken the undersides of the clouds. You can use a fingertip just like a brush!

Step 4. The side of the pencil darkens the patches of sky and adds more darks to the undersides of the clouds. A kneaded rubber eraser (called putty rubber in Britain) is squeezed to a sharp point, like clay, and used to clean away some of these gray tones to create luminous lights among the clouds. The tip of the eraser actually "draws" white lines among the dark smudges of the lower sky. The landscape below is completed with dark pencil strokes untouched by the fingertip. These crisp, dark strokes contrast nicely with the soft, smudged strokes of the sky.

Step 1. When you start to draw a tree, the most important thing is to focus your attention on the overall shape of the tree, not on the individual clusters of leaves or the individual branches. Try to fit the shape of the tree into some simple geometric figure. This tree begins with six straight lines to form a six-sided geometric shape. Then the trunk of the tree is carried from the ground upward into the center of the geometric figure. The drawing is done with a 2B pencil on smooth, white drawing paper.

Step 2. A few branches are added to the treetrunk with the tip of the pencil. Then a diagonal line is drawn across the midpoint of the geometric shape to indicate that the top half is just one big leafy mass. Some curving lines are drawn below to define the more irregular clusters of leaves that will appear in the lower half of the tree.

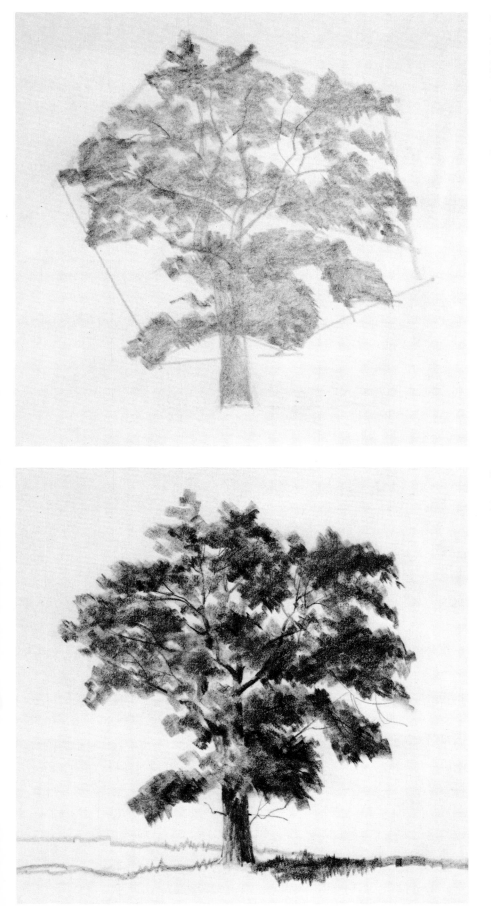

Step 3. The side of the pencil begins to scribble in the masses of leaves with an even, gray tone. The pencil is simply moved back-and-forth with a scribbling motion, gradually filling the shapes with tone. The upper half of the tree is almost completely covered with leaves, leaving just one gap of sky. This tone fills the curving lower lines that appeared in Step 2. Now the entire tree is covered with a middletone.

Step 4. The tree is completed by scribbling in the shadows, pressing harder on the pencil to make darker strokes. The dark strokes are short and decisive. The side of the lead also darkens the shadow sides of the trunk and branches. The point of the pencil strengthens the lines of the smaller branches and twigs. Scribbly, horizontal lines suggest the landscape beneath the tree. And some dark, up-and-down scribbles indicate a shadow to the right of the tree. Remember the drawing sequence: overall shape; secondary shapes within the overall shape; middletones; darks and details.

Foreground, Middleground, Distance. To give your landscapes a convincing feeling of deep space, observe the "rules" of aerial perspective. According to these "rules," the nearest objects look darkest, contain the strongest light and dark contrasts, and reveal the most precise detail. You can see this in the tree that occupies the immediate foreground. Objects in the middle distance are not quite as dark, show less contrast between light and shadow, and reveal less detail—like the smaller tree just beyond the big tree. Distant objects are paler, show the least contrast between light and shadow, and reveal very little detail—like the pale, highly simplified shape of the tree at the horizon. To see how aerial perspective works in a variety of subjects, look back at the landscape demonstrations in the color section. It should be easy to identify foreground, middleground, and distance, and see how they conform to the "laws" of aerial perspective. As objects recede into the distance, they not only grow paler, but cooler—which means bluer or grayer.

PART THREE

SEASCAPES
IN ACRYLIC

Seascapes in Acrylic. When most people hear the word "seascape," they visualize the classic drama of waves breaking against rocks. But this is only one kind of coastal scenery. *Seascapes in Acrylic* shows you how to paint much more than waves and rocks. You'll learn how to paint the rhythmic forms of sand dunes; the looming shapes of cliffs and headlands jutting out into the sea; rock-strewn beaches; and the atmospheric magic of sunlight, fog, and storm. You'll soon see that seascapes are as diversified as the landscapes you'll find inland. And acrylic is an ideal medium for painting these coastal subjects.

Why Acrylic? The best seascapes are painted outdoors—or from color sketches done outdoors. It's exhilarating to crouch in the shadow of a cliff and paint a picture as the salty wind hums around you. It's even more exciting to climb out on the rocks and paint as the water splashes at your feet and the surf flies by. But this sort of painting often means working under pressure, racing to finish before the weather or light changes—or before the tide comes up. Painting in acrylic requires very little equipment. And acrylic paint dries as quickly as watercolor. So it's perfect for painting at high speed, under pressure. If your style is broad and free, you can finish a painting in the first two or three hours of the morning and get back in time for lunch. If you favor precise detail—which takes more painting time—you can block in the major forms of the painting on location in a couple of hours, take the dried painting home under your arm, and complete it from sketches. Or you can make an armload of color sketches in a day and take home enough painting material to keep you busy in the studio for weeks.

Basic Techniques. If you're ready to paint seascapes in acrylic, chances are that you know the basic techniques already. But it's still a good idea to review these basic techniques and see how they apply to coastal subjects. In the pages that follow, you'll see how the opaque and transparent techniques, the wet-in-wet method, scumbling, and drybrush can be used to interpret some typical seascape motifs. First you'll see how to paint surf in the opaque technique. Then you'll learn how to paint waves in a combination of transparent and opaque techniques. You'll watch clouds painted in the wet technique—which means applying color to wet paper—and then more clouds painted with the scrubby brushwork of the scumbling technique. Drybrush is always an effective way to produce texture on rocks. Of course, no one insists that these subjects always be painted in these specific techniques. Surf is often painted in the transparent technique on wet paper. Rocks and impasto go well together. The various combinations are really up to you.

Color Sketches. The colors of the coastline can alter dramatically with changes in light and weather. A series of color sketches will compare waves, surf, skies, and tidepools on sunny and overcast days. You'll also find color close-ups of rocks, dunes, and headlands. Particularly revealing are "lifesize" close-ups of segments of paintings, showing how the paint is applied to interpret the detail of a breaking wave, the dynamic form of surf exploding against the side of a rock, the subtle lights and shadows on a dune, and the intricate planes and textures of a rock formation.

Painting Demonstrations. Following this review of the basic acrylic painting techniques, Rudy de Reyna demonstrates, step-by-step, how to paint ten of the most popular, seascape subjects for which he's famous. You'll watch each specific painting operation as de Reyna paints breaking waves, with their complex pattern of ripples and foam, and the conflict of surf and rocks, an interesting combination of brush and knife painting. Next, de Reyna goes on to paint storm clouds over a massive headland; the haunting light of the moon on a deserted beach; the mystery of fog, half concealing a rocky coastline. Then the artist focuses on the forms of the coastal landscape: a rocky beach with strong contrasts of light and shadow; the delicate colors and rhythmic curves of dunes with their special vegetation; a salt marsh, where the sea invades the land; a rocky headland; and finally, the tidepools left on the beach by the receding water.

Special Problems. Following the demonstrations, you'll find a number of guidelines for selecting seascape subjects, plus some useful dos and don'ts for composing successful seascapes. You'll see how the direction of the light can alter the look of your picture. You'll learn how to recognize and paint the effects of aerial perspective. You'll observe how to use the brush more expressively—by studying close-ups of the brushwork in various acrylic seascapes. And finally, to develop your powers of observation, there are studies of different wave, rock, and cloud forms that you're likely to encounter when you paint the coast.

Step 1. Here's a good coastal subject for trying out the opaque technique: surf exploding against the sky as a wave crashes into a massive rock formation. Solid, creamy color, diluted with just enough water or medium to make the paint flow smoothly, will capture the weight and solidity of the rocks. The foam will obviously contain lots of titanium white, which is one of the most opaque colors on your palette. The pencil drawing (on a sheet of illustration board) clearly defines the shapes of the rocks, but defines the surf with just a few casual lines that will soon be covered with strokes of opaque color.

Step 2. The sky and sea are quickly covered with opaque tones containing lots of white. It's important to lighten your tube colors with white, not with water. The foam will be painted with even lighter strokes that easily cover these underlying tones. At this stage, the surf and rocks remain bare illustration board.

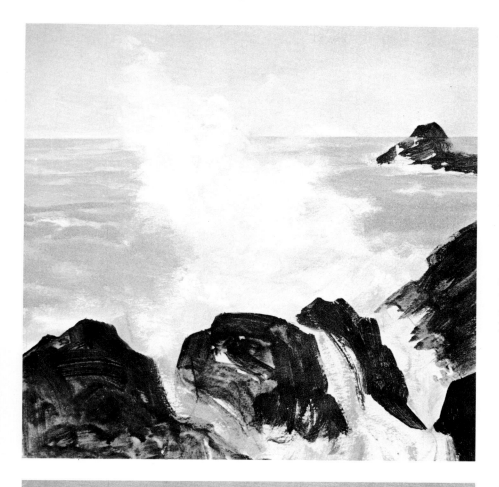

Step 3. A very pale tone, mostly white, is brushed over the foam area, covering the pencil lines and going slightly beyond the lines to cover some of the darker sea and sky. Smaller strokes of this mixture are carried over the sea to suggest the foamy tops of waves moving into shore. And some darker mixtures are brushed between these lighter strokes to suggest the shadowy faces of the distant waves. Darker tones are brushed loosely over the rocks with a brush that leaves the imprint of its bristles, suggesting the rocky texture. This dark tone contains more water than the other mixtures, so it's only semi-opaque, revealing some of the light tone of the illustration board.

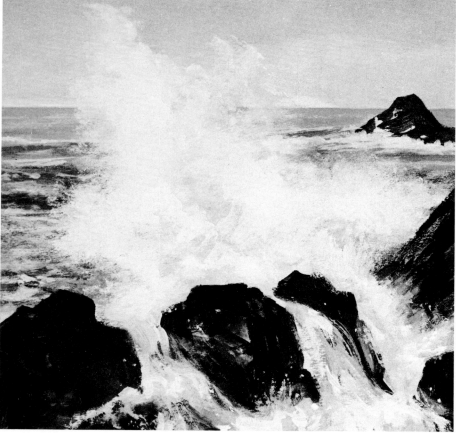

Step 4. The sky, sea, and rocks are darkened with more strokes of opaque color. Now the thick color on the rocks makes them look heavy and solid. The brush comes back to the surf with thicker color than before, extending the shape of the exploding foam farther over the sea and sky—easily covered by the dense white. Strokes of this mixture are carried across the distant waves to suggest more foam, then pulled downward over and between the rocks to suggest foam splashing and spilling into the foreground. The light tones easily cover the dark ones—which is the whole point of the opaque technique.

Step 1. There are many times when a subject calls for a combination of transparent and opaque color. The luminosity of water, for example, is easy to capture with transparent color that's diluted with water—and lightened with water rather than with opaque white. The white painting surface shines right through the transparent color and gives you a sense of inner light. On the other hand, crashing surf tends to look dense and opaque, which is a good reason for painting foam in thick color that's lightened with white, not with water. The pencil drawing traces the top edges of the waves and defines the shapes of the foam.

Step 2. The shallow water in the foreground is painted with horizontal strokes of tube color diluted with a great deal of water; thus the color barely conceals the white surface of the illustration board. The tone of the water is darkened—more tube color and less water—and the brush carefully paints the shadowy tones of the face of the wave plus the dark top. The tip of the brush moves around the shape of the foam, leaving the painting surface bare. Then the distant sea and sky are stroked with clear water. While this area is still damp, the brush suggests the distant waves with horizontal strokes of transparent color that blur slightly on the moist surface.

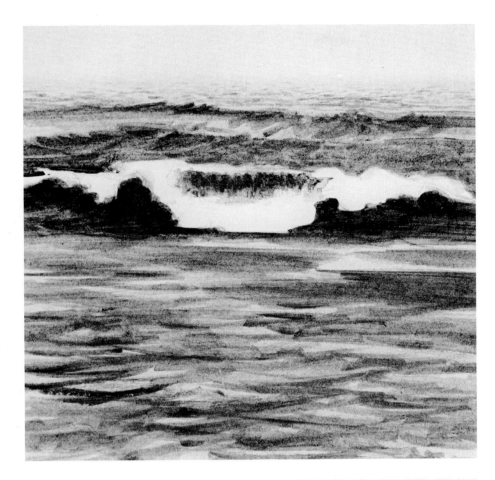

Step 3. Still working with transparent color, the tip of a round soft-hair brush adds slightly curving, horizontal strokes of dark, transparent color to the foreground. These strokes suggest the details and the movement of the shallow waves moving up the beach. More strokes of transparent color darken the face and the top of the big wave. And short, choppy strokes darken the faces of the distant waves to suggest the turbulent action of the water. So far, everything has been done with strokes of transparent color—just tube color and water.

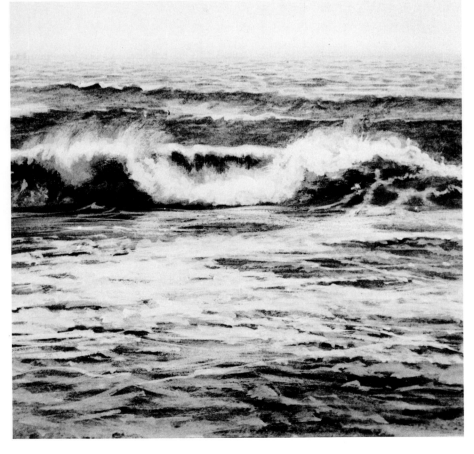

Step 4. In this final stage, the lighter tones of the foam are painted with strokes of opaque color carried right over the transparent darks. The tube color contains plenty of white and only enough water or medium to make the paint creamy. The tip of the round brush traces horizontal lines of foam across the foreground plus wandering lines of foam over the dark face of the big wave. The crashing surf is painted with thick, opaque white and so are the foamy tops of the distant waves. The shadows beneath the foam—which you can see most clearly at the left—are also opaque color, containing less white. Just as in nature, you have transparent water and opaque foam.

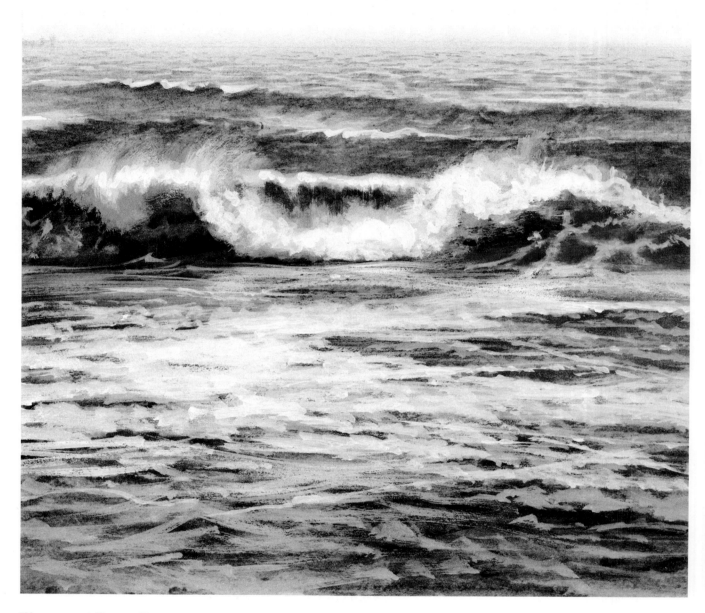

Waves and Foam. Here's a close-up of the final step of the preceding demonstration, showing the brushstrokes in their actual size. Over the dark, transparent tones of the shallow water in the foreground, the tip of a round softhair brush draws in the patterns of the foam. These strokes of opaque color express the movement of the water. The strokes are short and choppy—like dots and dashes—with spaces between them to allow the darker tone of the water to shine through. The crashing surf is painted with short, thick strokes at the center, where the surf strikes the water. But where the surf flies upward—particularly at the left—the brush pulls the foam upward with curving strokes. The more distant waves are painted with short strokes of dark, transparent color, suggesting the ripples in the water.

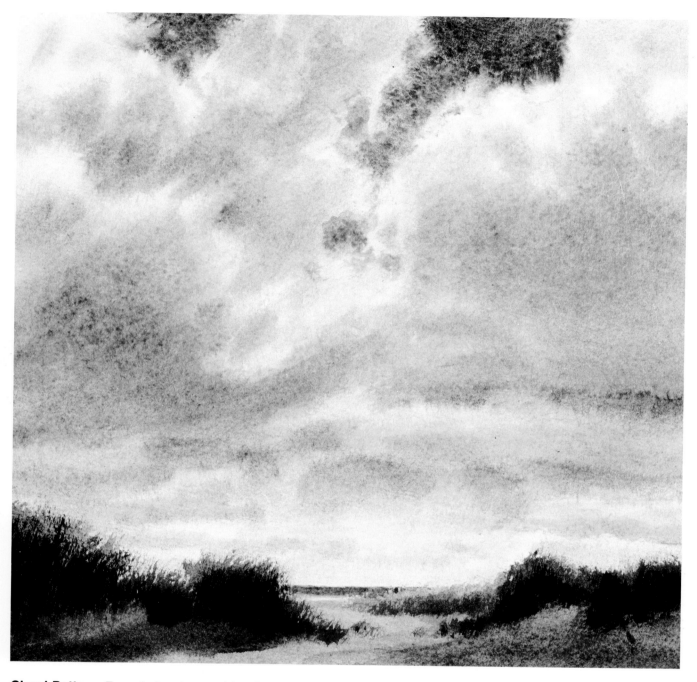

Cloud Pattern. For painting shapes with soft edges, such as these clouds, the wet-in-wet technique is ideal. It's also called the wet-paper technique because you literally paint on wet paper. The paper is first coated with clear water, using either a sponge or a flat brush, and then the color is applied to the painting surface before the water dries. As it strikes the wet paper, the color blurs slightly, so the shapes all have soft edges. Most often, transparent color is used for the wet-in-wet technique. The color is diluted only with water; the more water you add, the lighter the color. You get patches of white by leaving bare paper or by removing color from the paper while the paint is still wet. While the painting surface is still shiny, you can wipe away color with a damp sponge or with a brush from which you've shaken most of the water so that the bristles are just moist. That's how the sunlit edges of these clouds are done. It's also worthwhile to try painting on wet paper with *opaque* color, which won't blur quite as much because it's thicker. The color will also lose some of its opacity as it's diluted by the water on the painting surface; but this will give your color a lovely, smoky quality that's equally good for painting clouds, foam, or fog. When you work on wet paper, be sure to make your color a little too dark, since it will lighten as it spreads.

Step 1. This demonstration is painted on a sheet of cold pressed watercolor paper (called a "not" surface in Britain), which has an irregular texture that will hold the wet color in its peaks and valleys. After the clouds are drawn in pencil, the entire surface of the paper is brushed with clear water.

Step 2. As soon as the sheet is covered with clear water—and before the paper loses its shine—the shadow tones of the clouds are brushed in. When the strokes hit the paper, the color starts to spread and blur. The individual strokes disappear, leaving broad, soft tonal areas. Gaps of bare paper are left for the sunlit areas of the clouds.

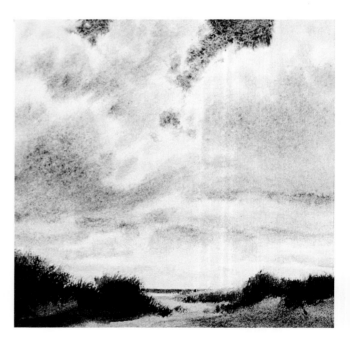

Step 3. Working quickly, while the painting surface is still wet and shiny, the brush adds the darker patches of sky that show through the clouds. The tip of the brush also adds the dark lines of the cloud layers just above the horizon. The paper is a bit drier than it was in Step 2, so these new strokes don't blur quite as much.

Step 4. Before the painting surface loses its shine completely, more dark strokes are added to the undersides of the clouds. Sunlit edges are lightened by blotting away color with a damp sponge, a damp softhair brush, or a paper towel. The landscape is completed in the drybrush technique demonstrated later.

Step 1. Another way to create the soft edges of clouds (or foam) is the scumbling technique. Working with thick color, the brush moves back-and-forth with a scrubbing motion that blurs the strokes. This method works best with opaque color, so you can scumble light over dark or dark over light. The pencil drawing, on a sheet of illustration board, defines the cloud shapes.

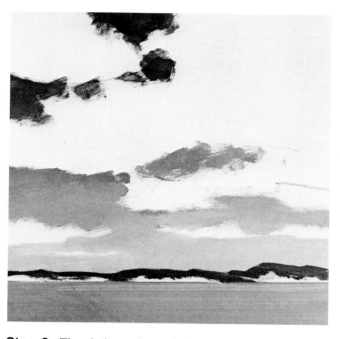

Step 2. The dark patches of sky showing between the clouds are painted first with thick, opaque color, darker at the top and lighter at the horizon. Notice that the scrubby, ragged strokes already suggest the soft edges of the clouds. The coast and water beneath are painted with smoother strokes of fluid color.

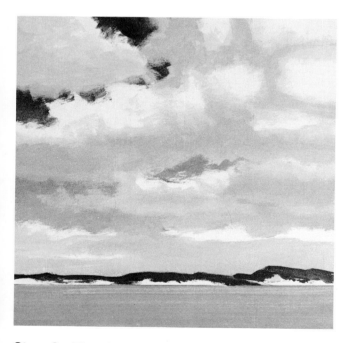

Step 3. The shadowy undersides of the clouds are scumbled with thick, opaque color, leaving bare painting surface for the sunlit areas. Once again, the scrubby strokes have ragged edges, so the shadows seem to melt into the lights.

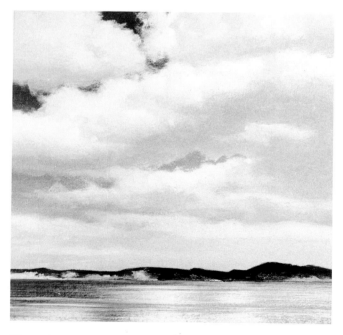

Step 4. The sky is completed by scumbling the sunlit planes of the clouds with soft, scrubby strokes that seem to blend into the shadows. Some of these strokes also overlap the dark patches of sky, which grow smaller as the clouds grow larger. The coastline and water are completed with the drybrush technique demonstrated next.

Step 1. For rough, intricate textures such as rocks or a pebbly beach, the drybrush technique is ideal. It's important to work on the textured surface of watercolor paper—cold pressed or rough—or possibly a sheet of illustration board or hardboard that's been coated with irregular brushstrokes of thick acrylic gesso. This demonstration is painted on a sheet of watercolor board, which means watercolor paper that's been mounted on thick cardboard by the manufacturer. The pencil drawing traces the contours of the rocks, but makes no attempt to indicate their texture, which will be left to the brush.

Step 2. A flat softhair brush is dampened with color and pulled horizontally across the distant water. Because the brush doesn't carry too much color, the tone isn't spread evenly over the painting surface. Instead, the brush tends to hit the peaks of the textured watercolor paper, skipping over many of the valleys, which remain white flecks. These flecks merge in the viewer's eye to look like ragged patches of foam. In the foreground between the rocks, the irregular texture of the sand is painted with quick touches of the damp brush. If the brush picks up too much color and starts to deposit solid tones rather than drybrush strokes, wipe the bristles on a paper towel or a sponge.

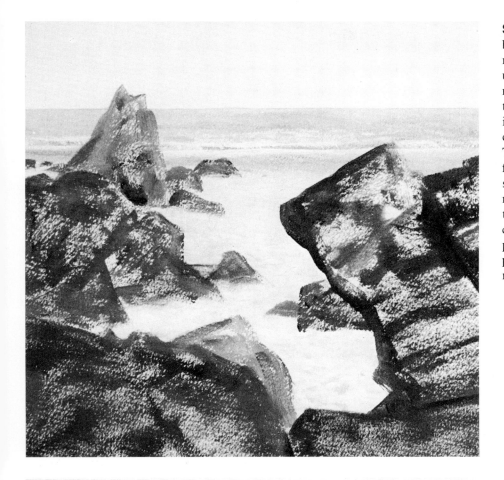

Step 3. Now you can see the drybrush strokes more distinctly in the rocks. The flat softhair brush picks up rich, dark color, but not too much. The damp brush moves over the painting surface without applying too much pressure, depositing color mainly on the high points. The low points of the painting surface remain bare. For the darker strokes, the brush picks up a little more color and presses harder, but the color is never fluid enough to cover the paper evenly. The rough pattern of dark and light flecks expresses the rugged character of the rocks.

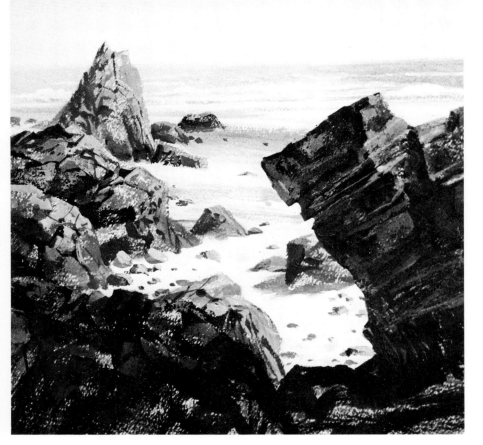

Step 4. The rocks are completed with drybrush strokes of thick color: light strokes for the sunlit planes and darker strokes for the shadows. The brush is dragged and skimmed over the paper, which breaks up the stroke into ragged flecks. It's hard to find a smooth, even tone here. More horizontal strokes of pale foam are drybrushed over the distant sea. Finally, the tip of a round softhair brush picks up some fluid color for the precise finishing touches: the cracks in the rocks and some pebbles and their shadows. Drybrush works equally well with opaque or transparent color; try them both.

Step 1. The Italian word *impasto* means thick paint. There are times when you're painting a subject with a particularly rough, rugged texture, and you want to capture that texture with especially thick, rough strokes. A rocky headland is an ideal subject for trying out the impasto technique. The painting surface is a sheet of hardboard covered with several coats of smooth gesso diluted with enough water to produce a milky consistency. Then the shapes of the headland are drawn in pencil lines that define the lights and shadows.

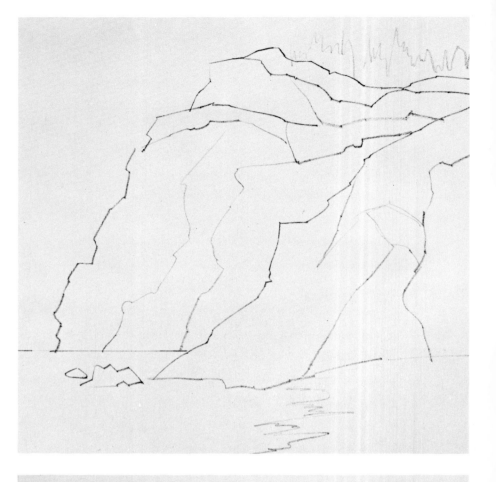

Step 2. Acrylic modeling paste, titanium white, and a touch of darker color are blended with the palette knife to form a thick mixture that stands up in a mound. A big, stiff bristle brush picks up gobs of this pasty mixture and applies it to the headland with thick strokes that retain the grooves made by the bristles. The brushstrokes follow the diagonal slopes of the headland but make no attempt to render the lights and shadows of the rock formations. At this point, the goal is just to create a rough, rocky texture. The ragged surface is now allowed to dry thoroughly before any more color is applied.

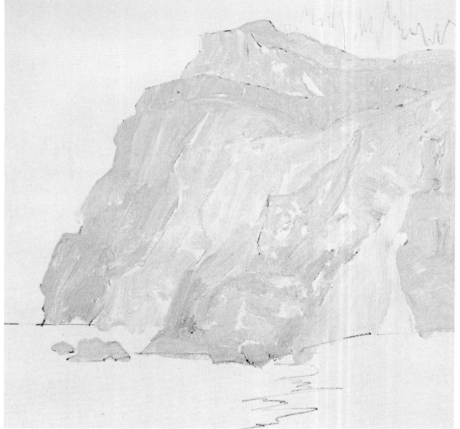

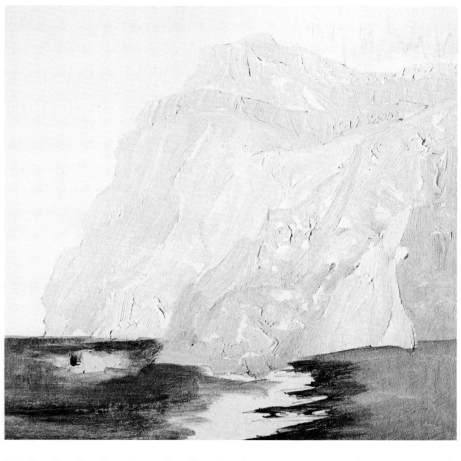

Step 3. The thick paste on the headland is now dry. The strokes are actually thick enough to cast shadows. Before going back to complete the headland, the tones of the beach, the water, and the foam between them are painted with fluid color. This liquid color is carried carefully around the base of the headland and around the small rock at the foot of the headland in the lower left.

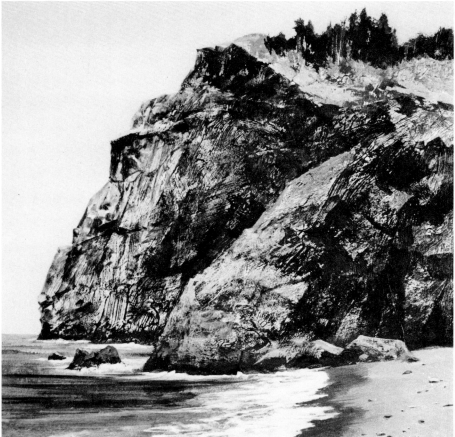

Step 4. The rough surface of the headland is now ideal for drybrush. A flat softhair brush is dampened with dark color and moves over the dried modeling paste, skimming lightly over the sunlit planes and pressing harder in the shadows. The brush goes back and adds more fluid color in the shadows, but all the strokes are damp, not sopping wet, so the texture of Step 3 comes through clearly in Step 4. The tip of a round softhair brush picks out some cracks and shadows among the rocks. The trees at the top of the headland—which aren't covered with modeling paste—are scumbled. So are the beach and the foam to get those soft transitions from dark to light. And the dark reflections in the water are completed with horizontal drybrush strokes.

Blues and Grays. Because the sky and the sea dominate most coastal subjects, blues and grays are the most common colors in seascape paintings. For this reason, it's particularly important to learn how to amplify the two blues on your palette to produce the great variety of blues that actually appear in nature. And it's equally important to realize that gray isn't merely a drab mixture of black and white, but a *family* of colors so incredibly diverse that many seascape painters work primarily in grays—and create pictures of great variety and richness.

Modifying Blues. As the light changes throughout the day, the blue of the sky changes too. And since the sea mirrors the sky, the blue of the sea also changes from hour to hour. Both sea and sky change with the weather. So even on the sunniest day, you must learn to mix a variety of bright blues. But not all days are sunny, so you must be prepared to create blues for cloudy and hazy days, for foggy weather, and even for storms. You must learn all the different ways to transform the two blues on your palette—ultramarine blue and phthalocyanine blue—into many other hues. Both these blues are dark when they come from the tube, so they need white to bring out their full brilliance. A minute touch of phthalocyanine green can make them look still more brilliant. A hint of yellow ochre will soften them without turning them green—but beware of adding the more powerful cadmium yellow light. A trace of burnt umber or burnt sienna will darken both blues, while a larger quantity of either brown (plus more white) will produce subtle, grayish blues. A speck of naphthol crimson will give you purplish blues. The brilliant phthalocyanine blue and the more muted, slightly purplish ultramarine blue will also modify one another, producing a lovely blue that's midway between the two.

Creating Grays. When the time comes to mix a gray, your first impulse will probably be to blend black and white, which will give you a steely gray that can be just right for stormy weather. But this is only one of many possible gray mixtures. The most interesting variety of grays will come from blending blue, brown, and white. You should certainly explore the various possibilities of mixing ultramarine blue or phthalocyanine blue with burnt umber or burnt sienna, plus white. When you change the proportions of blue and brown, these grays will change radically. When

blue dominates, you get a cool gray; when the brown dominates, you get a warm gray. You can then enrich any of these blue-brown mixtures by adding any other color on your palette. The greens will give you greenish grays. Yellow ochre will give you a golden gray, though the more powerful cadmium yellow is unpredictable: add just a speck at a time or you may suddenly find that your gray turns green! Violet grays are more common in nature than you might think, so a touch of naphthol crimson may be just what you need. But add cadmium red with care—it pushes these grays toward brown, not toward violet.

Painting Skies. Even on the brightest day, skies are rarely a uniform color, so you've got to watch for subtle variations in the blue. The deepest, brightest blue is apt to be at the top, while the sky often grows paler and warmer (with a hint of gold or pink) toward the horizon. On an overcast day, when the sky seems to be a uniform gray, you should also watch for gradual color changes from the zenith to the horizon. Also on an overcast day, the sun has a most unpredictable way of breaking through the gray at some point, producing an unexpected suggestion of gold. The colors of clouds are just as varied. Keep in mind that a cloud is a solid, three-dimensional object, with a light and shadow side, just like a rock. The sunlit area of the cloud isn't just white, straight from the tube, but often has a hint of golden sunshine at midday, pink or orange at sunrise or sunset, gray or blue-gray on an overcast day. In the same way, the shadow side of the cloud can be a bluish gray, a brownish gray, or even a golden tone.

Painting Water. Although many poets talk of the glorious colors of the sea, water really has no color of its own. Like a mirror, water takes its color from its surroundings. A bright blue sky generally means bright blue water, while a gray sky usually means gray water. At sunrise or sunset, the water can be red, pink, orange, or violet. Of course, water is also influenced by the colors of the shoreline. The brilliant blue-green of tropical waters is a combination of the bright blue sky above and the golden sands beneath the water. The colors of tidepools are often combinations of sky color and the reflections of the surrounding rocks and sand. In short, don't simply decide that water is always blue, gray, or green. You've got to look carefully and paint what you actually *see*.

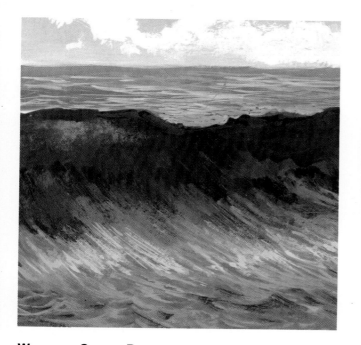

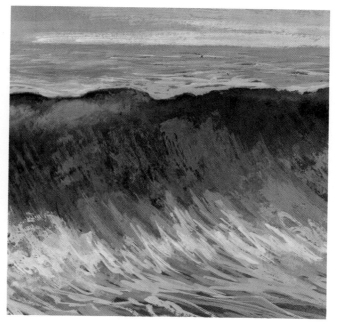

Wave on Sunny Day. Because the sea is essentially a reflecting surface, its color is strongly influenced by the weather and by the prevailing light. On a sunny day, you'll see bright blues and greens. The shadowy face of the wave, curving upward and tipping over slightly so it doesn't catch the direct sun, looks transparent and lets the light shine through.

Wave on Overcast Day. On a gray, overcast day, that same wave looks quite different. The water picks up the grayish tone of the sky. The shadowy face of the wave seems less transparent. However, the water is far from a dead, uniform gray. It's still full of color, but much more subtle color than you see on a sunny day.

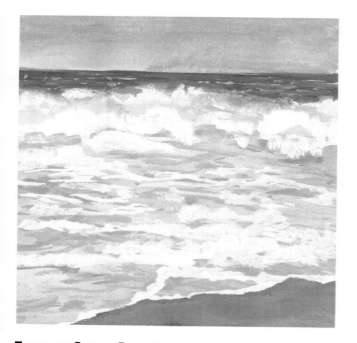

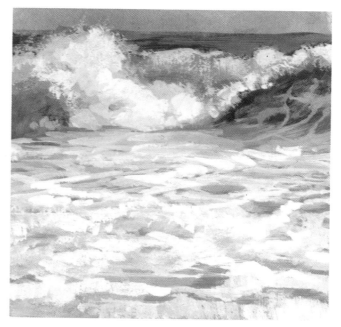

Foam on Sunny Day. Foam is water in a different form, but it's still a reflecting surface, affected by light and weather. On a sunny day, the foam reflects the golden warmth of the sun's rays. The sea beyond reflects the bright, cool tones of the sky. As the foam spills forward over the beach, the sandy tone shines through.

Foam on Overcast Day. When clouds cover the sky and block off the sun, the light loses its warm tone and turns grayish. The foam reflects this cool light, just as the water reflects the more somber tone of the sky. The beach looks grayer too, and these subdued sandy tones shine through the foam as it moves across the beach.

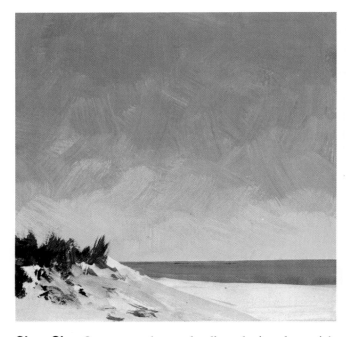

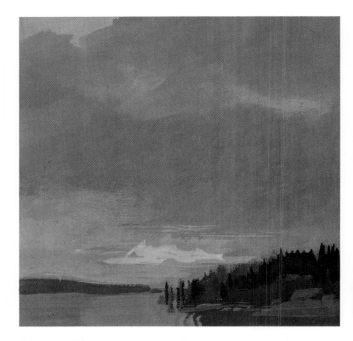

Clear Sky. On a sunny day, a cloudless sky is a deep, rich blue, but it's not a smooth, consistent tone from top to bottom. It's usually darkest at the zenith and grows lighter toward the horizon. Your two blues, phthalocyanine and ultramarine, plus white, will make a lovely sky tone. As you approach the horizon, you can add more white plus yellow ochre for a hint of warmth.

Overcast Sky. An overcast sky is actually full of subdued colors. Notice how these cloud layers are sometimes warm, sometimes cool. Try mixing blues and browns—ultramarine or phthalocyanine with burnt umber or burnt sienna—in different proportions to get blue-grays and brown-grays. Naturally, you'll need some white. And add yellow ochre for a more golden tone.

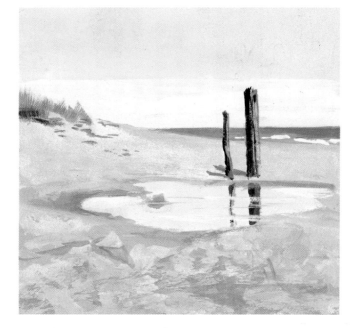

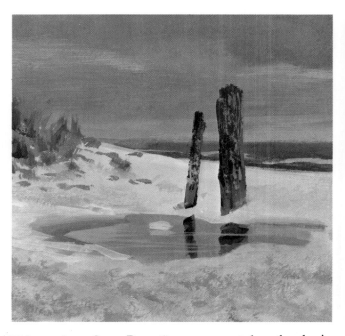

Tidepool on Clear Day. A tidepool usually looks like a patch of sky dropped onto the beach. On a sunny day, the pool mirrors the clear, bright tones of the sky overhead. Notice that the pool also reflects nearby objects like these two weathered wooden posts. The wind produces light and dark ripples that interrupt the reflections.

Tidepool on Gray Day. On an overcast day, the sky is often darker than the beach—and so is the tidepool. The shadowy tones of the sky are mirrored in the water, where the reflections of the wooden posts look darker too. Where a little light breaks through the sky, as it does on the left, this light reappears in the pool.

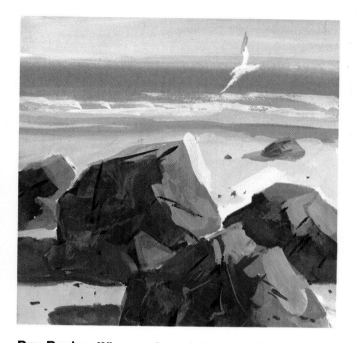

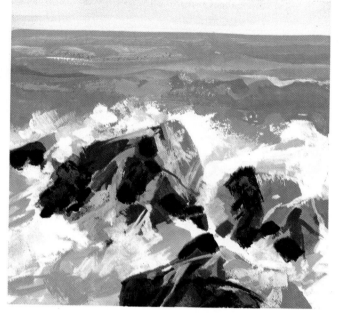

Dry Rocks. When you're painting coastal scenery, remember that the same subject can change radically in color, depending upon whether it's dry or wet. These dry rocks have warm, sunny tones on their sunlit sides. The shadow sides are darker—picking up warm reflections from the sand and cool reflections from the sky—but not nearly as dark as they'll be when the rocks are wet.

Wet Rocks. When the waves splash over these rocks, the color grows deeper and more intense. Now the rock is a bright, reflecting surface. The sunlit sides grow brighter and warmer, bouncing back the warm rays of the sun and also picking up some cool reflections from the water. The shadow sides become dark and glistening, but they too pick up cool reflections from the water.

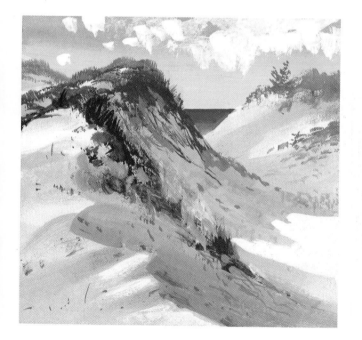

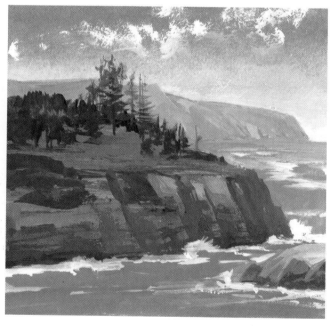

Sand Dunes. Even on the sunniest day, sand isn't a bright, golden tone, but tends toward a very subtle yellowish tan. In the shadows, the sand is a much cooler tone—as close to gray as it is to tan. The lighted planes seem to reflect the sunlight, while the shadows seem to pick up some of the cooler tone of the sky.

Headlands. Rocky headlands, near and far, are a good example of color perspective. The near headland is both darker and brighter, with stronger contrasts between the lights and shadows, than the far headland, which is paler, more subdued, and distinctly cooler in color, with much less contrast between the lights and shadows.

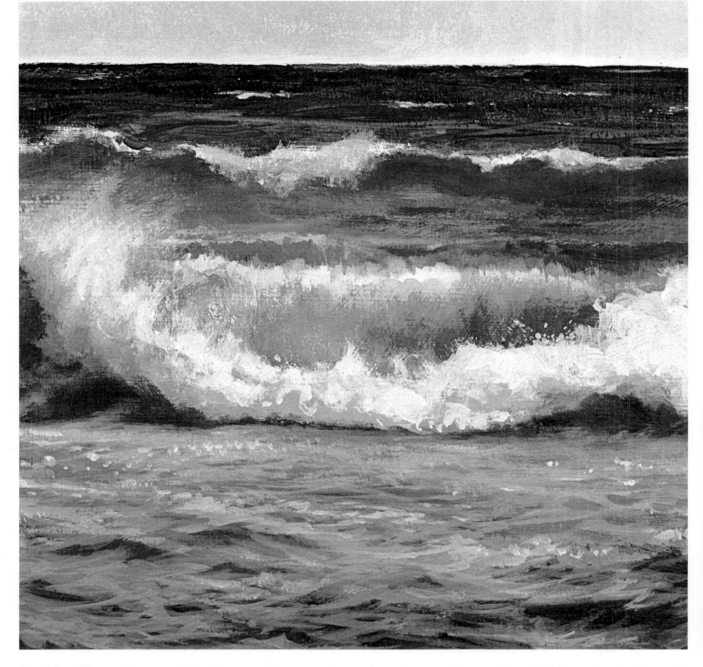

Breaking Wave. This actual size close-up—from a much larger painting—shows a variety of brushstrokes used to paint the action of a breaking wave and the surrounding water. The water in the foreground is painted with short, curving, arc-like strokes that capture the rippling movement. This foreground is painted from dark to light: dark strokes first; lighter strokes on top of these dark strokes; and lightest strokes last. The crashing foam is painted in two operations: first the smooth tone of the underlying shadow; then short, scrubby strokes of thicker color for the sunlit areas. The downward curve of the clear water directly behind the foam is painted with vertical, scumbling strokes that suggest the downward movement of the breaking wave. The flying foam at the left is lightly drybrushed over the dark background. The little blobs of foam that float over the foreground, as well as the flecks that are flung up by the crashing surf, are painted with tiny touches of the tip of the brush.

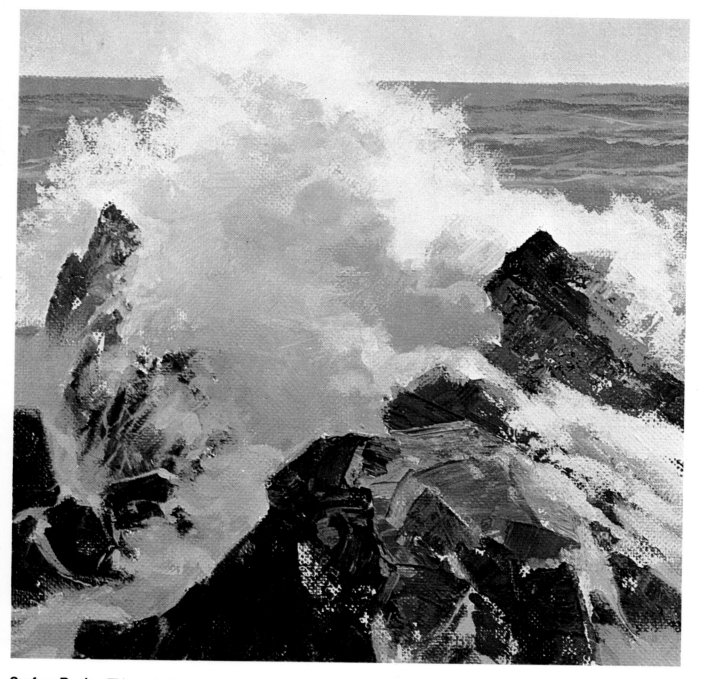

Surf on Rocks. This exploding surf is a particularly good example of scumbling. Within the shadow of the foam, you can see each individual scrub of the brush merging softly with the next stroke. One wet stroke is placed beside another, and they're lightly scrubbed together without merging completely. The sunlit edge of the foamy shape is scumbled with lighter color that blurs against the sky rather than forming a hard edge. In contrast with the soft brushwork of the surf, the rocks are painted with broad, flat, hard-edged strokes of the painting knife. Each stroke stands out sharply to make the rocks look blocky. Then more foam is scumbled over the dry knife strokes.

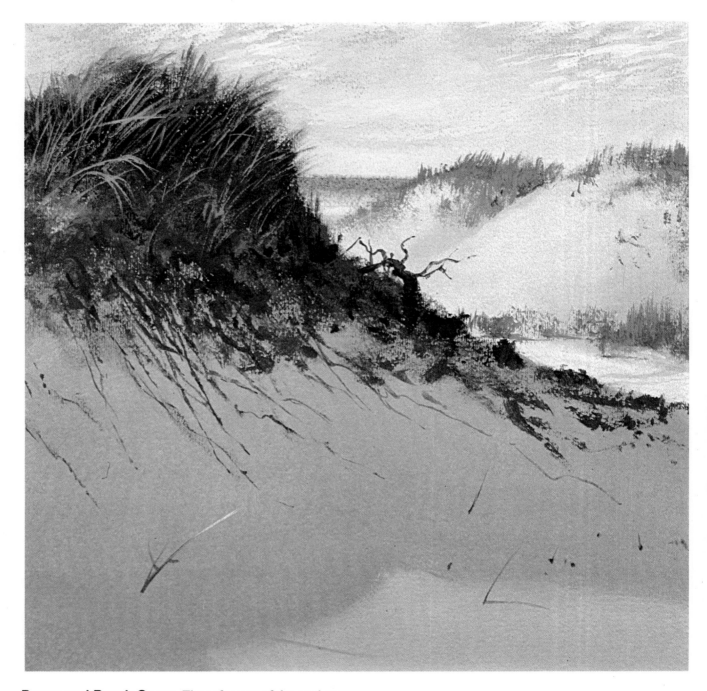

Dunes and Beach Grass. The soft tones of the sand are painted with thin, fluid color, smoothly applied with a soft-hair brush that irons out and blends the individual strokes into continuous tones. The individual strokes are invisible, fusing softly into one another. In contrast to these smooth tones, the beach grass at the tops of the dunes is painted with clearly defined brushwork. On the big dune to the left, dark tones are first applied with drybrush strokes of thick color, broken up by the texture of the watercolor paper. Then the tip of a round softhair brush carries dark strands of this tone downward over the dune. The same brush adds crisp, curving, individual strokes on top of the dark under-tone to suggest blades of grass. The sparse beach grass on the more distant dunes is suggested by slender drybrush strokes made with the tip of the brush.

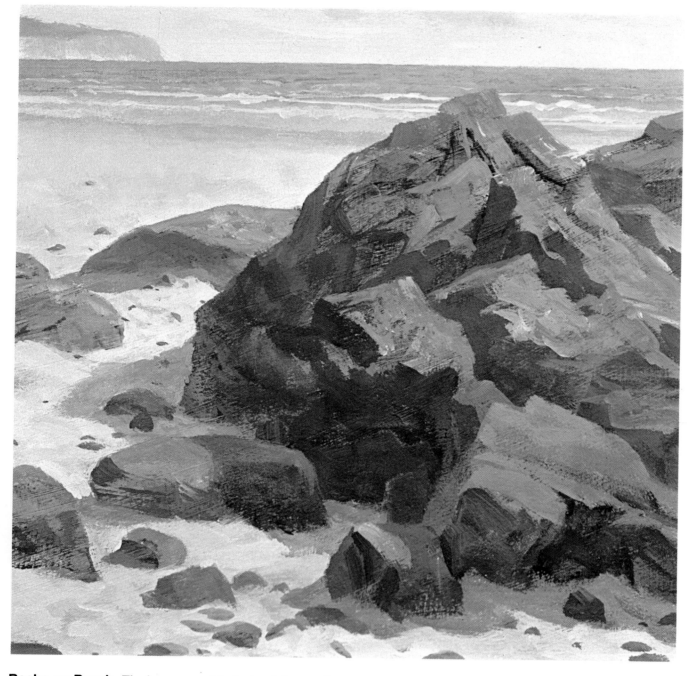

Rocks on Beach. The heavy, roughly textured forms of the rocks are painted with thick color on watercolor paper that adds its own texture to that of the paint. A flat brush lays thick strokes side-by-side, one wet stroke overlapping another, to cover the sunlit tops of the rocks. The strokes follow the diagonal tilt of the rocks. Then the same brush paints the shadowy sides of the rocks with straight, squarish strokes of thick color. The sand is painted with smoother, more fluid color, which grows smoother and more liquid as the beach approaches the water. The consistency of the paint matches the subject. It's usually a good idea to concentrate your thickest paint and your roughest brushwork in the foreground, using thinner, smoother paint in the distance.

Step 1. The horizon line, the horizontal lines of the distant waves, the curving shapes of the closer waves and foam, and the low waves in the foreground are all drawn in pencil on a sheet of hardboard. The board has been coated with two layers of acrylic gesso diluted with water to the consistency of thin cream. One coat is brushed from top to bottom and allowed to dry. And the other coat is brushed from side to side. This produces a subtle crisscross pattern, something like canvas.

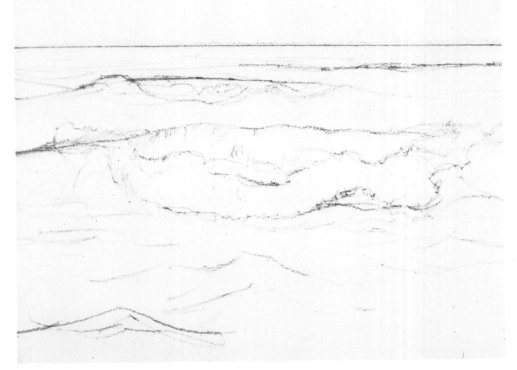

Step 2. A kneaded rubber eraser (called putty rubber in Britain) lightens the pencil lines so that they're almost invisible here. Then a semitransparent mixture of chromium oxide green, phthalocyanine blue, and just a hint of white is freely brushed over the entire sea, starting from the horizon and working down to the bottom of the picture, leaving bare gesso only for the surf. This mixture is lightened with water at the top of the big wave. The brushstrokes in the immediate foreground are a bit darker, and they curve to suggest the wave action. Then the distant sea is darkened with horizontal strokes of ultramarine blue, Hooker's green, and a little white.

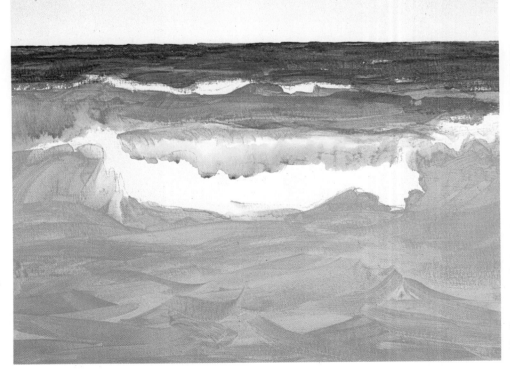

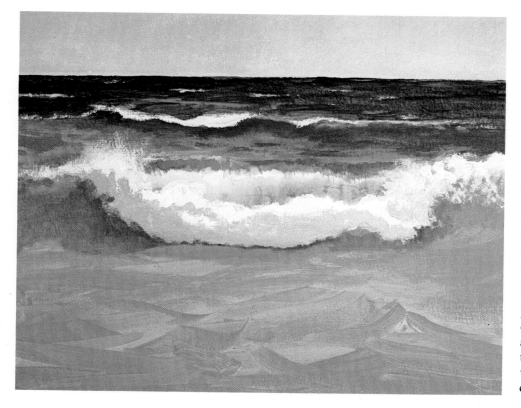

Step 3. The sky is brushed with a smooth mixture of phthalocyanine blue, napthol crimson, yellow ochre, and white. The distant sea and the strip of water behind the near wave are darkened with horizontal strokes of phthalocyanine blue, chromium oxide green, burnt sienna, and white. A few whitecaps are added to the distant water with touches of white tinted with sky tone. The shadow on the foam is painted with the sky mixture, and then the sunlit edge is painted with pure white tinted with a little sky mixture and some more yellow ochre. The face of the oncoming wave is darkened at the left with the same mixture—but containing more white—that's used for the distant sea.

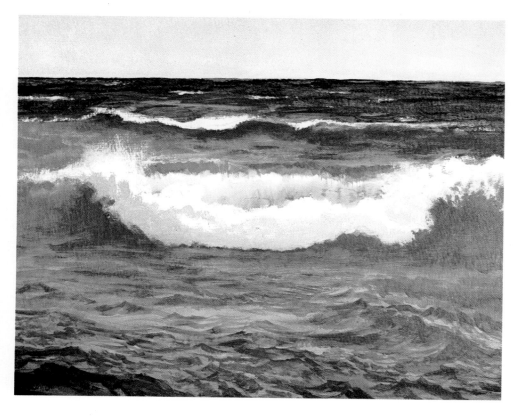

Step 4. Work now begins on the details of the rippling water in the foreground. Phthalocyanine blue, chromium oxide green, burnt sienna, and a little white are thinned with water to a fluid consistency necessary for precise brushwork. Then the tip of a round softhair brush strikes in short, curving strokes to suggest the dark faces of the ripples. The brush leaves spaces between these strokes, allowing the undertone to shine through. The face of the oncoming wave is darkened at right with this fluid mixture.

Step 5. The tops of the foreground ripples, which reflect the pale tone of the sky, are painted with a round softhair brush. This light tone is a mixture of phthalocyanine blue, chromium oxide green, yellow ochre, and white. The color is slightly thicker and more opaque than the dark undertone. Once again, the strokes are short curves, which you can see most clearly in the immediate foreground. These strokes don't cover the foreground completely, but leave gaps for the dark undertone to shine through. This mixture is carried upward over the face of the oncoming wave—to the right and left of the exploding surf—to suggest foam trickling over the clear water.

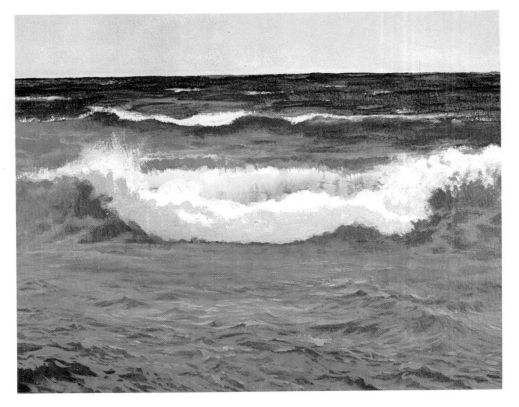

Step 6. The details of the foreground are completed with the tip of a small round brush that carries the same colors that are used in Step 5—but the mixture is lightened with more white. Curving strokes of this mixture suggest the light on the tops of the ripples. Then the brush picks up almost pure white, faintly tinted with sky tone, and adds touches of foam to the tops of the foreground waves. The brush also adds trails and flecks of foam that wander from left to right across the foreground. Once again, all these strokes are spaced out to allow the underlying darker strokes to come through. An intricate pattern of strokes suggests the sparkle and the action of the water.

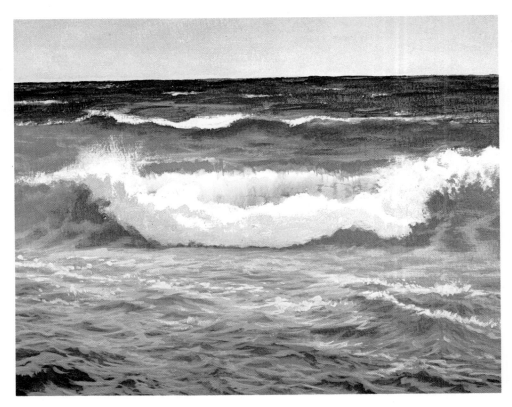

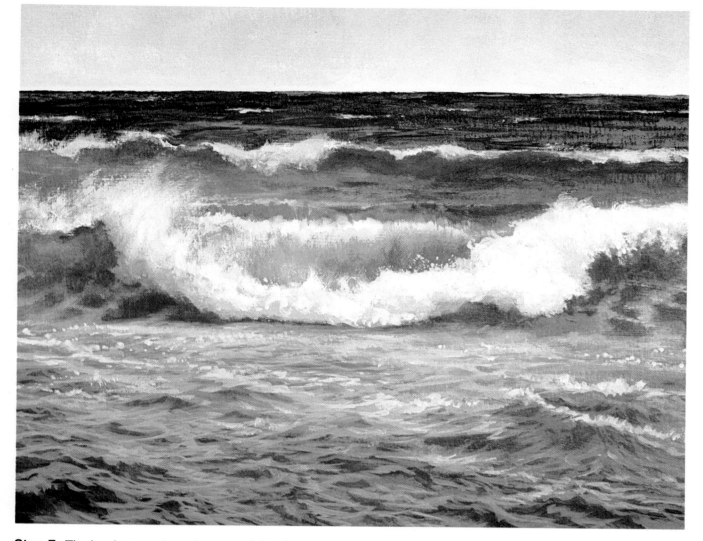

Step 7. The brush strengthens the tone of the wave that rolls downward behind the crashing foam. Darker tones of phthalocyanine blue, naphthol crimson, yellow ochre, and white are scumbled directly behind the foam to give the curving wave a more three-dimensional, barrel shape. Pure white tinted with a little sky tone is scumbled along the top of the barrel. Now there's a clear gradation from light to middletone to shadow, giving the wave a distinctly round shape. A bristle brush scumbles a thick mixture of white tinted with sky tone and a little more yellow ochre over the sunlit edge of the surf. These scumbling strokes cover some of the shadow tone that first appeared on the surf in Step 3.

At the extreme left, the face of the big wave is scumbled with a pale mixture of phthalocyanine blue, Hooker's green, and white, to suggest light breaking through the transparent water. More of the foam mixture is scumbled along the foamy edge of the more distant wave. A mixture of phthalocyanine blue, chromium oxide green, yellow ochre, and white is carried across the distant sea in horizontal drybrush strokes to suggest lighter tones on the water. Finally, the tip of a small brush adds some tiny dots of pure white to suggest foam flying upward from the crashing surf of the big wave.

Step 1. This study of surf and rocks will be painted on canvas whose texture is a bit too rough for pencil drawing. So the preliminary drawing is done on a sheet of transparent tracing paper. This smooth paper allows you to erase easily, which means that you can change your mind and redraw the lines until you get them right. When the drawing seems accurate, a second sheet of tracing paper is scribbled with soft pencil or charcoal. This transfer paper, as it's called, is laid over the canvas, and the drawing is laid on top. A sharp pencil goes over the most important lines of the drawing, which are then imprinted on the canvas via the transfer paper.

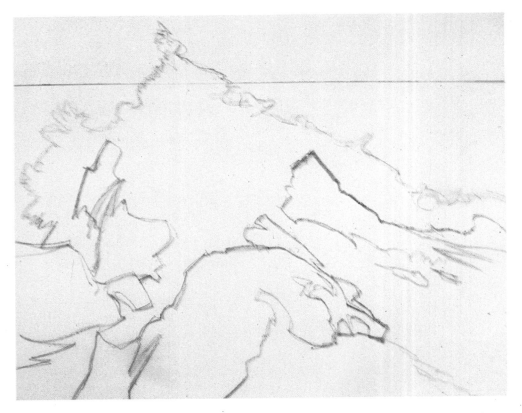

Step 2. The lines registered by the tracing paper are thinner, lighter, and simpler than the original drawing. Ultramarine blue, burnt sienna, yellow ochre, and white—straight from the tube—are mixed on the palette with the painting knife. The colors aren't smoothly blended. The mixture is lighter in some areas, darker in others. The knife picks up some dark tone on the underside of the blade and spreads this thick paste over the canvas with short, decisive strokes to suggest the shadows of the rocks. Then the knife picks up some lighter tones and spreads them over the darks to suggest the sunlit tops.

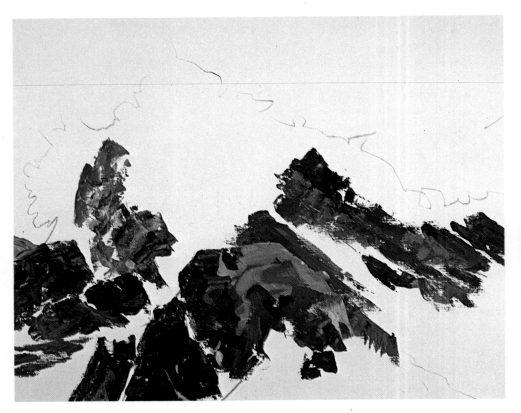

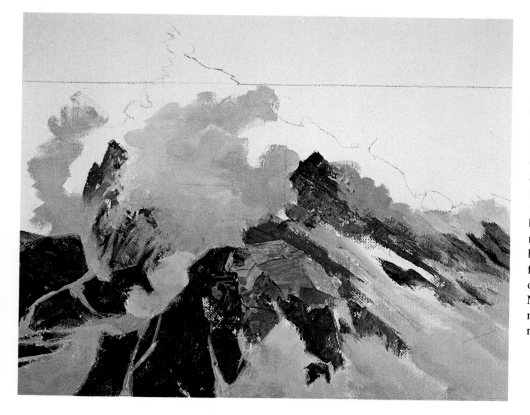

Step 3. The shadows of the crashing foam are scumbled with a stiff bristle brush that carries a mixture of ultramarine blue, naphthol crimson, yellow ochre, and white. The color is thick and creamy. One wet stroke is scrubbed into and over another, so they merge slightly, although you can still see the individual strokes. By now, the knife strokes are dry and brushstrokes of this foamy mixture are carried over and between the rocks to suggest foam splashing and running over the dark, blocky shapes. Notice the lines of foam running through the cracks in the rocks at the lower left.

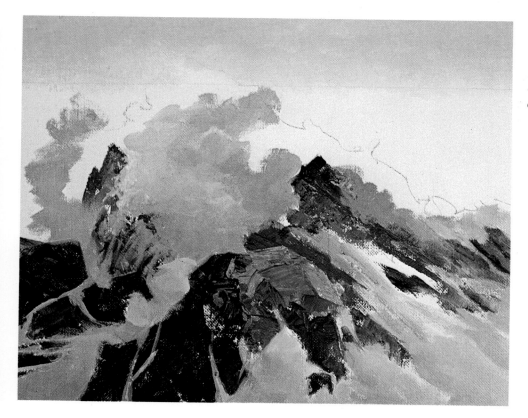

Step 4. The sky tone is painted with a smooth, fluid mixture of ultramarine blue, naphthol crimson, yellow ochre, and white, carried down to the horizon line.

Step 5. A darker mixture of the sky tone—ultramarine blue, naphthol crimson, yellow ochre, and white—covers the sea, leaving a ragged strip of bare canvas for the sunlit edge of the foam. This mixture is darkest at the horizon and grows slightly lighter—containing more white—as it moves forward toward the rocks. The color is smooth and fluid enough to paint a crisp horizon line. Yet the color is thick enough to scumble around the edge of the foam, which is soft and ragged.

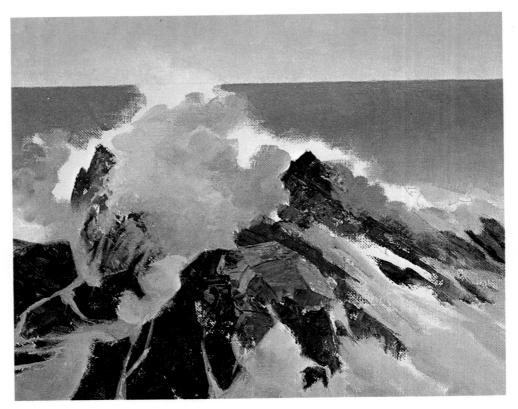

Step 6. When the underlying tone of the sea is dry, the point of a round softhair brush defines the darks and lights of the distant waves. The dark, horizontal lines are a mixture of ultramarine blue, a little naphthol crimson, some yellow ochre, and less white than the undertone. These strokes eliminate some of the foam at the extreme left. Then a lot of white is added to this mixture to paint the line of foam on the distant wave, just below the horizon, as well as the line of foam just above the rocks at the left. Now the canvas is almost completely covered with color, except for the sunlit edge of the exploding foam and some strips of sunlight on the foam that runs over the rocks.

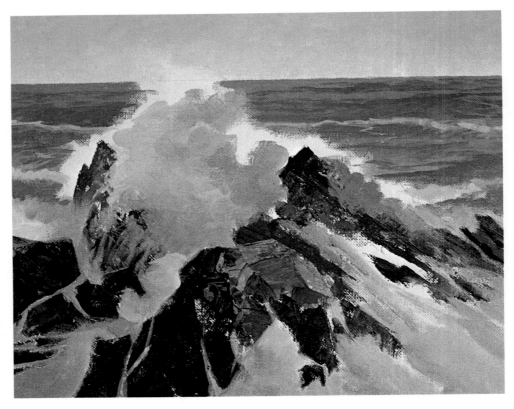

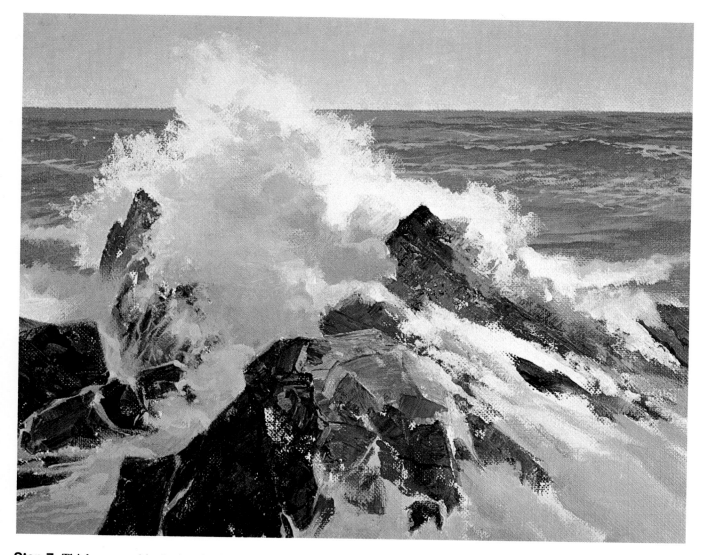

Step 7. Thick, pure white is tinted with a touch of the sky mixture and scumbled over the bare canvas around the edge of the foam that leaps up from the rocks. The brush scrubs back-and-forth to create a soft transition where the sunlit area melts into the shadow. Where the foam stands out against the dark sea beyond, the tip of the bristle brush applies the pale color in quick dabs that are broken up by the texture of the canvas. (Canvas is particularly receptive to scumbling because the fibers of the woven cloth have a lovely way of softening the stroke.) The bristle brush drags this thick, sunny mixture downward to the right, suggesting sunlight shining on the foam that runs over the rock formation. Then this pale mixture is darkened with a bit more sky tone and diluted with enough water for precise brushwork. So far, everything has been done with bristle brushes; but now a round softhair brush picks up this pale, fluid mixture and traces the lines of the foam on the distant sea with slender strokes. Moving into the foreground, the brush draws more trickles and streaks of foam over the rocks that are disappearing under the mass of surf. These trickles of foam are carried between the rocks and down into the lower left corner. This seascape shows the importance of finding the right tool for the subject: the painting knife for the rocks; the bristle brush for the waves and surf; and the softhair brush for the final details.

Step 1. Watercolor paper has a tender surface that won't take too much erasing when you're working out your composition with the pencil. So the complex forms of this rocky coast are first drawn on tracing paper and then transferred to the sheet of watercolor paper by the same method used in Demonstration 2. In transferring a drawing to watercolor paper, don't press too hard on the point of the pencil—you'll leave grooves in the sheet. Press just hard enough to leave a pale line.

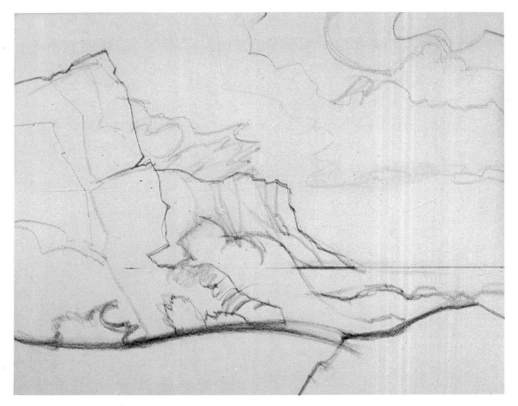

Step 2. When you're painting a stormy sky, it's important to decide just how dark that sky ought to be. If it's too light, it won't look stormy enough. But if it's too dark, you won't be able to see the shapes of the landscape below. So this painting begins with two dark areas of the landscape: the very dark tone on the tall cliff and the slightly lighter tone on the headland beyond. Now, when the dark sky is added, it will be easier to establish the right tone by comparing the sky with the rocky shapes. The darks of the rocks are a mixture of ultramarine blue and burnt sienna, which make a blackish tone that's more interesting than a simple mixture of mars black and water.

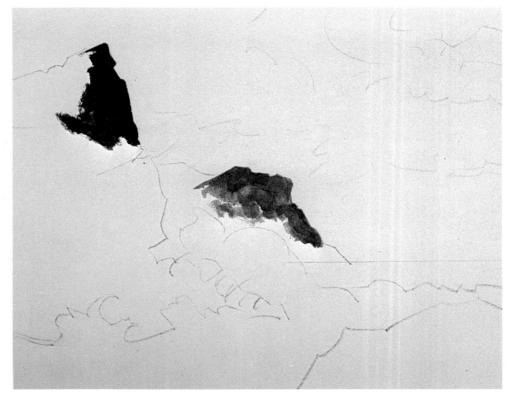

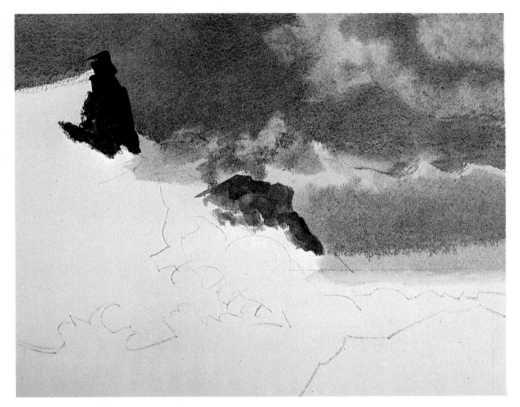

Step 3. The sky area is covered with a pale wash of ultramarine blue, naphthol crimson, yellow ochre, and lots of water. Now the sky has a faint tone over it, just one step removed from clear white. While this wash is still wet and shiny, the brush goes back in with a darker version of this same mixture containing less water. These dark strokes spread and blur to become the dark shapes of the clouds. A gap is left across the center of the sky and across the horizon to suggest light breaking through the clouds. A paper towel blots away some color at the upper right and just above the headland to suggest more breaks in the clouds.

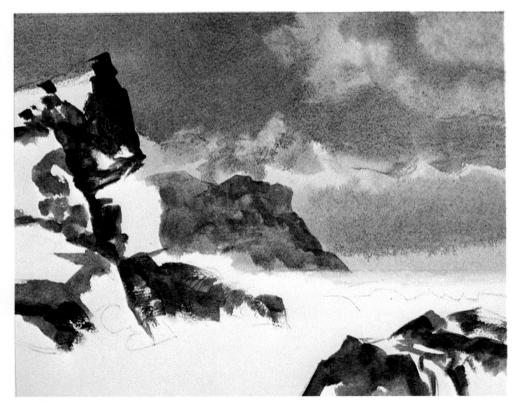

Step 4. The dark shapes of the cliff and headland at the left, plus the rock formation in the lower right, are painted with strokes of ultramarine blue, burnt sienna, and water. This is the same mixture that first appeared in Step 2. The squarish strokes are made with a flat softhair brush, leaving gaps of white paper for the lighter tones that will appear on the rocks later. Only the distant headland is completely covered with this color, containing more water to make the shapes seem paler and more distant.

Step 5. When the shadow tones of Step 4 are dry, more water is added to the same mixture of ultramarine blue and burnt sienna. Then this transparent tone is washed over the big cliff at the left and the rocks at the lower right. This transparent wash darkens the shadows and solidifies the shapes by giving them an overall tone. On a dark, stormy day, even the lighted areas of the rocks are quite dark.

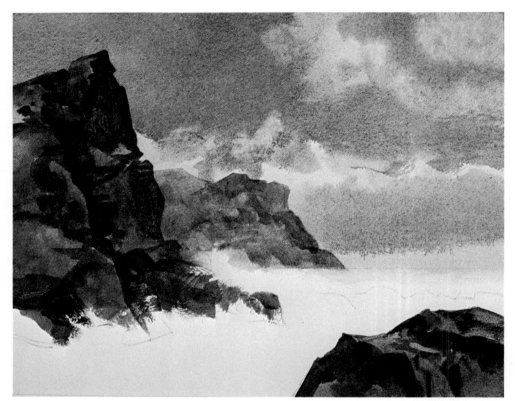

Step 6. The sea beneath the stormy sky must match the somber tones overhead. So the water is painted in transparent strokes of ultramarine blue, naphthol crimson, yellow ochre, and water. The distant water is painted in horizontal strokes that stop at the patch of bare paper that's left for the foam crashing against the rocks. Then, in the foreground, the water is painted with shorter strokes that curve to match the movement of the incoming waves. Another transparent wash of ultramarine blue, burnt sienna, and water is carried over the distant headland, the cliff, and the rock formation at lower right, making them darker and more powerful.

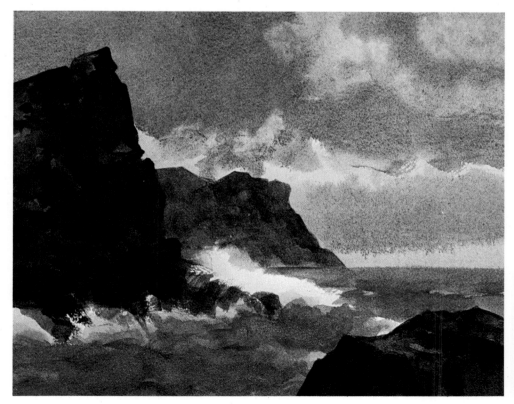

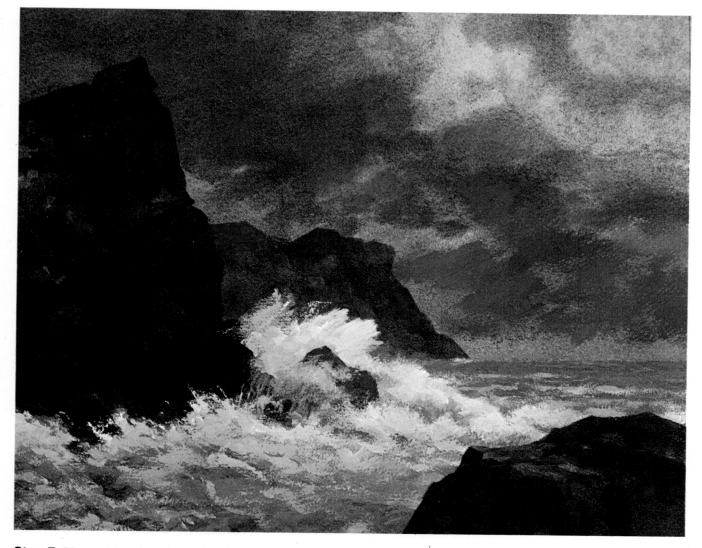

Step 7. Up to this point, the entire picture is painted in transparent color diluted only with water. No white has been added to make the color lighter or more opaque. Now the final touches are added with opaque color. The sky is brushed with clear water. While the surface is still wet, a bristle brush adds opaque strokes of ultramarine blue, naphthol crimson, yellow ochre, and white. These strokes blur on the wet surface, but the color is thick, and they don't blur quite as much as the strokes of transparent color in Step 3. Now there's a stronger contrast between the dark clouds and the patches of light that break through. Pure, thick white is lightly tinted with the water mixture, then diluted to a creamy consistency. This luminous white is scumbled at the foot of the cliff to indicate foam crashing against the rocks. Individual strokes of this mixture are drybrushed in the foreground to indicate more wave action. And more strokes are drybrushed over the distant sea to suggest the foamy tops of oncoming waves. This moody, atmospheric seascape is a particularly effective combination of fluid, transparent color and thick, opaque color.

Step 1. The effects of moon-light are so subtle that it's very difficult to capture them with pencil lines. All the pencil can do is draw the line of the horizon, the line of the beach, the silhouette of the distant shore, the jagged shape of the reflection on the water, plus the circle of the moon and a few rocks on the sand. The brush will have to do the work of defining the soft shapes of the moonlit clouds. The painting is done on a sheet of illustration board.

Step 2. The picture is painted from dark to light, starting with the most somber tones. The entire painting surface is covered with smooth, fluid strokes of ultramarine blue, burnt sienna, yellow ochre, and a touch of white for opacity. A little more white and some more water are added at the lower edge of the sky to suggest the glow at the horizon. Only the moon and its reflection remain bare paper. Then the reflection is slightly tinted with the sky mixture and lots of water.

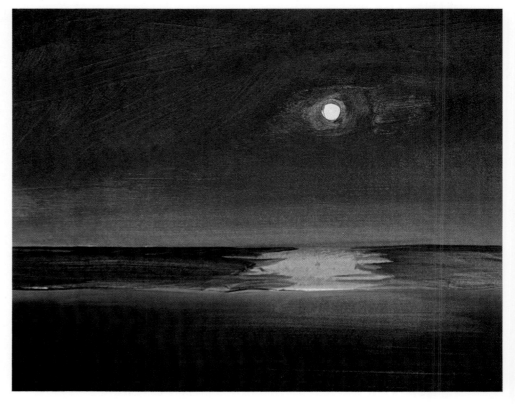

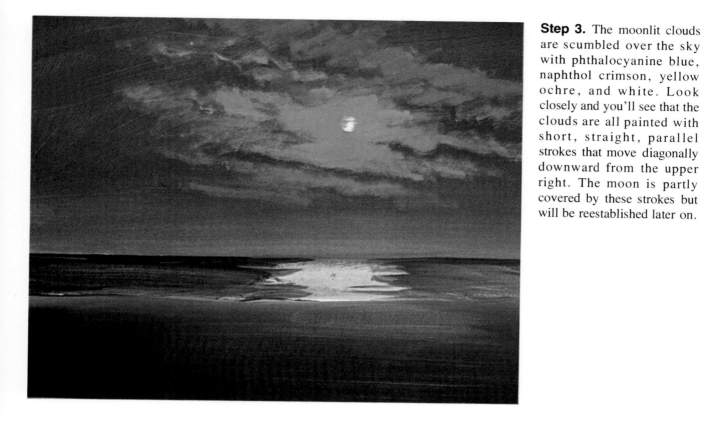

Step 3. The moonlit clouds are scumbled over the sky with phthalocyanine blue, naphthol crimson, yellow ochre, and white. Look closely and you'll see that the clouds are all painted with short, straight, parallel strokes that move diagonally downward from the upper right. The moon is partly covered by these strokes but will be reestablished later on.

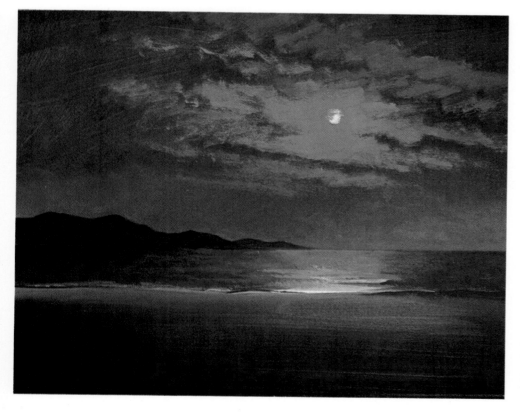

Step 4. To intensify the glow in the lower sky, a hint of this cloud mixture is scumbled upward from the horizon. The dark shape of the distant shore is painted with a smooth mixture of ultramarine blue, burnt sienna, and a touch of white. The cloud mixture, containing a little more blue, is scumbled downward from the horizon to cover most of the moon's reflection in the water. On each side of this reflection, the water is darkened with horizontal, scumbled strokes of the original sky mixture: ultramarine blue, naphthol crimson, and yellow ochre. A bit of the cloud mixture is scumbled over the edge of the beach at the left to suggest moonlight on wet sand.

Step 5. The original tone of the sky is darkened and solidified with a dense, creamy, opaque mixture of ultramarine blue, naphthol crimson, and yellow ochre, smoothly brushed with a flat softhair brush. This mixture covers some of the clouds and provides a dark background for more luminous tones that will be added to the sky in the final step. The moon's reflection is now re-established with a mixture that consists mainly of white plus some sky color. The reflection actually consists of small touches of color applied in rows with the tip of a bristle brush. These touches give the feeling that the moon is shining on the tops of waves that are moving into shore.

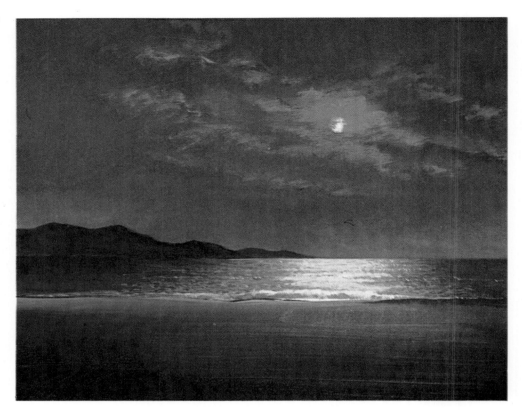

Step 6. The moonlit tops of the rocks on the beach are painted with short, smooth strokes of ultramarine blue, naphthol crimson, yellow ochre, and enough white to make them stand out in the darkness. The shadow sides of the rocks are scumbled with this same mixture, but containing no white. Then a little white is added to the mixture, which is then scumbled over the beach to give the sand a dark, unified tone. The moonlight mixture (from Step 5) is scumbled along the edge of the beach to suggest light reflecting on the wet sand.

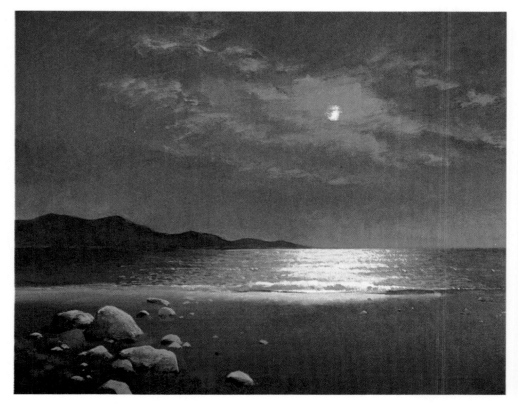

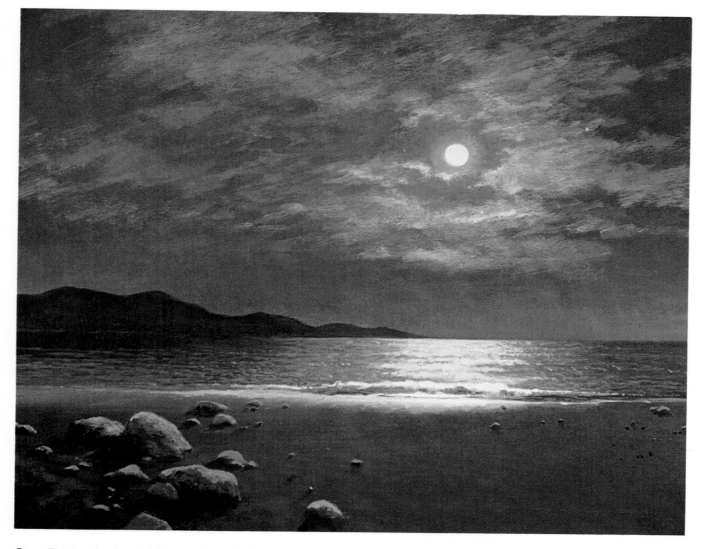

Step 7. The clouds, which seemed too insistent, were cut back in Step 5. Now they're painted in a much darker, more subdued tone and carried across most of the sky. This is a dark mixture of ultramarine blue, naphthol crimson, yellow ochre, and just enough white to make them stand out against the dark background. As you saw in Step 3, the clouds are painted with short, straight, parallel strokes that move diagonally downward from right to left. Now more white, naphthol crimson, and yellow ochre are added to this mixture and scumbled over the edges of the clouds that are closest to the moon. The same mixture is used to scumble the halo around the moon. The circle of the moon is repainted with almost pure white, tinted with a touch of this mixture.

On either side of the reflection in the water, the dark patches of sea are enlivened with slender, horizontal strokes of the dark cloud mixture, painted with the tip of a round brush. When you paint a moonlit seascape—or a moonlit landscape for that matter—keep several "lessons" in mind. First, remember that a moonlit sky is lighter than the dark shapes of the land below. Second, the colors, lights, and shadows of the sea reflect the sky, just as they do in daylight. Finally, *don't* overdo the moonlight on the clouds and water, scattering touches of white all over the picture; concentrate these light touches at the focal point of your composition.

Step 1. The shapes of the rocky coast are drawn in pencil on cold pressed watercolor paper, which is chosen for this painting because it will be done entirely in thin, fluid washes, very much like watercolor. Before the painting is begun, the pencil lines are lightened with a kneaded rubber eraser. To avoid abrading the surface of the paper, the eraser is pressed against the pencil lines and lifted away, rather than scrubbed back-and-forth. Thus, the lines are almost invisible in Step 2.

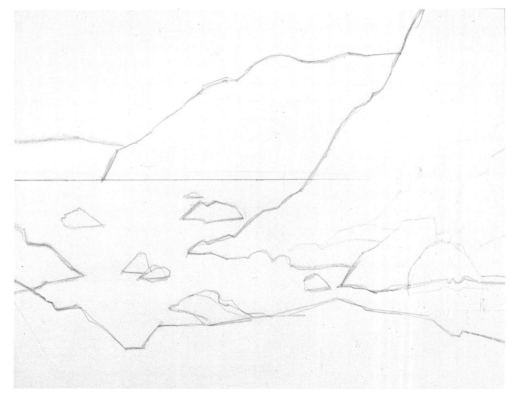

Step 2. The shadow planes and the cracks between the rocks are painted with a flat softhair brush carrying a fluid mixture of ultramarine blue, naphthol crimson, yellow ochre, and water. More water is added for the paler strokes. The color is transparent. Before painting the blurred top of the two distant cliffs, the sky is painted with a very pale wash of the same mixture used to paint the rocks in the foreground; while this wash is still moist and slightly shiny, the tops of the cliffs are painted with darker strokes that blur into the wetness. The lights of the foreground rocks and sea remain bare paper.

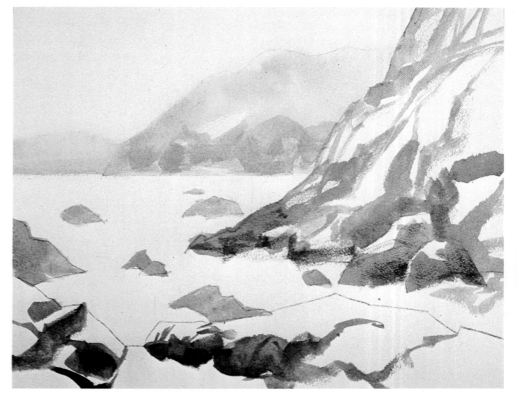

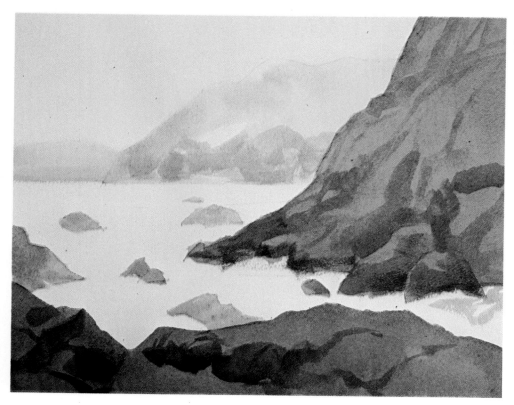

Step 3. When the shadow strokes are dry, a flat softhair brush covers the foreground rocks with a transparent wash of ultramarine blue, naphthol crimson, burnt sienna, and water. Now these shapes are distinctly darker—and therefore nearer—than the paler shapes in the distance.

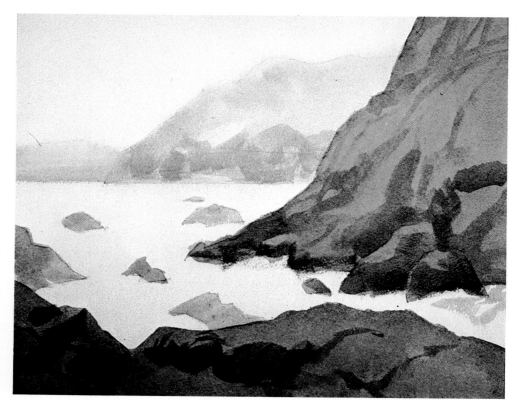

Step 4. Now a pale wash of phthalocyanine blue, naphthol crimson, yellow ochre, and lots of water is carried over the entire picture—the first step in creating a veil of fog that will gradually become denser in succeeding steps. Now the picture has a slightly cooler, more unified tone.

Step 5. When Step 4 is dry, a touch of white is added to the mixture of phthalocyanine blue, naphthol crimson, and yellow ochre. Diluted with a great deal of water, this misty tone is washed over the entire surface of the painting with a large, flat softhair brush. Now the fog is beginning to thicken as a slight veil appears over the rocks, both near and far.

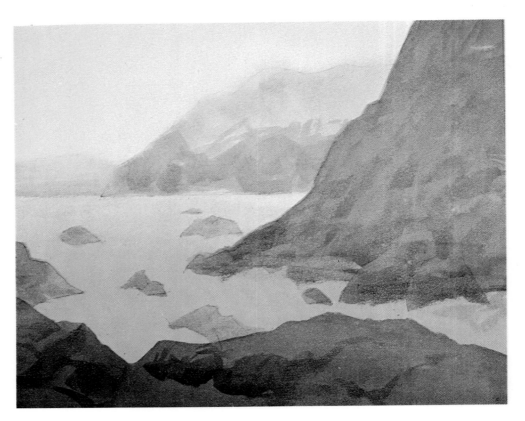

Step 6. When Step 5 is dry, another wash of this misty mixture is brushed over the rocks in the immediate foreground. Then a little more white is added—though not enough to make the mixture opaque—and this misty tone is carried over the sea, the cliff to the right, the distant cliffs, and the sky. Now each successive rock formation seems farther away. A little more white is added to the mixture, and the tip of a round brush adds lines of foam around the rocks.

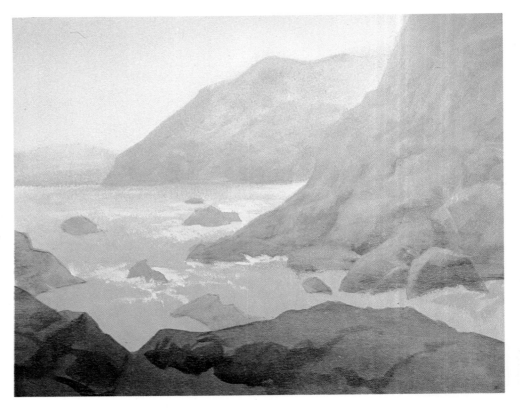

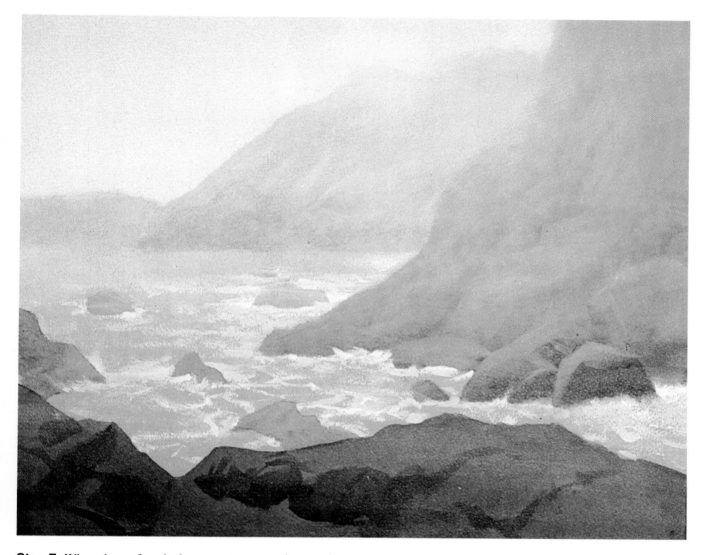

Step 7. When the surface is dry once more, another touch of white is added to the foggy mixture. This semi-opaque tone is brushed over the upper half of the picture and scumbled over the edges of the cliffs to blur their outlines. A round brush draws more lines of foam along the bases of the cliffs, around the rocks, and in the churning water. The completed painting is a dramatic example of the way acrylic color can be used in varying degrees of transparency and opacity to create atmospheric effects. Starting with transparent color, the painting is completed with veils of semi-transparent color, each a little more misty than the preceding veil. The whole trick is to proceed in very gradual stages, always adding a little *less* white than you think you need—so you don't risk covering all the careful work underneath.

Step 1. A sturdy sheet of watercolor board—cold pressed watercolor paper mounted on stiff cardboard by the manufacturer—is brushed with a thin coat of acrylic gesso. The gesso is diluted with water to a consistency of thin cream so that the white paint settles evenly over the paper, showing no brushstrokes. The texture of the watercolor paper is unchanged, but now the surface is slightly tougher and less absorbent than the bare watercolor paper. The gesso coating provides a particularly receptive surface for the opaque technique. Then the shapes of the rocks, the distant sea, and the coastline are drawn in pencil on the gesso surface.

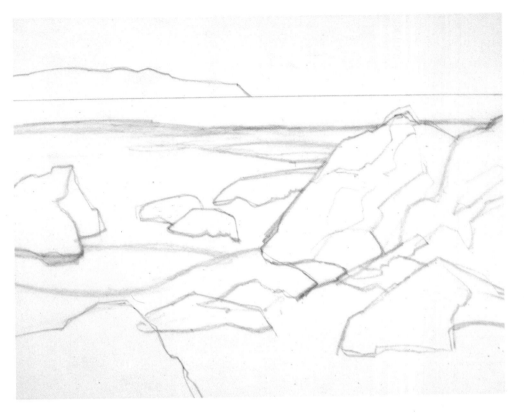

Step 2. A kneaded rubber eraser moves over the painting surface, removing all superfluous lines and lightening the few lines that remain. Then a flat nylon brush covers the rocks with transparent strokes of burnt sienna, ultramarine blue, and yellow ochre, diluted with water. On the gesso surface, these strokes stand out clearly instead of melting together, as they'd be inclined to do on bare watercolor paper.

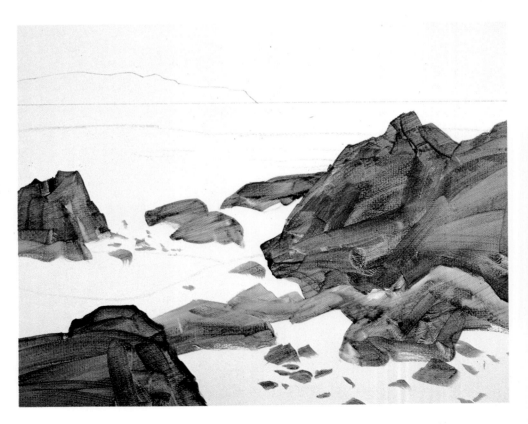

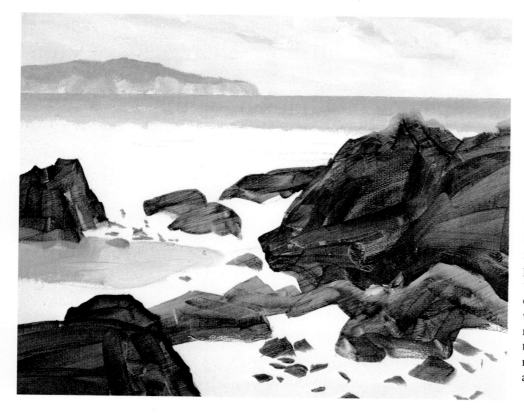

Step 3. The sea and the pool are brushed in with a mixture of phthalocyanine blue, naphthol crimson, yellow ochre, and white—with more white in the lighter passages. The cloudy sky is painted with this same mixture—containing more white in the clouds—since the sea and sky must match. The blues of the sky are painted first; then the clouds are scumbled over and into the wet blues. The distant headland is painted with this mixture, but in different proportions: more blue and less white on the dark top; more crimson, yellow ochre, and white on the paler slopes. The rocks are darkened with a transparent wash of ultramarine blue, burnt sienna, and water.

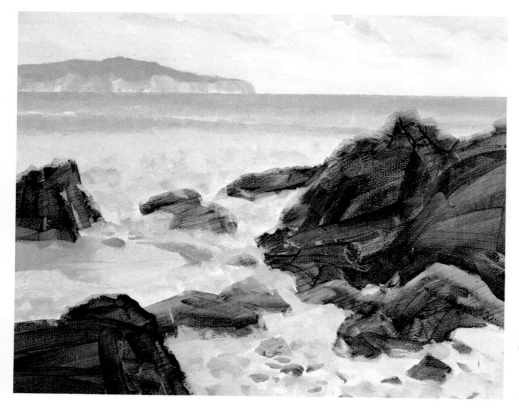

Step 4. The sand is covered with a smooth, opaque, but fairly fluid mixture of phthalocyanine blue, naphthol crimson, yellow ochre, and lots of white. Over this smooth undercoat, a small bristle brush adds individual touches and dabs of this same mixture—containing less white—to indicate pebbles and the irregular texture of the sand. Some of the sea tone is scumbled in at the edge of the beach to suggest the wetness of the sand. You can see that the surrounding colors are beginning to obscure the edges of the rocks, but this will be corrected when the rocks are repainted in thicker, more opaque tones.

Step 5. The lighted planes of the rocks are brushed in with a small bristle bright carrying thick, opaque color. This is a dense mixture of ultramarine blue, burnt sienna, yellow ochre, and white. The paint is the consistency of thick cream, and the brushstrokes are roughened by the texture of the watercolor board. The brush also touches the tops of some of the pebbles scattered between the larger rocks.

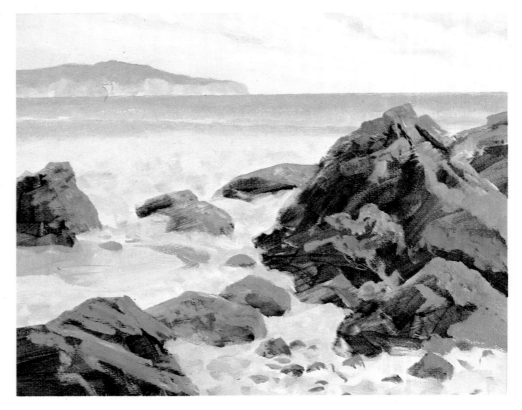

Step 6. The dark sides of the rocks are painted with a flat nylon brush carrying ultramarine blue, cadmium red, yellow ochre, and just a hint of white. Look carefully at the big rock on the right, and you'll see how the shapes of the shadows are painted with great care, slightly overlapping the edges of the lighted planes that were painted in Step 5. Thus, the planes change their shapes. The shadow sides of the foreground rocks aren't completed yet. More white is added to this shadow mixture, and this lighter tone is brushed over the sand to suggest the shadows cast by the big rocks.

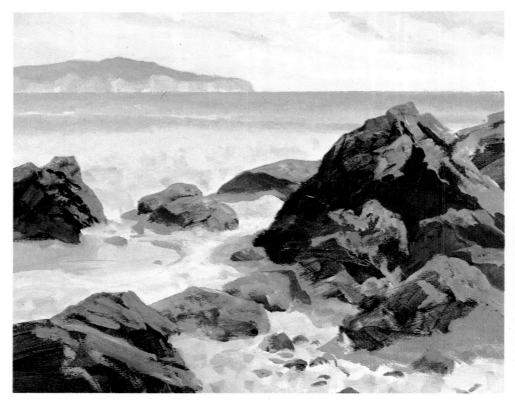

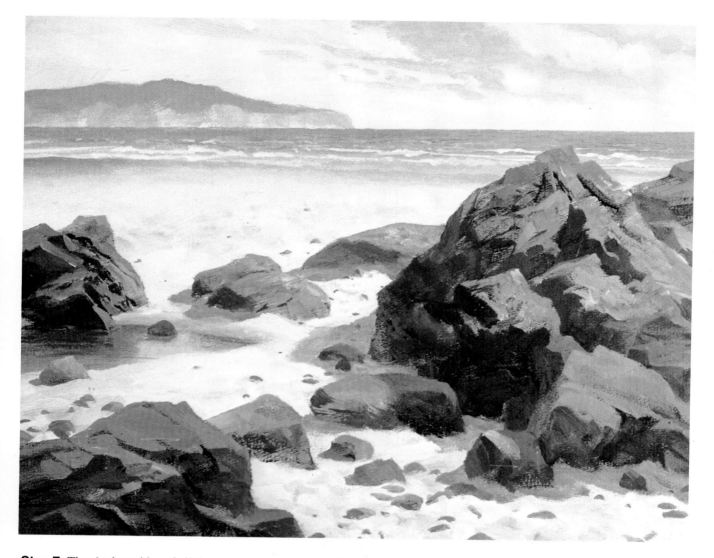

Step 7. The shadow sides of all the rocks are now darkened with a mixture of ultramarine blue, cadmium red, yellow ochre, and a little white. Then a bristle brush picks up more of the original mixture that was used to paint the lighted planes: ultramarine blue, burnt sienna, yellow ochre, and white, diluted with just a little water so that the paint is thick and pasty. Strokes of this mixture define the lighted planes of the rocks more clearly and give them a rougher texture. Some final dark touches are added to the shadow sides of the rocks with ultramarine blue, cadmium red, yellow ochre, and a hint of white. In the process of reinforcing the lights and darks, their shapes have changed to form a more satisfying design; compare the completed rocks in Step 7 with those in Step 6. The tip of a round softhair brush picks up the fluid shadow mixture to add some cracks and details among the big forms of the rocks. This same brush adds a dark reflection in the pool at the left. A bristle brush goes back over the sand with a slightly thicker version of the original mixture: phthalocyanine blue, naphthol crimson, yellow ochre, and lots of white. The sand in the distance is simplified and looks smoother. In the foreground, some of the darker touches and some of the pebbles are eliminated. Then a small bristle brush adds some other pebbles with the same light and shadow mixtures used to paint the rocks. Most of the pebbles are now concentrated in the center foreground—a big, distracting pebble at the lower right has been painted over with sand color. The sky needs more blue to harmonize with the water; a big patch of phthalocyanine blue, naphthol crimson, yellow ochre, and white is scumbled in to create a break in the clouds. The tip of a round brush draws wavy lines of white—tinted with some sky color—over the water to suggest the foamy tops of waves rolling toward shore.

Step 1. The curving, rhythmic shapes of dunes are extremely subtle, and they can be difficult to draw. To get the shapes exactly right, it's a good idea to draw them first on a separate sheet of paper that's tough enough to withstand repeated erasures. You can then blacken the back of the sheet with charcoal or soft pencil, place the sheet on top of the painting surface, and transfer the drawing by going over the lines with a hard pencil. This is obviously a variation of the tracing paper method you read about earlier. In this preliminary drawing, you can see that the lines have been drawn and redrawn to refine the shapes.

Step 2. When the drawing is transferred to the watercolor paper, the heavy, multiple lines of Step 1 become precise single lines. The sky is first covered with a fluid, semiopaque wash of phthalocyanine blue, yellow ochre, and white. Ultramarine blue and white are brushed across the top and blended into the wet undertone. Now the sky is darker and cooler at the top, paler and warmer at the horizon. When the sky dries, a single, dark stroke of the sky tone—now combining ultramarine blue, phthalocyanine blue, yellow ochre, and a little white—is carried across the sea. While this stroke is still wet, the lower edge is softened with a stroke of clear water.

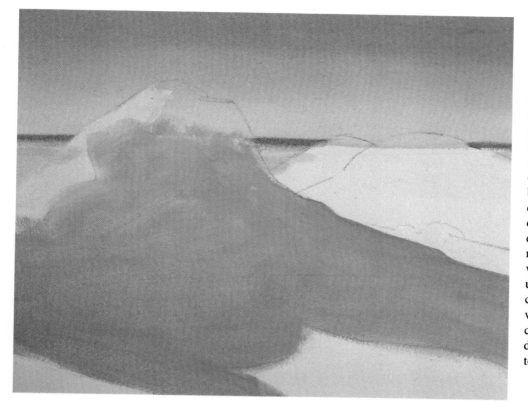

Step 3. Just beneath the dark line of the water, the small, triangular forms of the distant beach are scumbled with ultramarine blue, naphthol crimson, cadmium yellow, and white. The paint is thin and just slightly opaque. More white is added to this mixture, which is painted down the sunlit edge of the big dune. Before this tone is completely dry, the shadow of the dune is painted with darker strokes of the same mixture containing less white. The shadow tone gradually changes from warm to cool. The warm strokes toward the top contain more crimson and yellow. The darker strokes toward the bottom contain more blue.

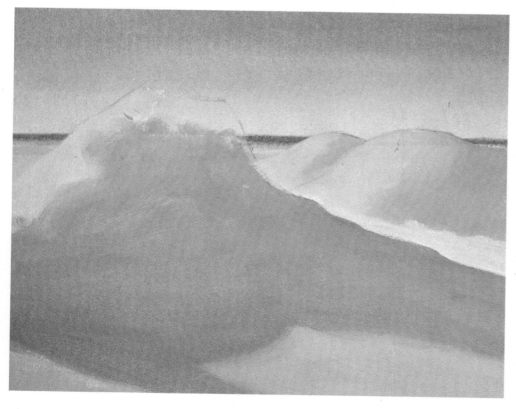

Step 4. The sunlit sides of the two smaller dunes, as well as the sunlit patches on the flat sand, are painted with the same mixture used for the lighted side of the big dune in Step 3: ultramarine blue, naphthol crimson, cadmium yellow, and a lot of white. While the sunlit planes of the small dunes are still damp, the shadow sides are scumbled with a darker version of this same mixture—containing less white—so that the light and shadow blend softly together. This blending gives a rounded shape to the dunes. The texture of the watercolor paper softens the brushstrokes and makes the blending easier.

Step 5. Over the blue sky, a flat nylon brush scumbles some clouds with diagonal strokes. These clouds are the same mixture used for the lighted sides of the dunes: ultramarine blue, naphthol crimson, yellow ochre, white, and enough water to make the paint flow smoothly. Then a small, flat bristle brush adds the first dark vegetation to the top of the dune with drybrush strokes. This is a thick mixture of ultramarine blue, burnt sienna, yellow ochre, a little white—and not much water. The drybrush strokes are particularly ragged because the brush is held almost parallel to the paper. The flat side of the brush does most of the work.

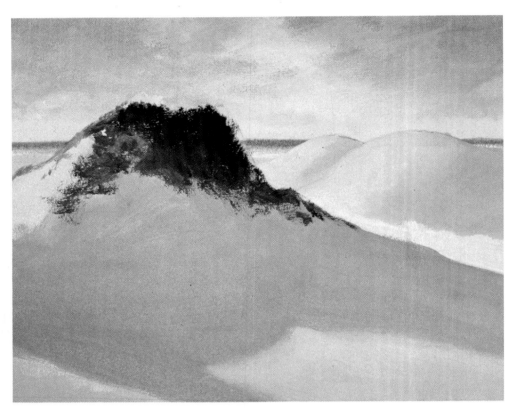

Step 6. The distant grass is drybrushed with the tip of a small bristle brush carrying the same mixture—plus more white—that was introduced in Step 5. The brush is pulled upward to make a ragged, vertical stroke that suggests individual blades and stalks. The tip of a small, round soft-hair brush adds a little water to the dark mixture, which now becomes more fluid and more suitable for precise brushwork. This brush carries some slender lines of grass down the side of the big dune and brings some individual blades from the top of the dune into the sky. The flat side of the bristle brush adds more smudges to the side of the big dune.

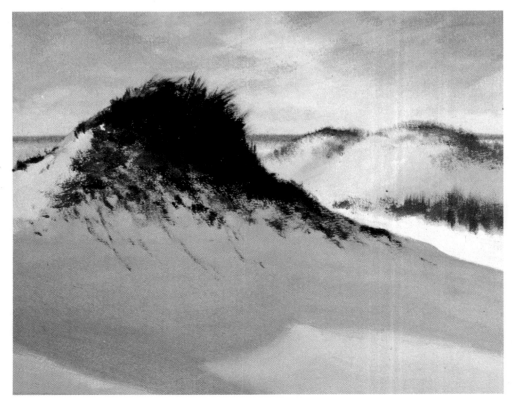

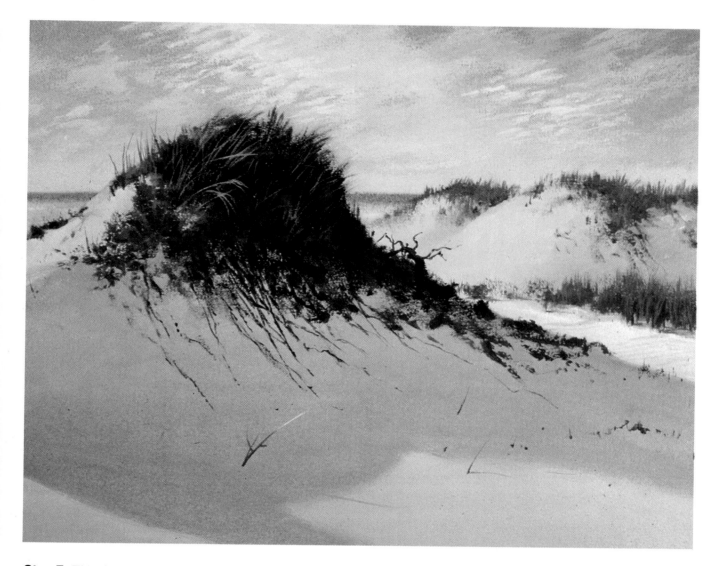

Step 7. The clouds are more precisely defined with short, parallel, diagonal strokes of white tinted with the slightest touch of phthalocyanine blue, naphthol crimson, and cadmium yellow. The brush skims lightly over the paper so that the texture of the painting surface roughens the stroke. The sharp point of a small softhair brush adds more vertical drybrush strokes to thicken the growth on the distant dunes: a mixture of ultramarine blue, cadmium yellow, cadmium red, and white. More water is added to this mixture for precise brushwork. Then the point of the brush adds pale blades of grass with straight and curving strokes against the darkness of the big dune at the left. Not *too* many strokes are added—just enough to suggest more detail than you actually see. The small brush picks up the original dark mix-ture of ultramarine blue, burnt sienna, and yellow ochre to draw more lines of vegetation that wander down the side of the dune. The bit of driftwood on the right side of the dune is painted with that brush too. The tip of the brush adds a few dark blades to the immediate foreground. The blade just left of center catches a glint of light: it's the same mixture used for the lighted sides of the dunes. Finally, a transparent wash of yellow ochre diluted with a lot of water is carried over the entire sand area, adding a hint of sunny warmth. As you look back at the various steps in this demonstration, you'll notice that the picture is painted mainly with semi-opaque color, containing just a little white and enough water to make the paint flow smoothly.

Step 1. The sea invades a shallow stretch of coastline to form a complex pattern of water and "islands" of marsh grass. The shapes of the water and the grass form an interlocking design that must be carefully drawn to keep the shapes varied and interesting. The painting surface is a sheet of illustration board on which the shapes of the composition are drawn in pencil. Then most of the pencil lines are erased with kneaded rubber, leaving just a few faint lines that you see in Step 2.

Step 2. A stiff bristle bright picks up ultramarine blue, yellow ochre, and a good deal of water. The brush is damp, rather than wet, and the bristles apply this transparent mixture with an up-and-down scribbling motion that retains the marks of the bristles. All the grassy shapes are indicated with these loose, scrubby strokes. As the brush moves back toward the horizon, more water is added. A flat softhair brush covers the sky with clear water. Then a round softhair brush mixes a wash of ultramarine blue, naphthol crimson, and yellow ochre, diluted only with water, and pulls this tone across the wet sky with long, horizontal strokes.

Step 3. The sky is allowed to dry. Then a cool tone is brushed over the entire painting surface with a large, flat softhair brush. This wash is a mixture of ultramarine blue, burnt sienna, and yellow ochre, plus enough water to produce a watercolor consistency. The brush starts at the top of the picture and works down to the bottom with a series of horizontal strokes, each slightly overlapping the stroke above it; the marks of the brush fuse into a continuous tone. More water is added to the strokes as the brush approaches the bottom of the picture. Thus, you have a *graded wash* that moves from dark to light.

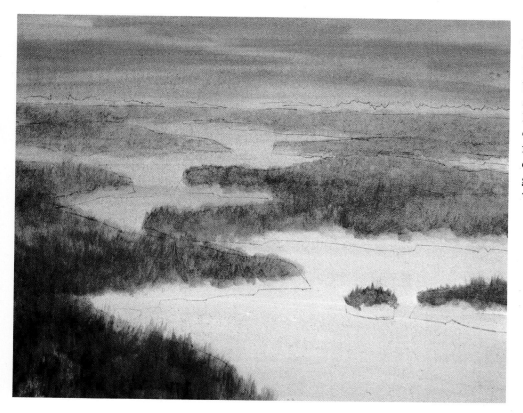

Step 4. The overall tone applied in Step 3 is allowed to dry. Then a large, flat softhair brush picks up a wash of burnt sienna, yellow ochre, and water. The brush is held like a pencil—almost perpendicular to the painting surface—and scribbled up-and-down over the "islands" of grass, which now take on a warm, rich tone.

Step 5. A small bristle brush paints the dark silhouette of the trees and dunes along the horizon. This is the first semiopaque color in the painting: ultramarine blue, naphthol crimson, yellow ochre, and white, diluted with water to a milky consistency. The dark tones beneath the "islands" of grass—and the dark reflections in the water—are painted with ultramarine blue, burnt sienna, yellow ochre, and a little white to add opacity. To paint the rough lower edges of the reflections, the brush is merely dampened with color and scrubbed up-and-down to make the reflection look slightly fuzzy.

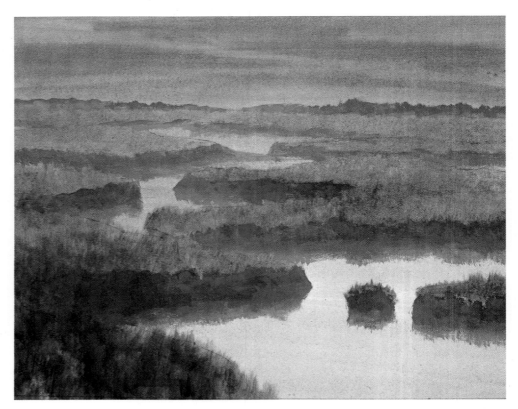

Step 6. Now the lighted tops of the grass are enriched with thicker, more opaque color. A bristle bright carries a creamy mixture of cadmium red, yellow ochre, ultramarine blue, and white. The brush is pressed lightly against the painting surface and stroked upward to suggest the rough marsh grass. The opaque color is applied unevenly, leaving some gaps where the undertone shows through. Notice the effect of aerial perspective: the distant grass is paler and cooler, containing more blue and white. There's also less contrast between light and shadow in the distance.

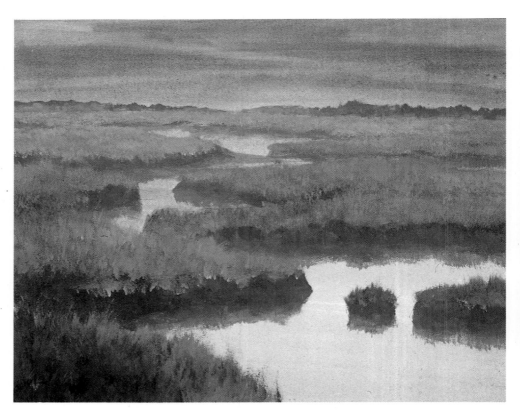

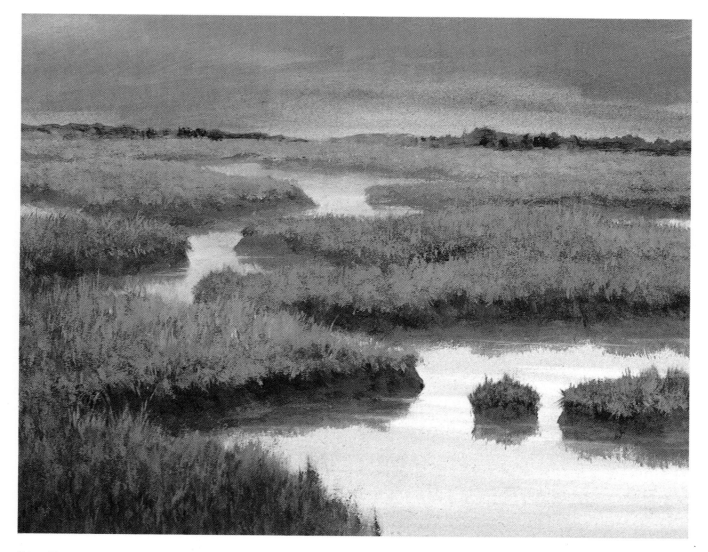

Step 7. This particular kind of illustration board is slightly rough, something like watercolor paper, and this surface becomes useful in suggesting the texture of the marsh grass in the final stage of the painting. The grass is completed with a thick mixture of cadmium red, yellow ochre, ultramarine blue, and white—the same colors used in Step 6, but containing less water, so the paint is quite dense. A bristle brush picks up this thick color and drybrushes the grassy tone over the "islands" in the marsh. The texture of the board roughens and breaks up the strokes, allowing dark flecks of the undertone to show through. The resulting color of the marsh grass is now a combination of all the different tones that have been applied at various stages in the painting, each color influencing the color applied on top. In this final stage, the bristle brush never covers the grass with an even tone, but moves lightly over the textured surface to deposit the thick color in ragged strokes. (It often helps to use the flat side of the brush, rather than the tip.) Then a round softhair brush picks up more of the grassy color to add slender, vertical strokes to suggest individual blades here and there. The horizontal streaks of light on the water are executed in an offbeat way. On this pale area, the color is so thin that it can be removed with the sharp edge of a hard rubber eraser. A ruler lies flat on the painting surface and guides the back-and-forth movement of the eraser as it removes streaks of color and reveals the bare board beneath. These lines are carried into the dark reflections with the tip of a brush that carries pure white diluted with a lot of water. Some darks are added to the horizon with touches of ultramarine blue and burnt sienna. Finally, the sky is simplified and darkened with a semi-opaque scumble of ultramarine blue, naphthol crimson, yellow ochre, and white.

Step 1. The headland is drawn like so many jagged building blocks with clearly defined vertical planes of light and shadow. The drawing is first made on a sheet of tracing paper and then transferred to a sheet of illustration board by the method you've already read about earlier. In the process of transferring the drawing—as you see in Step 2 below—many of the lines have been left out. However, the tracing paper is saved for reference. As the painting is executed, the original drawing will be consulted to determine the locations of the planes.

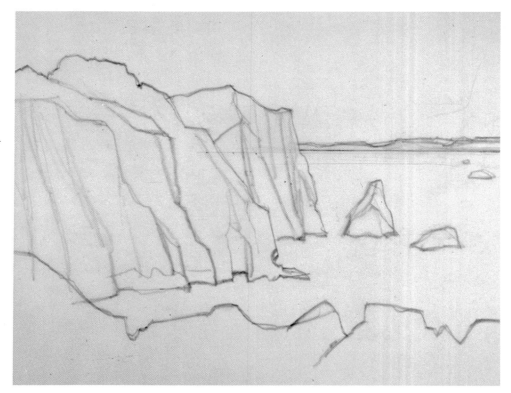

Step 2. The sea is painted with horizontal strokes of phthalocyanine blue, burnt sienna, yellow ochre, and white. As the strokes approach the horizon, more white is added. The shadowy undersides of the clouds are scumbled with the same mixture containing a bit more burnt sienna. The sunlit edges of the clouds are painted with yellow ochre and white scumbled into the shadows for soft transitions. The blue sky, breaking through the clouds at the top, is ultramarine blue, phthalocyanine blue, a little yellow ochre, and white. The blue patches in the middle of the sky are phthalocyanine blue, yellow ochre, and white. All these scumbling strokes are the work of flat bristle brushes.

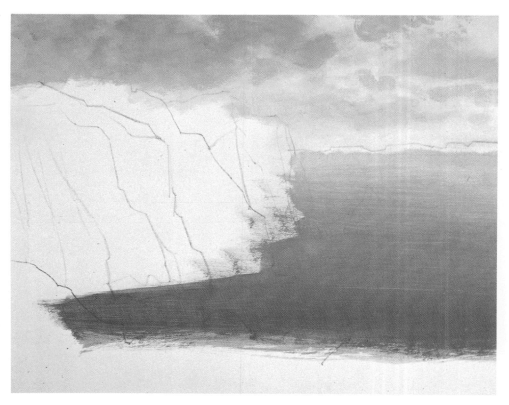

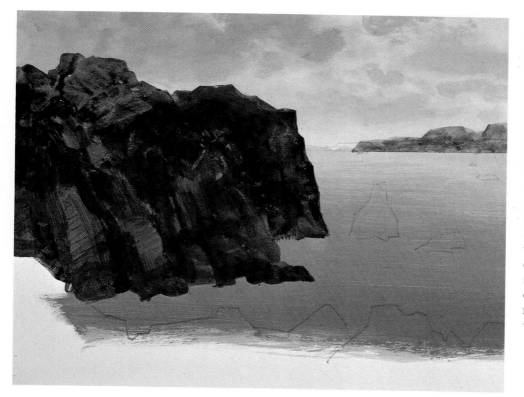

Step 3. The original drawing on tracing paper is laid over the painting surface once again, and the lines of the rocks are retraced. Then naphthol crimson, ultramarine blue, Hooker's green, and water are mixed to the consistency of transparent watercolor. A flat bristle brush scrubs this tone over the big headland and the distant shore. As you can see, the strokes vary in density. Some are much darker, containing less water. These darker tones become the shadow planes. The bristles of the brush leave scratchy marks in the wash; the marks will disappear in later stages.

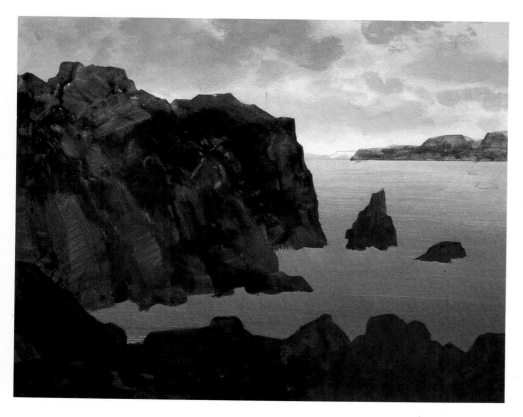

Step 4. This same mixture of naphthol crimson, ultramarine blue, Hooker's green, and water is brushed over the smaller rocks that stand offshore and the dark rock formation in the immediate foreground. The strokes of the foreground rocks contain less water, but they're still transparent enough to permit the light tone of the illustration board to shine through in some places.

Step 5. The dark, looming headland becomes darker still as a flat nylon brush subdues the color with a transparent wash of Hooker's green, burnt sienna, and water. A round softhair brush draws the foam at the foot of the headland with thin, horizontal strokes of white diluted with water to the consistency of thin cream and delicately tinted with phthalocyanine blue, yellow ochre, and naphthol crimson. The foreground rocks are lightened with an opaque mixture of ultramarine blue, burnt sienna, yellow ochre, and white. Now the dark, ominous form of the headland clearly dominates the picture.

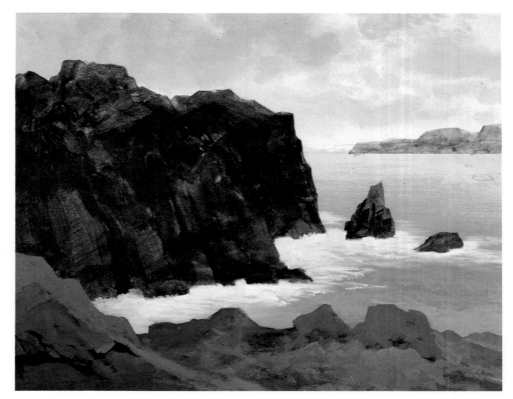

Step 6. The foreground rocks in Step 5 seem to obstruct the viewer's eye, which needs a "path" to enter the picture. The water tone—an opaque mixture of phthalocyanine blue, burnt sienna, yellow ochre, and white—blocks out some of the rocks in the lower right, so the viewer's eye can enter the picture more easily. Then a piece of white chalk is sharpened to redraw the foreground rocks in crisp lines applied directly over the dried color. As you've discovered by now, it's simple to change your mind and make corrections with acrylic paint, since it dries so rapidly and covers the underlying color so easily.

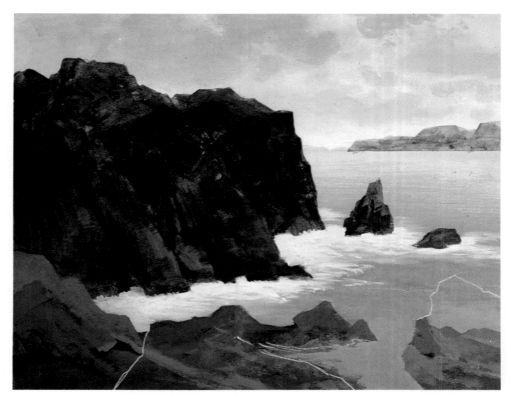

DEMONSTRATION 9. HEADLAND

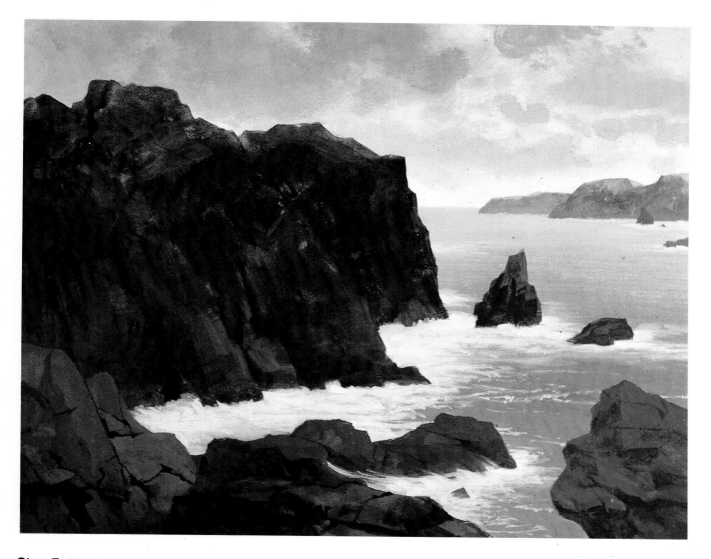

Step 7. The foreground rocks are repainted with thick, opaque mixtures of ultramarine blue, burnt sienna, yellow ochre, and white. The lighted planes of the foreground rocks contain more ultramarine blue and white, while the shadow planes contain more burnt sienna and less white. To draw the cracks and the crisp shadow lines on the foreground rocks, the tip of a round softhair brush adds thin strokes of burnt sienna and ultramarine blue, which make a rich dark. More dark notes, for additional crevices, are added to the big headland with this same mixture. The distant shoreline on the right is now divided into two separate headlands with strokes of ultramarine blue, naphthol crimson, yellow ochre, and white—obviously containing more white along the sunlit tops. The foam patterns along the near shoreline are completed with small strokes of white faintly tinted with the same mixture that's used on the distant shore. The strokes follow the movement of the foam as it moves up over the rocks in the center foreground, runs back down, and trails off into the water. A few more lines of foam are added to the edges of the distant rocks and shore.

Step 1. When the tide goes out, pools of salt water are often left in the low points of the beach. These pools frequently combine with rock formations to make an interesting coastal landscape. To take advantage of the texture of cold pressed watercolor paper, this demonstration is painted on a sheet of watercolor board. The drawing is made on tracing paper and then transferred to the surface of the board.

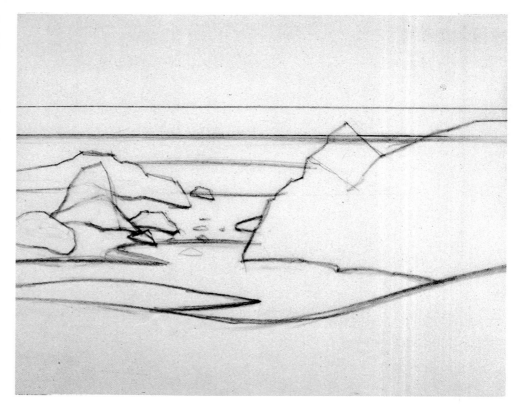

Step 2. The sky is painted with ultramarine blue, phthalocyanine blue, yellow ochre, and white, applied with a flat nylon brush. The brushstrokes at the top contain more ultramarine blue and less white. The warmer, paler tone above the horizon contains more yellow ochre and white. The narrow strip of sea is painted with ultramarine blue, yellow ochre, and white, applied in horizontal strokes; the bristle brush skims lightly over the painting surface, leaving some streaks of bare paper to suggest foam. Ultramarine blue, burnt sienna, and yellow ochre are thinned only with water to produce a transparent wash that's brushed over the tidepools on the beach.

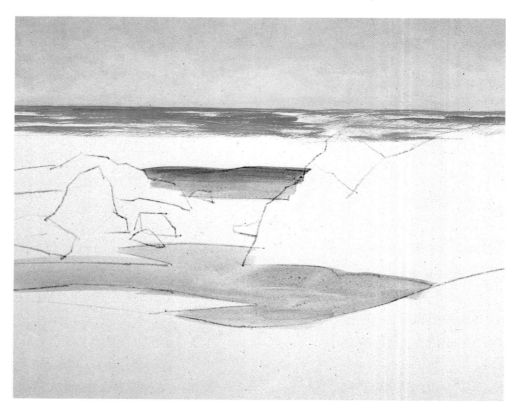

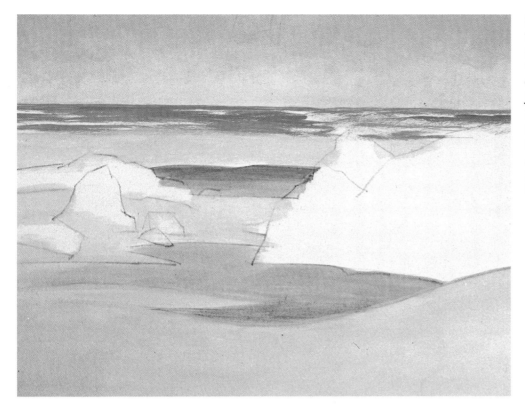

Step 3. Naphthol crimson, ultramarine blue, yellow ochre, and white are diluted with plenty of water to produce a thin, fluid tone that's just slightly opaque. This tone is brushed over the sand and also overlaps the bigger tidepool in the foreground. Although this color runs over the pencil lines, the mixture is thin enough to reveal them.

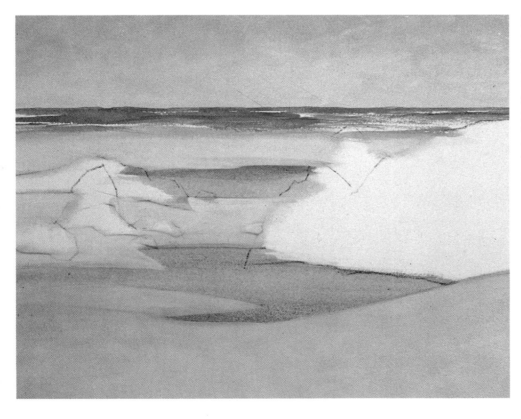

Step 4. The sand in Step 3 is too pale and warm. When the tone is dry, a flat softhair brush mixes another semitransparent wash of ultramarine blue, burnt sienna, yellow ochre, and a whisper of white. But the wash contains a bit more blue and is brushed over the entire beach, including both tidepools. Now the sand has a cooler, more subdued tone.

Step 5. The rocks are textured with thick, pasty color, undiluted with water or medium. The sunlit tops of the rocks are white tinted with naphthol crimson, ultramarine blue, and yellow ochre. The shadow planes are ultramarine blue, burnt sienna, yellow ochre, and white in varying proportions: some strokes contain more burnt sienna, while others contain more ultramarine blue or yellow ochre. But, at this stage, texture is more important than color. The rough, thick strokes of the bristle brush leave a craggy, impasto surface.

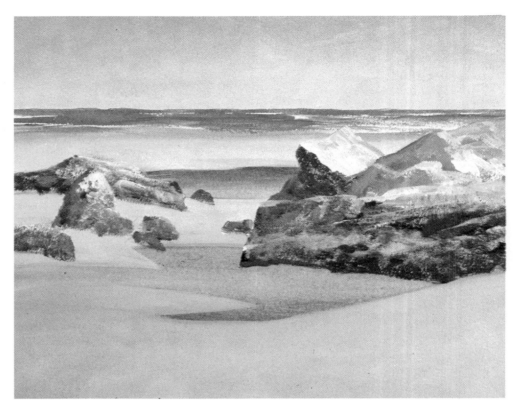

Step 6. The rough texture of the rocks is allowed to dry thoroughly. Then the rocks are glazed with a transparent mixture of ultramarine blue, burnt sienna, yellow ochre, water, and gloss medium. This fluid mixture sinks into the rough, impasto brush marks of Step 5 to produce a rocky texture. Less water is added to this glaze for the shadow planes of the rocks. This tone is carried downward into the pool beneath the big rock, where horizontal strokes render the reflection. When the reflection is dry, both tidepools are darkened with a transparent mixture that's mainly ultramarine blue and water, with a little burnt sienna and yellow ochre.

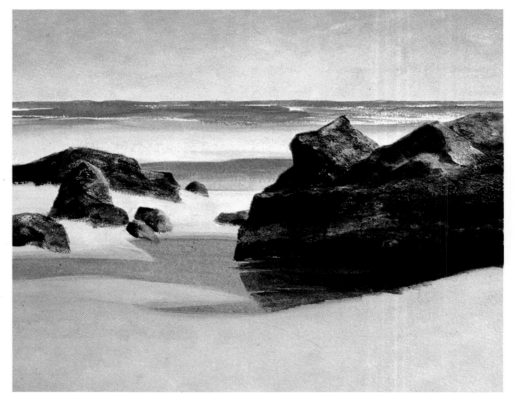

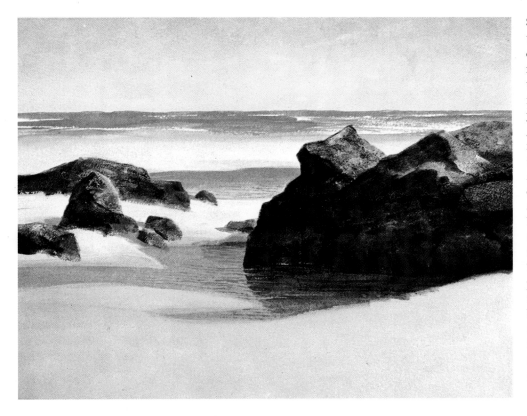

Step 7. The shadow sides of the rocks are darkened with drybrush strokes of the same mixture that was used to glaze the rocks in Step 6: ultramarine blue, burnt sienna, yellow ochre, water, and gloss medium. (The gloss medium thickens the glaze slightly and adds luminosity.) A pointed softhair brush draws cracks in the rocks with a dark mixture of ultramarine blue and burnt sienna. Some smudges of moss are added to the smaller rocks at the left. These are drybrush strokes of phthalocyanine blue, cadmium yellow, and a little burnt umber. Some sky tone and ripples are added to the tidepools with horizontal strokes of ultramarine blue, yellow ochre, and white.

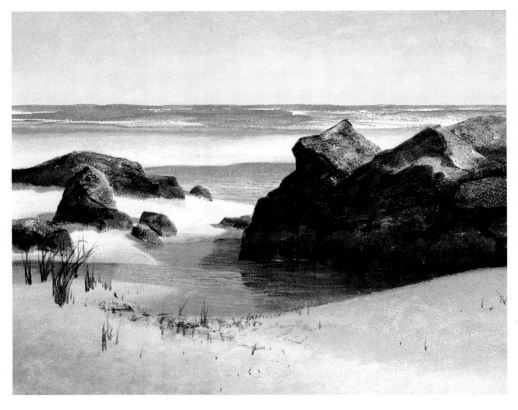

Step 8. More sky tone—phthalocyanine blue, ultramarine blue, yellow ochre, and white—is scumbled into the pools, which reflect the sunny sky overhead. Thin, horizontal lines of this mixture are carried across the pools with the point of a round brush to suggest ripples. A thicker, creamier sand tone is produced by mixing ultramarine blue, naphthol crimson, yellow ochre, and white; this is brushed over the sand in the foreground with short, scrubby strokes that allow the lighter undertone to come through. This brushwork suggests the irregular texture of the sand. The round brush begins to add some blades of beach grass with a fluid mixture of burnt umber, Hooker's green, yellow ochre, and water.

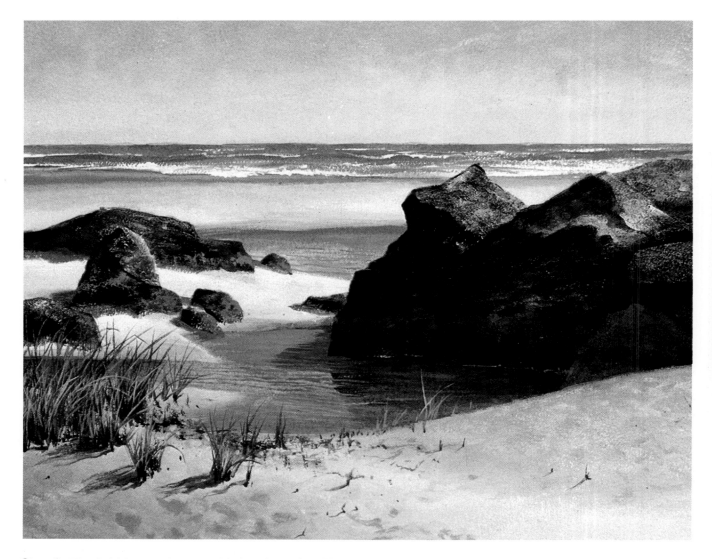

Step 9. The finishing touches are added to the rocks. The flat side of a bristle brush is used to drybrush some burnt sienna and ultramarine blue over the lighted tops of the rocks to produce a speckled texture. This drybrush work is then carried down over the shadowy sides. The moss on the rocks is strengthened with a mixture of phthalocyanine blue and yellow ochre. Additional drybrush strokes of sky tone are carried across the distant pool: a mixture of phthalocyanine blue, yellow ochre, and white. The cluster of beach grass is painted in two operations, very much like the grass on the dune in Demonstration 7. Some dark tones of Hooker's green and burnt umber are drybrushed. When these tones are dry, the point of a round brush adds indi-

vidual blades with Hooker's green, yellow ochre, burnt sienna, and white. Some blades, caught in sunlight, contain more yellow ochre and white. The curving beach in the immediate foreground is darkened with short, scumbling strokes of ultramarine blue, naphthol crimson, yellow ochre, and white—particularly at the extreme right and left. Some darker smudges of this color suggest footprints in the lower left. The shadows of the beach grass are drawn with thin, wavy strokes of burnt sienna, ultramarine blue, yellow ochre, and white. Finally, the sand is warmed with an almost invisible, transparent glaze of yellow ochre dissolved in pure water.

Center of Interest. Painters love the coastline because it's so easy to find dramatic shapes to paint. Finding the focal point of your picture—a looming cliff, a jagged rock formation, a crashing wave—may not take very long. What usually takes more time and more thought is finding the right vantage point, the right light effect, and the right subsidiary elements.

Vantage Point. You can just set up your painting gear on the beach, look up at the cliff or look out at the waves, and start to paint. But it's usually worthwhile to walk around a bit to find the right vantage point or the right angle from which the subject looks most impressive. If you walk closer to the cliff and then look up at it from the shore below, the horizon seems lower and the cliff seems taller. If you walk farther away, you may have a more panoramic view of cliff, foreground rocks, and distant sea. Either one might make a good picture. Crashing waves are often too far away—and there are often too many of them. They're more dramatic if you get closer. But it's usually hard to get close enough without getting soaked. So the next best solution is to isolate some segment of the biggest wave, plus one or two more waves and perhaps a few rocks, and paint the subject as if you're standing nearby. You'll also find that the picture can change dramatically when you change your eye level. First try sitting at the foot of a rock formation and looking out across the beach. Then climb to the top. See which vantage point you like best.

Lighting. Your vantage point or angle of view will also affect the lighting on your subject. At midday, the sun is directly overhead, and the lighting tends to be uniform everywhere, with very little shadow. But throughout most of the morning and most of the afternoon, the sun is lower in the sky. This means that things like rocks, cliffs, dunes, and waves will have a lighted side and a shadow side. As you walk around your subject, you can decide how much light and how much shadow you want to see. From one angle, you'll see a lot of the sunlit side of the dune, with just a little shadow. Walk halfway around the dune, and you'll see mostly shadow and just a bit of sunlight. The dune (or rock or cliff) may also cast an interesting shadow, which enhances the picture when you stand at a certain spot. Any one of these light effects might make an interesting painting. But try to avoid a 50-50 balance of light and shadow: let the light or the shadow domi-

nate. Especially interesting things happen to the light in early morning and late afternoon, when the sun is really low in the sky. That's when the light is literally *behind* the shapes of rocks, waves, surf, cliffs, headlands, and clouds. Now these shapes are seen as dark silhouettes—which many seascape painters love best.

Secondary Elements. Having found your center of interest, you then have to decide how many other elements you want to include. A crashing wave, throwing up a mass of foam against a rock, may look even more violent with a calm stretch of beach in the foreground and peaceful, horizontal clouds in the distance. The curving shape of a big sand dune may look even more rhythmic if its curves are echoed in a couple of smaller dunes in the distance. And you can call attention to the biggest dune by crowning it with beach grass. That headland may look taller and more jagged if you suggest some low, flat shoreline along the distant horizon. If you're lucky, these secondary elements may be in the picture or nearby. If not, you may have to rely on sketches or on your memory.

Working Indoors. All these suggestions are based on the assumption that you'll be painting outdoors—which isn't always true. Lack of time, changing weather, or just your personal preference may take you indoors more often than outdoors. It's also a lot easier to reorganize nature in the comfort and leisure of your home or studio. If you plan to do most of your painting indoors, the most practical solution is to treat the outdoors simply as a source of material. Go to the coastline with just the equipment you need to make pictorial notes, not to paint a finished picture. Use a sketchpad and a pencil to make quick drawings of ideas for pictures, just blocking in the shapes of waves, clouds, rocks, and dunes. Then turn the page and make more careful drawings of the most important elements in your future picture. Try to record the exact shape of the wave and the pattern of the foam trickling down its face. Or study the precise form of the rocks, with the pattern of light and shadow and texture of the cracks. To record colors, pack just enough painting equipment to make small, simple paintings on scraps of illustration board. Or paint on a pad of thick drawing paper or watercolor paper. An indoor painting does start on location. And a day of outdoor painting can give you enough material for many happy days of painting at home.

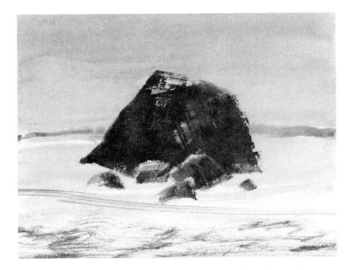

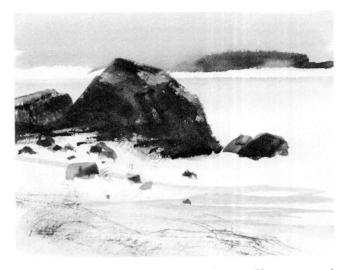

Don't drop the biggest, most important shape into the center of the picture, leaving the same amount of space on either side. And don't draw the horizon across the midpoint of the picture, splitting the composition into two equal halves.

Do place the focal point of your picture off center—and above or below the midpoint of the picture. Push the horizon line below the midpoint or raise it higher, as you see here. When the biggest, most important shape in the picture is off-center—as this rock is—you can then create a more interesting composition by balancing the big shape against some smaller ones.

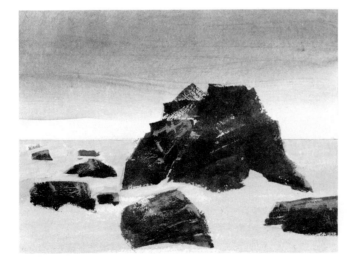

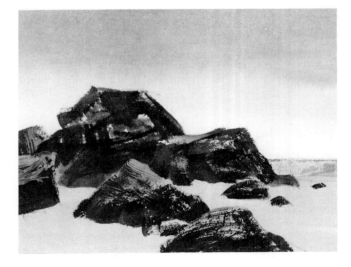

Don't scatter your shapes and make the eye hop around. Even if you find a lot of scattered rocks on the beach, you're under no obligation to copy them exactly.

Do organize the shapes so they interlock, with the smaller shapes leading the eye to the big one that dominates the picture. Now the rocks form a path that leads the eye upward to the big rock that becomes the focal point of the composition.

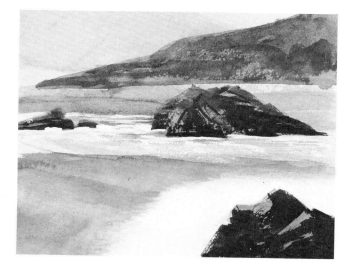

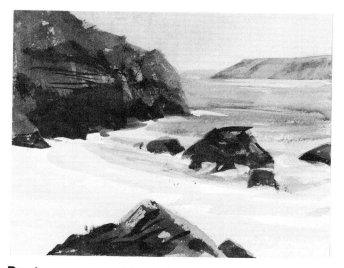

Don't organize the shapes in your composition so that they lead the eye out of the picture. In this coastal scene, the eye enters the picture at the lower edge, follows the line of the beach around to the right, and then keeps going straight out of the picture.

Do plan your composition so that the eye travels to the focal point of the picture. Here, once again, the eye moves along the edge of the beach. But now the curving line of the beach carries the eye to the big headland, which becomes the center of interest.

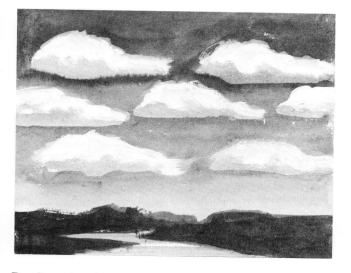

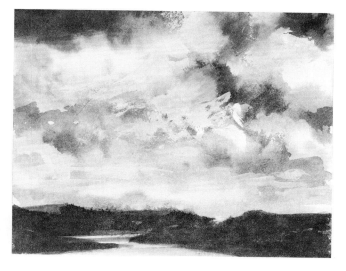

Don't make things the same size and shape, whether they're clouds or rocks or waves. Your composition will become as dull and repetitive as a piece of cheap wallpaper.

Do make your shapes varied and interesting. Merge the small, repetitive shapes of those clouds so that they become a few big, irregular, uneven shapes. Now the clouds themselves are more interesting—and so are the shapes between them, which are just as varied as the clouds themselves.

Rocks in 3/4 Light. The direction of the light is responsible for the distribution of lights and shadows on any three-dimensional form. For this reason, it's important to establish where the light is coming from before you start to paint a subject like this rock formation. Here, the light source—which means the sun—is above the rocks and somewhat to the left. Thus, the rays of the sun strike the tops and the left sides of the rocks, throwing the right sides into shadow. When the light source is above and somewhat to the side, this is called 3/4 light.

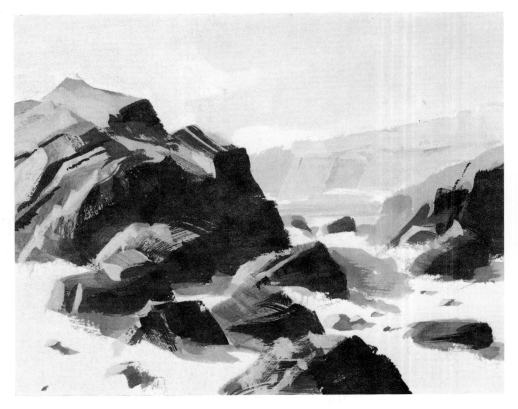

Rocks in Top Light. The sun is directly overhead, with its rays falling vertically on the top planes of the rocks. This plunges the side planes of the rocks into deep shadow. This is how things tend to look at midday, when the sun is high in the sky.

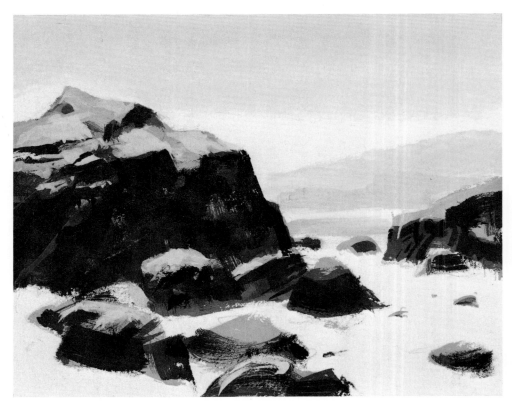

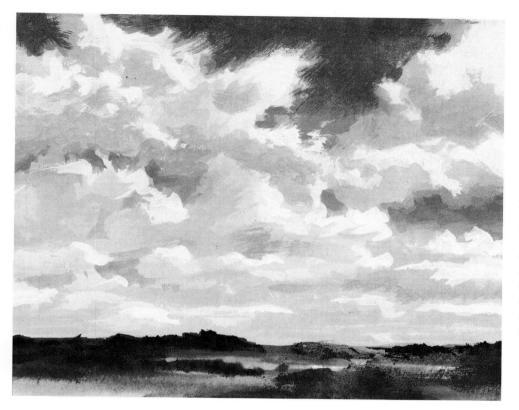

Clouds in 3/4 Light. Don't be deceived by the fact that clouds have softer, more irregular shapes than rocks. Clouds are still solid, three-dimensional forms. If you're going to paint clouds convincingly, you've got to pay attention to the direction of the light, so you can record the light and shadow planes just as you'd paint them on a rock formation. Here, the sun is above the clouds and to the right. Thus, the tops and right sides of the clouds are in bright sunlight, while the bottoms and the left sides are in shadow. Notice how the clouds also cast shadows on the landscape below.

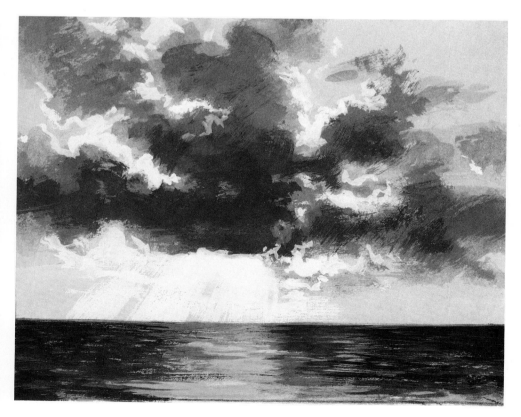

Clouds in Back Light. When clouds cover the sun, the sides facing you are in shadow. The clouds become dark, dramatic silhouettes with sunlit edges. In the early morning and late afternoon, the sun is low in the sky, behind headlands and rock formations, just as it is behind these clouds. Thus, the shapes of the shore are also particularly dramatic when they're backlit.

Rocks. The most effective way to create a sense of deep space in a coastal landscape is to emphasize the "laws" of aerial perspective. According to these "laws," near objects are darkest, show the most detail, and exhibit the strongest contrast between their lights and shadows. Objects in the middle distance are paler, less detailed, and lower in contrast. The most distant objects are the palest and least detailed, exhibiting little or no contrast between lights and shadows. Compare the rocks in the foreground, middleground, and distance to see how this works out in practice.

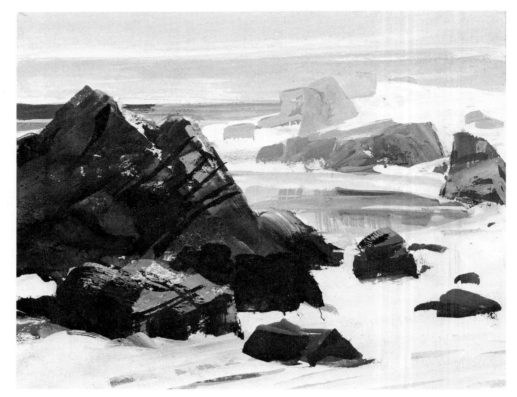

Dunes. The effects of aerial perspective are just as obvious in the dunes and beach grass of this coastal landscape. On the nearest dune in the lower left, the grass is darkest and most detailed. The big dune in the upper left—which represents the middleground—is obviously paler, and it's certainly harder to see the individual blades of beach grass. The most distant dunes are in the upper right: you can barely make out the difference between the lights and shadows; and the beach grass on the tops of the dunes is just a blur. Notice that the distant sea is even paler than the dunes.

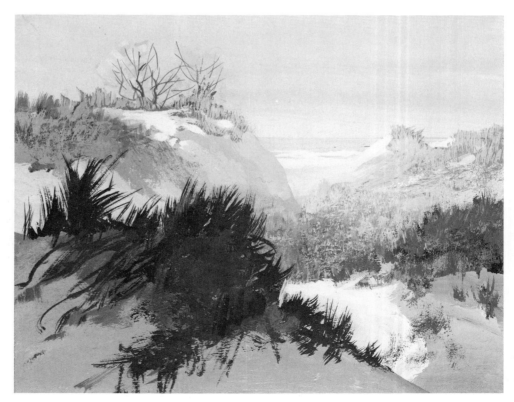

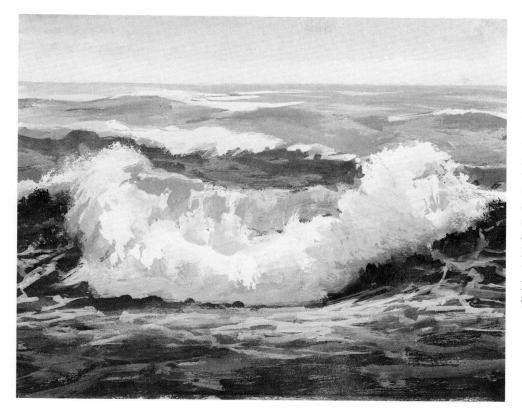

Waves. The nearest wave has strong lights and shadows. You can see a clear break between the sunlit and shadow planes of the foam. Clearly efined trails of foam run down the dark face of the wave to the right and left of the crashing surf. The wave in the middle distance is obviously paler and less detailed: you can no longer see a clear break between the lights and shadows on the foam; nor can you see any foam trickling down the dark face of the wave. The distant waves are paler still, revealing no detail at all.

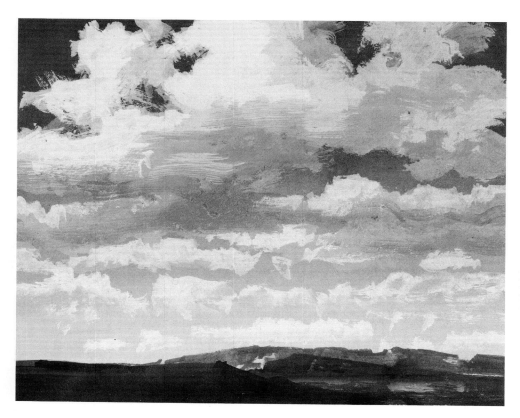

Clouds. Don't neglect perspective when you're painting clouds. The nearest clouds are directly overhead, which means they'll be high in the picture and bigger than more distant clouds. They'll also have stronger lights and shadows, and you'll be able to see the details of the edges more clearly. As the clouds move farther away, they'll be smaller and closer to the horizon. You'll see little or no contrast between their lights and shadows. And you'll paint their edges with less precision. The clouds at the horizon are the most distant and the least distinct.

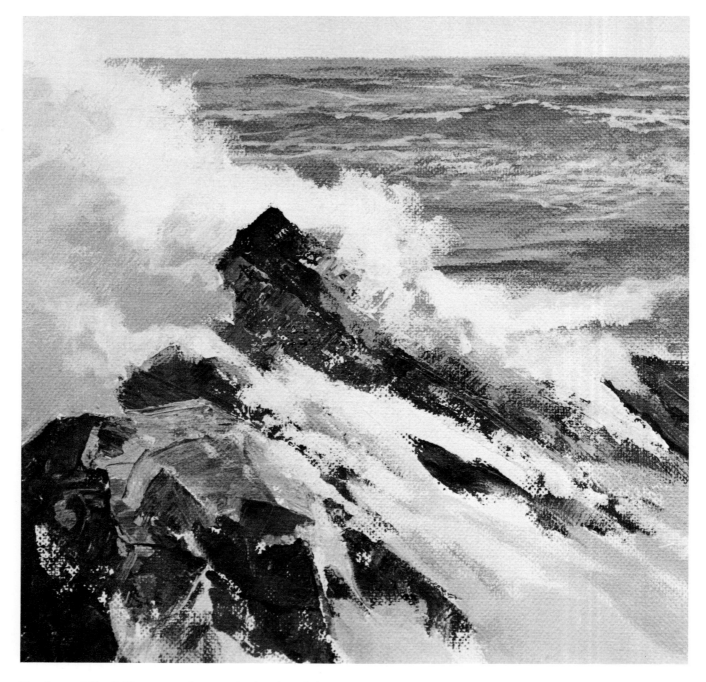

Rocks and Surf. The secret of expressive brushwork is to make the brush follow the movement or the direction of the form you're painting. The rhythmic swell of the distant waves is painted with slender, horizontal, rhythmic strokes of the tip of the brush, which actually moves over the water with a wavelike motion. As the surf explodes against the rocks, the brushwork changes totally. Now the strokes are short, decisive dabs and scrubs; the brush actually pulls the strokes upward and outward, moving as the foam moves. Then, as the foam spills over the rocks, the brush carries the foam across the flat tops of the rock formation with long, diagonal strokes that move from left to right. The rocks are painted with short, squarish, decisive knife strokes that correspond to the light and shadow planes of the form.

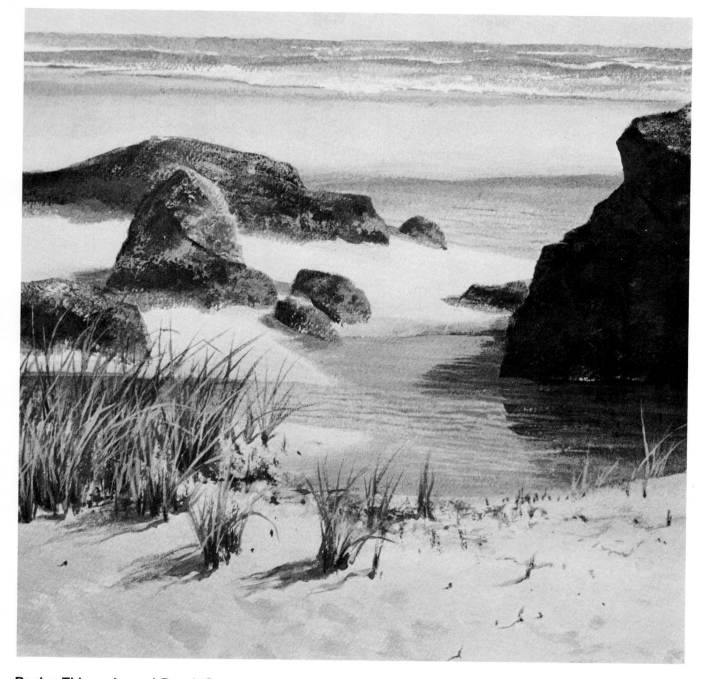

Rocks, Tidepools, and Beach Grass. The varied textures of this subject are reflected in the brushwork. The sand is painted with soft, smooth strokes of fluid color. In contrast, the rough texture of the rocks is rendered with drybrush strokes that emphasize the texture of the paper. The distant waves and the ripples in the tidepools are painted with wavy, rhythmic, horizontal strokes that suggest the movement of the water. The blades of beach grass are painted with slender strokes that start at the base of each blade and then curve upward, following the direction of the grass. The grass casts wavy shadows on the sand; these shadows are painted with wavy strokes.

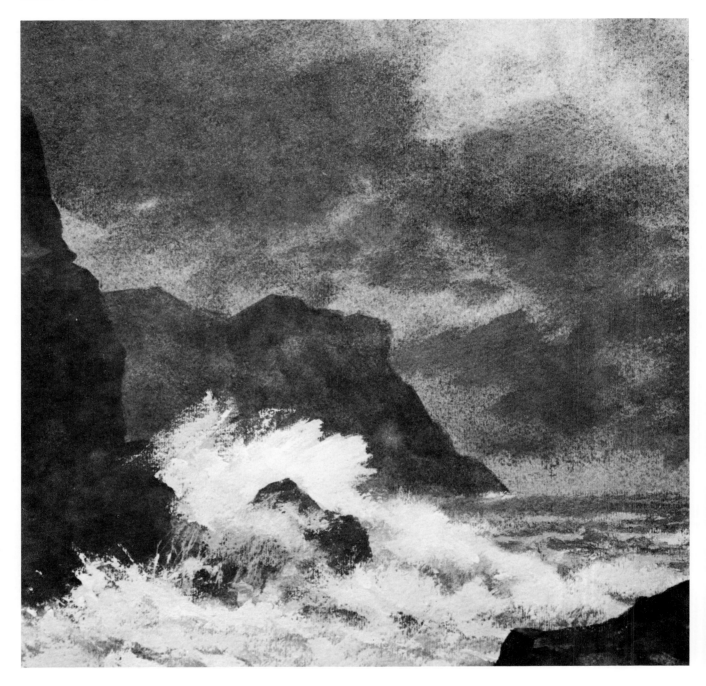

Storm Clouds and Surf. It's obvious that these dark clouds are being blown across the sky from left to right. The big, broad brushstrokes move across the sky in the same direction. Like the flying clouds, the strokes are rapid and turbulent. Where the surf strikes the rocky shore and flies back toward the sea, the strokes pull the paint diagonally upward, from left to right. The surf and the clouds seem to imitate each other's movements—and so does the brush.

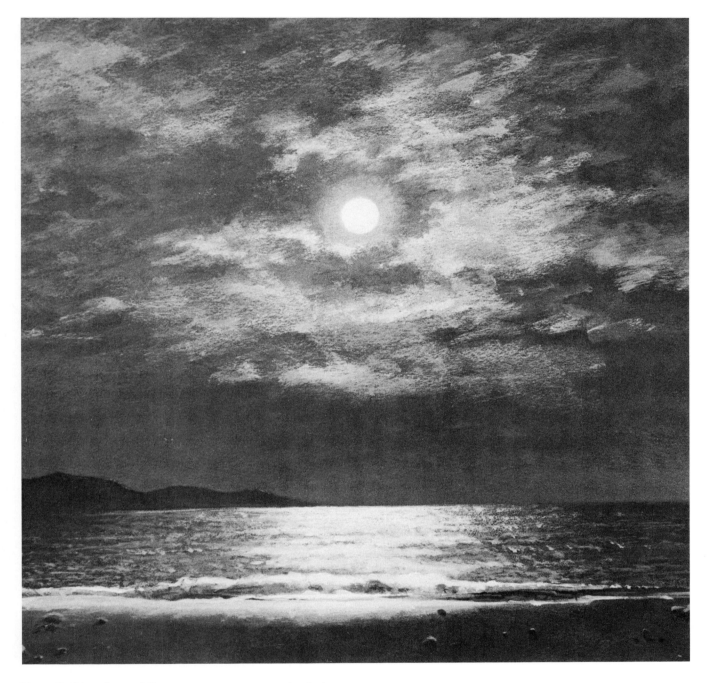

Moonlit Clouds and Sea. Like the clouds on the facing page, these moonlit shapes are obviously moving across the sky from left to right. But this is a serene sky, and the glowing clouds are moving more slowly. Now they're painted with soft scumbles. The brush moves gently back-and-forth over the textured paper, allowing the texture to come through and soften the stroke. The moonlight on the sea is also painted with gentle touches. The brush moves horizontally, depositing row upon row of small strokes. As the brush moves away from the bright reflection, the touches become smaller and farther apart, so the dark sea shows between them. The gentle movement of the clouds and water is expressed by gentle brushwork.

Swells. There are many different kinds of wave forms. Learn to identify them so you know what you're painting. In the open sea, the rhythmic shapes of the ocean are called swells. Their sides tend to be in shadow. Their tops and the troughs between the waves are lighter because they face upward and catch the light of the sky. Notice how these swells are painted with curving, arclike movements of the brush, suggesting the action of the water.

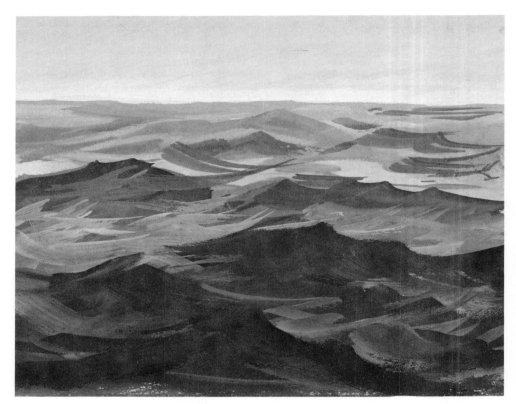

Whitecaps. When you see foam on a wave in the open sea, it's usually a whitecap. A high wind often tears up the crest of a swell, which turns white with foam. When the wind is especially violent, you may see the foam fly off into the air.

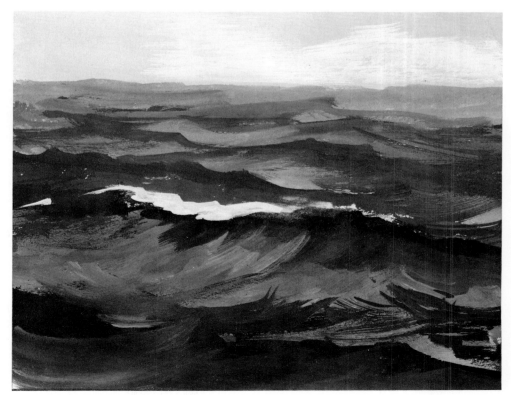

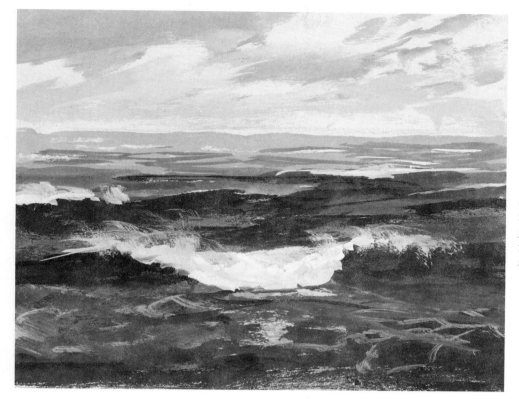

Breaker. As a wave approaches the shore, the curving face of the wave rolls over and explodes into foam. The foam often flies into the air and is swept away by the wind, as you can see to the right and left of this crashing wave. Beyond the big wave in the foreground, you can see more distant waves that are beginning to curve over and show their first traces of foam. In the immediate foreground, you can see trails of foam left by waves that have already broken.

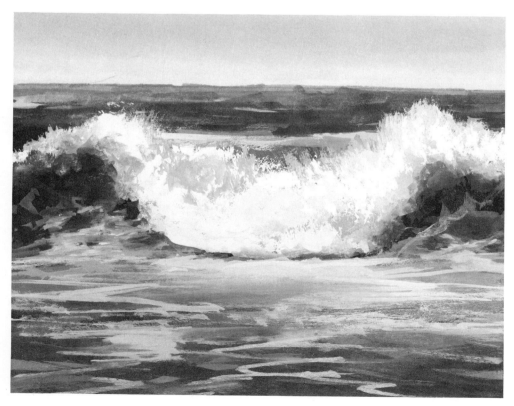

Close-up of Breaker. Here's the center of a breaking wave. The top edge of the wave has just curled forward and hit the surface of the water, producing an explosion of foam that flies upward. On either side of the crashing foam, you can see the dark face of the wave—it's dark because it's now in shadow—which will soon roll forward and explode too.

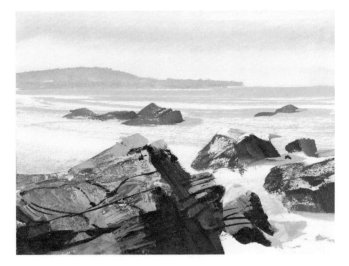

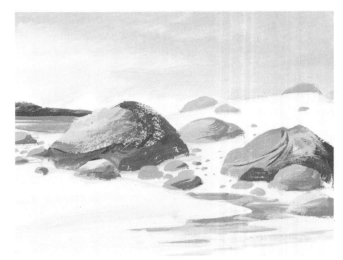

Blocky. On coastlines around the world, there are many different kinds of rocks. When you paint rocks, it's helpful to visualize them as simple geometric forms. Probably the easiest rocks to paint are the ones that look like shattered blocks, with clearly defined top and side planes. These planes tend to be fairly flat, although the blocky shapes are often tilted diagonally and half buried in sand and water. The planes are usually broken up by dark, irregular cracks.

Round. Nature also produces rocks that look more like soccer balls or footballs with their bottom halves buried in sand or water. On these curving shapes, the distinction between light and shadow planes isn't so clear. The lights merge softly into the shadows and demand subtle brushwork to show this gradation. This is when scumbling and drybrush are particularly helpful.

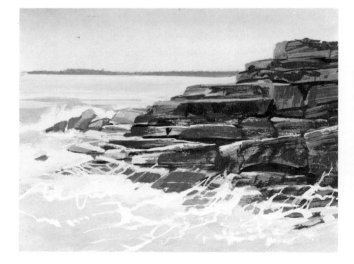

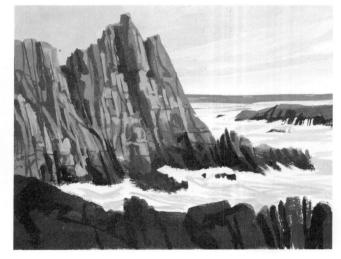

Horizontal. Rocks are often piled in horizontal strata, slab upon slab, like a badly made layer cake. These slabs tend to be blocky, with clearly defined top and side planes. So these rock formations are easy to paint if you pay careful attention to the flat planes of light and shadow.

Vertical. Nature sometimes turns that "layer cake" on its end, so the slabs are arranged vertically, rather than horizontally. The shapes of this vertical rock formation are like rectangular columns. They look complicated, but they're actually easy to paint because they have flat, clearly defined light and shadow planes.

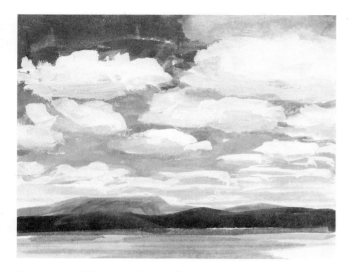

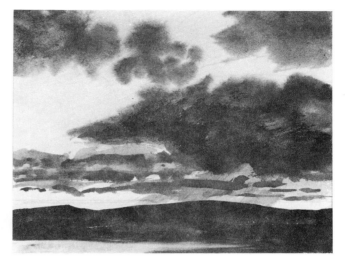

Cumulus. When you think of clouds, you probably visualize the big, round, puffy shapes that are called cumulus clouds. Because the sun is above, cumulus clouds usually have sunlit tops and shadowy undersides. When you paint a sky full of cumulus clouds, avoid making them look like a flock of sheep, all the same size and shape. Vary their shapes a bit and make the distant clouds—the ones at the horizon—much smaller than the big, nearby clouds at the top of the picture.

Storm. Storm clouds are darker and more ragged than cumulus clouds. The violent wind of the storm tears up the clouds and flings them across the sky. As you can see here, there's no "standard" shape for a storm cloud. At the top of the picture, the clouds have been torn into small fragments by the wind. The biggest cloud turns to a wedge-shape as it's pulled across the sky. And the clouds at the horizon have been torn into slender ribbons.

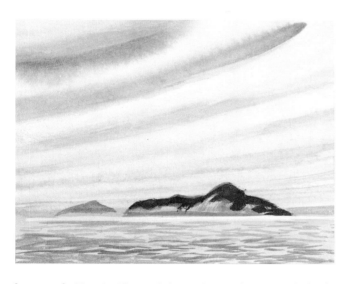

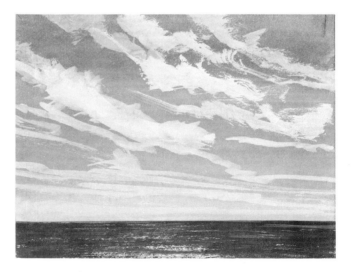

Layered. Clouds, like rock formations, often occur in horizontal layers. These may be parallel to the horizon, like the cloud layers just above this island, or they may tilt diagonally upward at one end, like the clouds higher in the sky.

Windswept. The wind constantly reshapes the clouds, creating dramatic and unpredictable forms. Here, the wind has torn the clouds into strips and then shredded the edges of the bigger clouds overhead. In painting clouds, the most important thing to remember is that each cloud formation has its own unique "personality." These evanescent shapes must be studied just as carefully as "solid" forms like rocks and dunes.

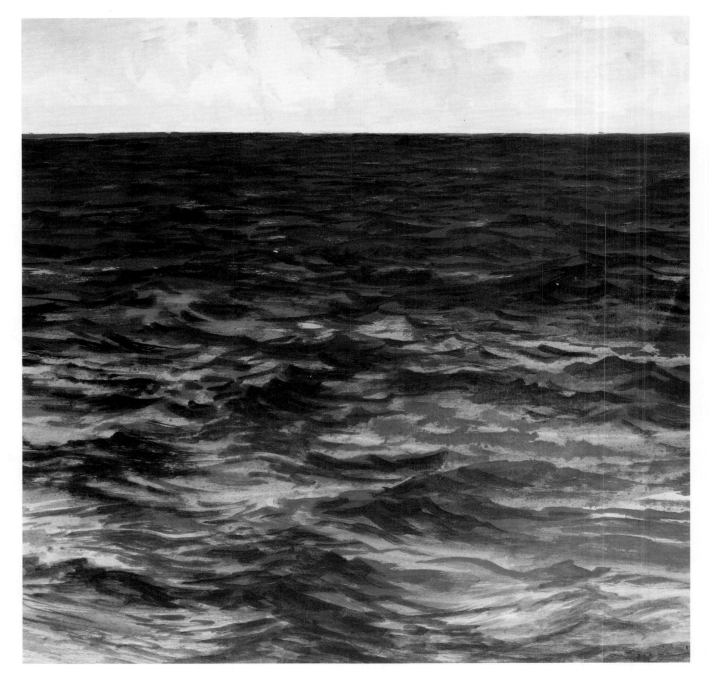

Open Sea. On a clear day, the sea often defies the "laws" of aerial perspective. You may be surprised to find that the sea is actually darkest at the horizon, growing paler in the foreground. This is probably because the more distant waves show us their shadowy faces—rather than their sunlit tops—and these strips of shadow seem to blend together on the distant water. As the waves approach us, we can see more of their sunlit tops.